TREASURES OF
THE HOLY LAND

ANCIENT ART FROM THE ISRAEL MUSEUM

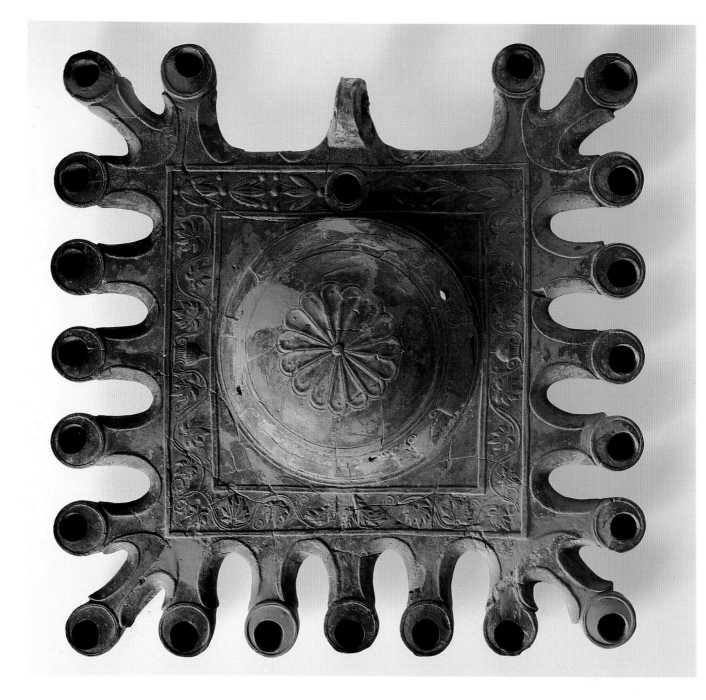

TREASURES OF THE HOLY LAND

ANCIENT ART FROM THE ISRAEL MUSEUM

THE METROPOLITAN MUSEUM OF ART

This publication was issued in connection with the exhibition *Treasures of the Holy Land: Ancient Art from the Israel Museum* held at The Metropolitan Museum of Art from September 25, 1986, through January 4, 1987; at the Los Angeles County Museum of Art from April 9, 1987, through July 5, 1987; and at The Museum of Fine Arts, Houston, from October 31, 1987, through January 17, 1988.

The exhibition *Treasures of the Holy Land: Ancient Art from the Israel Museum* has been made possible, in part, by Mr. and Mrs. Milton Petrie, Messrs. Frederick, Daniel, and Elihu Rose, Mr. and Mrs. Laurence A. Tisch, an anonymous donor, Mr. and Mrs. Eugene M. Grant, and Mortimer B. Zuckerman.

Transportation assistance provided by El Al Israel Airlines.

Copyright © 1986 The Metropolitan Museum of Art

Published by The Metropolitan Museum of Art, New York
BRADFORD D. KELLEHER, Publisher
JOHN P. O'NEILL, Editor in Chief
KATHLEEN HOWARD, Editor
JAMES PILGRIM, Project Director
JOHN K. McDONALD, Project Coordinator
HEIDI HAEUSER, Production Associate
ABBY GOLDSTEIN, Designer

Maps drawn by Wilhelmina Reyinga-Amrhein, New York

All works in the exhibition photographed by David Harris, Jerusalem

Type set by Columbia Publishing Company, Inc., Frenchtown, N.J.
Printed and bound by Dai Nippon Printing Co., Ltd., Tokyo

Front cover/jacket: Synagogue at En Gedi. Photograph: David Harris
Frontispiece: Multiple-nozzle lamp (cat. no. 102).

ISBN 0-87099-470-0
ISBN 0-87099-471-9 (pbk.)
ISBN 0-8109-1692-4 (HNA)

TABLE OF CONTENTS

FOREWORD

The land of Israel stirs in us all deep passion. To invoke even a few of its ancient places such as En Gedi, Qumran, Samaria, and Gezer stimulates yearnings for our cultural and spiritual origins. In our time these passions have often run dark and anguished, yet the land excites more joyous feelings as we reflect on a shared cultural and religious past, for Israel nurtured Judaism, bore Christianity, and supported Islam and thus commands the attention of nearly a quarter of the world's believers. Since time immemorial this land has been the alembic where, not always gently and frequently at great human cost, the Judeo-Christian ethos was distilled.

The exhibition *Treasures of the Holy Land: Ancient Art from the Israel Museum* presents nearly two hundred objects from the exceptionally rich collections of the Israel Museum. It is an overview of the artistic triumphs of the people who dwelled in Israel from the dawn of modern settlement in the Levant nearly twelve millennia ago until the eclipse of Byzantium in the seventh century of the current era. Positioned between the great riverine civilizations of Egypt and Mesopotamia, Israel welcomed—at times endured—the transit of many peoples. This ethnic and cultural diversity is fully reflected in the arts: from the tiny clay figurines of Horvat Minha to the burnished bronze statue of the emperor Hadrian from Tell Shalem.

The most ancient piece in the exhibition, a carved-bone sickle handle from HaNahal Cave in the Carmel range, comes from a habitation site nearly twelve thousand years old. It recalls that painful moment when early humans perceived their disjunction from the natural world. Sundered from the perfection of creation, the artist strove to close that chasm by a creative act: a closely observed carving of a young animal. The work sums up a poignant longing for unity and wholeness. Through the ages this same impulse produced the other great works in this exhibition. Whether creative leaps seemingly without parallel like the copper treasure from Nahal Mishmar or inspired borrowings from the arts of neighboring countries like the Samaria ivories, all these objects elicit our admiration even as they give pleasure.

We are fortunate that a high proportion of the objects in the exhibition are derived from controlled excavations. These works, so temporally remote, are isolated from their cultural matrix, and beautiful though they are, they may often perplex the viewer. To minimize this difficulty, the design of the installation and catalogue reflects the ancient context wherever possible.

The Metropolitan Museum of Art had long hoped to bring the archaeological material of the Israel Museum to the American people, and it is through the understanding and patience of our colleagues at the Israel Museum, in particular its Director, Dr. Martin Weyl, and Mrs. Miriam Tadmor, the Curatorial Coordinator of the project, that this hope has been made manifest. What at times seemed a long gestation period proved beneficial in many respects, as it permitted us to refine the exhibition which, given the ample riches of the Israel Museum, was not an easy task. Once the selection of material was made, the Israel Department of Antiquities and Museums generously approved all our requests and in so doing ensured the success of the exhibition. The President of the American Friends of the Israel Museum, Romie Shapiro, and its Executive Director, Mrs. Michele Cohn Tocci, were always available to clarify and speed the transmission of information between the respective museums and have immeasurably simplified our task.

As with all international exhibitions, the need for sensitivity and tact in dealing with a welter of domestic and foreign agencies was of paramount importance and was admirably met by William B. Macomber, the Museum's former President, and by James Pilgrim, Deputy Director, who in his added role as Project Director, supervised the curatorial and administrative progress of the exhibition. John McDonald, my assistant, coordinated all the numerous aspects of the project with intelligence and energetic care. He and Maxwell L. Anderson of the Museum's Greek and Roman Department were responsible for shaping the exhibition at the Metropolitan Museum. John P. O'Neill, Editor in Chief, deserves great credit for the conception of the exhibition catalogue and Kathleen Howard, Senior Editor, for carefully balancing a text that was the product of many minds. Other staff members have provided invaluable assistance through their tireless efforts. I acknowledge especially the contributions of the Museum's Registrar's Office, Objects Conservation Department, and Design Department.

An essential corollary to such exemplary demonstrations of goodwill and cooperation, and without which the exhibition surely would not have come to fruition, is the financial support of many good friends. We are especially grateful for the generosity of Mr. and Mrs. Milton Petrie, Messrs. Frederick, Daniel, and Elihu Rose, Mr. and Mrs. Laurence A. Tisch, and an anonymous donor, as well as for the added support provided by Mr. and Mrs. Eugene M. Grant and Mortimer B. Zuckerman.

PHILIPPE DE MONTEBELLO
Director
The Metropolitan Museum of Art

FOREWORD

This exhibition reflects the character of the peoples that endowed the Holy Land with its unique civilization. It begins with the prehistoric periods and concludes with the fateful conjunction of Judaism and Christianity that laid the foundation for modern western civilization. In most cultures the visible is the dominant element, but in the Holy Land the invisible—the one and ineffable God—has left an indelible imprint. The word rather than the monument, the script rather than the impressive edifice, characterized this civilization.

The works included in this exhibition lead us from primitive paganism through a variety of stages to the culmination of the cultural and religious experience, expressed in the Bible, which formed the foundation of western spirituality. Indeed, it is with the Bible that our land and its history have always been associated. This association has, however, frequently been expressed in literary and visual images that bear little resemblance to the reality of biblical times. When facing the actual remains of antiquity, visitors may be startled to realize how little the objects conform to the images they have lived with since childhood. All of these works have, of course, been taken out of their contexts. Many of them are more meaningful within their original settings—the soil of Galilee, the sands of the Negev, the mountainous area around the Dead Sea, an ancient excavated city, the Mount of Olives, or the Temple Mount in Jerusalem. Perhaps this exhibition will encourage visitors to come to the source: Israel itself. Indeed, nothing evokes the spirit of biblical times more than a walk on the ramparts of Jerusalem looking out over the hills of Judaea, the desert in the distance sloping toward the Jordan Valley, the olive trees and fruit trees, the many archaeological gardens and sites with their history and legends.

It is within this setting that the Israel Museum was created twenty years ago atop a hill overlooking the fifth-century Monastery of the Cross. Its establishment demonstrates the great thirst for aesthetic and cultural exploration, even while existential problems remain dominant. The museum was intended to be universal in its collections with an emphasis on Israel's past as well as on its contemporary creativity. The largest section of the Museum—The Samuel Bronfman Biblical and Archaeological Museum—was therefore dedicated to the country's archaeological material (the Dead Sea Scrolls are exhibited in a separate building, the Shrine of the Book). Here the visitor can see a most comprehensive display of archaeological material from prehistoric and prebiblical times through the bibli-

cal and postbiblical periods. We are also fortunate in the richness of our other collections. The sections of Jewish ceremonial art and ethnography reflect the material culture of the Jewish people in the Diaspora. At the same time, the Museum is actively involved in showing Israeli art and design through permanent and temporary exhibitions. There are collections of old master paintings, Impressionist and Post-Impressionist paintings, drawings, and prints, and modern and contemporary art and design; there are a number of important period rooms. The Billy Rose Art Garden, designed by Isamu Noguchi, is an outstanding sculpture park. There are areas dedicated to the arts of Oceania, Polynesia, Africa, Pre-Columbian America, and the Far East. Through its active program of changing exhibitions, its schedule of cultural events, and its emphasis on educational programs for young people, the Israel Museum has become the largest cultural institution in the country, and it is a major attraction for both Israelis and visitors from abroad.

It is well known that through the ages the Jewish people have had an ambivalent attitude toward art. The Ten Commandments prohibit the making of "graven images," and in the Pentateuch there are repeated stern warnings against making divine images in human or animal form. However, at various periods in history these prohibitions were ignored. The Book of Exodus relates that the tribes of Israel adorned their sanctuary in the wilderness with representations of cherubim. Solomon's Temple in Jerusalem was also decorated with cherubim, and the great laver in the Temple was supported on the backs of twelve oxen cast in bronze. All these works must have been aesthetically impressive. Thus, at times the biblical prohibitions were meticulously observed and at others ignored. During the later biblical period and classical antiquity, when the worship of deities represented in sculptures and images was widespread throughout the Mediterranean world, the Jews reacted strongly against representational art. Under Byzantine and Islamic rule, there were also periods marked by iconoclastic tendencies. However, when the Jews moved more into the mainstream of western culture, they started sharing the artistic outlook of their European neighbors. With the Emancipation in Europe, the prejudice against representational art diminished, and today, except for Orthodox circles, it has almost completely disappeared. Contemporary Israel is home to a multitude of artists, art schools, and galleries with the greatest possible variety of attitudes and concepts.

The Israel Museum plays an important part in our modern, emerging nation. Walking through its galleries, the visitor understands our links with a long and distant past. The exhibitions themselves represent a renewed creativity after a long quiescence. Compared to the Metropolitan Museum, the Israel Museum is still a young and inexperienced institution, and it is therefore particularly grati-

fying that this prestigious sister institution has enabled us to exhibit our growing collections in the New World. We sincerely hope that these works from a far-off land and time will generate the same interest and enthusiasm in the United States as they do in Israel.

This exhibition is the result of the fruitful collaboration between The Metropolitan Museum of Art, New York, and the Israel Museum, Jerusalem. For our part, it was a very special pleasure to collaborate with our colleagues in New York who brought to the organization of the exhibition a spirit of warm cooperation. We acknowledge with gratitude the leadership of William B. Macomber, the former President of the Metropolitan Museum, and of Philippe de Montebello, the Museum's Director. It was a pleasure for us to work closely with James Pilgrim, Deputy Director, and we appreciate the great efforts and enthusiasm of John McDonald, Curator and Coordinator of the exhibition, and Maxwell L. Anderson of the Museum's Greek and Roman Department who were so instrumental in forming the exhibition.

After closing in New York, this exhibition will travel to Los Angeles and Houston. We thank Dr. Earl A. Powell III of the Los Angeles County Museum, and Peter Marzio, Director of The Museum of Fine Arts, Houston, for their cordial welcome and for their work on behalf of the exhibition.

Our warm gratitude is extended to Teddy Kollek, Mayor of Jerusalem and Chairman of the Board of the Israel Museum. We also note with deep appreciation the efforts and guidance of the members of the exhibition steering committee in Israel: Chairman Michael Arnon, Aviva Briskman, Avraham Eitan, Yehudit Inbar, Ruth Peled, David Rivlin, and Avner Shalev. Special thanks are due to our Ministry of Education and to the Foreign Office for their continuous support and especially to the Department of Antiquities and Museums for having loaned the objects for the exhibition.

The American Friends of the Israel Museum, New York, formed a vital link between the two museums; our very warm thanks go to Romie Shapiro, President, Michele Cohn Tocci, Executive Director, and the entire staff of AFIM.

Finally I wish to acknowledge the dedicated staff of the Israel Museum, in particular Yael Israeli, Chief Curator of Archaeology, Miriam Tadmor, Curatorial Coordinator for the exhibition, the curators who wrote the catalogue texts, and the very long list of staff members from all departments whose devoted efforts contributed to the success of this project.

MARTIN WEYL
Director
Israel Museum, Jerusalem

THE HOLY LAND
AN ARCHAEOLOGIST'S INTRODUCTION

Israel is a small country, comparable in size to the state of New Jersey. In antiquity more than half its area was uninhabitable desert, and much of the rest consisted of coastal dunes, malarial marshes to the north, and rugged hill country in the center, which was accessible only by arduous ascents from the maritime plain or the desolate Jordan Valley. These major topographical features are still evident. Lacking perennial streams and arable river valleys, the land is watered chiefly by unpredictable and often treacherous winter rains sweeping in from the Mediterranean. The soil is thin and rocky, scattered in small plots on terraced hillsides or in intermontane valleys, and always there is too much or too little water.

Israel looms large in our imaginations, but because of its size and meager resources, it was always overshadowed in the ancient Near East by its richer, more powerful, and more sophisticated neighbors, the colossi of Egypt and Assyria-Babylon. Compared to these great empires, Israel was almost a backwater. The Egyptians called the ancient Semitic inhabitants "Sand Dwellers"; one well-known text declares: "Lo the wretched Asiatic—it goes ill with the place where he is, afflicted in water, difficult from many trees, the ways thereof painful because of the mountains."

Israel's broken terrain contributed greatly to the land's political instability. Fragmented by regional factions, impossible to unite for more than a few generations, Israel has rarely known more than one hundred successive years of relative peace in its five-thousand-year history. Yet in the end its weakness was Israel's strength. Israel proved to be a fertile ground for the human spirit whose imagination, creativity, and endurance would flourish there, stimulated by the very harshness of the land.

Israel lies within the Cradle of Civilization, the arc sweeping from the Nile Valley, up the Levantine coast, along the Orontes River and through the Bika Valley, across northern Syria, and down the Tigris-Euphrates to the Persian Gulf. The earliest known civilizations lie at the ends of this arc in Egypt and Mesopotamia. And it was here that humans first made those extraordinary advances that ultimately formed the modern world: the domestication of plants and animals; the start of urban life; the rise of the state, of organized religion, of international relations and trade, of sociopolitical and economic order; the beginnings of art and monumental architecture; the invention of writing; the dawn of consciousness and of history. Israel, while sometime lagging behind in these developments, participated in them all, as its abundant archaeological remains testify.

THE LAND OF THE BIBLE

The fascination of ancient Israel is rooted in its connection with the Bible. For both East and West this is the Holy Land. Israel is sacred for Jews and Christians because it is the land that gave the world the Bible. It could be argued that when used for Israel, the term "Land of the Bible" is too exclusive, since the biblical world in the larger sense extended from ancient Mesopotamia to Egypt. And it could also be said that the term is too inclusive, for the biblical period proper is only a small part of this region's long history. Nevertheless, the term "Land of the Bible" stresses several important points. It was principally in this land that the People of the Book, both Jewish and Christian, lived, and the land helped to shape their collective religious experience. Here there occurred the central historical events that formed the core of the biblical tradition: promise to the fathers; deliverance from Egypt and settlement in Canaan; covenant–community; exile and return; the coming of Jesus and the new Kingdom of God. The Bible, the record of that experience and faith, is the preeminent heritage that ancient Israel has given to the world. People, Land, Book—they are inseparable, and their spiritual legacy makes them holy.

In fact, three religions call this land holy—not only Jews and Christians but also Muslims, who regard both Moses and Jesus as prophets and Jerusalem as a sacred shrine. These three religions, with their historical ties to the land, embody both the eastern and western traditions, and their adherents represent a large percentage of the world's population. Thus the Holy Land's place in history has always been disproportionate to its size and its political and economic importance. This was true in the Iron Age, in the Roman-Byzantine era, in the Middle Ages; it remains true today. The Holy Land's spiritual significance has, of course, its tragic aspects; no comparable bit of land has been fought over so fiercely.

ARCHAEOLOGICAL INVESTIGATION IN THE HOLY LAND

Israel is a vast outdoor museum, its countryside littered with the remains of once-flourishing societies. Large tells (mounds) dot the land, tombs honeycomb the hills, wall stubs protrude from the ground, and pottery sherds are strewn over the surface. Buried beneath nearly every town and village there lie layers of accumulations from previous occupations at the sites, sometimes going back almost continuously for as many as five or even ten thousand years. At every kibbutz plows turn up stone tools, fragments of inscriptions, and other relics of the past. Regional museums are filled with antiquities of every kind from every period. These are the bits and pieces that archaeologists use to reconstruct an astonishing succession and array of cultures: Canaanite, Amorite,

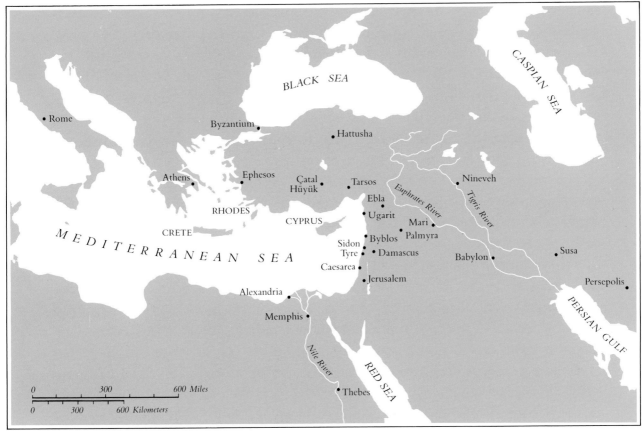

Fig. 1. The ancient Mediterranean world.

Hittite, Hurrian, Egyptian, Philistine, Israelite, Aramaean, Assyrian, Babylonian, Persian, Greek, Roman, Byzantine, Arab, Muslim, and Turkish.

With the nineteenth-century rediscovery of the lost civilizations of the ancient Near East, the archaeological exploration of the Holy Land galvanized the western world. The first actual clearance of antiquities was appropriately in Jerusalem, where in 1850 the French consular official Félicien de Saulcy dug the "Tombs of the Kings," which were mistakenly thought to be the tombs of the kings of Israel (this complex was actually the tomb of Queen Helena of Adiabene). In 1867 the British undertook deep soundings around the compound of the Dome of the Rock, and they completed the first modern mapping of the Holy Land in 1872–78. The first excavation deserving of the name was carried out in 1890 at Tell el-Hesi in the Wadi Gaza by Sir Flinders Petrie, the Father of Palestinian Archaeology. It was Petrie who developed and first applied the basic principles of field archaeology: stratigraphy, or peeling off a mound's superimposed layers systematically; and ceramic typology, or dating by charting the evolution of change in ceramic forms and decoration. The Germans began by excavating Jericho, Megiddo, and other sites just after the turn of the century. Americans became involved in 1908–10, when George Andrew Reisner excavated Samaria

on behalf of Harvard University. Many of these early excavations were relatively primitive, and they unwittingly destroyed more evidence than they preserved.

Jewish archaeology began in the 1920s and continued in the 1930s with synagogue excavation, with the Joint Excavation to Samaria, and with work in the necropolis at Beth Shearim. The Jewish Palestine Exploration Society, the predecessor of the Israel Exploration Society, was founded in 1913 and began to publish its scholarly journal in 1933. Jewish-sponsored excavations came to full maturity, of course, after the proclamation of the state of Israel in 1948.

We have mentioned a number of national "schools" active in the archaeological exploration of this region. There were also different methodologies, which developed through several phases before modern archaeology emerged. In the early phase, from 1890 until World War I, the first archaeological maps were drawn, accurately placing and identifying the major sites, and excavation was begun at several sites such as Megiddo, Jericho, Shechem, Samaria, and Gezer. Although most of these relatively primitive early excavations uncovered impressive objects and architectural remains, they generally failed to date or to elucidate the major archaeological periods.

Between World Wars I and II, methods of digging and dating gradually improved, especially under the leadership of the great American orientalist William Foxwell Albright, who directed the American School of Oriental Research in Jerusalem in the 1920s and 1930s. Albright was succeeded as director by another American scholar, the distinguished rabbi-explorer Nelson Glueck. Between them they launched a distinctive approach that came to be called "biblical archaeology," which has dominated the American school (and the Israeli school in part) until quite recently. This approach combined biblical history and theology with archaeology, in the hope of solving certain problems in biblical exegesis. It led many people, especially in the United States, to regard the validation of the Bible as the purpose of archaeology in the Holy Land. At its best this school pioneered in chronological and historical synthesis and generated an enormous popular following, but it was often marred by amateur work and by biblical bias.

After World War II, archaeology made rapid strides. British and Americans now worked largely in Jordan and introduced sophisticated stratigraphic methods that allowed a complex mound's deposits to be viewed three-dimensionally. The leading proponent of the new techniques and procedures was the great British archaeologist Dame Kathleen Kenyon, whose work at Jericho in 1952–58 was a watershed in methodology. The Americans followed up at Shechem, beginning in 1957 under G. Ernest Wright, Albright's principal protégé. Meanwhile, the Israeli school had gotten underway soon after 1948. In 1955–58 Yigael Yadin mounted a large, well-organized expedition to the great site of Hazor in Upper Galilee. The young archaeologists who were trained there went on to direct many other projects in the 1960s and 1970s.

The burgeoning Israeli school was supported by the Department of Antiquities and Museums as well as by the institutes of archaeology established at the Hebrew University, Jerusalem (1925), at Tel Aviv University (1968), and finally at the Ben Gurion University of the Negev and at Haifa University. In addition, the Friends of Archaeology, an Israeli group, grew to include thousands of members and is probably the largest amateur archaeological society in the world. Today archaeology in Israel is controversial, vital, lively. The open and progressive archaeological climate has encouraged the foreign schools in Jerusalem to continue their work. At present the schools active in Israel include several American groups as well as British, French, German, and Spanish centers. There are few countries in the world where archaeology is carried out on such a large scale or where there is such a spirit of international cooperation.

The Israeli school was characterized at first by a conventional architectural orientation and thus stressed large-scale exposures at virgin sites. The British and Americans, by contrast, preferred more meticulous stratigraphic cuts, often most efficiently carried out in the reexcavation of sites previously dug with imprecise methods. Both systems had their obvious advantages and their proponents, but by the late 1960s the two approaches were beginning to be combined. One difficulty persisted: achieving the prompt publication of the vast amount of accumulating material. The Israelis have provided organs for publication in the quarterlies *The Israel Exploration Journal* and *Tel Aviv*, in serials such as the Department of Antiquities' *'Atiqot* (English and Hebrew series) and the Hebrew University's *Qedem*, in the Israel Exploration Society's *Eretz-Israel*, and in the semipopular periodical *Qadmoniot*. The Israel Museum also publishes the periodical *Ariel* as well as occasional volumes of archaeological field reports.

Since about 1970 the "new archaeology" has made an impact on both American and Israeli archaeology. The first real signs of change came in the multidisciplinary approach. Earlier archaeologists, especially of the biblical archaeology school, had concentrated on stratigraphy, pottery chronology, and major architecture such as temples, palaces, and defense works. These categories of evidence were subjected to minute examination because they were pertinent to the basic orientation toward what may be termed "political history." *Social* history was, however, neglected.

In the 1960s we began to realize that our rather parochial approach overlooked much data of potential significance, and in many cases vital evidence had even been discarded. Individual sites had been excavated with no consideration of environmental factors. Why had ancient settlers chosen a particular location? How had defensible position, water supply, rainfall, climate, and the availability of arable land and raw materials shaped the culture that developed in a particular time and place? And what could bones, seeds, and other organic remains reveal about economic strategies, social differentiation, diet, disease, longevity, and the

like? We began to see that if *total* retrieval of the material remains were possible, and if they were studied in both natural and cultural contexts, we could begin to discern social, economic, ethnic, and perhaps even religious patterns. Moreover, we might then get at what we had really sought all along (and what was now defined by many as the true objective of archaeology): an understanding of the phenomenon of cultural process and change.

Prompted by these broader theoretical interests and research objectives, archaeologists began in about 1970 to employ larger, multidisciplinary excavation staffs. The trend began at Gezer, where self-conscious experiments in methodology had started as early as 1966, and within a few years most digs in Israel and Jordan exhibited the "new look." Alongside the traditional biblical scholars, historians, stratigraphers, and ceramic experts, one increasingly found such specialists as geologists, geomorphologists, climatologists, paleo-ethnobotanists and zoologists, physical and cultural anthropologists, ethnographers, historians of technology, and more recently statisticians and computer programmers. Archaeologists will undoubtedly continue to expand their methodology, borrowing and adapting from other disciplines. It is a young discipline, and today's methods will certainly be built upon and surpassed in the future.

Of course, any discussion of this discipline draws its strength and excitement from the extraordinary structures and objects that archaeologists have rescued from obscurity. The works of art in the present exhibition express the character of the unique land and people that produced them. They are often more eloquent than texts in bringing the past to life. They educate and elevate us—they are truly glorious works of the human spirit.

WILLIAM G. DEVER
Professor of Near Eastern Archaeology
University of Arizona

INTRODUCTION

It is a truism that every museum is a prison of a kind. In an archaeological exhibition each object is detached not only from its physical context in an excavation but also from its original environment—the ancient civilization in which it was made. It is the curators' task, sometimes bordering on the impossible, to bring the realities of the past to life. To meet this challenge, they rely primarily on the information that archaeology itself provides; they also draw on a variety of scholarly disciplines and sources of knowledge, striving to combine them so that a gestalt of the past is reconstructed and presented to the public.

From the beginning of archaeological research, scholars have sought objective criteria, inherent to the discipline and based on material culture, that would provide a sound chronological framework for the development of human civilization. The first and crucial step was the realization that tells—the artificial mounds that rise like hills in the Near Eastern landscape—are formed by the remains of ancient settlements, superimposed on each other like layers in a cake. A further breakthrough came with the perception that the most common stone, pottery, and metal artifacts, produced in great quantities in antiquity and preserved in bulk, can provide the basis for systematic, typological classifications. Eventually, these vessels, tools, and weapons were used to establish a relative chronology, dividing the past into a sequence of consecutive archaeological periods. These common objects form the backbone of any comprehensive museological presentation. Curators use them in various groupings when exploring everyday life in antiquity as well as when illustrating burial customs, cults, and other topics.

In the twentieth century archaeological research expanded, and archaeology became closely involved with other scientific fields. Geology, botany, and zoology, as well as sociology and anthropology, have long been indispensable components of archaeological research; in recent decades chemistry, physics, and nuclear sciences have become equally important. Archaeology has broadened its methods and become "new archaeology" in its search for modern tools to achieve the old aim—a comprehensive understanding of human environment, ways of life, and history through the ages.

The study of prehistory—the long period before the invention of writing—benefited most from the interaction with environmental and exact sciences. Geological criteria have long served for dating purposes and provided the first frame of reference for the study of ancient humans. A case in point is the settlement at Ubeidiya in the Jordan Valley. It is the earliest known human settlement,

predating the formation of the great Syrian-African rift. Its layers, once horizontal, were tilted in these earth movements and were found almost vertical in excavations. Paleobotany and paleozoology helped in understanding the human environment, the domestication of plants and animals, and consequent transition of humans from hunters and food-gatherers to farmers and food-producers. Examples can be quoted from the most recent excavations at Yiftahel in the Lower Galilee and Gilgal in the Jordan Valley, where cereals and pulses were unearthed and, at Gilgal, stored in a silo. The many kinds of seeds and grains discovered in the third-millennium city at Arad cast light on the human diet in that period. Ethnography and sociology, employed as comparative disciplines, have been used in reconstructing ancient societies and everyday life as well as in penetrating the world of the spirit, of cults and religious concepts.

Physics and nuclear sciences now add a new dimension, often providing tangible proof for what previously could be no more than a theoretical assumption. Powerful microscopes and radiography offer invaluable nondestructive methods of examination, which actually enable us to see the interior structure of objects. They have become indispensable in the study of ancient technologies; they are also essential in the quest for the provenance of various raw materials—a problem that to a large extent is still unsolved. The study of ancient trade and of the transmission of various technologies will certainly rely more and more extensively on laboratory analyses based on these new scientific methods. Problematic issues—such as the earliest copper technology in the Chalcolithic period, the earliest use of iron, or the study of the culture of the Philistines through their pottery—will be greatly clarified by interdisciplinary studies.

The major incentive for historical and archaeological research of the Land of the Bible was, of course, the Bible itself, and it was also instrumental in the birth of Near Eastern archaeology in the nineteenth century. The Bible remained alive during the centuries, its imagery continuously reinterpreted by artists and writers. Most of us have our own images of the burning bush, of King David, and of Jerusalem drawn from childhood stories, from Michelangelo and Raphael, or from spectacular biblical movies. For curators working in the Israel Museum, this living heritage of the Bible is a challenge. Our archaeological reality has little in common with such childhood or artistic visions, and the remains of material culture—as important as they are—tell only part of the story. However, they provide the background material for reconstructing a wider picture: the ancients' dwellings and household vessels, the weapons they fought with, the jewelry they wore, the idols they worshiped. Therefore, in most cases we choose to exhibit groups of antiquities, making the assemblages as rich as possible in the belief that each group leads us closer to understanding the past.

Occasionally such an archaeological assemblage illuminates a biblical passage. Images of deities—such as Astarte, Resheph, or Baal—fashioned in pot-

tery, ivory, bronze, or gold, give a reality to pagan cults, which are otherwise known only from biblical references. Conversely, the words of the prophet Amos against the luxurious "ivory palaces" of the kings of Samaria bestow an additional meaning to the exquisite ivory inlays unearthed at Samaria. From later times, the symbolic art of the Second Temple period, devoid of human or animal form, vividly illustrates the contemporaneous religious dictates that fostered the growth of normative Judaism and the birth of Christianity. Still later, representations on mosaic pavements from synagogues, churches, and public buildings demonstrate the unity as well as the diversity in the attitudes of the various monotheistic creeds.

The most direct and forceful witness is, however, the written word. Indeed, no source can compare in importance with epigraphic material contemporaneous with the events it describes. Such are a cuneiform mentioning "the king of Hazor," found on the high mound of Hazor, and fragments of a cuneiform stela commemorating the victory of Sargon of Assyria, found in the excavations at Ashdod. Early inscriptions in Paleo-Hebrew and related languages are a complementary source to the Bible, providing insight not only into historical events but also into administrative and religious matters, daily life, commerce, and so on. The tombstone of Uzziah sheds light on the fate of the leper king of Judah, and the Pontius Pilate inscription from Caesarea is the only archaeological relic of that governor of Judaea, otherwise known only from the New Testament.

In the course of time, the epigraphic material grew in volume and became varied in character. We have the writings of early historians, foremost among them being those of Josephus. The recent excavations in the Upper City of Jerusalem have provided important rehabilitation of the often-questioned historicity of his statements about the planning and growth of the Judaean capital. The extrabiblical books (the Apocrypha), as well as the writings of the Early Church Fathers and the Roman-Byzantine historians, are also among the important written sources. Of the greatest importance are the Mishna and Talmud, the monumental body of information on Jewish daily life, customs, and laws, crystallized in the Hellenistic and Roman periods.

In a special category of epigraphic material are the Dead Sea Scrolls, counted among the most important archaeological discoveries of the twentieth century. The manuscripts of biblical books predate by almost a thousand years the earliest previously known biblical manuscript, and the commentaries and the nonbiblical scrolls provide an invaluable source of knowledge about the Dead Sea sect itself. The scrolls are still in the process of publication and will be studied by scholars for generations to come. For the layperson and scholar alike, they are an unfailing source of interest and inspiration.

From its opening in 1967, The Samuel Bronfman Museum of Bible and Archaeology, the archaeological wing of the Israel Museum, became the national

showcase of archaeology. It draws its exhibits from the collections of the Israel Department of Antiquities and Museums, the legal owner and the depository of all material excavated or found in Israel. The Israel Museum is among the few major national museums which, by means of finds unearthed in excavations, endeavor to present the complete cultural history of their countries. A collection of this kind—based almost exclusively on excavated material—has both limitations and advantages. On the one hand, the material is not only unpredictable but also varies in quality and quantity from period to period. On the other hand, an overview of the archaeological investigations of many years can be of immense historical, cultural, and aesthetic importance.

In the halls of our permanent exhibition area, we display the complete historical sequence, while in our temporary and special exhibitions we try to illuminate a topic, a period, or a newly excavated site. Seldom do we present a selection chosen according to purely aesthetic criteria. Indeed the mark left by the inhabitants of Israel throughout the ages was in the realm of ethics and religion rather than that of high artistic achievement. For scholars of Mesopotamian, Egyptian, or Roman art, antiquities from this region have always been "peripheral," and consequently little known. Only recently has this "peripheral" art been studied on its own merits by applying modern criteria of art history and archaeology.

The exhibition *Treasures of the Holy Land: Ancient Art from the Israel Museum* posed an unusual challenge to the curators in Jerusalem—it is the largest exhibition ever sent abroad, and it emphasizes the aesthetic aspect of ancient artifacts. The two hundred objects selected represent the quintessence of our collections. They are messengers from the great cultures of the past, which turned this small, variegated Mediterranean country into a cornerstone of western civilization. To the modern viewer they present a picture of customs and beliefs, sometimes mysterious, sometimes beautiful, always fascinating.

YAEL ISRAELI
Chief Curator of
Archaeology
Israel Museum

MIRIAM TADMOR
Senior Curator of Chalcolithic
and Canaanite Periods
Israel Museum

CONTRIBUTORS

URI AVIDA, Rodney E. Soher Curator of Hellenistic, Roman, and Byzantine Periods, Israel Museum. *Late Second Temple Period and the Period of the Mishna and the Talmud; cat. nos. 99–103, 117–32, 142–45, 147–48*

MAGEN BROSHI, Curator of the Dead Sea Scrolls, Israel Museum. *The Dead Sea Scrolls; cat. nos. 149–50*

MICHAL DAYAGI-MENDELS, Curator of Israelite and Persian Periods, Israel Museum. *Israelite Period / Iron Age; Ivories from Megiddo; Kernos Bowls; Ivories from Samaria; Pottery Heads from Akhziv; Ancient Hebrew Script; Persian Period; cat. nos. 68–98*

YAEL ISRAELI, Chief Curator of Archaeology, Israel Museum. *The City of Jerusalem; Burial Customs in Jerusalem; Ancient Glass; Tomb Group from Mishmar Haemek; cat. nos. 104–16, 133–41, 146*

PROF. YAAKOV MESHORER, Curator of Numismatics, Israel Museum. *Ancient Coins; cat. no. 116*

DR. TAMAR NOY, Curator of Prehistoric Periods, Israel Museum. *Prehistory; The Natufian Culture; Neolithic Period; Figurines from Horvat Minha; cat. nos. 1–12*

MIRIAM TADMOR, Senior Curator of Chalcolithic and Canaanite Periods, Israel Museum. *Chalcolithic Period; Ivories from Beersheba; Vessels from Gilat; The Judaean Desert Treasure; Canaanite Period / Bronze Age; Sculptures from Hazor; Ivories from Lachish; Jewelry from Tell el-Ajjul; cat. nos. 13–67*

NOTE FOR THE READER

The abbreviations B.C. and A.D. have been used for dating throughout the catalogue.

The first major publication of each work is indicated by an asterisk preceding the appropriate citation in the reference section of each entry.

All biblical quotations are taken from *Tanakh: A New Translation of The Holy Scriptures According to the Traditional Hebrew Text* (The Jewish Publication Society, 1985).

Photographic credits for comparative figures are given in the captions. Unless otherwise indicated, the objects are in the institutions that have provided the photographs.

ACKNOWLEDGMENTS

The authors would like to thank the exhibition team at the Samuel Bronfman Biblical and Archaeological Museum — Aviva Schwarzfeld, Associate Co-ordinator; Inna Pommerantz, Editor; Tamar Sofer, Map Maker; Osnat Misch-Brandl, Assistant Curator; Ruth Goshen-Oved, Curatorial Assistant; and Hannah Bar-Ner, Liora Brenner, Lisa Cahn, Janine Harpaz, Shoshana Israeli, Malka Levi, and Marianne Salzberger—and Monique Birenbaum and Rebecca Rushfield of AFIM.

Warm gratitude is also extended to the following staff members of the Israel Museum: Ehud Loeb, Registrar, and Baruch Brimmer; Dodo Shenhav, Head of Laboratories; Ruth Yekutiel, Head of Laboratory for Restoration of Antiquities; Shlomo Benjan, David Bigelajzen, Galya Gavish, Connie Kestenbaum, Elias Matzkin, Adaya Meshorer, and Andrei Vainer of the Laboratories' staff; Nahum Slapak, Head of Photography Laboratory; Irene Lewitt, Head of Photographic Services and Photo Editor (collateral catalogue photographs); Orah Yafeh, Head of Publications Department; Rita Gans, Head of Department of Commerce; Shlomo Malkai, Security and Administrative Adviser, and Amnon Bello, Security Officer; Shula Eisner, Assistant to the Chairman of the Board of Directors; Meira Bossem and Judith Goldstein, Director's office; and Adina Ben-Horin, Judith Goldberg, Ophra Shai, and Lindsey Taylor.

PREHISTORY

The very long era that marks the beginning of human history lasted from about a million and a half to eighteen thousand years ago. Termed the "Pleistocene" by geologists, this period is called by archaeologists the "Paleolithic" (Greek *palaios*, old, and *lithos*, stone) and is customarily divided into the Lower, Middle, and Upper Paleolithic, followed by a short transitional period, the Epipaleolithic. The dates for this prehistory period have been established by various scientific means, the most important of which are radiocarbon and other isotope datings, paleomagnetism, and geological and paleontological research.

Since the 1920s a great deal of information concerning early humans and their physical and intellectual development has been accumulated from scientific excavations and surveys. There is now also a fairly continuous, if generalized, picture of the changes in the landscape, climate, and flora and fauna of the prehistoric Near East.

LOWER PALEOLITHIC
1,500,000–100,000 Before Present

The earliest known site in Israel is Ubeidiya, situated in the Jordan Valley near the confluence of the Jordan and Yarmuk rivers. It has been dated to the Early Acheulean period (about a million and a half years ago), and its flint industry recalls that of Olduvai Bed II, one of the most famous East African sites. Ubeidiya was located near a large freshwater lake extending south from the present Sea of Galilee (fig. 3). The faunal remains are of African, Asian, and European species, reflecting Israel's position as a land bridge connecting these three continents. The tools are still restricted to only a few very early types, such as

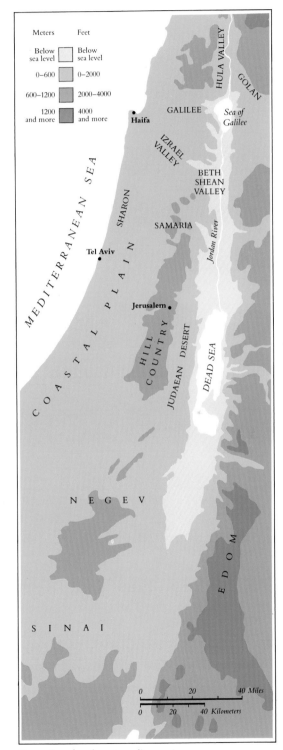

FIG. 2. Israel and surrounding region.

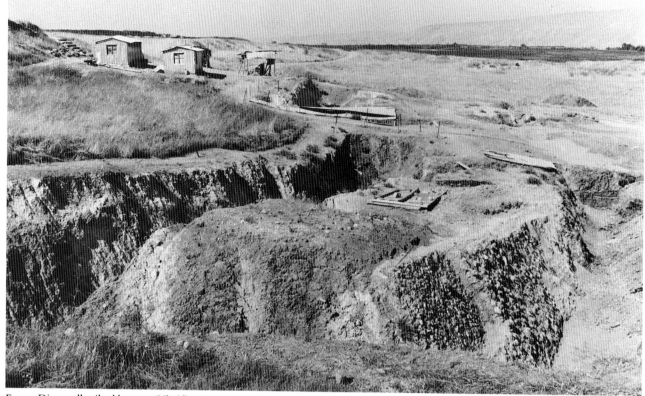

FIG. 3. Diagonally tilted layers at Ubeidiya. Lower Paleolithic period, ca. 1,500,000 Before Present. Photograph: Institute of Archaeology, Hebrew University, Jerusalem.

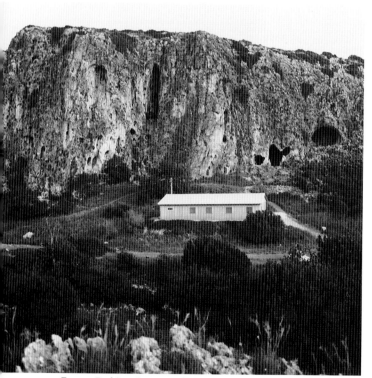

FIG. 4. Prehistoric caves of Mount Carmel (excavators' hut in foreground). Photograph: David Harris.

choppers, picks, spheroids, and large, crudely fashioned hand axes.

Two parts of the country were favored for exploitation at this early period: the Jordan Valley and the coastal plain. The presence of large bodies of sweet water and the favorable climate were well suited to the hunting and food-gathering economy of these early people. Toward the end of the period, in the Upper Acheulean, early humans began to exploit the mountainous forested zones, as well as regions that are today arid, and to inhabit caves in mountainous areas (fig. 4).

Humans' growing facilities and mastery over various techniques found expression in the differentiation of tool types. The hand ax, used for at least a million years, was refined over time into several different types. Most significant is the transition that occurred at the end of this era, to the technique of striking flakes from a flint core, thus allowing the production of many more tools from a single core (solid piece of flint).

MIDDLE PALEOLITHIC
100,000–40,000 Before Present

Changes in human environment, culture, and physical development mark this period, which includes the Lower and Upper Mousterian cultures. *Homo sapiens* appeared in much of the Old World; in Israel two human types have been defined, one with Neanderthal affinities and the other of the *Homo sapiens sapiens* appearance. There is no decisive evidence as to whether or not they were contemporaneous.

For the most part, the freshwater bodies of the Lower Paleolithic disappeared, and a large saltwater lake, of which today's Dead Sea is a remnant, extended along the central and southern part of the Jordan Valley. The Mediterranean shoreline fluctuated, sometimes drastically. On the whole, cold weather prevailed, and forests covered the hills and reached into the Negev. Large animals, mainly of African origin, disappeared, and the fallow deer became the most frequently hunted animal.

Large open-air sites have been found in the Negev highlands, while in the Mediterranean zone and the Judaean Desert many caves were occupied, including those at HaTannur (el-Tabun) (fig. 6), Kebara, and Kedumim (Qafze) where rich occupation layers have been uncovuncovered. Hearth and ash layers are well documented, and flint implements and animal bones are numerous. A revolutionary method of flint working—the Levallois technique—was developed; this involved the preparation of the outer edges of the core from which many flakes were struck. After the flint was struck, its edges were finished, or "retouched," by fine blows. Various retouched flakes and points, as well as scrapers and burins, were among the tools in common use. Many were probably fixed in wooden hafts, such as the flint points which served as spearheads.

Human burials have been found both in the caves and on their terraces, revealing much information about funerary customs, such as the frequent placement of animal horns or jaws on

FIG. 5. Paleolithic sites.

Fig. 6. Excavation at HaTannur (el-Tabun) Cave, revealing many layers of human occupation. Middle Paleolithic period, 150,000–40,000 Before Present. Photograph: University of Haifa.

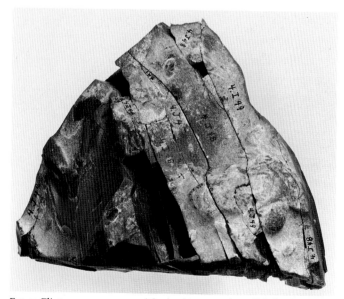

Fig. 7. Flint core reconstructed from a large number of blades found at Boker Tahtit in the Negev. Transitional phase of Upper Paleolithic period, 45,000–40,000 Before Present. Photograph: Israel Museum/Nachum Slapak.

the bodies of the deceased, perhaps reflecting a belief in the supernatural power of animals. The use of red ocher paint to decorate the deceased appears at this time.

UPPER PALEOLITHIC
40,000–18,500 Before Present

The Upper Paleolithic culture has been discovered in many parts of the world, including the New World. During this period Cro-Magnon humans, virtually modern *Homo sapiens*, appeared and made their mark, especially in the realm of artistic expression. They produced the spectacular cave paintings of Europe, as well as the large number of carved stone and bone art objects that have been found from Western Europe to Siberia.

In Israel, one of the areas on the fringe of these artistic and spiritual developments, the Proto-Mediterranean type of *Homo sapiens* probably evolved from predecessors in the region. The environment remained similar to that of the previous period. Caves (such as HaNahal and Kebara caves on Mount Carmel and Hayonim and Kedumin caves in Galilee), as well as open sites, indicate that the Mediterranean zone was extensively inhabited. Caves in the Judaean Desert (such as Erq el-Ahmar) and open-air sites in the Negev and Sinai are also numerous.

At a few sites a transitional phase between the Middle and Upper Paleolithic assemblages has been distinguished, followed by two major flint-working traditions that were at least partially contemporaneous: one, characterized by a large percentage of blade tools, is found mainly in the Negev and Sinai (fig. 7); the other—the "Levantine-Aurignacian," with its many short flake tools—is common to the Mediterranean zone. Microliths, the small tools that were to become the hallmark of the following period, begin to appear. Most characteristic of this period is the introduction of a wide variety of fine tools made by a new technique that produced long,

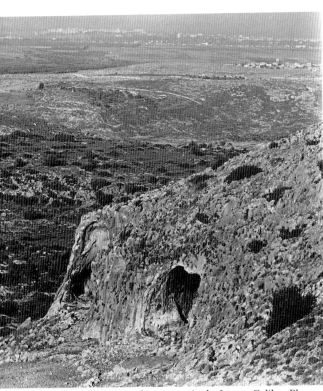

FIG. 8. Hayonim Cave and its terrace in the Lower Galilee. Photograph: Institute of Archaeology, Hebrew University, Jersualem.

narrow blades. Bone implements were also added to the tool repertoire at this time.

Information about the spiritual and religious aspects of life is gradually accruing, although few burials have been found. One burial revealed funerary offerings and the use of ocher. Beads and pendants made of shells and animal teeth form the earliest evidence of personal adornment. A unique find from Hayonim Cave is a limestone plaque with the figure of a horse, sketchily incised on one side, and traces of a layer of ocher paint (figs. 8 and 9).

EPIPALEOLITHIC
18,500–10,300 B.C.

This period coincides with the end of the last Ice Age in Europe, which also affected the climate and landscape of Israel. The few skeletal remains

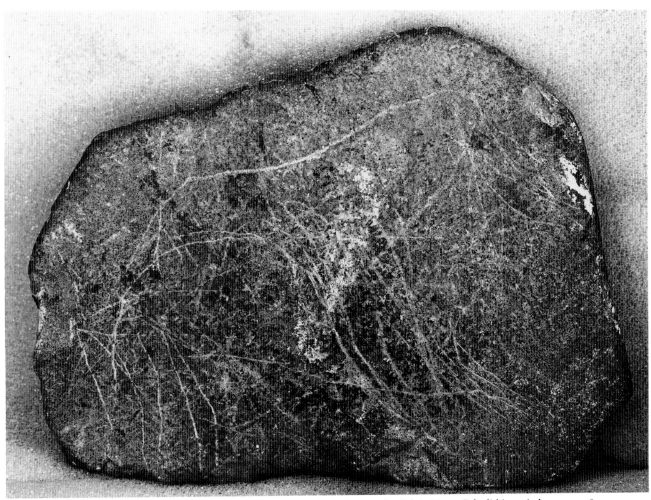

FIG. 9. Plaque from Hayonim Cave with incised figure of horse (horse faces to the right). Upper Paleolithic period, 40,000–18,500 Before Present. Photograph: Israel Museum/David Harris.

indicate a continuation of the local Proto-Mediterranean type.

The broader distribution of the sites is evidence of a growing ability to deal with varied ecological zones. Humans lived in small groups consisting of a few families and settled more often in open sites than in caves. A major innovation of the period is the use of grinding and pounding utensils, among them basalt mortars and pestles and limestone bowls. These are evidence of new methods of food preparation and perhaps also of the gathering of wild grains.

The Epipalaeolithic is characterized by its great variety of local cultures, each having a specific microlithic flint industry. Only the Geometric Kebaran, which appears throughout the Levant. Microliths have been found in great quantities, because each tool consisted of a number of flints fitted into one wooden haft. Every culture had its own characteristic microlith forms. Toward the end of the period the new microburin technique facilitated the production of geometric microliths.

Very little is known about spiritual life during this period. Burial was apparently inside huts, and bodies were often interred with grinding and pounding utensils and with seashell jewelry as personal adornment.

The experience in specialization that humans gained while adapting themselves to various environmental zones led to the development of the unique Natufian culture that followed.

REFERENCES: A. Horowitz, *The Quaternary of Israel*, New York, 1979; O. Bar-Yosef, Prehistory of the Levant, *Annual Review of Anthropology* 9 (1980), pp. 571–604; A. J. Jelinek, "The Middle Palaeolithic in the Southern Levant with Comments on the Appearance of Modern *Homo sapiens*, in *The Transition from the Lower to the Middle Palaeolithic and the Origin of Modern Man*, BAR International Series 151, A. Ronen (ed.), Oxford, 1982, pp. 57–101; E. Tchernov, The Biostratigraphy of the Middle East, in *Préhistoire du Levant*, J. Cauvin and P. Sanlaville (eds.), Paris, 1981, pp. 67–98.

THE NATUFIAN CULTURE

ca. 10,300–ca. 8500 B.C.

The Natufian culture was one of the richest and most innovative in the Near East, and the achievements of the Natufians brought them to the threshold of modern civilization—the "Neolithic revolution." The gradual transition to sedentary life (side by side with cave dwellings), the architecture, the burial customs, the new tools, and the art objects expressing religious concepts—all these reflect the great strides made by the Natufians. The core area of this culture was in the southern Mediterranean regions of the Levant, where it is known mainly in Israel, although cultures with close affinities are also known from Syria, Lebanon, and Jordan. Three stages of the Natufian culture have been distinguished: the earliest is restricted mainly to the Mediterranean area, while the later stages also occur in the arid zones. Climatic variations played a part in the culture's development and geographical expansion.

The name of the culture is taken from the cave in Wadi en-Natuf, in the western Judaean hills, which was discovered in the late 1920s. Similar remains were excavated very soon afterward in HaNahal (el-Wad) and Kebara caves in the Carmel range and in the 1930s in the Judaean Desert. Among the important sites recently excavated are Eynan (Mallaha) in the Jordan Valley near Lake Hula, Nahal Oren on Mount Carmel, Hayonim Cave in western Galilee, and Rosh Zin and Rosh Horsha in the Negev. These excavations, which included extensive environmental studies, revealed large settlements and a wealth of material. The thorough study of the Natufian population has been possible because of the numerous burials that have been uncovered at almost every site.

The Natufians were the first to establish per-

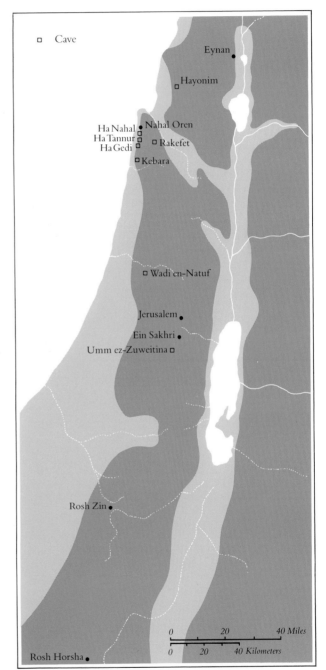

FIG. 10. Natufian sites.

manent settlements, with roughly circular houses built of local limestone and measuring 3–7 meters (3¼–7⅝ yards) in diameter. Many installations were found, including hearths, silos, and other facilities, both inside and outside the structures. With the possible exception of one building at Eynan, which is distinguished by its size and shape and may have had a roof supported by wooden poles, no structure from the period can be clearly identified as a public building. It is estimated that the population of some settlements exceeded one hundred individuals. This growth in size, remarkable when compared to earlier periods, must have necessitated some form of social organization.

Though these dense settlements were probably inhabited all year round, there is no evidence that plants were cultivated or that animals, except dogs, were domesticated. These highly skilled and talented people chose to settle in relatively hospitable areas. Thus they found abundant food and a favorable environment, with water and forests, in the Hula Valley, in the Carmel range, and in western Galilee. In the Judaean Desert and the Negev, on the other hand, the Natufian economy must have been

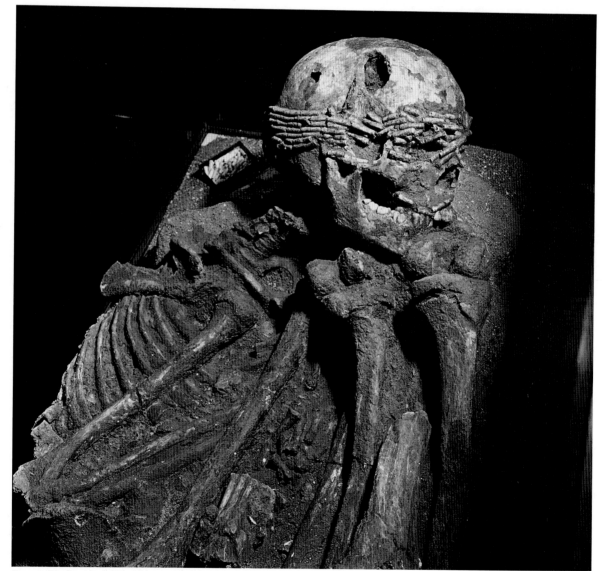

FIG. 11. Skull with shell headdress. HaNahal (el-Wad) Cave; Natufian period, 10,300–8500 B.C. Israel Department of Antiquities and Museums. Photograph: Israel Museum/David Harris.

based on marginal hunting and gathering in a climate that was wetter than today's. The faunal remains recovered on Natufian sites are varied, but they indicate that the inhabitants preferred gazelles to the other animals they hunted and ate. The gathering of wild grains is documented by the numerous sickle blades, large mortars, and grinding implements present in every Natufian site.

Among the new tools developed for fishing and hunting were harpoons, hooks, and net sinkers. At the end of the period arrowheads also appear. Sickle blades were originally set into wooden or bone handles, a few of which have survived. Some of the tools may have been used in crafts, such as basketry or weaving, of which no evidence has survived; others were used to work animal hides and wood. Both the Helwan retouch technique and relatively small flint tools characterize the earlier stage of this period. Another feature of the Natufian toolkit is the group of bone implements, remarkable for the skill of their manufacture.

Evidence for the spiritual life of the Natufians is furnished by various installations of a cultic character and by their burial practices, ornaments, and art objects. Thus, at the extensive Natufian site of Rosh Zin, there is a stone-paved area with a large upright stone at the edge, which may have functioned as a cultic pillar. Small upright stones, which may also have cultic significance, were uncovered in the Rakefet Cave.

The numerous graves show evidence of established burial customs, and some features may indicate a degree of social hierarchy. Particularly striking is the custom of burying the dead, elaborately adorned with jewelry, in the villages inhabited by the living, in single, family, or communal graves (fig. 11). Some connection between the orientation of the body and the cardinal points of the compass probably existed. Skull burials have occasionally been found.

The Natufians were equally inventive in their art. Animal and human representations,

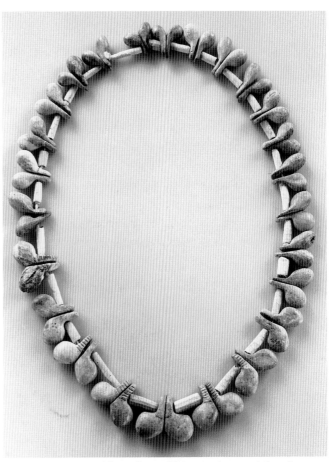

FIG. 12. Restrung necklace of carved bone pendants and dentalium shells. HaNahal (el-Wad) Cave; Natufian period, 10,300–8500 B.C. Israel Department of Antiquities and Museums. Photograph: Israel Museum/David Harris.

previously unknown in this region, now appear and are undoubtedly connected with the spiritual and cultic life of the Natufians. Eight of the fourteen known animal figures are carved in bone; the other six are stone. Though stylized and often fragmentary, the majority can be identified as ruminants (a lion, a dog, a fish, and a bird can also be recognized). Some scholars believe that most of the ruminants represent gazelles; others regard them as representations of a number of different animals. In any case, these carvings express the significance of game animals in the world of these hunters/food-gatherers. Even the use of bone for many of the animal images may be due not only to its availability but also to the belief that it was invested with a special meaning or power. The representation of

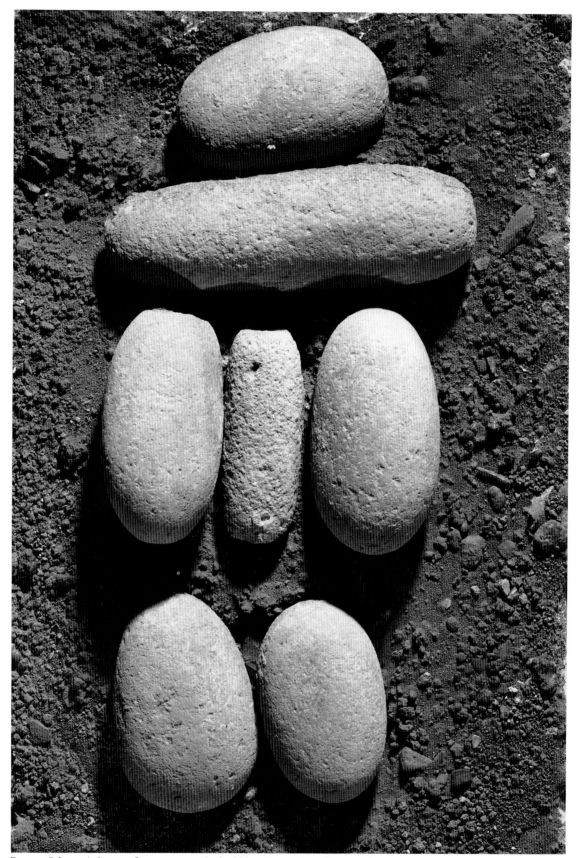

FIG. 13. Schematic human figure composed of pebbles. Eynan; Natufian period, 10,300–8500 B.C. Israel Department of Antiquities and Museums. Photograph: Israel Museum/David Harris.

animals on sickle handles expressed the dependence of the Natufians on their main sources of food—hunting and harvesting wild grain.

The representation of animals, mainly in the Paleolithic art of Europe but also to some extent in Natufian art, has been the subject of much discussion. There is a marked similarity in Natufian art to that of the Upper Paleolithic in Europe, whose last phase is roughly contemporaneous with the beginning of the Natufian period. This is especially evident in the use of bone as the principal material for a wide range of tools and animal carvings; moreover, the contexts in which the carved animals are used, usually as part of an object, are similar.

The representation of humans in Natufian art is less common than that of animals. Most of the human figurines are stone, and unlike the animal figurines, they do not form part of objects. Their style ranges from the schematic to the naturalistic. In addition to cat no. 4, about eight human figurines are known, four of which are of particular interest. A head from HaNahal Cave is carved in the round, with huge oval eyes and a broad nose. A figurine from Eynan (its head missing) has a broad band of red paint on one side of the body. Another, also from Eynan, is constructed of seven oval basalt pebbles and pestles, forming an approximation of a human figure (fig. 13). An erotic figurine from Ein Sakhri represents a couple embracing. A similar scene is known from rock engravings at Kilwa in southern Transjordan.

The question of how these expressive and skillfully made art objects could be produced without a long tradition of carving in this region remains open. However, it is possible that such objects were previously fashioned from perishable materials that have not survived. In any case, just as there seems to have been a sudden flowering of art, so an equally sudden decline came later, and in the following period an entirely new approach to art is evident.

The jewelry—in a wide range of shapes and materials including bone, shell, animal teeth, colored stones, and ostrich shell—reveals great skill in the fashioning of new forms. Most of the shell ornaments are made of dentalium from the Red Sea and the Mediterranean. These shells and a green stone that must have been brought from afar show the extent of trading links. The bone jewelry is the most striking, in particular the twin (bilobe) elements, skillfully carved into splendid necklaces and pendants, which may have served as amulets (fig. 12). The Natufians' penchant for ornamentation is also evident in their utilitarian tools. Geometrical patterns of dots, triangles, meanders, and straight lines are incised on mortars, bowls and bone objects, and ostrich eggshells.

The Natufian culture made its own distinctive, highly advanced contribution in a period of transition from a society subsisting on hunting and intensive food-gathering to a society of agriculturists.

REFERENCES: J. Perrot, La Préhistoire palestinienne, in *Supplément au Dictionnaire de la Bible VIII*, Paris, 1968, cols. 379–80; O. D. Henry, *The Natufian of Palestine: Its Material Culture and Ecology*, Ph.D. dissertation, Southern Methodist University, Dallas, Texas, 1973; F. R. Valla, *Le Natufien, une culture préhistorique en Palestine*, Cahiers de la Revue Biblique 15, Paris, 1975; O. Bar Yosef, The Natufian in the Southern Levant, in *The Hilly Flanks and Beyond*, Studies in Ancient Oriental Civilization 36, T. Cuyler Young, Jr. et al. (eds.), Chicago, 1983, pp. 11–42.

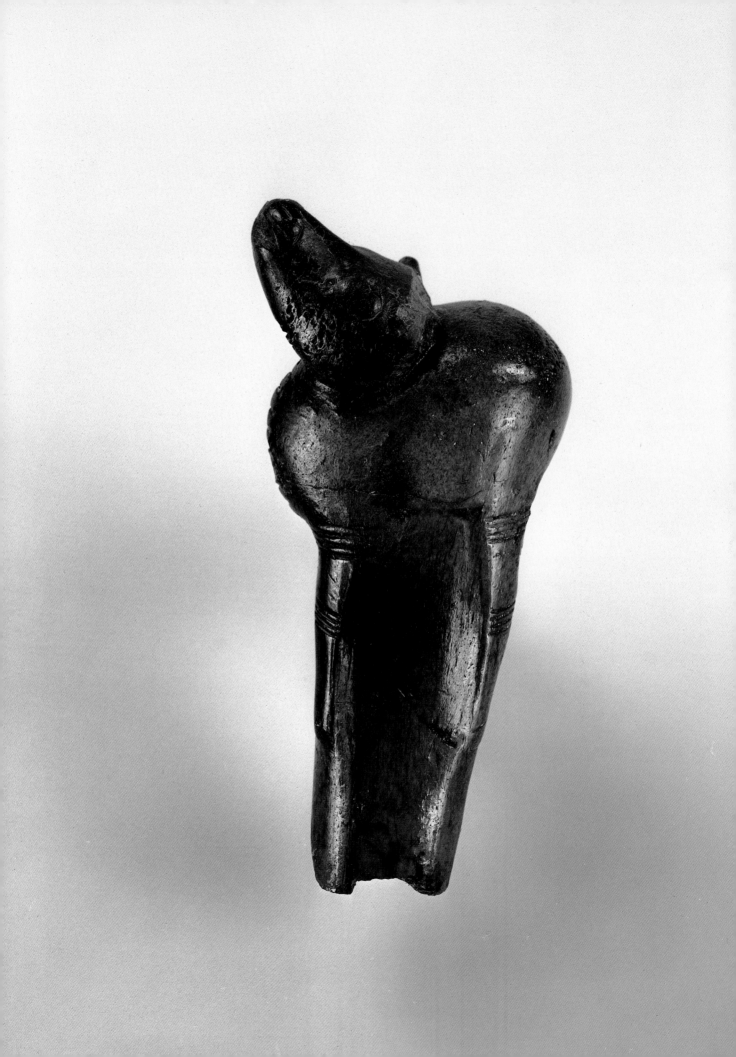

1. Handle with Animal Figure

HaNahal Cave
10th millennium B.C.
Carved bone; length 10.5 cm. (4⅛ in.)
Soundings by the Mandatory Department of
Antiquities followed by excavations of the
American School of Prehistoric Research and the
British School of Archaeology in Jerusalem
IDAM I.1727

On the western face of Mount Carmel, facing the sea
where Nahal Hamearot (Wadi Mughara) meets the
coastal plain, are three caves of karst formation—
HaTannur (et-Tabun), HaNahal (el-Wad), and HaGedi
(es-Sukhul). Rich in burials, tools, faunal remains,
and art objects, these caves have yielded an almost
complete prehistoric sequence. In HaNahal Cave the
later prehistoric sequence from the Upper Paleolithic
to the Natufian is represented. This masterly carving
was found in HaNahal Cave during a brief explora-
tion in 1928 in the wake of stone quarrying for the
construction of Haifa harbor. The following year full-
scale excavations revealed a group of Early Natufian
burials immediately below the spot where the animal
figurine had been found.

Originally this carving was described as "a young
deer," but this identification is by no means certain.

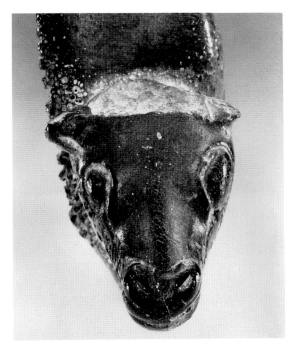

FIG. 15. Detail from cat. no. 1. Photograph: Israel Museum/
David Harris.

The figure is complete and was carved from a long
bone; the bone was split in two, including the joint.
Employing the natural protuberances of bone articu-
lation, the artist used the upper part of the joint to de-
pict the head in three dimensions and the lower part
to carve the body and legs in what can be termed low
relief (fig. 14). After carving, probably with a sharp
flint knife, the surface, including the inner side, was
carefully smoothed and polished. The head is shown
tilted upward, perhaps to indicate a suckling animal.
Details such as the mouth, muzzle, eyes, and horns—
one of which is broken—are all depicted with great
skill (fig. 15). The body, though shown with few de-
tails, conveys the suppleness of a young animal. The
delicate legs continue on both sides of the bone, and
at their joints are groups of four short incised lines.
Eight short lines are engraved on the neck. With its
naturalistic style and its deep understanding of ani-
mals, this piece is one of the most beautiful examples
of prehistoric art.

In the light of the discovery in Kebara Cave of
two animal figures decorating bone sickle handles
(cat. no. 2), it was assumed that this piece too once
formed the end of such a handle, although there is no
evidence of this from the surviving fragment.

REFERENCES: *D. A. E. Garrod, Note on Three Objects of
Mesolithic Age from a Cave in Palestine, *Man* 30 (1930),
pp. 77–78; D. A. E. Garrod and D. M. A. Bate, *The Stone
Age of Mount Carmel I*, Oxford, 1937, pp. 38–39, pl. XIII:3;
T. D. McCown and A. Keith, *The Stone Age of Mount Car-
mel II*, Oxford, 1939; T. Noy, in *Highlights of Archaeology:
The Israel Museum*, Jerusalem, 1984, pp. 18–19.

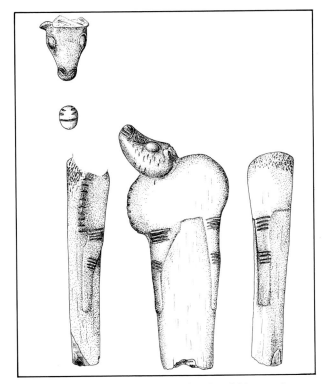

FIG. 14. Drawing of cat. no. 1. Drawing: Israel Museum/
Florica Vainer.

2. Sickle Handle with Animal Figure

Kebara Cave
10th millennium B.C.
Carved bone; 30.8 × 5 cm. (12⅛ × 2 in.)
Excavations of the British School of Archaeology
in Jerusalem and the American School of Prehis-
toric Research (1931), the Israel Department of
Antiquities (1951–57, 1964–65), and the Hebrew
University (1982)
IDAM I. 10700

Found more than fifty years ago in the Kebara Cave,
this is the most complete surviving example of a
sickle handle with an animal figure at one end. In the
same cave, a similar, almost complete handle was dis-
covered together with additional head fragments that
probably also formed parts of sickle handles.

The Kebara Cave is located on the west escarp-
ment of the Carmel range, facing the coastal strip and
the sea beyond. It is a karstic cave with a chimney and
is situated about 50 meters (165 feet) above sea level.
The first prehistoric remains were discovered there in
1927, and several major cycles of excavations were
subsequently carried out, of which the latest is still in
progress. Layers from the Mousterian to the Natufian
have been uncovered in the cave, but the Natufian
layer, to which this carved sickle handle belongs, is
located principally on the terrace in front of the cave.

The sickle handle is fashioned from a long bone,
with the thicker end—the joint—used by the carver for
the animal's head. The other end tapers to a point. The
bone is not symmetrical in section: the inner side is
flat, indicating that it was cut in half lengthwise and
was then carved. After carving, the bone was pol-
ished. Traces of wear on the bone are mostly on the
inner side.

The animal head is executed in a naturalistic man-
ner. The head is carved in the round, without any ad-
ditional incisions. The muzzle is set within a circular
frame, with a straight line marking the mouth and
two other lines descending from it. As in other animal
heads, there is no representation of the nose. The eyes
are formed by oval projections. Next to one eye is an-
other round projection that may perhaps represent the
ear. The two elongated horns end in round knobs. No
body details are indicated.

The sickle blade segments were fitted into a V-
shaped groove in the lower part of the handle with
asphalt, bitumen, or perhaps tree resin. A sickle frag-
ment still holding its original flint blades was pre-
served in HaNahal Cave. On the bottom part is a
large, rounded projection. Similar or smaller projec-
tions appear on a few other specimens; they may rep-
resent the male sexual organ, or they may have some
other functional or symbolic meaning.

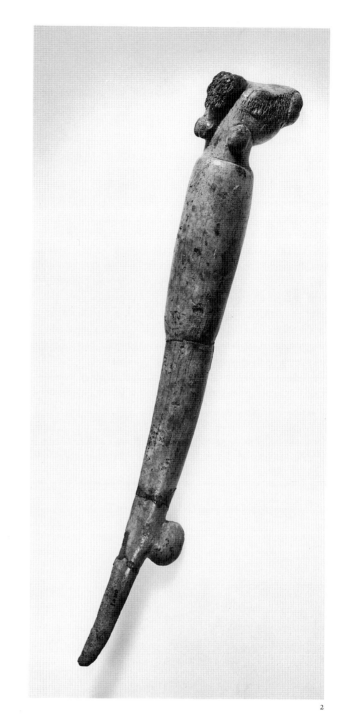

2

In spite of the considerable naturalism in the treat-
ment of the head, the schematization and stylization
are so great that it is difficult to identify this animal.

REFERENCES: *F. Turville-Petre, Excavations in the Mugharet
el-Kebarah, *Journal of the Royal Anthropological Institute* 62
(1932), pp. 270–76; M. Stekelis, Late Mesolithic Art of
Eretz-Israel, *Eretz-Israel* 6 (1960), pp. 21–24 (Hebrew),
English summary, p. 27*; J. Cauvin, *Réligions néolithiques
de Syro-Palestine*, Paris, 1972.

3. Gazelle

Umm ez-Zuweitina Cave
10th millennium B.C. (?)
Limestone; 7.2 × 14.9 cm. (2⅞ × 5⅞ in.)
Excavations of the Institut de Paléontologie
Humaine, Paris
IDAM 33.3498

This crouching gazelle is one of the finest works of prehistoric art. The artist has shown great powers of observation and a rare sense of proportion. Both its size and its naturalistic approach are exceptional.

The figurine was found in the 1930s in a cave in the Judaean Desert. Almost the entire prehistoric sequence, with the exception of the very earliest periods, was represented in the caves and rock shelters in this region. Given today's arid conditions, the area is inhospitable to human life, but study of fauna, pollen, and geomorphology indicates that there were periods when the climate was sufficiently favorable to sustain hunters/food-gatherers and even early farmers.

Although the Natufian finds from the Judaean Desert were much less abundant than in contemporaneous northern locations, two art objects of stone (this gazelle and an embracing couple), a few pieces of jewelry, and some fine bone tools were recovered.

Unfortunately, the remains in the cave in which the present figurine was discovered were severely disturbed at one time, and its precise relationship to the Natufian levels cannot be established.

The gazelle was carved from a piece of hard gray limestone with a flint knife or burin, whose marks are still visible. It was then polished, and traces of red ocher paint indicate that it may have been painted with a pattern. The legs, belly, and short tail are worked in relief, with the hindlegs thicker than the forelegs. The graceful neck bends downward, and the head, which unfortunately has not survived, probably reached the level of the legs.

Some scholars doubt the attribution of this piece to the Natufian period, not only because the Natufian levels in the cave were scanty and disturbed but also because of the figure's style and size. However, other scholars compare it to animal representations on the cave walls and in the *art mobilier* of the Upper Paleolithic in Europe. An animal figure in a similar attitude is known from Tell Bouqras in northern Syria, dated to the sixth millennium B.C.

REFERENCES: *R. Neuville, Le Préhistorique de Palestine, *Revue Biblique* 43 (1934), pl. XXI; R. Neuville, *Le Paléolithique et le Mésolithique du désert de Judée*, Archives de l'Institut de Paléontologie Humaine 24, Paris, 1951, pp. 21–25, pl. XIV.

3

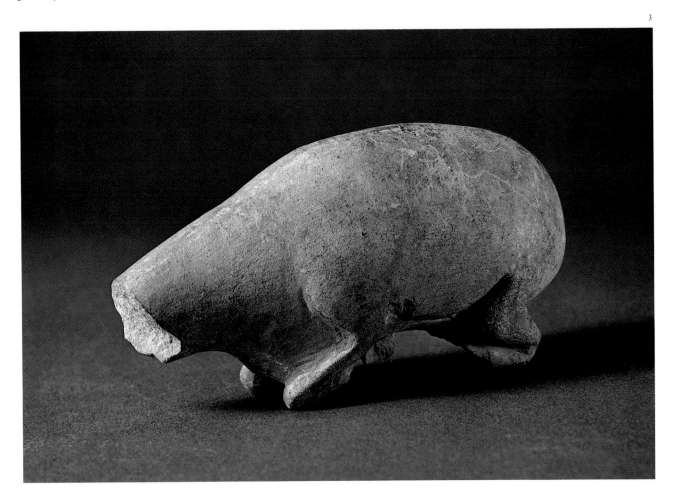

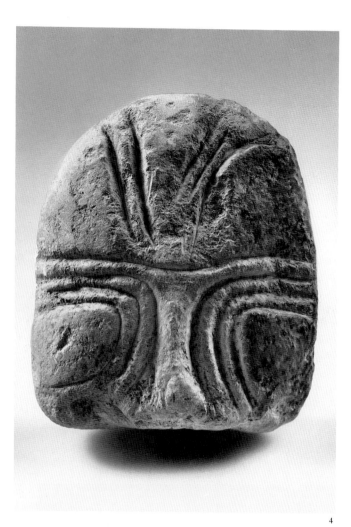

4

these two extremely rich ecological zones provided the ancient inhabitants with a variety of economic possibilities, including both fishing and the seasonal exploitation of a wide range of resources.

This early village was discovered in 1954, and in the course of several seasons of excavation, three Natufian cultural assemblages—early, middle, and late—were distinguished. Several strata of massively built circular and semicircular stone structures were uncovered, as well as many features such as pits, some of which may have served as granaries and others for human burials. The abundant finds included, in addition to the numerous flint tools, many basalt tools (reflecting the site's proximity to basalt sources), art objects, decorated utensils, and pieces of jewelry, mostly of dentalium shell. Among the art objects found at the site the human figurines are especially noteworthy; this carving is one of two very similar examples found in the excavations which are unusual in that they portray only the head. No animal representations were discovered at Eynan.

This head is made of limestone, carved with a stone hammer and flint knife. Traces made by the tools can be seen in the straight lines on the stone. After the figure had been roughly engraved, it was polished.

The base of the head is flat, probably so that it could stand upright, while the upper end is rounded. The features were formed by deep, sometimes uneven, incised lines, and traces of reworking and repeated incision can be seen here and there. The face is bisected by a broad horizontal line, which separates the forehead from the other features. Below this line, the large eyes, which cover most of the face, are formed by three curved concentric lines. The innermost lines may represent the nose, narrow at top and broader below. Above the horizontal line are two groups of almost vertical engraved lines, whose meaning is not clear. On the upper and lower parts of the face are two marks, and the back of the head is almost flat with some deeper marks.

These carved heads are so far unknown elsewhere, and their function is unclear. However, the line separating the forehead from the rest of the face also appears on a figurine from HaNahal Cave, whose carving of the broad nose is also similar. The pattern of concentric circles is repeated frequently on other objects from Eynan.

4. Human Head

Eynan
10th millennium B.C.
Limestone; 8 × 6.3 cm. (3⅛ × 2½ in.)
Excavations of the Centre National de Recherche Scientifique
IDAM 57–895

The site of Eynan (Mallaha) is a single-culture Natufian site, one of the largest of that period, with an area of about 2,000 square meters (2,400 square yards). It is situated on a gentle slope descending to Lake Hula from the hills of Upper Galilee, which during the Natufian period were covered with Mediterranean forest. The site is near a freshwater spring and pool, Ein Mallaha, which is surrounded by abundant marsh vegetation. The proximity of the site to

REFERENCES: *J. Perrot, Le Gisement natoufien de Mallaha (Eynan), *L'Anthropologie* 70 (1966), pp. 437–84; F. R. Valla, Les Établissements natoufiens dans le nord d'Israël, in *Préhistoire du Levant*, Lyons, 1980, pp. 409–19.

NEOLITHIC PERIOD

ca. 8500–ca. 4500 B.C.

The Neolithic period, spanning almost four millennia, is generally subdivided into two major parts, each of which has further internal divisions: the Pre-Pottery Neolithic, A and B (8500–6000 B.C.), and the Pottery Neolithic, Early and Late (6000–4500 B.C.). While some scholars use numerical divisions for this period, others apply to each cultural phase the name of the site where it was first recognized (the Yar-mukian culture, for example, is named after the Yarmuk River on whose banks it was found).

Using the accumulated experience of many generations and advancing beyond it, the creativity of Neolithic humans and their changing attitudes to many aspects of their lives led to innovations that justify the term "Neolithic revolution." This socioeconomic revolution, a momentous step forward in the ability of humans to deal with their environment, included the systematic cultivation of plants and the domestication of animals, followed by the growth of settlements, which had to accommodate expanding permanent populations. In time, a more complex society evolved, which practiced a variety of crafts, engaged in trade, and developed a rich religious and spiritual life.

Gathering wild plants, fishing, and hunting still played a role in the Neolithic economy. At the same time humans gradually learned to cultivate plants taken from the wild (emmer wheat, einkorn wheat, barley, peas, lentils, chickpeas, broad beans, and flax); thus the harvest could be controlled, and food could be stored for use during the seasons when nature was less generous. This agricultural activity demanded preparation of the fields for sowing, manufacture of tools for tilling the soil, harvesting, and grinding, and

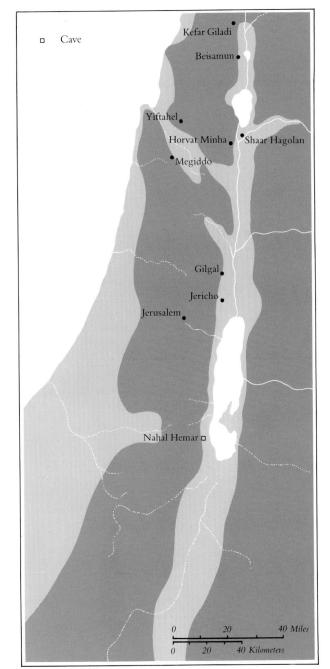

FIG. 16. Neolithic sites.

construction of silos. Indeed, in excavations at Gilgal and Yiftahel, depressions in the floors of excavated houses have been found to contain large quantities of seeds. Toward the end of the period fruit was also cultivated.

Raising livestock domesticated from wild local species—first goats and sheep and later pigs and cattle—ensured a constant supply of meat, skins, and bones. As time went on, wool and milk products were also used.

By 5000 B.C. the new technology spread west and east from its nuclear area in the Fertile Crescent to Europe and central Asia.

Flint tools reached a peak of functional sophistication (fig. 17). Arrowheads had begun to appear at the end of the Natufian period, and in

Fig. 17. Flint arrowheads. Neolithic period, 8500–4500 B.C. Israel Department of Antiquities and Museums. Photograph: Israel Museum/David Harris.

the Neolithic period they developed from simple forms with notches to large forms with tangs, attesting to the mastery of the bow and arrow, a new and efficient hunting weapon. Sickle blades and axes were adapted to the needs of agriculture. New techniques included pressure retouch, the use of naviform cores to attain long, symmetrical flint blades, and the heating of flint for greater uniformity as well as for attractive color. In addition to flint tools and weapons, limestone and basalt domestic utensils, such as grinding implements, have been found in every excavated house and courtyard.

Until recently, mats and other objects of woven reeds or rushes, which demonstrate a well-established tradition in basketwork, were

FIG. 18. Bone tools, including implements used for weaving and basket making. Nahal Hemar Cave; Pre-Pottery Neolithic B period, 7th millennium B.C. Israel Department of Antiquities and Museums. Photograph: Israel Museum/David Harris.

known mainly from imprints in clay and plaster. However, the important discovery of well-preserved organic materials in the Nahal Hemar Cave in the Judaean Desert (see cat. no. 6) has greatly contributed to knowledge of Neolithic crafts (fig. 18); among the techniques now known is the manufacture of both large and small containers by applying a coat of clay or asphalt to an interior frame of coiled cordage.

There is little doubt that basket-making was practiced much earlier than present evidence shows. Weaving, on the other hand, was probably an invention of the Neolithic period. The thin flexible yarn necessary for weaving textiles was available in flax fibers, and flax was among the earliest plants cultivated in the Levant. Again, the Nahal Hemar Cave has provided data concerning weaving techniques that are surprisingly complex, considering that the loom does not seem to have been known at that time (fig. 19).

Substantial changes also occurred in habita-

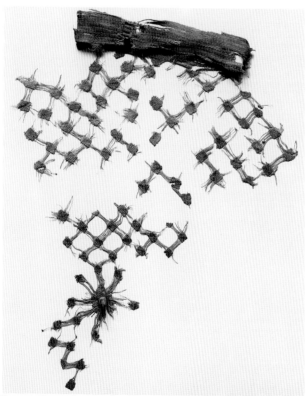

FIG. 19. Knotted network of flax fiber, combining various weaving techniques. Nahal Hemar Cave; Pre-Pottery Neolithic B period, 7th millennium B.C. Israel Department of Antiquities and Museums. Photograph: Israel Museum/Nachum Slapak.

tions. Instead of round dwellings, rectangular houses were built in the Pre-Pottery Neolithic B period (in the Negev and Sinai, however, round structures continued to be used). In the Pottery Neolithic, pit dwellings were followed by rectangular structures.

Except for the postholes and occasional wood fragments that have survived, little is known of the building methods that involved perishable materials. However, in addition to the ubiquitous use of stone, there is a great deal of evidence for other building-related materials, such as unbaked bricks. The impressive plaster production is also well attested. Limestone was crushed, burned at a high temperature, soaked in water, and then applied to the floors and walls of dwellings. Red ocher paint was applied to floors and walls and probably had other uses as well.

An important aspect of the Neolithic period is the evidence of extensive trade connections furnished by obsidian from Anatolia and green stone axes and seashells, including the previously unknown cowrie shell, from the Mediterranean and the Red Sea. Ideas must have traveled by the same routes, and indeed there is clear evidence of cultural contacts. On the whole, however, each culture maintained its strong local character.

Pottery, a great invention of the Neolithic period, came into use in the sixth millennium B.C. and provided a reliable means of cooking, transporting, and storing food. The potter fashioned the vessels by hand and baked them in an open fire (later in a kiln). Pottery is easily breakable, but the fragments are practically indestructible; these pieces give evidence of the forms and decorations unique to each culture and each period. Therefore, from this point on, pottery is important in archaeological dating.

Very little is known of the cult structures of the period. They seem to have been included in the dwelling area, although there is an example toward the end of the period of a cult site outside the settlement. There are, however, some indications that major changes took place in spiritual life and religious practices during the Neolithic

period. For the first time the human figure becomes a common subject of representation. Can this mark the beginning of the conception of gods and spirits in human form? The emphasis placed on the human head—evidenced by the numerous plastered skulls and masks—suggests that it was considered to have magical power and to be the seat of ancestral spirits. It is likely that the various animal and human figurines were used in religious rites and ceremonies.

The Neolithic style of representing animals differs from that of the previous period. The small figures were now modeled naturalistically out of clay, while larger figures were carved of stone. Toward the end of the period animals were depicted in rock carvings or in arrangements of small stones stuck in the ground, such as the row of leopards guarding a shrine at Biqat Uvda. The frequent representation of the leopard seems to indicate that it was a symbol of great power.

The human figure, besides occurring more frequently, was also depicted in a new way in this period. Female figurines, usually in a seated position, represent "fertility figurines" or "mother goddesses." Made of unbaked clay, they appear in the Pre-Pottery Neolithic A period. In the Pottery Neolithic period, the Yarmukian culture is especially rich in examples of this type of cultic symbolism.

A special treatment of the human figure is attested in the seventh millennium—the Pre-Pottery Neolithic B—at Jericho (fig. 20) and Nahal Hemar and at Ein Ghazal in Jordan. Almost life-size statues and busts were made of chalky clay built up around an inner framework of reeds (see cat. no. 5). The limbs and main features of the body were modeled, with details added in paint. The figures are short and squat, with flat heads. The eyes are painted, outlined with bitumen, or inlaid with shells. Some statues seem to be arranged in family groups—male, fe-

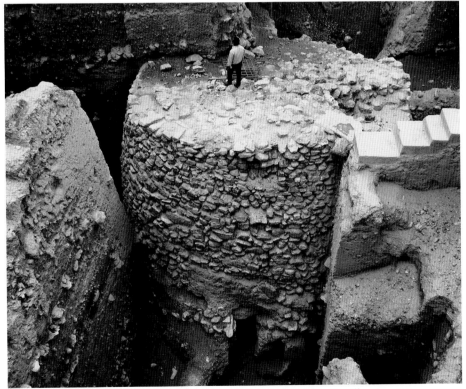

FIG. 20. Stone tower at Jericho. Pre-Pottery Neolithic B period, 8th–7th millennium B.C. Photograph: David Harris.

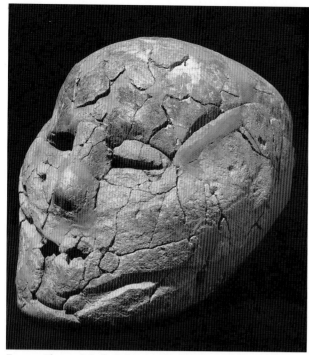

FIG. 21. Plastered skull. Beisamun; Pre-Pottery Neolithic B period, 7th millennium B.C. Israel Department of Antiquities and Museums. Photograph: Israel Museum/David Harris.

FIG. 22. Stone mask. Horvat Duma, near Hebron; Pre-Pottery Neolithic B period, 7th millennium B.C. Photograph: Israel Museum/Zeev Radovan. (Gift of Wilma and Laurence A. Tisch)

male, and child—and at Ein Ghazal the busts are arranged in a semicircle around the statues.

Although burial of human skulls occurs as early as the Natufian period, it is only in the Pre-Pottery Neolithic B that skulls are found with the features vividly modeled in plaster (fig. 21). In some cases, the skulls are deformed, and in many the lower jaw and the teeth are missing, perhaps because of some belief concerning these parts. The eye sockets were filled with shells or pellets of clay, and the base of the skull was built up to allow it to be placed at the desired angle. In many cases the plaster was covered with red-brown paint. The top and back of the skull were usually left untouched, but occasionally they were painted. Most of the plastered skulls were found below the floors of dwellings and may well represent some kind of ancestor cult.

Another sculpture type characteristic of the seventh millennium—apparently confined to the Judaean hill country—is the life-size, human-featured stone mask (fig. 22; see also cat. no. 6). Human figures wearing animal masks are depicted in Paleolithic cave art in Europe, as well as in Neolithic rock drawings in Africa. But nowhere else is a human mask, as an independent object, found at such an early date. These masks are sophisticated in shape and painted decoration. Whether they were placed on the dead or whether they were worn by the living, obviously they had an important place in religious belief and ritual.

REFERENCES: G. Childe, *New Light on the Most Ancient East*, New York, 1952; R. J. Braidwood, *Prehistoric Man*, Chicago, 1967, pp. 81–128; J. Perrot, La Préhistoire palestinienne, in *Supplément au Dictionnaire de la Bible* VIII, Paris, 1968, cols. 384–416; R. J. Braidwood, The Prehistoric Investigations in Southwestern Asia, in *Proceedings of the American Philosophical Society* 116 (1972), pp. 310–20; J. Cauvin, *Les Premiers Villages de Syrie-Palestine du IXème au VIIème millénaire avant J.C.*, Lyons, 1978; A. M. T. Moore, The First Farmer in the Levant, in *The Hilly Flanks and Beyond*, Studies in Ancient Oriental Civilization 36, T. Cuyler Young, Jr. et al. (eds.), Chicago, 1983, pp. 91–111.

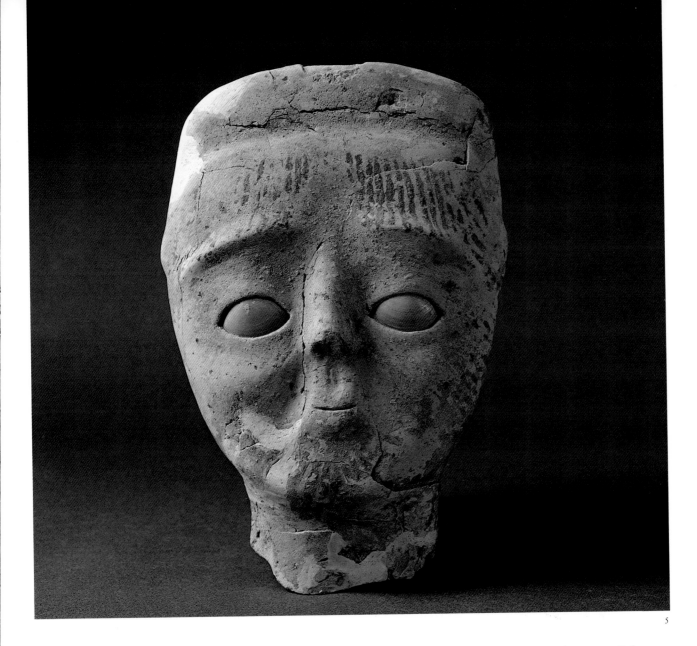

5. Head of a Statue

Jericho
7th millennium B.C.
Chalky clay; 22.5 × 15 cm. (8⅞ × 5⅞ in.)
Excavations of the Institute of Archaeology of
the University of Liverpool (1930–36) and the
British School of Archaeology in Jerusalem
(1952–58)
IDAM 35.3289

Ancient Jericho (Tell es-Sultan) is situated in the
Jordan Valley, 250 meters (820 feet) below sea level,
near an abundant spring that irrigated a large oasis.
From the earliest stages of archaeological investiga-
tion, the tell attracted the interest of many scholars,
mainly because of the biblical account of Joshua's
conquest of the city. However, the lowest strata of
the tell, dating from the Natufian and Neolithic to the

Early Canaanite period or Bronze Age, are of the
greatest importance for the study of early civiliza-
tions. And, indeed, for years Jericho was known as
the earliest city on earth.

In several seasons of excavations in the 1930s and
again in the 1950s, two main periods of occupation
were uncovered, comprising several strata of a large
village dating from the Pre-Pottery Neolithic A and B
and the Pottery Neolithic A and B. The excavations
of the earliest Neolithic level revealed a stone tower
(fig. 19), a wall or terrace for protection against
floods, and brick houses which were round in the ear-
lier phases and rectangular in the later. Some of the
rectangular structures have been identified as shrines.
Numerous tools of various types, seeds, and faunal
remains attest the beginnings of agriculture and the
domestication of animals.

Among the most outstanding discoveries at Jericho
was a series of plastered skulls and the fragments of

large chalky-clay statues of humans. Parts of such statues, including the present head, were found in the 1930s; stylized busts came to light in the 1950s. These large statues were constructed on a framework of reeds, twigs, or rushes, which left their imprint on the inside. The mode of construction is similar to that employed in a group of statues and busts that have recently come to light in the excavations of a Neolithic village at Ein Ghazal in Jordan; some of these are complete, while others, including a foot with six toes, are fragments. Fragments have also been found in the Nahal Hemar Cave. These large chalky-clay figures of humans, often found in what seem to be family groups, perhaps indicate a new religious concept. They bring to mind the myths concerning the creation of man from dust or clay in Sumerian and later Near Eastern mythologies and especially in Genesis 2:7: "The Lord God formed man from the dust of the earth."

This head and parts of the body of a plaster statue were found in the upper layers of what was later called the Pre-Pottery Neolithic B period. The head, like the rest of the statue, was modeled in chalky clay; the surface was then made smooth by spreading fine chalk over it. The head is life-size, flat in the back and almost disk-shaped in profile. Part of the neck has been preserved. The eyes, arched eyebrows, high cheekbones, and small nose with nostrils marked by holes are modeled symmetrically and delicately. The small mouth is pinched out; a short line indicates the lips, and the lower lip protrudes slightly. The ears, represented by small projections, are set high up, in line with the forehead. The eye sockets are cut out with a sharp knife and inlaid, probably from the inside, with Mediterranean conches of a type common on the southern coast of Israel. A radial design of dark brown painted stripes starts on the forehead, extends down to the eyebrows, and covers the entire face. The stripes and the intervals are of uniform width. A similar symmetrical pattern—a radial design painted in several colors—appears on the stone mask from Nahal Hemar (cat. no. 6), though it does not cover the lower part of the face. One of the recently discovered statue heads from Ein Ghazal also has painted vertical stripes on the forehead and diagonal stripes on the cheeks. Beyond their decorative character, the significance of the overall designs is not clear and may well be cultic.

REFERENCES: *J. Garstang, City and Necropolis (Fifth Report): General Report for 1935, *Annals of Archaeology and Anthropology* 22 (1935), pp. 166–67, pl. LIII; R. Amiran, Myths of the Creation of Man and the Jericho Statues, *Bulletin of the American Schools of Oriental Research* 167 (1962), pp. 23–25; K. M. Kenyon, *Excavations at Jericho III*, London, 1981; G. O. Rollefson, Ritual and Ceremony at Neolithic Ain Ghazal, *Paléorient* 9 (1983), pp. 29–38.

6. Mask

Nahal Hemar Cave
7th millennium B.C.
Limestone; 26.5 × 17 cm. (10⅜ × 6¾ in.)
Excavations of the Israel Department of Antiquities and Museums
IDAM 84–407

The cave in which this mask was found is situated on the bank of Nahal Hemar, a dry riverbed in the Judaean Desert, named for the asphalt (Hebrew, *hemar*) which wells up in it near the Dead Sea. Bedouin, looking for Dead Sea Scrolls, burrowed in the cave and left debris in front of its entrance. In 1983 this debris was examined by members of the Israel Department of Antiquities; the objects they found led to soundings and excavations which revealed three strata of the Pre-Pottery Neolithic B period, dated to the seventh millennium B.C. The abundance of finds and the exceptional preservation of perishable materials—due to the special conditions in the Judaean Desert—have added considerably to knowledge of the Neolithic period.

The finds consisted of objects of obvious cultic significance as well as other artifacts. The assemblage includes seashells from the Red Sea and the Mediterranean (some with the thread used to sew them on garments or baskets still attached); beads made of colored stone, painted wood, and clay; and many pieces of cordage with loops, as well as rigid cordage containers coated with asphalt and clay (a previously unknown feature). Of special importance are mats and

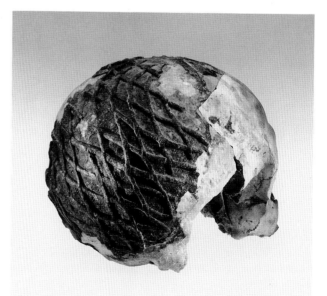

FIG. 23. Skull with applied-asphalt decoration. Nahal Hemar Cave; Pre-Pottery Neolithic B period, 7th millennium B.C. Israel Department of Antiquities and Museums. Photograph: Israel Museum/Nahum Slapak.

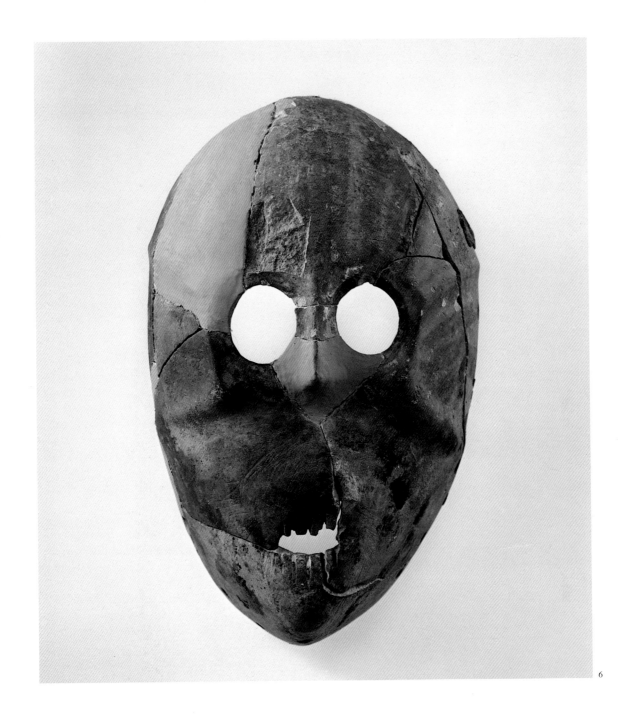

6

basketwork executed in various techniques, as well as textile fragments, some of them of delicate texture, which are decorated with sewn-on beads and shells. Among the outstanding items made of flax fiber are an elaborate piece of knotted network and another of fine twining whose border is worked in a buttonhole stitch. The almost pedantic attention to detail may indicate that some of the fabrics were not intended for daily use. In the aggregate they convey much information about Neolithic crafts—spinning, weaving, basketry, and the preparation of paint.

Among the objects with a definite cultic connotation are the present stone mask, a fragment of another, and the skulls of adult males (one complete with an asphalt net pattern on the back [fig. 23]). Other finds include fragments of a life-size human head made of chalky clay, decorated with paint and thin asphalt strips (see cat. no. 5). A fragment containing a large eye outlined in red and green paint is especially impressive. Four bone figurines of human heads (fig. 24), which were originally covered with paint, an animal figurine, and a sickle complete the group. Each item, with the exception of the bone figurines, is paralleled from other Neolithic sites, but the Nahal Hemar assemblage is the richest and most varied of the period.

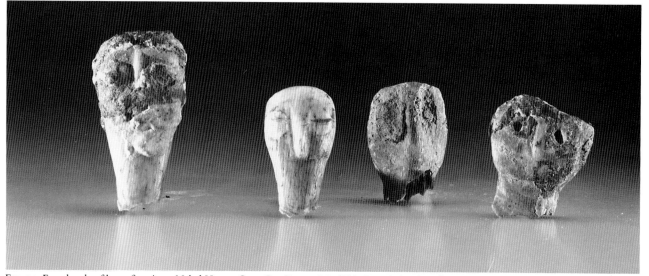

FIG. 24. Four heads of bone figurines. Nahal Hemar Cave; Pre-Pottery Neolithic B period, 7th millennium B.C. Israel Department of Antiquities and Museums. Photograph: Israel Museum/Nachum Slapak.

How should this assemblage be interpreted? It has been suggested that these objects were cult paraphernalia, which were stored in the cave, or that the cave was a cult site where ceremonies were performed. In this context it should be noted that the flint tools usually present in contemporaneous Neolithic sites were rare and that only some special types of tools, evidently not produced in the cave, were found. Most importantly, the cave provides a glimpse into the enigmatic spiritual world of Neolithic humans.

Masks are extremely rare among prehistoric archaeological finds, and those from the Pre-Pottery Neolithic period found in Israel are so far unique. All the masks are of limestone, and all represent human faces. In addition to the two from the Nahal Hemar Cave, two were found in the southern Judaean hills.

Since the earliest times, masks have had many functions in human societies. They appear in Paleolithic cave paintings in Europe and in rock drawings at Tassili in the Sahara Desert and in those of Bushmen in the Kalahari Desert, where some are dated to the sixth millennium B.C. In present-day tribal societies, masks are used in cult ceremonies such as initiations and rituals commemorating death, marking the seasons of the year, and the like. Masks are found in societies of nomads and hunters, as well as among agriculturalists. The mask changes the identity of the wearer, investing him with mystery and supernatural powers. Most masks in use today are made of wicker or wood, materials that are close at hand and are believed to be inhabited by spirits.

The mask from Nahal Hemar, slightly over life-size, is the largest of the Pre-Pottery Neolithic stone masks found thus far in Israel. It was pieced together from several fragments (the nose is restored). Some of the fragments are blackened by fire. The back is hollowed out, and the thickness of the stone is uniform and symmetrical throughout. The chin is painted. The small mouth is open, and there are four teeth in both the upper and lower jaw. The cheekbones are prominent, and the high forehead is domed. Patches of asphalt, some still with hair adhering to them, are visible around the mouth, along the edge of the mask, and on the head. A painted radial design decorates the mask, and it may well be that the entire surface was originally painted red and the radial design was added in green and perhaps also in white paint. The round eyes are outlined by thin red and white lines. Paint stains superimposed on the designs may indicate that the colors were refurbished or changed. Traces of white paint have survived between the teeth. Eighteen irregularly spaced holes are cut into the edge of the mask; these holes may have been used to attach the mask to a garment, or ornaments may have been fastened to them.

The appearance of limestone masks in the Neolithic period in a fully developed form does not exclude the possibility that earlier or even contemporaneous masks were made of wicker or wood.

Nothing is known about the function of these masks. Were they placed on the faces of the dead or of the living; were they carried on poles during cult ceremonies; or were they used in other ways?

REFERENCES: J. Perrot, *Syria–Palestine 1: From the Origins to the Bronze Age* (Archaeologia Mundi), Geneva, 1979, pls. 20, 26; *O. Bar Yosef, *A Cave in the Desert: Nahal Hemar*, Israel Museum, Jerusalem, 1985, cat. no. 258.

FIGURINES FROM HORVAT MINHA
Cat. nos. 7–9

7th millennium B.C.
Excavations of the French Archaeological
Mission and the Israel Department of
Antiquities and Museums

These three clay figurines belong to a class of
miniature human representations which have
been found at many Pre-Pottery Neolithic B sites
in the Levant.

Such figurines were made from fine sun-
baked clay and were sometimes burnished with
a pebble. The bodies are elongated, and the arms
are only occasionally marked. The legs are not
indicated, and the figures stand on a splayed base.
The head is usually flattened, with the eyes and
the nose represented by applied clay pellets. The
mouth is lacking in all three figures, in continua-
tion of an earlier tradition. Animal figurines in
the same style are known from a few sites in the
Levant (Ghoraife in Syria, for example).

The large Neolithic site of Horvat Minha
(Munhata) in the Jordan Valley, 215 meters (705
feet) below sea level, was extensively excavated
from 1961 to 1967 and an area of 800 square
meters (960 square yards) was exposed (fig. 25).
Of the six occupation layers, levels VI–III are
from the Pre-Pottery Neolithic B period, and
they reveal that the village was inhabited contin-
uously for many generations. The population
enjoyed abundant hunting, food gathering, and
fishing, and there is no doubt that agriculture
was practiced from the earliest phase of that site.
The excavations revealed rectangular houses
with plastered floors, circular platforms, vari-
ous installations, and an abundance of flint, ba-
salt, and limestone tools. Obsidian implements,
semiprecious stones, and shells attest the exist-
ence of trade relations with both northern and
southern regions.

REFERENCES: J. Perrot, La Troisième Campagne de fouilles à
Munhata (1964), *Syria* 13 (1966), pp. 49–63; H. de Conten-
son, L'Art du Néolithique Préceramique en Syrie-Palestine,
Bolletino del Centro Camuno di Studi Preistorici 18 (1981),
pp. 60–61.

7. Male Figurine

Clay; 5 × 1.5 cm. (2 × ⅝ in.)
IDAM 67-664

This complete figurine consists of a roughly cylindri-
cal body, flattened at the bottom and pinched out at
the top to form the head. The pellets representing the
eyes have fallen off. It lacks any features with the ex-
ception of a male sexual organ which is grooved at the
end. When the figurine was made, part of it was fold-
ed over while the clay was still wet; on the back there
is a hollow also made before the clay hardened.

8. Female Figurine

Clay; 3.6 × 1.5 cm. (1⅜ × ⅝ in.)
IDAM 67-665

This figurine is more carefully modeled than cat. nos.
7 and 9. It is made of gray clay and bears traces of
burnishing. The breasts are pinched out of the clay,
and each has a hole in its center. The slight bulges on
the sides may represent the arms, and the fold on the
chest may be the right hand. There is a hollow in the
back. The lower part of the figurine is broken off.

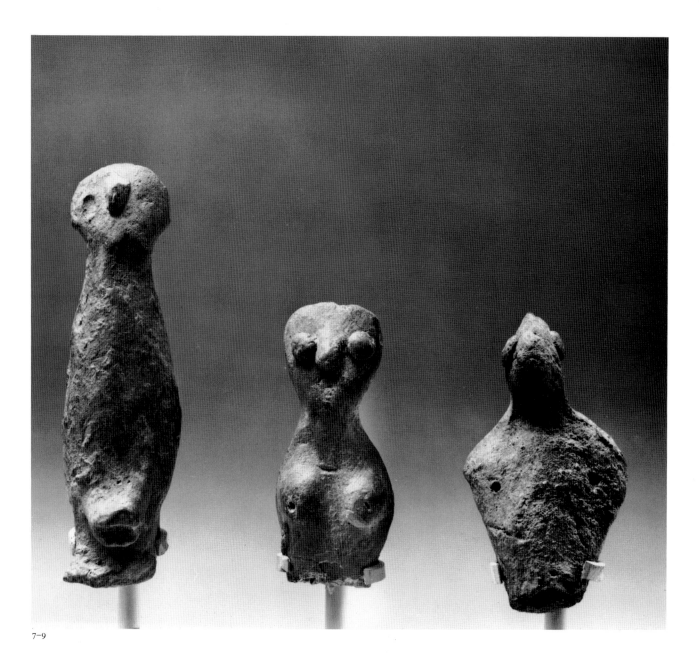

7–9

9. Female Figurine

Clay; 3.5 × 2 cm. (1⅜ × ¾ in.)
IDAM 67–666

This figurine is made of reddish clay without burnish.
It differs from cat. nos. 7 and 8 as well as from other
figurines found on the site—its pinched head is point-
ed instead of round, its body is triangular, and its
back is concave. The small bulges on the wide shoul-
ders may be sketchy indications of arms. Two small
holes in the chest represent nipples, but the breasts are
not shown. The eyes are placed asymmetrically, and
the nose is formed by the sharp angle of the face. The
lower part of the figurine is broken off.

10. Seated Woman

Horvat Minha (Munhata)
6th millennium B.C.
Pottery; 11 × 6.5 cm. (4⅜ × 2½ in.)
Excavations of the French Archaeological
Mission
IDAM 67–684

This impressive pottery figurine is the only complete
example of its kind to have been found. Its iconogra-
phy, rich in realistic as well as symbolic details, be-
longs to the Yarmukian culture, which flourished in
the sixth millennium B.C.

The figurine was found during the excavation of

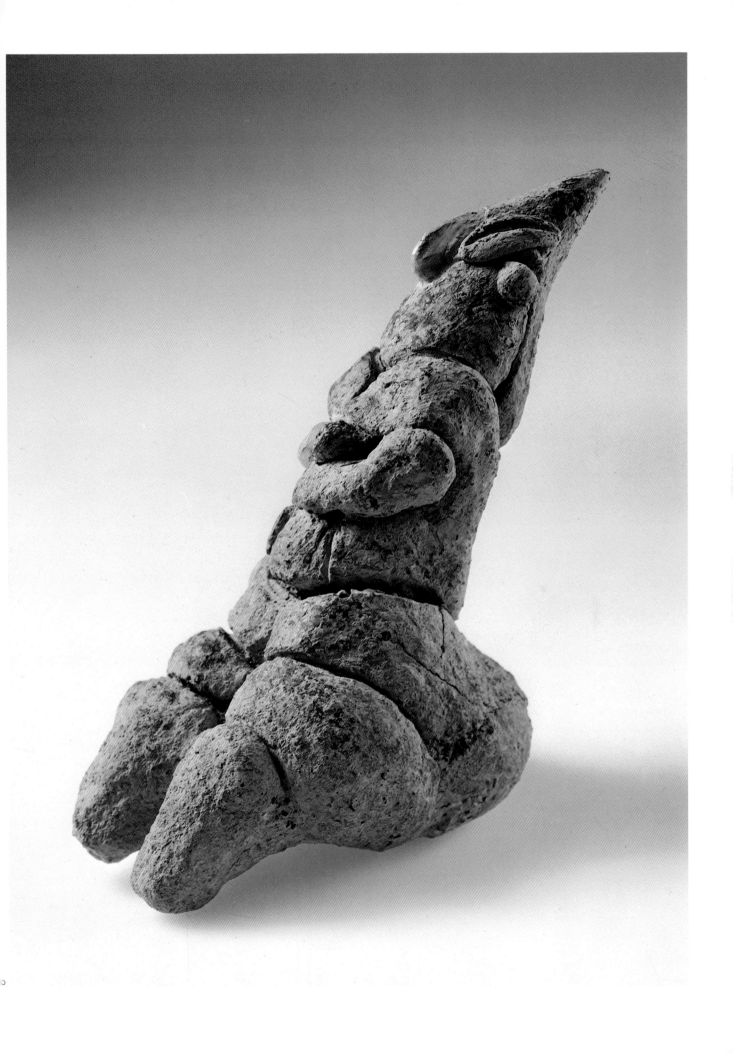

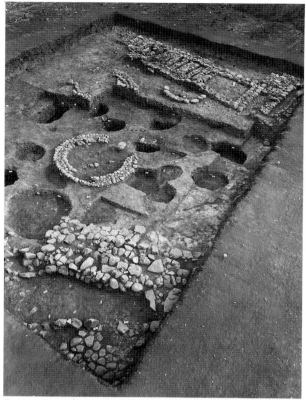

FIG. 25. Two phases of habitation at Horvat Minha: dwelling pits (6th millennium B.C.); rectangular houses (5th millennium B.C.). Photograph: Centre de Recherche Français de Jerusalem.

the separately made parts of the body. Details were indicated by applied bits of clay, and the separate body elements are clearly demarcated by incisions made with a sharp tool. Vessels and other objects were fashioned from the same clay used for the figurine.

The figurine has many parallels. Perhaps the earliest example is a figure from Kefar Giladi. Contemporaneous pieces belonging to the same iconographical group include the numerous figurines from Shaar Hagolan and the other figurines from Horvat Minha itself, as well as figurines found at Megiddo, Tel Aviv, and Byblos.

Seated figurines are known from the beginning of the Neolithic period, and with the passage of time they become more formal and regal. A figurine from Çatal Hüyük in Anatolia, depicting a woman seated on a chair and flanked by felines, is the culmination of this genre of "fertility figurines" or "mother goddesses."

REFERENCES: *J. Perrot, La IVᵉ Campagne de fouilles de la mission archéologique française en Israël, à Munhata, *Académie des Inscriptions & Belles-Lettres: Comptes rendus des séances de l'année 1965*, Paris, 1966, pp. 407–11; E. Yeivin and I. Mozel, A *Fossil Directeur* Figurine of the Pottery Neolithic A, *Tel Aviv* 4 (1977), pp. 194–200; T. Noy, in *Highlights of Archaeology: The Israel Museum*, Jerusalem, 1984, pp. 26–27.

Horvat Minha (see cat. nos. 7–9 and fig. 25). The main characteristics of the Pottery Neolithic settlement are numerous dwelling pits and silos, a rich range of tools made of flint, limestone, and basalt, and handmade pottery vessels decorated with incised herringbone patterns and red paint. Of particular interest are the figurines, the majority of pottery and a few of stone. Most of the pottery figurines depict females; although many are broken, they share a common style.

The present figure represents a seated woman with a full body and steatopygous lower parts. No stool or throne was found with it. The breasts are relatively small, with the bent left arm supporting them. The right arm, now broken off, probably hung down along the body. A garment covers the shoulders, the back, and the waist. The triangular head rests directly on the shoulders. The mouth is not indicated, and the broken nose is restored. The slanted eyes of "coffee-bean" shape are each made of an oblong clay pellet grooved down the center. The ears are similarly fashioned of applied clay pellets, with the groove perhaps representing an earring. At the back of the head is a slight projection which may represent either the hair or a headdress.

The figurine was fashioned by wrapping a layer of clay around a cylindrical core, also of clay, and adding

11. Head of Human Figurine

Shaar Hagolan
6th millennium B.C.
Pottery; height 6.5 cm. (2½ in.)
Chance find
IDAM 74–561

The site of Shaar Hagolan is located on the bank of the Yarmuk River, which drains into the Jordan south of the Sea of Galilee. This river gave its name to the Yarmukian culture, which was first discovered here. The Jordan Valley has rich alluvial soil and abundant water, which allowed early farmers to raise a plentiful supply of food.

The site, which today is covered by a fish pond, was discovered in 1943, and many figurines were collected on the surface by members of Kibbutz Shaar Hagolan. Limited excavations in 1949–52 revealed an occupation layer of the Pottery Neolithic period and a flint and stone industry reflecting the mixed economy of the Neolithic village—fishing (net sinkers), farming (sickle blades, mortars, and grinding tools), and hunting (flint arrowheads). The pottery vessels, the

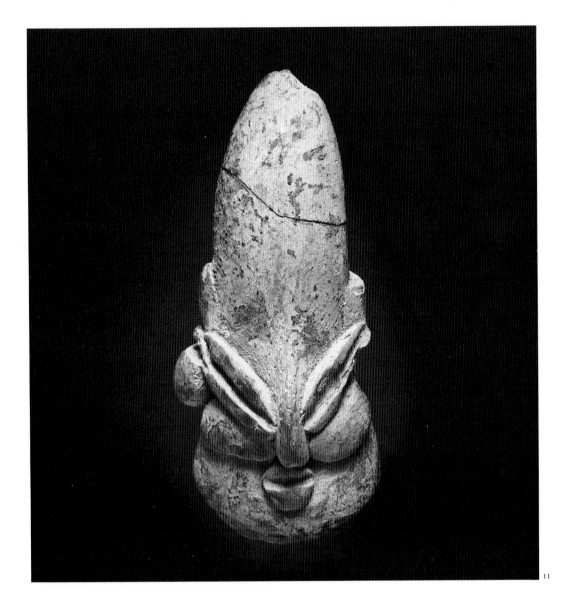

earliest to appear in Israel, are decorated with incised herringbone patterns and red paint. The art of the Yarmukian culture is particularly well represented by more than 170 objects that have been discovered at Shaar Hagolan, including numerous incised pebble figurines and small stone statuettes, as well as some pottery figures.

This perfectly preserved head formed part of a pottery figurine; the body has not survived, but it must have resembled the complete figurine from Horvat Minha (cat. no. 10). Like many of the other finds from this site, it was picked up on the surface. The head is made of buff clay with small basalt particles as temper. It is broad at the base and tapers to a high, narrow top, curving slightly backward. It was modeled in several stages: a cylindrical inner core was covered with a layer of clay which gave the head its shape. The facial features were modeled separately and applied, with the exception of the long nose,

which was pulled out from the basic clay lump. The mouth is round with the lips indicated by a straight line. The nose reaches the mouth and is flanked by bulging cheeks. The eyes, the most impressive feature of the face, are placed at an oblique angle; a deep groove down the center of each produces the "coffee-bean" shape. The groove was made by a piece of wood whose traces are visible in the clay. The distinctive shape of the eye is reminiscent of forms found in nature, such as date pits and grains of wheat or barley. Thus, it is tentatively suggested that the eyes may be realistic depictions invested with symbolic meaning. This concept of the eye seems to continue in the Levant and in Mesopotamia well into the fourth millennium. Next to the right eye is a round lump, one of the two elements probably intended to represent an ear with a round decoration (earring?) attached to its lower part. The upper part of the head is smooth and ends in a point, like those of most other contempora-

neous figurines. A piece at the back, now missing, probably represented the hair or a headdress, which came down to the shoulders. Red paint covers parts of the head.

This head is one of the most impressive examples of Yarmukian art. It also provides an example of the depiction of the mouth, a rare exception to the iconographic norms of the period.

REFERENCES: *M. Stekelis, On the Yarmukian Culture, *Eretz-Israel* 2 (1953), pp. 98–101, pl. xv (Hebrew); E. Anati, *Palestine Before the Hebrews*, New York, 1963, pp. 266–67; M. Stekelis, *The Yarmukian Culture of the Neolithic Period*, Jerusalem, 1972.

12. Anthropomorphic Figurine

Shaar Hagolan
6th millennium B.C.
Pebble; 23.5 × 10.1 cm. (9¼ × 4 in.)
Chance find
IDAM 79–493

Pebbles carved into schematic human representations have been found in several sixth-millennium sites in Israel and Lebanon, but the largest collection comes from Shaar Hagolan.

The present figurine, like most of the other finds, was discovered on the surface of the site. It is made from a large oval limestone pebble, which bears traces of the hammer blows that gave it its symmetrical shape. The face is schematic, with eyes shown by horizontal incised lines and a round mouth made by an awl or a flint borer. In spite of the stark economy of features, the figurine achieves an elemental forcefulness.

Most of the figurines found at this and other Yarmukian sites are schematic representations of the human figure, with a few features incised on a symmetrical pebble, which is usually oval but may sometimes be round. There are, however, variations of this basic typology. Some figurines present more detailed representations, at times using both sides of the pebble. The position of the eyes also varies; they may be marked by one or several straight or oblique lines. (The oblique eyes are reminiscent of the eyes so characteristic of the contemporaneous clay figurines.) Another type of figurine combines the three-dimensional and the schematic type, with only the upper part carved in the round.

REFERENCES: J. Cauvin, *Religions néolithiques de Syro-Palestine*, Paris, 1972, pp. 72–81; M. Stekelis, *The Yarmukian Culture of the Neolithic Period*, Jerusalem, 1972; *T. Noy, in *Highlights of Archaeology: The Israel Museum*, Jerusalem, 1984, pp. 28–29.

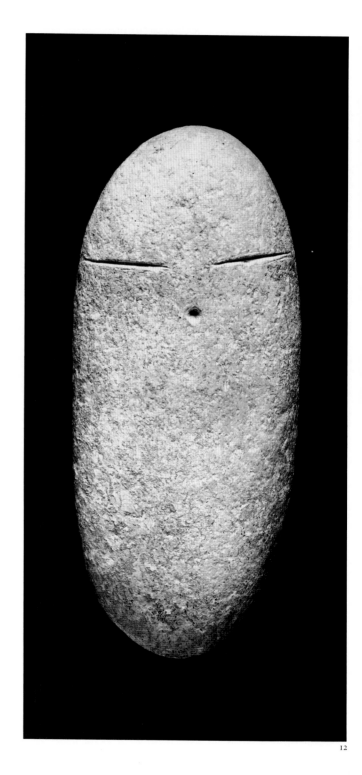

12

CHALCOLITHIC PERIOD

4500–3150 B.C.

Archaeological excavations conducted mainly during the last three decades have revealed the remains of a fourth-millennium culture that was, in many respects, surprisingly advanced. Combining elements of copper (Greek, *chalcos*) and stone (*lithos*) technologies, the Chalcolithic period forms a bridge between the earlier Stone Ages and the subsequent Bronze Ages and heralds the end of prehistory. At this stage of knowledge, there is no evidence that copper was known in the early part of this period. But, by its first appearance in the Late Chalcolithic, techniques for its use were already highly advanced, and copper was of economic and cultural significance.

In their attempts to establish the relative chronology of this age, scholars rely mainly on the typological study of flint and pottery artifacts, using conventional methods of archaeology (absolute dating can only be obtained through such methods as the measurement of carbon 14 present in organic materials). The end of the Chalcolithic is determined by the abandonment of the Late Chalcolithic settlements and by the onset of the subsequent Early Bronze culture and is placed in the last quarter of the fourth millennium. Its beginnings are more difficult to date. Conventional archaeological chronology allows more than a millennium for the Chalcolithic period, beginning about 4500 B.C. Calibrated carbon 14 datings, however, push the incipient stage of the Early Chalcolithic back a few centuries, allowing for a longer period of slow development.

The Early Chalcolithic material culture is known mainly through the study of local and regional assemblages. Chronological correlations between these groups are often uncertain, and

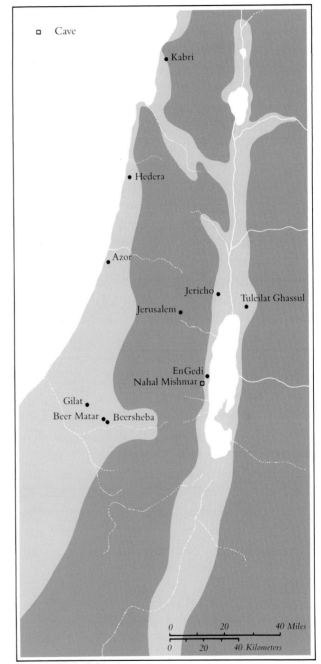

FIG. 26. Chalcolithic sites.

the attribution of some assemblages to either the Late Neolithic or the Early Chalcolithic remains open. One of these assemblages is the so-called Wadi Rabbah culture, which takes its name from the river in the Tel Aviv region where it was first recognized and which has been found at sites as far distant as the northern valleys. The origins of this and related local groups, characterized by dark-faced burnished pottery with occasional anthropomorphic and geometric ornaments, should be sought in Lebanon and still further north. Also related to northern cultures is the intriguing group of outstanding stone artifacts from Kabri (see cat. no. 32), which includes objects of obsidian, a volcanic material that could have reached a site in Israel only by trade or through population movements.

The history of the Late Chalcolithic period in the northern and central regions of Israel still remains largely unknown. In the Plain of Sharon excavations of ossuary cemeteries have revealed funerary customs unique to the Chalcolithic period (see cat. nos. 18–20). But a turning point in knowledge of this phase was brought about by excavations in the peripheral areas of the south and east. A distinct cultural phase was first encountered at Tuleilat Ghassul, located east of the Jordan River opposite Jericho (the Ghassulian culture). A settlement pattern of villages situated in river valleys was found to have existed in the northwestern Negev and in the Beersheba Valley (the Beersheba culture), that is, in semi-arid zones. Traces of occupation were found in caves in the Judaean Desert, culminating in the epoch-making discovery of the Nahal Mishmar copper treasure (see cat. nos. 21–31). A related

regional aspect of the Late Chalcolithic culture is currently being investigated in villages in the Golan. Agriculture and pastoralism were the chief means of subsistence of these sedentary and nomadic or seminomadic societies, but they also engaged in specialized crafts requiring expert artisans and smiths. No fortifications and very few public buildings have been revealed in excavations. A temple at En Gedi is the sole exception to date: isolated and not associated with any particular village, this large sacred compound must have served as a cultic center of regional importance (fig. 110).

The most remarkable achievements of this culture lie in the realm of art, with figurative sculpture the preferred medium. Naturalism and abstraction are found side by side in the pottery sculpture from Gilat (cat. nos. 16 and 17), in the ivory figurines from Beersheba (cat. nos. 13–15), and in the copper artifacts from the Judaean Desert (cat. nos. 21–31). Raw materials were carried by traders, sometimes from afar, and excavations have shown that at least some of these superb and unusual objects were locally produced. Indeed, there is an originality in the Late Chalcolithic art of Israel that finds no direct stylistic comparisons among contemporaneous cultures and is probably indigenous. These Late Chalcolithic coppersmiths, potters, stone cutters, and ivory carvers joined the Near Eastern cultural explosion of the fourth millennium, masterfully creating what we perceive as art but what for them must have had a deep cultic or ceremonial significance. This unique and seemingly meteoric burst of artistic expression ceased when the Chalcolithic villages were abandoned.

IVORIES FROM BEERSHEBA
Cat. nos. 13–15

Second half of 4th millennium B.C.
Excavations of the French Archaeological
Mission in Israel

Excavations conducted in Nahal Beersheba during the 1950s revealed remains of a Chalcolithic culture, today known as the "Beersheba culture." Several small villages were discovered on both banks of the Nahal Beersheba; each contained a few dwellings, and the population of each village could not have exceeded several hundred persons. These settlements probably existed for no more than a few centuries.

The earliest dwellings were subterranean, a network of rectangular—later, round or oval—rooms, courtyards, and corridors, connected by galleries and reached by shafts. This architecture may have evolved in response to the trying climate with its heat and sandstorms. There was a break in settlement, and in the last phase the buildings were constructed on the surface. These were fairly large rectangular houses built of sun-dried mud-brick laid on stone foundations.

Additional remains found in recent excavations in the Beersheba Valley indicate that the villages were more numerous and that some were larger than previously thought. No public buildings, temples, or palaces have been unearthed in these unwalled Chalcolithic settlements. Numerous remains of sheep and goats indicate that the principal source of subsistence was animal husbandry; wheat, barley, and pulses, as well as sickles, querns, pestles, and numerous silos, prove that agriculture was also well developed.

Arts and crafts attained an impressive variety and degree of specialization and illustrate the existence of trade in raw materials or in finished products. Finished copper tools, bits of ore and slag, and fragments of crucibles all indicate the existence of an advanced local metal industry. Flint tools were common, while bone tools were relatively scarce. Most of the pottery was hand-made, but a primitive wheel (tournette) was already in use. Stone vessels were found, among them basalt bowls and high-footed stands, beautifully smoothed and decorated with incised patterns. Jewelry included pendants of bone, ivory, turquoise, or stone and necklaces of mother-of-pearl, glassy paste, and carnelian beads.

Especially remarkable are the ivory objects. In a workshop discovered in one of the subterranean dwellings at Beer Safad (Bir Safadi), a complete tusk was found, together with a stone worktable and cutters' tools, including a copper borer set in a bone handle. This evidence of a local ivory industry, in addition to the large number and variety of ivory objects found in the Beersheba region, suggests the existence of a prolific and creative school of highly competent artisans (fig. 27).

For the present the Beersheba ivories remain stylistically unique. The prehistoric Egyptian sculptures provide a general rather than specific comparison. The three anthropomorphic statuettes illustrated here display an originality of

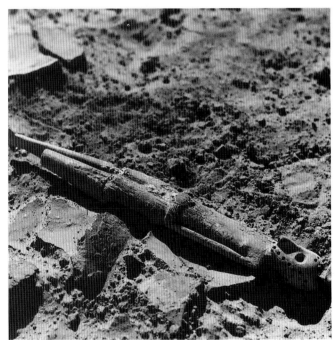

FIG. 27. Male ivory statuette in process of excavation at Beer Safad. Chalcolithic period, second half of 4th millennium B.C. Photograph: Centre de Recherche Français de Jerusalem.

style and a technical skill that mark the Beersheba ivories as masterpieces of ancient sculpture. Very little is known of Chalcolithic cult or religious ritual, and despite an unusually large group of representational sculpture, the code of Chalcolithic iconography has not yet been deciphered. Therefore the identity, the purpose, and the meaning of these statuettes—whether images of deities or of worshipers—still remain obscure.

REFERENCES: J. Perrot, Syrien, Palästina und Zypern, in *Propyläen Kunstgeschichte*, Band 13, Frankfurt, 1974, pp. 51–60, pls. 119–28; J. Perrot, *Syria-Palestine I: From the Origins to the Bronze Age* (Archaeologia Mundi), Geneva, 1979, pp. 156–60, pls. 49–84.

13. Male Statuette

Beer Safad
Ivory; height 33 cm. (13 in.)
Excavations of the French Archaeological
Mission in Israel
IDAM 58–579

This statuette, carved with both naturalism and stylization, has a sense of serenity and mystery.

The rather small head has a deep, conical depression at the top, which may have been crowned by a separate element. Facial details are numerous: the now-hollow, round eye sockets were originally inlaid. The nose, flush with the forehead, is the most prominent element in the face; there is no mouth. The ears consist of protruding circular frames with concave centers. Pairs of interconnected perforations, which encircle the head and surround the face, were undoubtedly used for attaching a beard and hair. The almost square shoulders frame the narrow torso, on which the ribs are faintly visible. The thin arms are separate from the body; the hands are set perpendicular to the arms, and the fingers are indicated by incisions. The navel was formed by drilling. It appears that the statuette has some type of belt and a phallic sheath. The small buttocks protrude sharply from the completely flat back, which shows no signs of modeling. The thighs are very short, while the calves are disproportionally long. The ankles are well marked; the feet are small and clublike with incised toes.

Some of these stylistic features consistently appear in the Beersheba school of ivory carving and are characteristic of the Late Chalcolithic sculpture in general. Foremost among these are the prominent nose, the lack of a mouth, and the round eyes, as well as the figure's frontality and nudity.

The statuette, found in one of the subterranean houses, is carved in its entirety from a single piece of ivory and, following the shape of the tusk, is narrow and elongated. When found, it was missing the lower part of the left leg, which is now restored. The ivory, whose surface is cracked and damaged, is in a poor state of preservation.

REFERENCES: *J. Perrot, Statuettes en ivoire et autres objets en ivoire et en os provenant des gisements préhistoriques de la région de Beersheba, *Syria* 26 (1959), pp. 8–19, pl. II; M. Tadmor, in *Highlights of Archaeology: The Israel Museum*, Jerusalem, 1984, pp. 32–33; M. Tadmor, Two Chalcolithic Figurines—Technique and Iconography, *Eretz-Israel* 18 (1985), pp. 428–34, pls. 92–93 (Hebrew), English summary, p. 80*.

14. Female Statuette

Provenance unknown
Ivory; height 29 cm. (11⅜ in.)
IMJ 79.46.162
Gift of Mrs. Sarah Salomon, Haifa

This statuette, though not found in the Nahal Beersheba excavations, is assigned to the Beersheba ivories because of its striking similarity to the male statuette (cat. no. 13) and to several other sculptures from the region of Beersheba.

It may well be that the statuette was broken during carving and that the large, solid face was therefore left unfinished. The eyes, nostrils, and mouth are not represented; the ears are marked by tiny protuberances. Unlike the male, this female statuette gives the impression of fleshiness: she has broad shoulders and a rounded belly. The full breasts, which are the most prominent feature of her body, most probably indicate the connection of this female figure to milk and fertility. Although the surface is damaged in the area

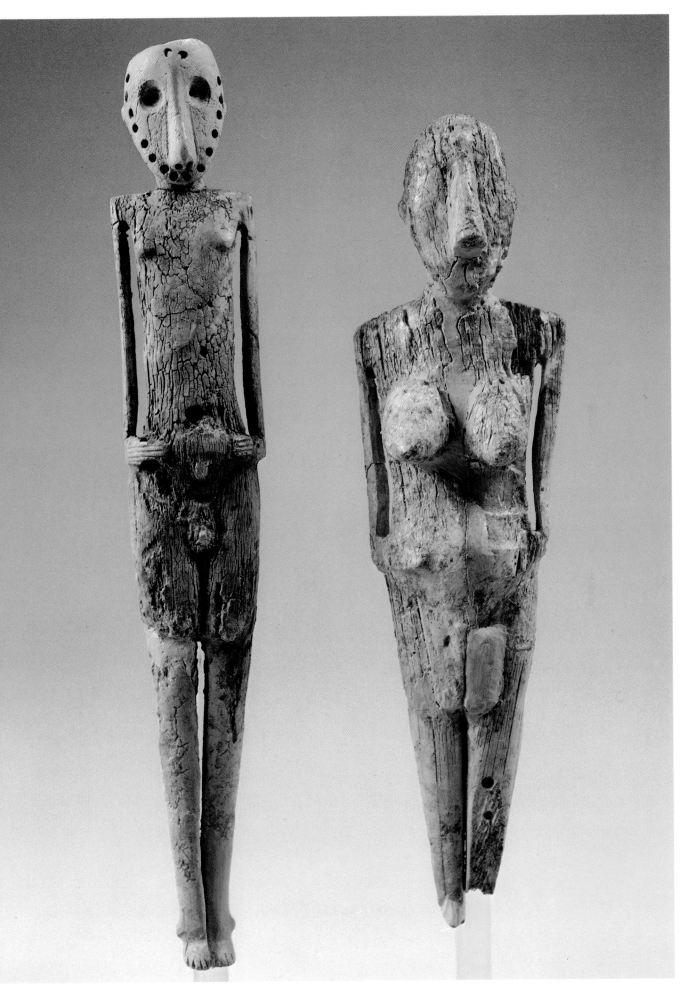

of the pubic triangle, it appears that the genitalia were not represented.

Like the male, this statuette was carved from a single piece of tusk. The lower part of both legs and the feet, which were missing, are now restored. The nose is repaired and is therefore even larger than originally intended.

REFERENCE: *R. Amiran and M. Tadmor, A Female Cult Statuette from Chalcolithic Beer-sheba, *Israel Exploration Journal* 30 (1980), pp. 137–39, pl. 17.

15. The "Beersheba Venus"

Beer Safad
Ivory; height 12 cm. (4¾ in.)
Excavations of the French Archaeological Mission in Israel
IDAM 58–586

There is an unusual degree of naturalism in this delicately rendered statuette of a pregnant young woman which was named the "Beersheba Venus."

There is no angularity or rigidity in the youthful body. The shoulders are rounded; the arms are separate from the body, with the hands resting below the abdomen; the fingers are indicated by three incisions, rather clumsily cut. The small breasts and the high, protuberant belly are well defined; the nipples and the disproportionately large and deep navel must have been inlaid. Also exaggerated in size is the pubic triangle, delineated by a deep incision and twenty-eight round perforations, originally filled with bitumen. The legs are separated, with very long thighs and foreshortened calves. The knees are indicated. The unarticulated feet are small, uneven, and clublike. The back is flat, and the buttocks are small. Two circular perforations have been drilled at the base of the back.

The head and the right arm are missing, but the ivory is beautifully preserved, its surface smooth and glossy. The figurine was carved from a single piece of tusk. Like the male statuette (cat. no. 13), this figurine was found in a subterranean house.

REFERENCE: *J. Perrot, La 'Vénus' de Beershéba, *Eretz-Israel* 9 (1969), pp. 100–101, pl. XIII.

VESSELS FROM GILAT
Cat. nos. 16 and 17

Second half of 4th millennium B.C.
Excavations of the Israel Department of Antiquities and Museums

A wealth of artifacts, some of them unique, were collected at Gilat over the last forty years, as members of the moshav deep-ploughed their fields. Following these finds, a salvage excavation was conducted at the site, and one of the most important Chalcolithic settlements known to date in the northern Negev was revealed. Situated west of Beersheba on the east bank of Nahal Pattish, the site covers about 10 hectares

(25 acres). In the area excavated, three occupation levels were found, which, like all the objects previously found at Gilat, date from the Chalcolithic period. The settlement at Gilat, like the villages along Nahal Beersheba, was abandoned some time toward the end of the Chalcolithic period. Among the outstanding finds were violin-shaped figurines of granite and crystalline chalk, copper and stone mace heads, cosmetic palettes, and sculptured objects. Numerous pottery vessels, including churns, as well as flint tools typical of the Chalcolithic period, were also found.

In the excavation, levels I and II were found to be much damaged. However, preserved in level III, the lowest, were the remains of a spa-

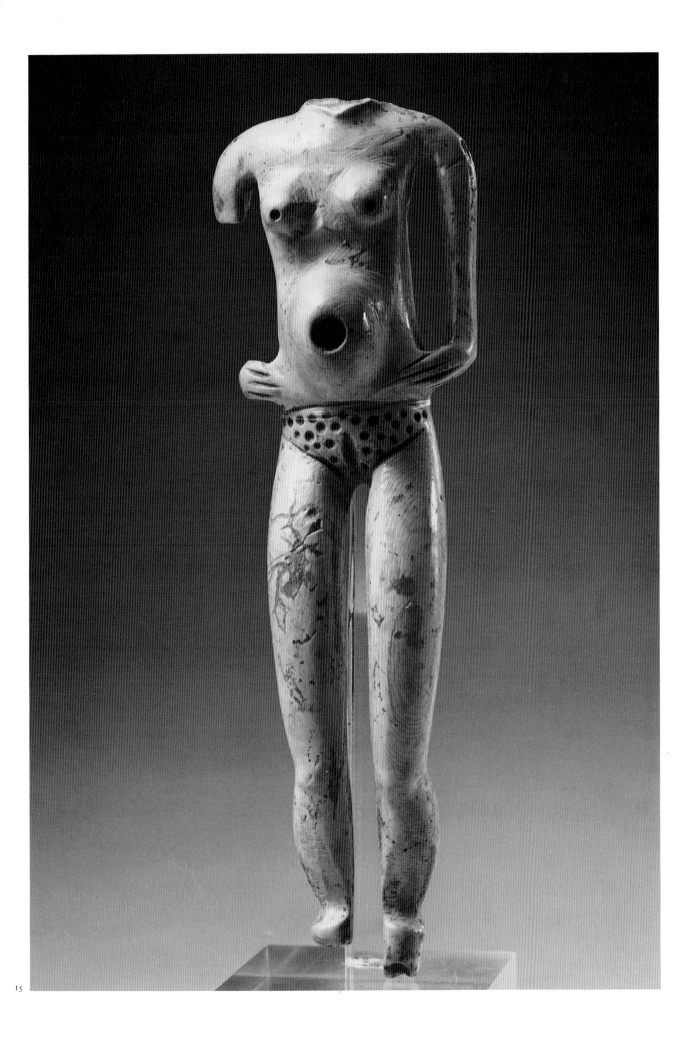

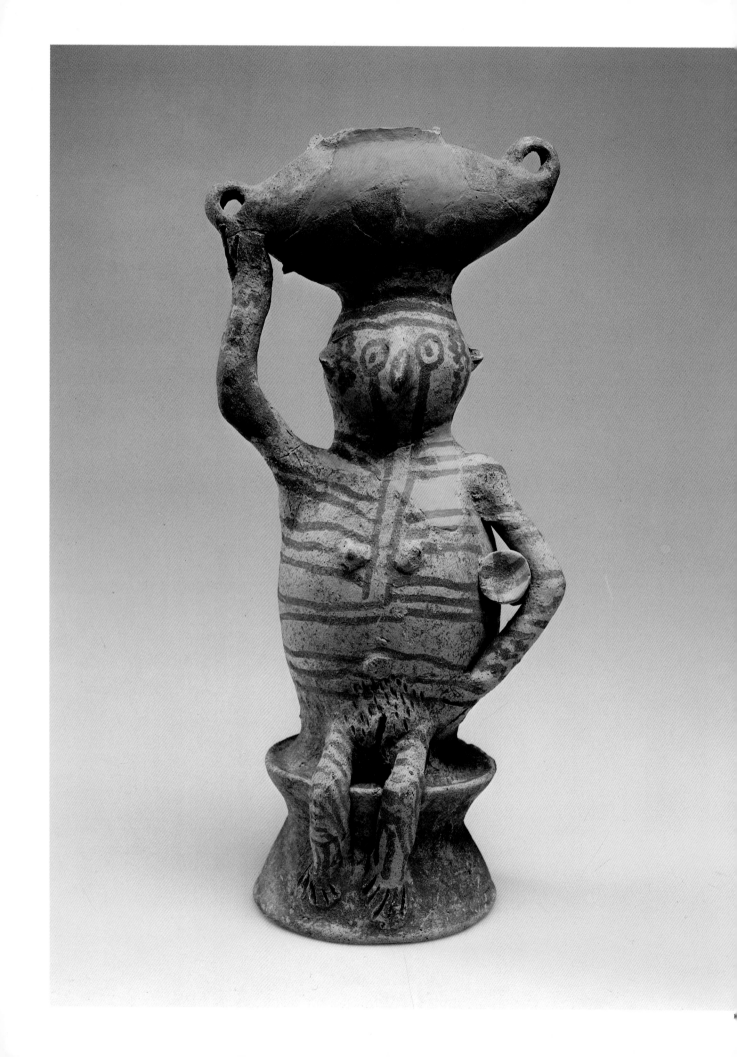

cious building, of which two rooms were exposed. Because of its size and contents the structure was identified by the excavator as a shrine, and if so it is the first occurrence of a shrine within a Chalcolithic settlement. The two vessels described below were found in the building, together with a violin-shaped figurine, a granite grindstone, and a basalt ax.

REFERENCES: D. Alon, Two Cult Vessels from Gilat, *'Atiqot*, English series II (1976), pp. 116–18, pls. 23, 24, 26; R. Amiran, Note on the Gilat vessels, *'Atiqot*, English series II (1976), pp. 119–20.

16. Woman with Churn

Pottery; height 30 cm. (11¾ in.)
IDAM 76–54

This complex sculpture is a container, designed in the shape of a seated woman balancing a churn on her head and holding a vessel in the crook of her left arm. It remains a unique example, although many of its stylistic details are drawn from the rich repertoire of Chalcolithic representational art. The vessel is made of four main components: the red-painted hollow and biconical stool; the nude figure with barrel-shaped body, globular head, thin arms, and foreshortened legs; the red-painted churn (restored; neck missing); and the small high-footed bowl, decorated in red. Certain details of the body are depicted in paint, while the genitalia, fingers, and toes are represented by incisions, and the ears, breasts, and navel are formed by small applied pellets of clay.

As in all anthropomorphic representations of the period, the eyes are circular, the nose is prominent, and there is no mouth. Special attention was given to the coiffure: curled strands of hair frame the face and

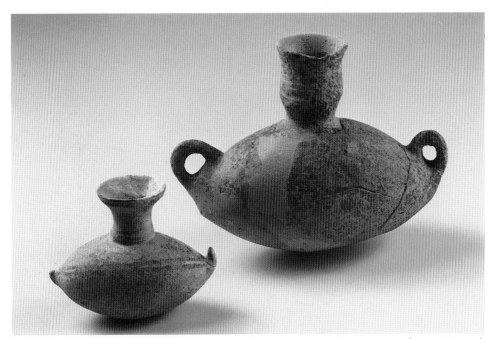

FIG. 28. Pottery churns. Chalcolithic period, 4th millennium B.C. Israel Department of Antiquities and Museums. Photograph: Israel Museum/David Harris.

cover most of the neck. The three horizontal bands on top of the head appear to represent a support for the churn rather than hair. The body is covered by horizontal red bands, arranged in groups of two or three.

The complex design and the skillful execution, as well as the provenance of the vessel, strongly suggest that this unusual container had cultic significance. The presence of the churn (fig. 28) may indicate an association with milk and fertility rites.

REFERENCES: *D. Alon, Two Cult Vessels from Gilat, 'Atiqot, English series 11 (1976), pp. 116–18, pls. 23, 24, 26; M. Tadmor, in *Highlights of Archaeology: The Israel Museum*, Jerusalem, 1984, pp. 30–31; M. Tadmor, Naturalistic Depictions in the Gilat Vessels, *The Israel Museum Journal* 5 (1986), pp. 7–12.

17. Ram Carrying Jars

Pottery; 23 × 27.5 cm. (9 × 10⅞ in.)
IDAM 76–53

Similar in artistic conception to the anthropomorphic vessel of a woman with a churn (cat. no. 16), this is also a sculptured container. The three jars are connected to the body of the ram by openings, so that liquid poured into them would flow into the ram's hollow body.

The head is narrow and elongated, with curved horns, circular eyes, and indented mouth. The long body features schematically rendered short, tubular legs, prominent sexual organs, and the broken stump of a tail. The lower part of the body and the legs are covered with red paint; the dewlap is accentuated by

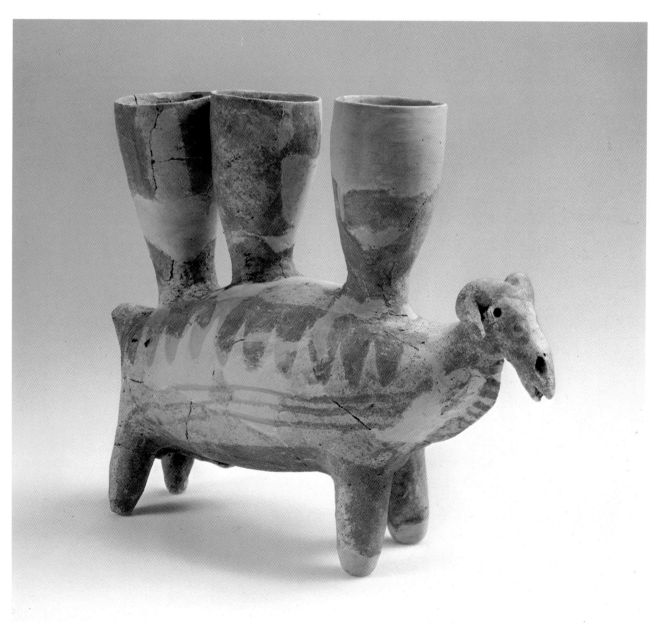

short, parallel red bands. Both Gilat vessels share a markedly realistic approach to detail.

The upper part of the body is covered by a bold design of triangles and horizontal lines, which appears to depict the blanket that covered the ram. The blanket had three openings into which the red-painted jars were inserted and firmly secured. The large design may indicate that the blanket was made of felt or of leather. No remains of felt have so far been found in excavations, but the use of leather is attested from the Chalcolithic period.

The depiction of the ram as a beast of burden clad in an ornamental blanket implies that, like the seated woman, this vessel was intended for cultic use.

REFERENCES: *D. Alon, Two Cult Vessels from Gilat, 'Atiqot, English series 11 (1976), pp. 116–18, pls. 23, 24, 26; M. Tadmor, Naturalistic Depictions in the Gilat Vessels, *The Israel Museum Journal* 5 (1986), pp. 7–12.

OSSUARIES FROM AZOR
Cat. nos. 18–20

Second half of the 4th millennium B.C.
Excavations of the Israel Department of
Antiquities and Museums

The ossuaries discovered in 1934 in the necropolis at Hedera in the Plain of Sharon provided the first evidence of the custom of secondary burial in the fourth millennium B.C. Since then numerous ossuaries have been found, and they have become one of the most distinctive Chalcolithic assemblages. Their greatest concentration is in the coastal plain of Israel, but ossuaries discovered in recent years in the Negev and in the hill country indicate that this burial custom was widespread in the Chalcolithic period.

Secondary burial was a complex procedure. The body was interred until the flesh decomposed; then the bones were collected, deposited in ossuaries, and placed in burial caves, often together with tomb offerings. There is no evidence from the Chalcolithic ossuaries that cremation was practiced.

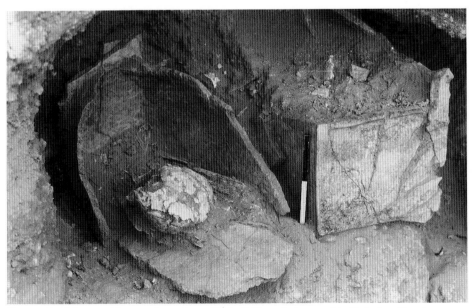

FIG. 29. Burial cave with ossuaries at Azor. Chalcolithic period, second half of 4th millennium B.C.
Photograph: Centre de Recherche Français de Jerusalem.

Several types of ossuaries can be distinguished. The vast majority are made of pottery, but some are of stone. The latter are rectangular chests, sometimes with rounded corners and always without lids. Among the pottery ossuaries the most numerous are roughly rectangular with an opening on one of the short sides and a vaulted roof. Their shape and architectural details, such as "windows" and "doors," raise the possibility that these ossuaries are house-shaped and were intended to represent actual dwellings, though different from contemporaneous local houses. A few ossuaries are zoomorphic in shape; others are round, in the form of a jar, with an opening in the upper part. All have high frontons. A recurring element, characteristic of Late Chalcolithic symbolic and figurative art, is a prominent nose jutting out from the fronton, sometimes accompanied by round eyes. The ossuaries, and especially the facades and the frontons, are richly decorated; the designs are executed in paint, incision, or appliqué. No two ossuaries are identical. Both the shape and the decorative elements of these ossuaries are rich in symbolism. The imagery cannot be deciphered easily, but it must have been associated with funerary cults and mortuary beliefs.

The custom of secondary burial in ossuaries was short-lived in the Chalcolithic period and was practiced again by the Jews only during the Herodian period (see cat. nos. 113 and 115). It is interesting to note that the custom of secondary burial, frequently associated with cremation, is attested in different periods and in many other parts of the world, where ossuaries and urns were also often house-shaped and included many symbolic and representational elements.

The ossuaries illustrated here were among some 120 intact and fragmentary ossuaries discovered in a cave at Azor (fig. 29), near Tel Aviv.

REFERENCES: J. Perrot, Une Tombe à ossuaires du IV^e millénaire à Azor près de Tel Aviv, 'Atiqot, English series 3 (1961), pp. 1–83, pls. I–X; J. Perrot and D. Ladiray, Tombes à ossuaires de la région côtière palestinienne au IV^e millénaire avant l'ère chrétienne, Paris, 1980; M. Tadmor, in Highlights of Archaeology: The Israel Museum, Jerusalem, 1984, pp. 34–35.

18. House-Shaped Ossuary

Pottery; 65 × 63 × 33 cm. (25⅝ × 24¾ × 13 in.)
IMJ 68.32.170

This chest has a curved ceiling, a projecting rear wall, a rectangular opening placed high in the front wall, and a fronton. Two vertical "columns" flank the opening in the facade, ending in two flattened knobs that rise above the fronton. A tool-like object is represented above the left corner of the opening. A pair of "knobs" appears at each of the upper corners of the opening, and a third pair is centrally placed on the fronton, below a protuberant nose.

The meaning of all these features is still obscure, but the ossuary is an excellent representative of the genre and of the symbolic and abstract nature of Chalcolithic cultic art.

This richly decorated ossuary forms one of the most important stylistic links with the Judaean Desert Treasure (cat. nos. 21–31). Several of the elements that adorn its facade have parallels in some of the maces and standards and especially in the "crown" (cat. no. 21).

REFERENCES: J. Perrot, Une Tombe à ossuaires du IV^e millénaire à Azor près de Tel Aviv, 'Atiqot, English series 3 (1961), fig. 21:1; J. Perrot and D. Ladiray, Tombes à ossuaires de la région côtière palestinienne au IV^e millénaire avant l'ère chrétienne, Paris, 1980, p. 48, figs. 12, 13.

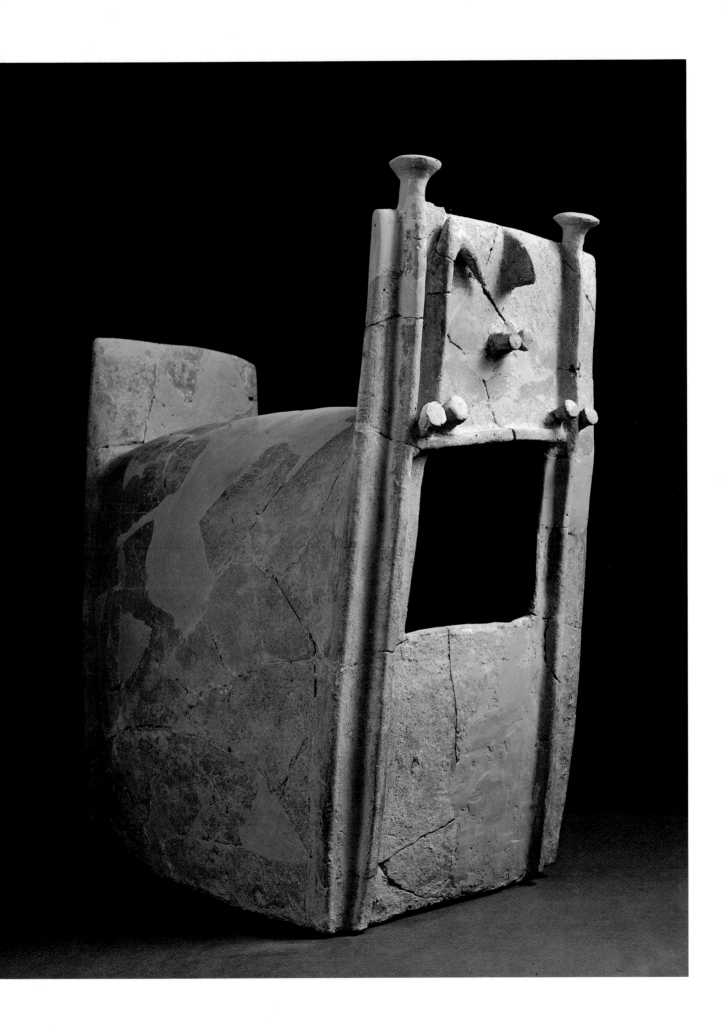

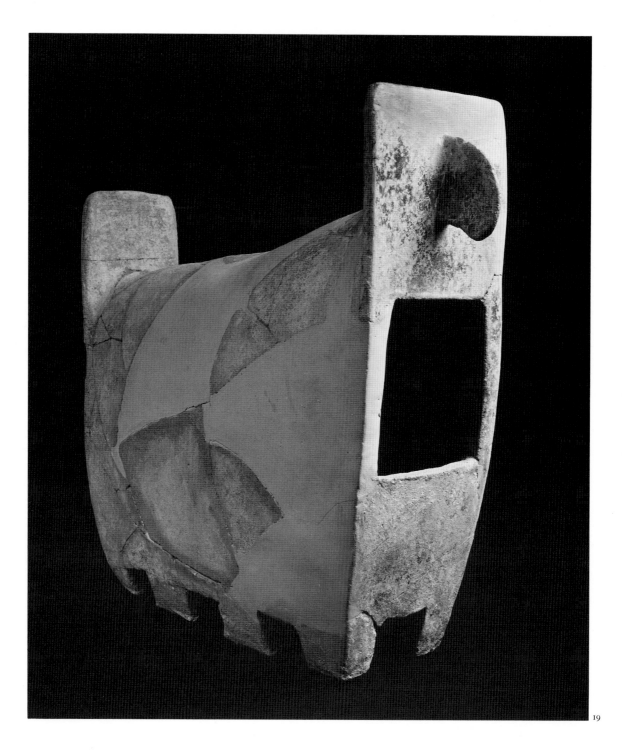

19

19. Zoomorphic Ossuary

Pottery; 64 × 75 × 22 cm. (25¼ × 29¼ × 8⅝ in.)
IDAM 58–339

This unique ossuary is clearly zoomorphic, although it retains most of the elements of the house-shaped examples. The potter intended to depict a sheep in a stylized and simplified manner. His skill as a sculptor is evident: the shape of the animal is created in a masterly curving outline, without the addition of any other details of the body. Only the large, drooping nose is added; it differs from the usual sharply triangular noses on other ossuaries. The legs are suggested by four short stumps on each side; they are separated by arched openings cut out from the wall, thus ingeniously creating the illusion of a four-legged animal.

REFERENCES: *J. Perrot, Une Tombe à ossuaires du ivᵉ millénaire à Azor près de Tel Aviv, 'Atiqot, English series 3 (1961), fig. 26:2; J. Perrot and D. Ladiray, *Tombes à ossuaires de la région côtière palestinienne au ivᵉ millénaire avant l'ère chrétienne*, Paris, 1980, pp. 48–49, figs. 34–35.

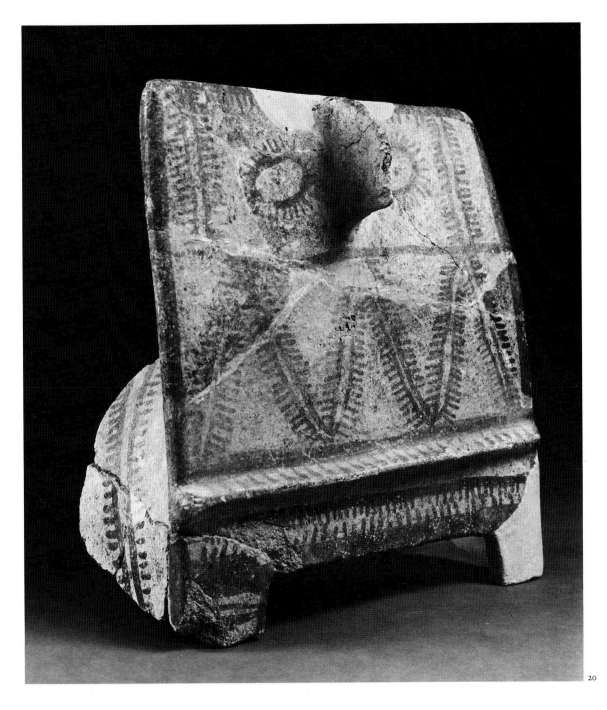

20

20. Fronton from an Ossuary

Pottery; 29 × 30 cm. (11⅜ × 11¾ in.)
IDAM 63–1424

This fronton must have belonged to an especially
large ossuary, richly decorated with red paint. The
curved nose, which projects from the facade, is
flanked by two large, circular eyes; a central dot and
short strokes around the circumference represent each
eye's pupil and lashes. Short diagonal lines at the
upper edge may indicate the hair. A painted design
appears on both sides of the face, and a horizontal line
separates the face from a bold zigzag design of similar
components. These two designs may be interpreted as
a symbolic depiction of beard and sideburns, but this
is by no means certain.

A raised ridge separates the fronton from the fa-
cade of the ossuary; both are covered with painted de-
signs. The fragment, broken in antiquity, ends at the
upper line of the opening.

REFERENCES: *J. Perrot, Une Tombe à ossuaires du IVᵉ millé-
naire à Azor près de Tel Aviv, 'Atiqot, English series 3
(1961), fig. 27:5; J. Perrot and D. Ladiray, *Tombes à ossuaires
de la région côtière palestinienne au IVᵉ millénaire avant l'ère
chrétienne*, Paris, 1980, p. 48, frontispiece, fig. 60:1–4.

THE JUDAEAN DESERT TREASURE
Cat. nos. 21–31

Cave of the Treasure, Nahal Mishmar
Second half of the 4th millennium B.C.
Excavations of the Israel Department of
Antiquities and Museums, the Hebrew
University, Jerusalem, and the Israel
Exploration Society

The Cave of the Treasure is situated in the steep cliff-face of the Nahal Mishmar canyon, 50 meters (55 yards) below the top, with a sheer drop of 250 meters (275 yards) from the cave into the gorge (figs. 30 and 31). The narrow path that existed in antiquity is nearly obliterated, and the cave can be reached only with the aid of a rope ladder and a harness.

The cave consists of two halls. Remains of occupation in the Roman period (Bar Kokhba Revolt, second century A.D.) were found, including domestic utensils, fragments of papyruses, and ostraca. Below this layer, remains of habitation in the Chalcolithic period (fourth millennium B.C.) came to light, as well as five human burials from the same period, discovered in a crevice in Hall B. The finds included a considerable quantity of Chalcolithic pottery of various types, textiles and weaving equipment, leather objects, and a wealth of basketwork and ropes, as well as the remains of a great variety of cultivated plants.

The treasure, consisting of 429 objects, was discovered on March 21, 1961, hidden in a natural rock-crevice in Hall B. Chalcolithic sherds were found at the bottom of the niche. The objects were wrapped in a mat woven of Cyperus reeds, measuring 120 × 80 centimeters (47¼ × 31½ inches). When deposited in the niche, some objects remained covered while others spilled out and were found spread on the mat in apparent disorder, as if hurriedly left behind.

The Judaean Desert Treasure is the largest group of ancient copper objects found in the Near East. The objects are remarkable for the strangeness and beauty of shape and ornamentation, the perfection of execution, and the quality of materials. The hoard has become the chief source for the study of ancient metalworking and of the art and iconography of the Chalcolithic period. The quality of the artifacts is unique in the context of the fourth millennium, and the discovery revolutionized knowledge of early metalworking and of the Chalcolithic period.

Of the 429 artifacts, 416 are made of copper, 5 of hippopotamus ivory, 1 of elephant ivory, 6 of hematite, and 1 of limestone. The types of

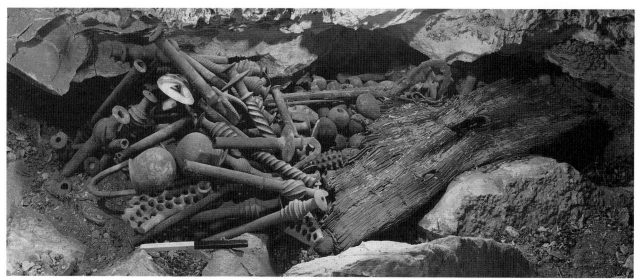

FIG. 30. The Judaean Desert Treasure at the moment of its discovery in the Cave of the Treasure, Nahal Mishmar. Chalcolithic period, second half of 4th millennium B.C. Photograph: Werner Braun.

objects are relatively few, consisting mainly of mace heads and maces, standards, scepters, and crowns. In contrast, the variety of shape and ornamentation is so great that no two objects are alike; the objects are so strange and unfamiliar that most escape proper definition. The names they have been given are for the sake of convenience and do not imply any certain knowledge of their function. This unusually large collection of seemingly nonfunctional shapes must have been of ceremonial or cultic nature. Originally the hoard may have formed part of the equipment of a temple or palace, removed in a time of danger and hidden in the cave.

Trace-element analyses of thirty objects indicate that the tools are made of unalloyed copper, while the mace heads and the standards are made of arsenical copper, sometimes with a very high percentage of arsenic. The use of arsenical copper is known in the earliest stages of metal production in the Caucasus, the Near East, Anatolia, and Europe. There exists a certain similarity between this hoard and later objects (second half of the third millennium B.C.) discovered in the royal tombs at Alaça Hüyük in Anatolia as well as a generic resemblance to still later artifacts from Luristan in Iran. However, apart from the local Chalcolithic culture, no direct comparisons to this hoard can as yet be produced, and thus it may have been of local origin.

With the exception of the tools, all the artifacts examined were cast, most probably by the lost-wax method. Thermal neutron radiography showed that even the most complex shapes were

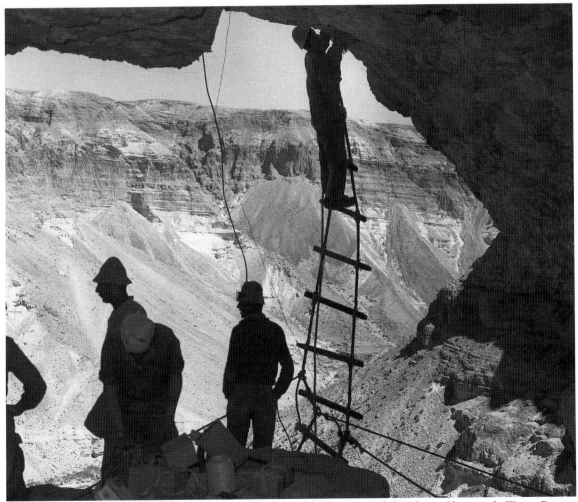

FIG. 31. The Judaean Desert seen from the entrance to the Cave of the Treasure, Nahal Mishmar. Photograph: Werner Braun.

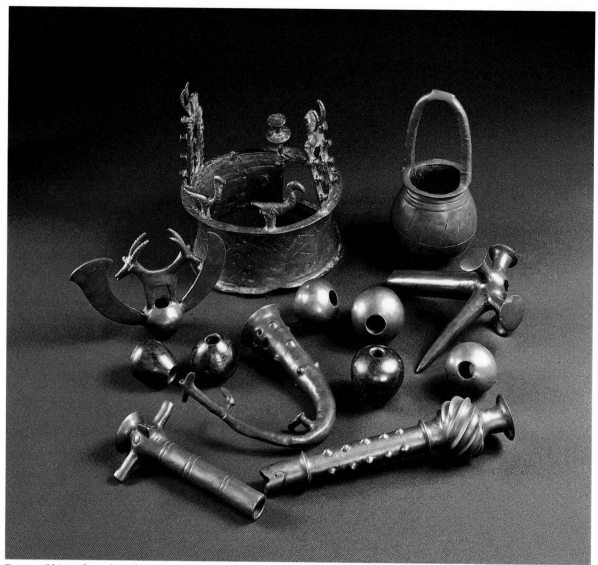

FIG. 32. Objects from the Judaean Desert Treasure. Israel Department of Antiquities and Museums. Photograph: Israel Museum/David Harris.

made in a single casting, which included all the ornamental elements. Thus the treasure proves that coppersmiths in the Chalcolithic period had mastered the most complex processes of casting and finishing techniques, had a good knowledge of the properties of metals, and could obtain the required metal, even from afar.

At the time of discovery direct comparisons could be found for very few of the objects. The dating of the Judaean Desert Treasure was thus based mainly on a comparative study of the decorative elements. Stylistic similarities, adduced from ossuaries and from ivory sculptures found in excavations in the Negev (and later from the sculptured basalt stands from the Golan), place the hoard in the Chalcolithic horizon. The recent discoveries of virtually identical objects at the Chalcolithic sites of the northern Negev have corroborated this assessment. Conventional archaeological dating assigns the Judaean Desert Treasure to the Late Chalcolithic period in the second half of the fourth millennium B.C., contemporaneous with the adjacent Beersheba culture.

REFERENCES: *P. Bar-Adon, The Cave of the Treasure: The Finds from the Caves in Nahal Mishmar, Jerusalem, 1980; M. Tadmor, in Highlights of Archaeology: The Israel Museum, Jerusalem, 1984, pp. 36–37; R. Cohen, Notes and News, Israel Exploration Journal 35 (1985), pp. 73–74; Y. Baumgarten and I. Eldar, Neve Noy: A Chalcolithic Site of the Beer-Sheba Culture, Biblical Archeologist 48 (1985), pp. 134–39.

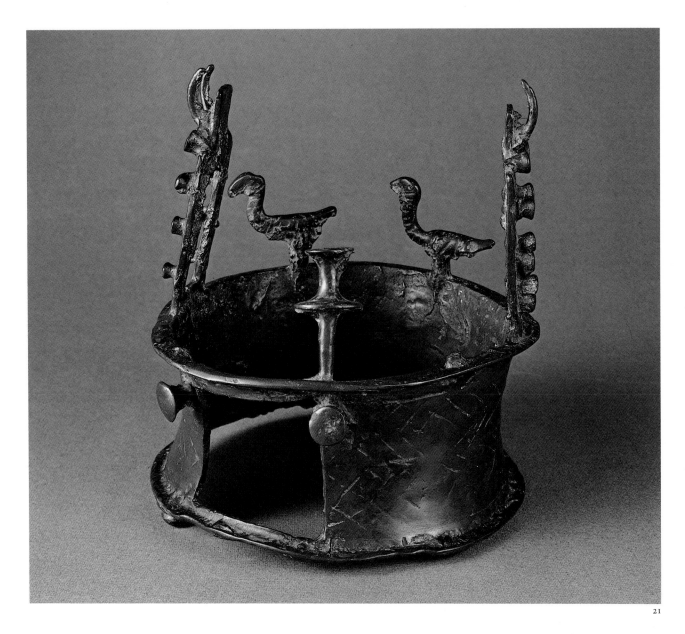

21. "Crown"

Copper; maximum height 17.5 cm. (6⅞ in.),
height of ring 7 cm. (2¾ in.), diameter
16.8 cm. (6⅝ in.)
IDAM 61–177

This is the most ornate of the ten "crowns"—so named
for want of a better term—which were found in the
Treasure. It is an open-ended cylinder with slightly con-
cave walls and splayed rims at both ends. One foot, pro-
jecting from the bottom rim, is preserved in entirety;
two others are broken. The crown is decorated with
an incised herringbone design in two registers separated
by an intermittent horizontal line. A square opening is
cut in the side and is flanked by two nail-like knobs with
flattened heads.

Several elements tower above the rim. A "pillar"
placed above the right side of the opening has a vertical
stem and is topped by two horizontal disks. A second
such pillar must have been placed above the left side but
is now broken off. Opposite the opening two birds
(griffon vultures) perched on the rim have incised
mouths and eyes and grooved bodies and necks. Two
gatelike structures stand on opposite sides of the rim.
The jambs flanking their rectangular openings have four
"nails" each, vertically arranged at equal intervals. A
pair of horizontally grooved horns projects from the
fronton above the entrance. A broken-off projection to
the right of the opening indicates the existence of a now-
lost element.

The crown is made of arsenical copper cast in a
single casting, including all the projecting elements.
The outer surface is smoothed and polished, while little
effort was invested in finishing the inner surfaces, al-
though these are visible.

The architectural features of this object are striking: the opening in the side turns the crown into a structure that may represent a round building or an enclosure with an entrance. The two "gates" projecting upward strengthen this impression. Stylistically, the crown is a most complex object: geometric, abstract, and naturalistic elements combine in a symbolic entity whose meaning remains obscure. Certain elements, however, are well known in the iconography of the Chalcolithic period. The linear representation of the birds can be compared to an ivory bird from Beer Matar, one of the Beersheba Chalcolithic settlements. The use of horns or of horned animal heads is attested in two standards and in another crown of the Judaean Desert hoard (cat. no. 26). Horns also appear on the sculptured high-footed basalt bowls from the Golan settlements, where they are a consistently recurring iconographic element. Most importantly, the two gates find a striking comparison in the ossuary facades, whose entrances are flanked by nails and knobs and are surmounted by frontons that are sometimes adorned with horns (cat. no. 18). This stylistic similarity implies an iconographic affiliation, which found its expression in the repeated use of the same artistic elements.

REFERENCE: *P. Bar-Adon, *The Cave of the Treasure: The Finds from the Caves in Nahal Mishmar*, Jerusalem, 1980, pp. 24–28.

22. Scepter

Copper; length 49.4 cm. (18½ in.)
IDAM 61-156

Five long solid scepters, each of different shape, were found in the Judaean Desert Treasure. The shaft of this one is round and slightly bent toward the top, ending in a flattened disk. There are five horizontal ridges ringing the shaft, the two uppermost bordering a rounded beadlike swelling. Two pairs of flattened branchlike projections curve out from the shaft. The shape of this scepter and its soft curving lines, so very unusual in ancient metalwork, create the impression of a long slender plant. However, the highly stylized, almost abstract shape precludes any botanical identification.

Floral representations are virtually nonexistent in the Chalcolithic repertoire known to date. Thus this scepter, unique in shape and design, is also the only representative of an otherwise unknown category.

REFERENCE: *P. Bar-Adon, *The Cave of the Treasure: The Finds from the Caves in Nahal Mishmar*, Jerusalem, 1980, p. 91.

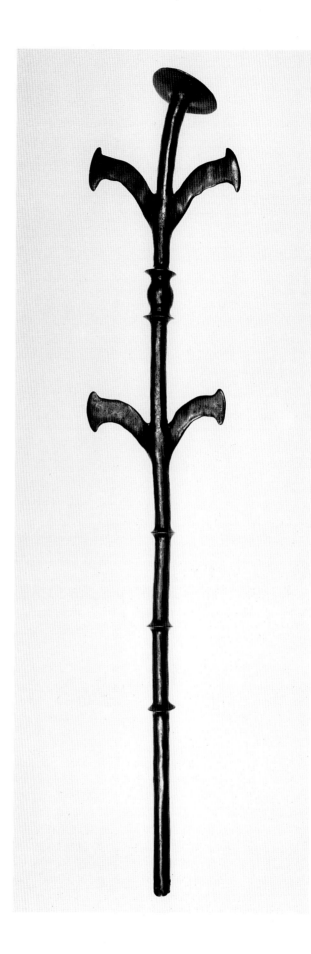

22

23. Jar with Basket Handle

Copper; total height 17.8 cm. (7 in.), height of
body 8.3 cm. (3¼ in.), maximum diameter
8.9 cm. (3½ in.)
IDAM 61–164

This small jar is one of three similar vessels found in
the Judaean Desert Treasure.

The wide mouth of the jar has a slightly everted,
broad, flattened rim. The body is roughly globular
with a high, thick basket handle, which is angular on
the inside and rounded on the outside and which has a
projection centrally placed at the top. The body is dec-
orated with a pattern of diagonal grooves converging
at the base. Two horizontal grooves run parallel to the
rim, and a third surrounds the body at its widest point.
Evenly spaced horizontal grooves decorate the handle.

This is the earliest example of a type of vessel that
was to become popular in later times. Well-known ex-
amples are the buckets depicted on Akkadian cylinder
seals and those held by the protective genii on the
reliefs of imperial Assyria in the first millennium B.C.
An early example from Egypt is the vessel seen on the
Narmer palette, held by "the sandal-bearer of the
King of Upper Egypt." Basket-handled vessels also
appear later in Egypt, especially in the second millen-
nium B.C. However, despite its popularity in neigh-
boring countries, this type of pottery vessel is very
rare in Israel. A few examples of pottery basket-
handled jars can be cited from the Chalcolithic period
and from the earliest phases of the Early Bronze Age,
occurring mainly in tomb assemblages. Apart from
the three from the Cave of the Treasure none is
known in copper.

REFERENCE: *P. Bar-Adon, *The Cave of the Treasure: The
Finds from the Caves in Nahal Mishmar*, Jerusalem, 1980,
pp. 108–9.

23

24. Horn-Shaped Object

Copper; height 14 cm. (5½ in.)
IDAM 61–169

Three horn-shaped objects were found in the Judaean
Desert Treasure, each with different ornamentation.
This "horn" is hollow from the mouth to the lowest
line of three horizontal rows of small knobs; the rest
is solid. The wide everted rim is flattened. Below the
rim are three openings in an arrangement reminiscent
of eyes and mouth (though this may well be acciden-
tal, as the mouth is rarely depicted in Chalcolithic

24

obscured by massive additions. The most dominant element is the long beaklike projection which points downward from the head. At the top a boss is bent upward, and three similar bosses jut out horizontally; all the bosses have disk-shaped heads. The beak has a circular cross-section.

Only one other object in the Treasure is comparable to this: a plain, elongated mace head with a beaklike projection that is shorter but otherwise very similar to that of this scepter.

The bold asymmetry of design and the powerful impact of the dominant beak set this object in a special category. This enigmatic work could be defined as a powerful weapon or alternatively as a scepter that had a special purpose.

REFERENCE: *P. Bar-Adon, *The Cave of the Treasure: The Finds from the Caves in Nahal Mishmar*, Jerusalem, 1980, pp. 98–99.

art). The tip ends in a schematic representation of a bird with wings outspread as if in flight. By analogy, the two other additions should probably also be interpreted as figures of birds, cast in an even more schematic way. A representation of a bird is found on one of the other horn-shaped objects, where it was added to the tip.

All three "horns" are perforated beneath the rim. The remains of a twisted rope, threaded into the holes from outside, are preserved in one of them. Thus there is little doubt that these unique objects were suspended by means of a rope, but their use and significance are still an enigma.

REFERENCE: *P. Bar-Adon, *The Cave of the Treasure: The Finds from the Caves in Nahal Mishmar*, Jerusalem, 1980, pp. 104–5.

25. Scepter

Copper; length 14.1 cm. (5½ in.)
IDAM 61–92

This short hollow scepter has a plain shaft, devoid of any decoration. The bulbous head is, however, almost

26. Ibex Scepter

Copper; length 27.5 cm. (10⅞ in.)
IDAM 61–88

Beauty of design is matched by technical skill in this masterly creation. The shaft of this scepter is straight; the lower rim is splayed and the upper is wide and disk-shaped. Two horizontal grooves are the only decoration of the otherwise plain shaft. The exterior surface is smoothed and polished. The ornamental elements are arranged in two tiers.

Two narrow elongated heads of horned animals are perched on the upper rim. Their straight horns are horizontally grooved. The ears protrude, and the eyes and mouths are only faintly marked. The lower tier is composed of three animal heads which jut out from the shaft on long cylindrical necks. Except for their larger size and longer horns, two of the heads are similar to those in the upper tier. Centrally placed is a head with majestic twisted horns. The importance of the central head is evident from its position and from the bold outline of the twisted horns; in every respect it is the focal point of the scepter.

There is a striking symmetry in the composition of this scepter: the two upper heads, placed close to one another, seem to be a continuation of the shaft. The long necks of the lower pair of animals form a horizontal element that counterbalances the shaft's vertical thrust.

The animals with straight horns have been identified as ibexes, and that with twisted horns as a prim-

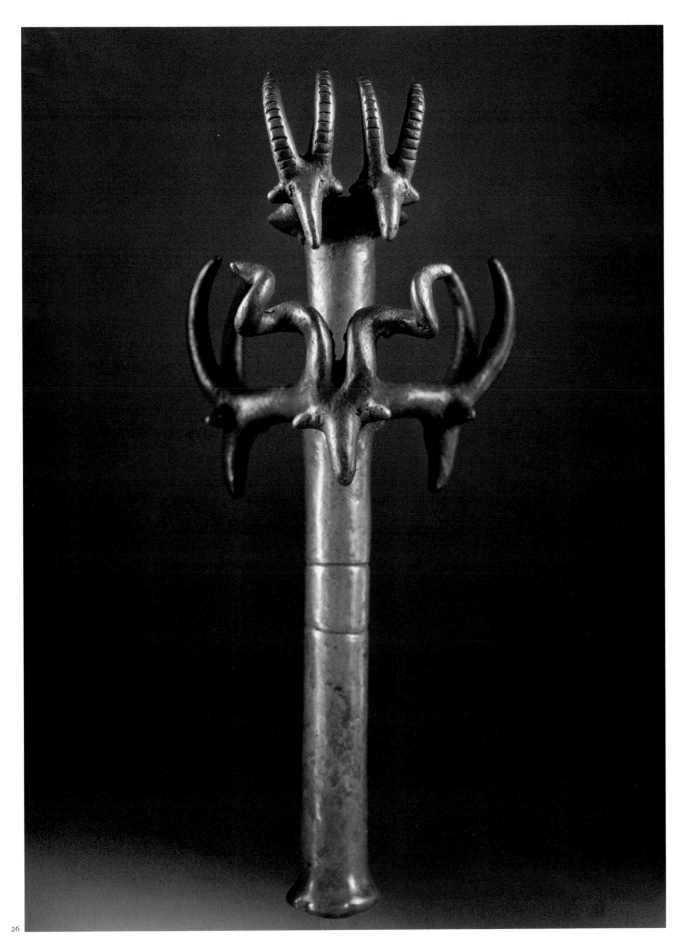

itive domesticated goat. Similar animal heads with straight horns appear on one other scepter and on one "crown" (cat. no. 21) in the Treasure. The twisted horns have no parallel in the Treasure, but horned heads and horns as a separate element are frequently depicted in Chalcolithic iconography.

REFERENCE: *P. Bar-Adon, *The Cave of the Treasure: The Finds from the Caves in Nahal Mishmar*, Jerusalem, 1980, pp. 42–45.

27. Vulture Standard

Copper; length 15.3 cm. (6 in.)
IDAM 61–151

This is a flat plaque with a central shaft socket project-ing on both sides from within a raised rectangular frame. In striking contrast to the linear, geometric shape of the plaque is the three-dimensional head of

the bird, centrally placed above a pair of asymmetrical spread wings. The eyes are marked by deep holes, and the beak is open.

The decoration consists of short incised lines representing, in a schematic manner, the details of the body. The tail is depicted by a row of short incisions, and the feathers on the body and wings by a herringbone design. A pattern of double zigzag lines delineates the borders of the plaque. The swelling of the neck is accentuated by a single zigzag groove. The edge of the plaque, both rims of the shaft socket, and the area inside the rectangular frame are all covered in a closely set herringbone pattern.

Representations of birds appear elsewhere in the Treasure (cat. nos. 21 and 24) but usually as one of several elements. This is the only object in the Treasure that is made in the shape of a bird, identified as a griffon vulture. When mounted on a wooden staff and carried high, it must have successfully conveyed the impression of a soaring bird.

REFERENCE: *P. Bar-Adon, *The Cave of the Treasure: The Finds from the Caves in Nahal Mishmar*, Jerusalem, 1980, pp. 102–3.

28. Human-Headed Scepter

Copper; length 13.2 cm. (5¼ in.)
IDAM 61–84

The straight hollow shaft of this scepter ends in a disk-shaped rim and is decorated with three pairs of parallel horizontal grooves. The uppermost pair forms the base of the mace head, which is transformed here into a human head with facial details. The eyes are indicated by incised circles; the aquiline nose boldly projects forward. There is a faint suggestion of a mouth. Two solid cylinders project from the sides of the head; the stub of a third is at the back of the head.

The selective use of human features as components in symbolic representations is a characteristic of Chalcolithic iconography. Of all facial features, the nose is the most frequently depicted. It is prominently represented, often with the eyes, while the mouth is consistently omitted. In spite of the slight indication of a mouth, this scepter is an excellent example of these artistic conventions.

REFERENCE: *P. Bar-Adon, *The Cave of the Treasure: The Finds from the Caves in Nahal Mishmar*, Jerusalem, 1980, p. 49.

28

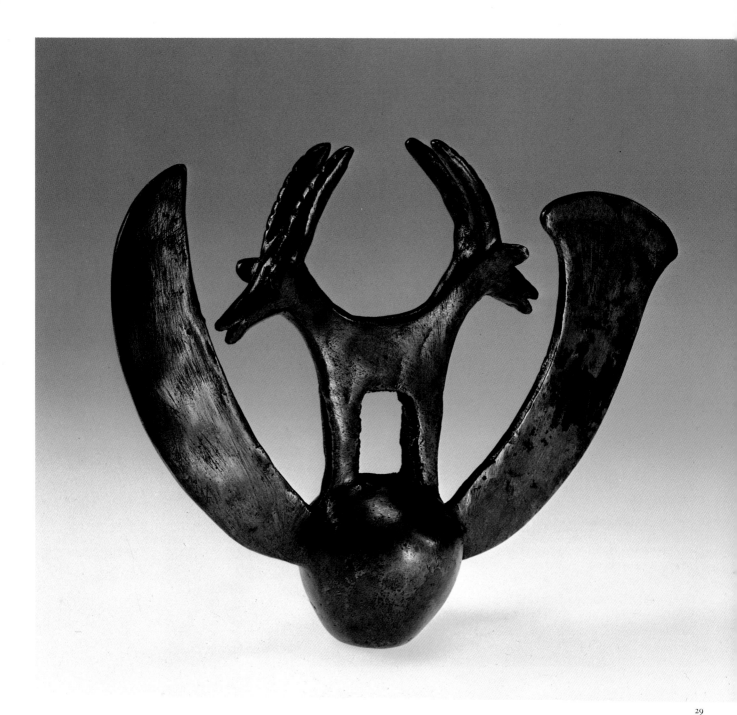

29

29. Mace Head

Copper; height 11 cm. (4⅜ in.)
IDAM 61–119

The addition of ornamental elements transforms this plain, pyriform mace head of a type very common in the Treasure (see cat. no. 31) into a work of art.

Perched astride the socket is a two-headed horned animal; its sculpted heads and forelegs are joined to a single body. The horns curve slightly and are horizon-tally grooved; eyes, nostrils, mouth, and ears are indicated. The heads, identical to those on the ibex scepter (cat. no. 26), have also been identified as ibex heads.

On each side of the mace head is a tool-like arm. One is curved and has a pointed end. The other, also curved, ends in a splayed convex blade. Neither blade is sharp.

REFERENCE: *P. Bar-Adon, *The Cave of the Treasure: The Finds from the Caves in Nahal Mishmar*, Jerusalem, 1980, pp. 100–101.

30. "Mace"

Copper; length 20 cm. (7⅞ in.)
IDAM 61–48

This "mace" is representative of about eighty similar artifacts which were found in the Treasure. The fact that no two are identical proves that each was cast separately in an individual mold that was most probably broken when opened after casting.

The top is disk-shaped. The spherical head is decorated with sharply delineated diagonal ridges. Four vertical rows of five small knobs are evenly spaced between two horizontal ridges on the shaft. Two diagonal incisions are all that remain of an incised pattern that decorated the lower part of the mace.

As with the other maces, the shaft, head, and decorative elements of this object were cast in one piece. After casting, the outer surface was highly polished, obscuring any fault or scar, while the inner surfaces remained rough. Unlike that of most maces, this shaft is damaged at the lower end; a hole near the edge is probably the result of faulty casting. The mace is made of arsenical copper.

Mace heads of stone or copper are frequently found in excavations in Chalcolithic and Early Bronze levels. Thus it can be assumed that in these periods maces were a common weapon with the mace head mounted on a staff usually made of wood, which eventually disintegrated, while the stone or copper head survived. The maces of the Judaean Desert Treasure are different, in that both the shaft and the head, cast in one piece, are made of metal and both are decorated. The great variety of decoration, based on ever-changing combinations of geometric elements, is amazing. Also amazing is the technical skill of the ancient smiths, who cast these elongated thin-walled maces together with bulbous heads and often with heavy projecting elements. Remains of wood, found in several scepters, show that some were mounted on wooden staffs.

REFERENCE: *P. Bar-Adon, *The Cave of the Treasure: The Finds from the Caves in Nahal Mishmar*, Jerusalem, 1980, p. 80.

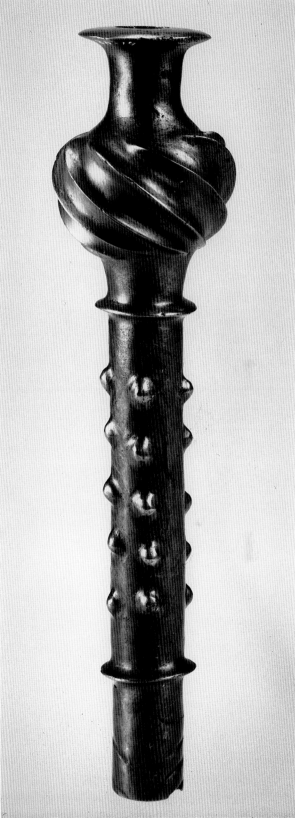

30

31. Six Mace Heads

Hematite: IDAM 61–183, height 4.6 cm. (1¾ in.); IDAM 61–185, height 4.1 cm. (1⅝ in.); IDAM 61–187, height 3.8 cm. (1½ in.). Copper: IDAM 61–198, height 6.2 cm. (2⅜ in.); IDAM 61–262, height 4.3 cm. (1¾ in.); IDAM 61–308, height 4.1 cm. (1⅝ in.)

These six mace heads represent the largest category of artifacts in the Treasure. More than 240 mace heads were found; except for six made of hematite and one of limestone, all are of copper. The vast majority of the mace heads are pyriform, while others are disk-shaped, spherical, or elongated and flattened. Most are plain and carefully polished, but several are decorated with incised, ridged, or grooved patterns, and a few have additional projecting elements.

Despite their similarity, no two mace heads are identical. Even the plain ones vary in size and shape and in the technique of manufacture. Some are made of a thin layer of metal, while others have thicker

walls; many are solid with a shaft socket. Those made of a thin layer of metal frequently contain remains of the ceramic investment that was used in the process of casting.

Several mace heads were formed by an especially complex technique. These are made of a hollow metal shell filled with ceramic matter. The casting is so skillful that no seams can be discerned between the various components. Only their weight discloses that these mace heads are not composed of solid metal.

In some cases remains of the wooden staffs on which the mace heads were mounted are preserved. A piece of linen fabric which survived in one of the mace heads was used to secure it firmly on the wooden staff.

Maces were a common weapon in the Chalcolithic and Early Bronze periods, and mace heads made of various kinds of stone are frequently found in excavations. But this huge hoard of copper mace heads is unique. The exclusive use of metal, the variety of techniques, and the fact that the thin-walled mace heads were not strong enough to serve as weapons indicate that even these plain mace heads were meant for ceremonial rather than practical use.

REFERENCE: *P. Bar-Adon, *The Cave of the Treasure: The Finds from the Caves in Nahal Mishmar*, Jerusalem, 1980, pp. 116–31, especially nos. 185–87, 203, 253, 297.

32. Mirror

Kabri
ca. 4500 B.C.
Obsidian; diameter 18 cm. (7⅛ in.), thickness 1 cm. (⅜ in.)
Chance find followed by excavations of the Israel Department of Antiquities and Museums
IDAM 56–908

A tractor working in the fields of Kibbutz Kabri in western Galilee some thirty years ago turned up an outstanding group of objects: this obsidian mirror, an exceptionally large obsidian core (length 36 cm. [14⅛ in.]), five stone vessels, a small bone statuette of a bearded male, and a handful of beautifully worked beads of various semiprecious stones. Some bones found with them indicated that these objects might have been offerings accompanying one or more burials. Subsequent excavations indeed revealed several cist graves and a few similar funerary offerings, dated to the Early Chalcolithic period.

The present mirror is a unique example of highly advanced stone technology. Obsidian is a hard and extremely brittle volcanic glass. Only an experienced master could produce such a large circular disk, regular in shape and thickness, with a handle carved from

the same block of obsidian. One face of the mirror is smoothed and polished to a high gloss. The other was first polished and then intentionally roughened, leaving a smooth surface only on the margin of the mirror and the edges of the flat ribbon-like handle. Two parallel grooves frame these borders and are repeated on the thick edge of the mirror. The finished product is a technological tour de force; the effort and skill invested in its production and decoration must have been immense. It is the finest, largest, and most ornate obsidian mirror ever found.

Obsidian is a rare material found in areas of recent volcanic activity, and it occurs only in a few areas in the Near East. Melos was the main source of obsidian in the Greek Islands. Several sources of obsidian exist in Cappadocia; others are located in Armenia, e.g., in Nemrut-Dag in the Van region and in the Kars district. The surviving material evidence indicates that obsidian was the first raw material to be traded over vast areas. Naturally, it was most commonly used in proximity to the source areas, becoming progressively rarer with increasing distance. Thus, obsidian is only sporadically found in Israel, and it never replaced the native flint. The analysis of an obsidian flake from Kabri showed trace-element properties of Armenian obsidian. The exact source-area cannot yet be located, but the Van area in East Anatolia seems to be a likely possibility. It is noteworthy that obsidian specimens from Byblos and Ras Shamra belong to the same category, while specimens from Jericho (Pre-Pottery Neolithic A and B levels) point to a much nearer source—Giftlik in Cappadocia.

Obsidian was traded and used mainly in the Neolithic and Chalcolithic periods. Its popularity waned in the third millennium, when metal technology replaced the older stone technology.

REFERENCES: C. Renfrew, J. E. Dixon, and J. R. Camm, Obsidian and Early Cultural Contact in the Near East, *Proceedings of the Prehistoric Society*, new series 32 (1966), pp. 30–72; *M. Prausnitz, The Excavations at Kabri, *Eretz-Israel* 9 (1969), pp. 122–29, pls. 36–37 (Hebrew), English summary, p. 137*.

CANAANITE PERIOD/BRONZE AGE

3150–1200 B.C.

The long span from the closing centuries of the fourth millennium until 1200 B.C. is customarily classified under a common heading—the Canaanite period or Bronze Age. The term "Bronze Age," which has its roots in European archaeology, refers to the introduction of the alloy bronze into the material culture, which was supposed to have occurred at that time. The term "Canaanite period" stresses the ethnic components that were predominant before the conquest of Canaan by the Israelite tribes.

However, as knowledge has grown, it has become clear that both terms are far from precise. With regard to the term "Bronze Age," the numerous analyses of metal implements and weapons have shown that bronze—an alloy of copper and tin—was rarely used before the beginning of the second millennium, and in the third millennium artifacts were still produced largely of copper. Early in that period, arsenical copper was still in use, continuing the metallurgical traditions of the Chalcolithic Age.

The term "Canaanite period" also poses problems when applied to the third millennium. There are no indigenous written sources for this early stage; no inscriptions have as yet been found in excavations, nor is this region clearly referred to in inscriptions from Egypt, Mesopotamia, or the Syrian states. The application of the term "Canaanite period" to the third millennium is based on the supposition that the country was populated by West Semites (Canaanites) during the third millennium, although written sources do not confirm their presence until the second millennium.

Despite such reservations, both terms—"Bronze Age" and "Canaanite period"—have acquired respectability from long usage in schol-

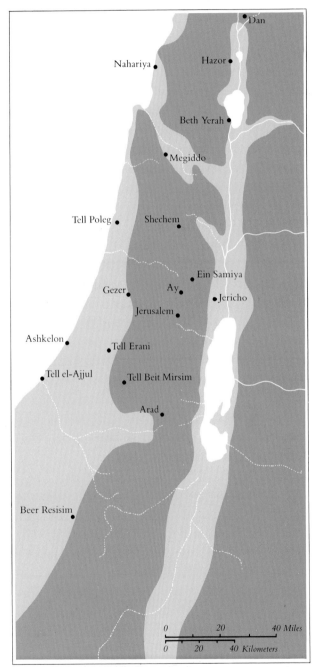

FIG. 33. Early and Middle Canaanite sites.

87

arly research, and both have been retained here. For the end of the third millennium, the terms "Middle Canaanite I" and "Middle Bronze I" have also been retained, though numerous scholars suggest alternative terms, such as "Early Bronze IV" or "Intermediate" for this period of time, which in many respects can still be regarded as a "dark age."

This span of time is traditionally divided into three main periods: Early (3150–2200 B.C.), Middle (2000–1550 B.C.), and Late (1550–1200 B.C.), with a short intermediate stage at the end of the third millennium (Middle Bronze I, 2200–2000 B.C.). Each period is further divided into smaller time-units. The divisions are determined by a combination of archaeological and historical factors. Alterations in settlement patterns and observed changes in such items as pottery and metalwork permit the relative dating of material from third-millennium sites. With the increase in written sources during the second millennium, historical data closely complement the archaeological evidence, and absolute dating becomes more exact. In the course of time the synchronisms supplied by Egyptian chronology are supplemented by information derived from the cuneiform archives of Mesopotamia, Anatolia, and the Syrian states. Toward the end of the period connections with Cypriot and Mycenaean material cultures provide archaeologists with additional chronological criteria.

Finally, the Bible has preserved and transmitted various aspects of Canaanite culture and religion. It is a major source of information both for the historian and for the archaeologist. The urge to prove the Bible true was a powerful factor in the birth of archaeology and its evolution during the nineteenth century, and the quest for correlations with the biblical account has remained an important aim of archaeological research. It has been widely accepted that the Patriarchal Age should be placed in the Middle Canaanite period (the first half of the second millennium) or even earlier, at the end of the third millennium. However, no exact dates should be posited for the Patriarchs, as, by their very nature, these biblical narratives cannot be regarded as a factual historical source. The Joseph cycle is set against the background of Egypt in the New Kingdom in the second half of the second millennium. About 1200 B.C., when the Israelite tribes and the Philistines gained the upper hand, conquering sizable parts of the land and settling in extensive areas, the Canaanite period came to an end. The conquest and, in biblical terminology, the time of the Judges usher in the Israelite Age.

EARLY CANAANITE PERIOD/ EARLY BRONZE AGE
3150–2200 B.C.

The emergence of the Bronze Age civilization heralds a decisive departure from the earlier Chalcolithic culture. Reasons for these far-reaching and as yet unexplained changes have been sought in climatic fluctuations and in population influx from the north. Settlement patterns changed: villages in the semiarid northern Negev and in the Golan, abandoned at the end of the Chalcolithic period, were not resettled. Surveys and excavations have shown that the previously unoccupied hill country was first settled at the beginning of the Early Bronze Age by people who were familiar with methods of Mediterranean agriculture and could thus grow a variety of produce, such as almonds, plums, figs, vegetables, and legumes. They raised sheep and goats, as well as cattle and donkeys, for domestic use and transport. The small, unwalled villages, though in no sense cities, provided the foundation upon which the urban civilization of the third millennium was built.

Changes and innovations, along with a small measure of continuity, can also be perceived in the material culture. Knowledge of this culture is based mainly on tomb equipment, though evidence from settlement layers uncovered in recent excavations is growing. The study of pottery shows regional peculiarities. Some indirect stylistic links with Mesopotamia can be seen in the

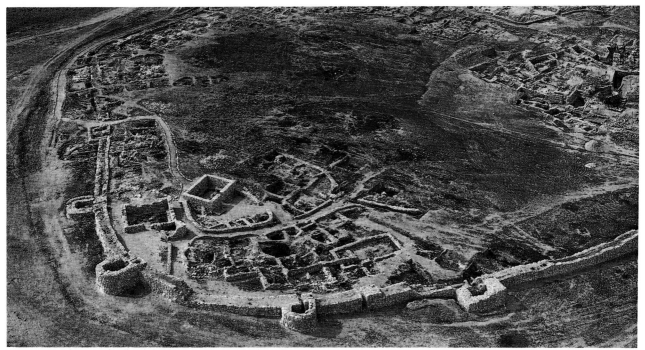

FIG. 34. Aerial view of Tell Arad. Photograph: Dr. Richard Cleave.

shapes and surface decoration of vessels and most significantly in the use of cylinder seals, which began at an early stage. Connections with Egypt were direct and based mainly on trade. Cosmetic palettes and necklaces of semiprecious stones were imported from Egypt. There was a continuity in the metal industry, which was already highly developed in the Chalcolithic period.

The second stage of the Early Bronze Age, roughly synchronous with the beginning of the First Dynasty in Egypt, saw the establishment of cities. And indeed, the third millennium is the age of urbanization, in which numerous cities were founded, from Dan in the north to Arad in the south, in the hill country as well as in the great valleys.

Arad in the northern Negev, extensively excavated by an Israel Museum expedition, is the best-preserved model of a third-millennium town that was not resettled (figs. 34 and 35). An area of some 10 hectares (25 acres) was encircled by walls and fortified with bastions. Within its confines were residential quarters, a network of streets and open squares, palaces, and temples. The water supply was controlled, with a centrally located reservoir. Satellite rural settle-

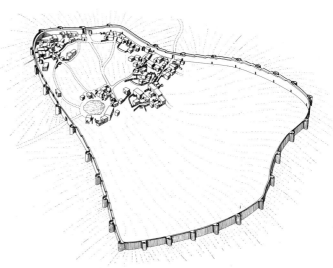

FIG. 35. Fortified city of Arad, an isometric reconstruction. 3rd millennium B.C. Drawing: Lane Ritmeyer.

ments were in the immediate vicinity. Ancient Arad controlled the routes leading to the copper mines and to the miners' villages in Sinai, over 300 kilometers (190 miles) to the south, thus safeguarding the steady flow of copper.

Contacts with Egypt were close. Egyptian imports and pottery vessels bearing royal cartouches testify to an Egyptian presence, mainly in the south. Trade connections were beneficial to both countries. Wine and precious oils were exported to Egypt in typical pottery vessels (Abydos ware) and were placed among the offerings in royal tombs.

A distinctive type of pottery vessel—the Khirbet Kerak (Beth Yerah) ware (cat. no. 35)—heralds the next stage of the Early Bronze Age, which can be correlated with the Pyramid Age in Egypt (Third to Fifth Dynasty). These lustrous, handmade vessels, so different from local wares, were probably introduced by foreign craftsmen who arrived from the north. From that time on, a slow but continuous change can be observed in the urban map. Some towns flourished and prospered; others were abandoned or were reduced in size. In the last stage of the Early Bronze Age, there was a deterioration in traditional pottery forms, while northern influences can be detected in new shapes. By the time of the Sixth Dynasty, Egyptian influence was virtually nonexistent, and Egyptian royal names are absent even in the copper mines of Sinai. The collapse of the urban order is synchronous with the fall of the Old Kingdom in Egypt and with the collapse of the Akkadian empire in Mesopotamia. The reasons for such widespread destruction must have been manifold and complex. Ethnic movements from the north have been singled out as a decisive factor, but climatic and internal changes have also been emphasized.

The artifacts produced in the course of the third millennium give an overall impression of skill and experience. Best known is the potter's craft. Pottery vessels display a variety of shapes, and they are well proportioned, attractive, and functional. Much care was given to their decora-

tion: surfaces were burnished, painted, or finely combed to give a pleasing effect. Coppersmiths produced tools and weapons which, though seldom outstanding, were always effective and well made. It is therefore astonishing that so few objects of high artistic quality have been unearthed: a handful of human or animal representations, some bone carvings, a few small ivories and sculptures, and some jewelry. Cylinder-seal impressions add some lively designs but are simple and crudely made. There is a striking contrast between the somewhat utilitarian material culture of the Early Bronze Age and the richly artistic achievements of the preceding Chalcolithic period.

MIDDLE CANAANITE PERIOD I/ MIDDLE BRONZE AGE I
2200–2000 B.C.

The principal sources for the study of this short period were traditionally tomb offerings—pottery, weapons, and some jewelry—unearthed in excavations of extensive cemeteries. Traces of contemporaneous settlements were encountered in the excavation of only a few mounds. Without exception these settlements were poor, limited in size, and of short duration. The absence of towns is in sharp contrast to the rich remains of the preceding and succeeding urban civilizations.

Recently, however, an alternative pattern of occupation based on small villages has begun to emerge as a result of extensive surveys and excavations, especially in the highlands of the Negev and in the central hill country (fig. 36). The sporadic occurrence of typologically similar villages in other parts of the country points to a widespread occupational pattern. To date, no true urban centers of that period have been uncovered.

In Egypt this time corresponds to the turbulent First Intermediate period, ending with the Eleventh Dynasty, and no Egyptian activity or influence can be detected, not even in the southern regions bordering on Egypt. There is evi-

Fig. 36. Round houses in the Middle Bronze I village at Beer Resisim in the Negev. End of 3rd millennium B.C. Photograph: Israel Department of Antiquities/Rudolf Cohen.

dence of links with the north, where urban civilization was not disrupted. This is well known from the excavations at Hama on the Orontes and, more recently, from the excavations at Ebla. The links with Syrian sites, as far north as the Amuq plain, and even with the Khabur region in northern Mesopotamia are proved by typological similarities in weaponry and pottery.

This was a time of unrest and turmoil, and personal weapons—mostly short daggers and javelins—were in great demand. Men were also buried with their weapons. It is not surprising, therefore, that coppersmiths were active, traveling among local villages with copper ingots, trading in copper, and producing weapons.

Pottery vessels of this period have been classified into regional "families" of typological similarity. Known mainly from funerary assemblages, they were functional but bore little decoration. They are occasionally adorned with monochrome or incised designs and are largely handmade. Only one group, similar to a Syrian ware from Hama and found only in Galilee and in the northern valleys, is wheelmade.

The emerging picture is that of a sparsely populated country open to the influx of tribes from the north after the collapse of the earlier political units. Nomadic elements coexisted with village dwellers. Hunting and pastoralism reappeared as major means of support; potters and traders-smiths were among the specialized artisans. Despite the disruption of urban life, the land was certainly not completely deserted or depopulated, and scarcely two hundred years later urban civilization was vigorously resumed.

MIDDLE CANAANITE PERIOD II/ MIDDLE BRONZE AGE II
2000–1550 B.C.

The beginning of the second millennium B.C. was marked by the gradual return of urban institutions, which ultimately led to the creation of city-states. These remained the paramount political divisions in Canaan throughout this and the following Late Canaanite period until ca. 1200 B.C. In Egyptian New Kingdom sources, cuneiform inscriptions, and numerous verses in the Bible, the country is known as Canaan and its inhabitants as Canaanites. Cultural continuity corroborated by excavations indicates that both terms can be safely applied to the entire second millennium.

At the beginning of this era, under the vigorous Twelfth Dynasty, Egypt recovered its sta-

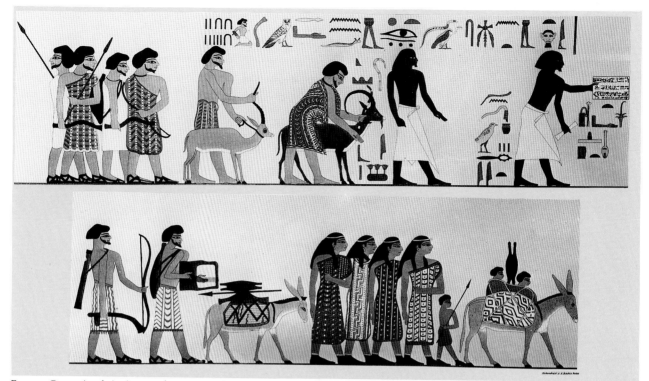

FIG. 37. Canaanites bringing goods to Egypt, from a wall painting from Beni Hasan, Egypt. 19th century B.C. Illustration from Lepsius, *Denkmäler aus Ägypten und Ethiopien*, Berlin, 1891, Abth. II Bl. 133.

bility. In the course of this period Canaan came under its cultural influence, though it was never actually incorporated into Egypt. A caravan of thirty-seven men, women, and children of an Asiatic tribe carrying eye-paint to Egypt, which is depicted in a wall painting at Beni Hasan, exemplifies the connections between the two countries (fig. 37).

In Mesopotamia and in northern Syria, Amorite dynasties established themselves in numerous kingdoms. In Mesopotamia the foremost were Assyria under Shamshi Adad I and Babylonia in the age of Hammurabi (eighteenth century B.C.); Mari on the middle Euphrates and Aleppo (Yamhad) and Qatna in Syria were among the city-states. Hazor in Canaan is mentioned in cuneiform documents from Mari. The description of the kingdom of Hazor as "the head of all those kingdoms" appears in the Bible (Joshua 11:10), and a king of Hazor, most probably of the seventeenth century B.C., is mentioned in a lawsuit, described in cuneiform script on a tablet found at Hazor. This tablet and other

cuneiform inscriptions dated to the seventeenth–fifteenth century B.C. are the earliest written documents from Canaan. Fragments from the Babylonian *Gilgamesh Epic* (Megiddo) and clay liver-models used in divination (Hazor) were also found. They indicate that during the Middle Bronze Age Canaan was part of the Mesopotamian cultural sphere. Its scribes were versed in cuneiform script, and the literate were acquainted with Babylonian myths and epics.

Two Egyptian sources contribute substantially to knowledge of Canaan. The story of Sinuhe tells of an Egyptian courtier in the twentieth century B.C., who for many years took refuge among the tribes of northern Canaan, married the daughter of the local chieftain, and became a chieftain in his own right. He passed through the land of Qedem and lived in upper Retenu and in the land of Yaa (northern Canaan). "It was a good land, called Yaa. Figs were in it and grapes. It had more wine than water. Abundant was its honey, plentiful its oil. All kinds of fruit were on its trees. Barley was there and emmer,

and no end of cattle of all kinds" (M. Lichtheim, *Ancient Egyptian Literature: A Book of Readings*, vol. 1, Berkeley, 1975, p. 226). Sinuhe then was pardoned by the pharaoh and returned to Egypt, so that his corpse would be properly buried.

The second source consists of the Egyptian "Execration Texts," which contain names of cities and rulers—enemies of Egypt—inscribed on clay figurines and vessels. They were broken in a ceremonial act intended to cause the destruction of these enemies by sympathetic magic. Two groups contain mostly West Semitic names: one group (the earlier) has some twenty names, the other more than sixty. Jerusalem and Ashkelon are included in the earlier group, together with names of tribal units. The latter are also mentioned in the second group, but city names are now much more numerous, indicating a definite development in urbanization and political organization in Canaan in the twentieth and nineteenth centuries B.C.

Archaeological discoveries reflect a similar development. Major mounds were resettled in this period (among them Dan [Laish], Hazor, Megiddo, Aphek, Gezer, and Tell Beit Mirsim) and new sites were occupied (Shechem and Tell Poleg). Massive fortifications, a hallmark of second-millennium urbanization, began to be erected early in the period (figs. 38 and 39). In the course of the following centuries they developed into complex systems, combining vertical stone walls, fortified slopes of beaten earth (*terre pisée*), and moats. To these were added fortress gates, symmetrically arranged with double or triple gateways, each flanked by a pair of massive piers. Within the enclosed area were palaces, temples, and patrician houses, while nearby villages provided the agricultural produce needed by the urban populace.

Some aspects of Canaanite religion in its early stages of development are illuminated by the numerous temples uncovered in excavations. Some are fortress-temples (as at Shechem and Hazor), with massive walls and two towers flanking the entrance. The holy of holies was placed on a straight axis opposite the entrance at

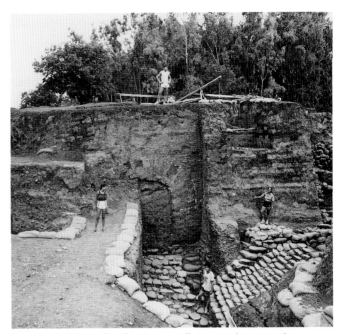

FIG. 38. Mud-brick fortifications at Tell Dan, with a uniquely preserved arched gate and paved street. 18th century B.C. Photograph: Nelson Glueck School of Biblical Archaeology, Jerusalem.

FIG. 39. Aerial view of Beth Shean. Photograph: Werner Braun.

the center of the rear wall. Open-air sanctuaries were also found, for instance, at Megiddo and Nahariya. Copper, silver, and gold figurines, some of male but most of female deities, convey the figurative imagery of the Canaanite pantheon (see cat. no. 39). Pottery vessels, jewelry, and other luxury items illustrate cult and ritual.

Numerous offerings were also associated with funerary customs. In this period the dead were usually buried in large family-tombs, which were used for several generations. Furniture and equipment were placed with the bodies of the dead, as well as offerings of food, drink, and luxury gifts.

The crafts of the potter and the jeweler reached an unprecedented standard of skill. Much care was devoted to household vessels, while special types, like Tell el-Yahudiyeh ware (cat. nos. 37 and 38) or ceremonial and cult vessels, were richly decorated; zoomorphic and anthropomorphic representations in clay were frequent. In the course of this age—and especially toward its end—beautiful jewelry was produced, most often of gold but sometimes of silver. Throughout this time contacts with the north and with Egypt were frequent and close. Later in this period trade connections with Cyprus were also established, and pottery vessels imported from Cyprus begin to appear in excavations.

The later stage of the Middle Canaanite Age corresponds to the Thirteenth Dynasty (eighteenth–seventeenth century B.C.) and to the subsequent foreign Hyksos rule in Egypt, which was centered in the Eastern Delta. Much has been written concerning the ethnic identity of these foreigners, whose names include Semitic, Hurrian, and Indo-European elements, and the extent of their dominion. During the Hyksos period—when no political borders divided the two areas—the material cultures of the Eastern Delta and of Canaan, especially its southern regions, are virtually identical.

LATE CANAANITE PERIOD/ LATE BRONZE AGE
1550–1200 B.C.

In the mid-second millennium Canaan entered a new stage in its history. In their royal inscriptions, the pharaohs of the Eighteenth and Nineteenth Dynasties commemorated their victorious battles against the major powers of the period: Mitanni, the Hurrian state on the upper Euphrates and upper Tigris, and later the Hittite empire in Anatolia. Beginning with Tuthmosis III (1504–1450 B.C.) who fought at Megiddo against the king of Qadesh on the Orontes at the head of a coalition of Syrian rulers, every pharaoh on his way to the north had to march through Canaan. No longer was Egypt simply a Nilotic kingdom; it grew into a major power. Though the Canaanite princes continued to rule over their small city-states, Egyptian overlordship was asserted: an Egyptian governor and his staff resided in Canaan, and Egyptian soldiers were stationed in a network of garrison cities, such as Gaza, Jaffa, and Beth Shean. The complex relations between Egypt and the local petty rulers are best illustrated by their letters to the pharaohs. More than 360 cuneiform tablets, discovered nearly a century ago at Tell el-Amarna, Egypt, record the diplomatic correspondence that passed between the great and small rulers of Asia and the Egyptian court. Among them are six letters from Jerusalem, six from Megiddo, seven from Ashkelon, twelve from Gezer, and some seventy letters from the prince of Byblos. Each ruler declares his loyalty to the pharaoh, while his neighbors denounce him as a traitor; continuous fights are reported and never-ending complaints are voiced; garrison troops are requested for protection from neighboring rulers, from the Habiru bands, and from rebellious citizens. Cuneiform inscriptions unearthed in excavations provide additional information, most significant being the cuneiform tablets from Taanach and those recently unearthed at Aphek.

Through compulsory "gifts," taxation, and booty, Canaan supplied Egypt with slaves and artisans, silver and agricultural products, mainly oil. It also provided local corvée labor for Egyptians residing in Canaan. In a letter to Milkilu, prince of Gezer, the pharaoh writes that he is sending "Hanya, the commissioner of the archers . . . to procure fine concubines (i.e.) *weaving women*: silver, gold, (linen) garments, *turquoise*, all (sorts of) precious stones, chairs of ebony, as well as every good thing" (W. F. Albright, The Amarna Letters, in *Ancient Near Eastern Texts Relating to the Old Testament*, Princeton, 1950, p. 487). And indeed, the selection of fine gold jewelry, ivories, and sculpture presented in this catalogue exemplifies the many "good things" that were common at that time in Canaan. Representations of Canaanites carrying gifts and booty were frequent in Egyptian tomb paintings of the New Kingdom (fig. 41).

The Amarna letters, Egyptian topographic lists, and archaeological excavations help to fill out the urban map of Canaan and to gain some understanding of the institutions and the layout of Canaanite cities. The king and the nobles, priests, and charioteers lived on the acropolis. Outstanding in this period is the city of Hazor, which, in addition to the Upper City, also had a Lower City and comprised some 80 hectares (200 acres), equaling in size the few large cities of the ancient Near East. Excavations have shown that palaces and temples sometimes covered a major part of the acropolis, leaving little room for the rest of the population, which lived in areas adjacent to the mound. Jewelers, smiths, potters, and stone cutters must have been employed by the court.

This was an age of international relations. Diplomatic activity was intensive between the major powers—Egypt, Babylonia, Mitanni, and the Hittites—and between lesser rulers. Gifts were exchanged and given as dowry in political intermarriages; booty was carried off in frequent wars. Most important, international trade connections flourished to a degree previously un-

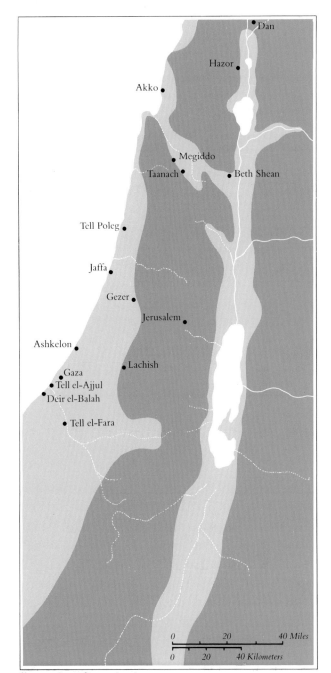

FIG. 40. Late Canaanite sites.

FIG. 41. Syrian or Canaanite merchant ships unloading at an Egyptian port, from a tomb painting at Thebes, Egypt. 14th century B.C. Detail from drawing by Norman G. Davies, in *Journal of Egyptian Archaeology* 33 (1947), pl. VIII.

known. Precious materials—gold, ivory, lapis lazuli, copper, and tin—as well as finished products and commodities were traded over vast areas. Canaan was open to trade with Cyprus and to a lesser degree with the Mycenaean world. The quantity of Cypriot wares found in settlements and among tomb offerings is incredibly large, and Cypriot styles were imitated by local potters. Cylinder seals were brought from Mitanni and were reproduced locally; Syrian flasks came through trade; glass ingots, a new man-made material, were imported, and fine multicolored vessels, glass beads and pendants, and even glass figurines have been found in excavations. Connections with Egypt were especially close, often based on reciprocity of styles and two-way imports and exports.

The realm of Canaanite cult and religion is of special interest. A fragmentary and often distorted picture of both was transmitted through biblical sources, which postdate the Canaanite period by centuries or even by a millennium. For the prophets of Israel and Judah, the pagan Canaanite religion was synonymous with idolatry and vice; Canaanite gods and goddesses were regarded as abominations.

The myths and epics discovered at Ugarit in northern Syria are the major contemporaneous source of information. There, the gods El, Baal, Reshef, and Hadad, accompanied by the goddesses Asherah, Astarte, and Anat, were cosmic powers, who roamed freely in the heavens and on the earth, in the depths of the sea and in the abyss below.

Archaeology makes its contribution by unearthing temples and their equipment, cult objects, and tomb offerings. However, little of the monumental architecture and sculpture that would have been representative of the official cult has survived the destruction caused by time and man. The Shrine of the Stelae and the lion orthostat from Hazor (cat. nos. 41 and 42), the lion orthostat from Beth Shean (cat. no. 44), and the temple equipment from the Fosse Temple at Lachish (cat. nos. 45–49) are among the most important objects preserved. Minor sculpture in copper or gold and especially clay plaque figurines are examples of cult objects from the more humble sphere of the personal cult.

By the end of the second millennium, Canaanite religion and culture were fully developed, and they have sometimes even been called "baroque" or "decadent." Gradually they were overcome and eventually absorbed by the aggressive young cultures that were to shape the history of the following age.

33. Model of a House

Arad
ca. 2950–2650 B.C.
Pottery; height 21 cm. (8¼ in.), top 26.5 × 12.5
cm. (10⅜ × 4⅞ in.), bottom 26.5 × 17 cm.
(10⅜ × 6¾ in.)
Excavations of the Israel Museum, the Israel
Department of Antiquities and Museums, and
the Israel Exploration Society
IDAM 64–236

It is in the nature of archaeological excavations that
they reveal only fragmentary remains of ancient sites.
A house is rarely preserved to its original height or
extent; roofs are the first element to collapse; only a
section of a building, the foundation of a wall, or the
corner of a room may escape the destruction wrought
by man and time. Architectural models occasionally
found in excavations are therefore an important com-
plementary source of information, since they are con-
temporaneous three-dimensional representations of
complete buildings.

The present model, found in a small room of a
private house, represents a one-room building. Such

basic dwelling units have been traced in the ancient
city of Arad in the third millennium, and they were
also common in other cities of that period. As in this
model, the door in Arad houses was set in the middle
of the long front wall, and there were no windows.
No roof has been preserved, but the model strength-
ens the assumption that the roofs were flat.

The model does not, however, represent all the ar-
chitectural features of Arad houses as revealed by the
excavations, such as benches, steps, and columns sup-
porting the roof. The network of vertical and hori-
zontal bands covering the walls and roof of the model
house, as well as the plastic elements and red paint
framing the entrance, should probably be regarded as
decorative elements rather than as factual architectural
details. Below the roof, on both narrow sides, there is
a pair of perforations. Their function is unknown, but
they too are difficult to connect with an architectural
prototype.

The purpose of the house model is unknown. Its
findspot, in a private house, proves that it was not an
ossuary. It could have served as a container or as a
house-shrine in which a divine image was placed.

REFERENCE: *R. Amiran et al., *Early Arad I*, Jerusalem, 1978,
pp. 52–53.

34. Bull Head

Beth Yerah
2650–2350 B.C.
Ivory; 4.4 × 3.4 cm. (1¾ × 1⅜ in.)
Excavations of the Israel Department of
Antiquities and Museums
IDAM 55–426

This bull head, found in the excavations of Beth Yerah on the Sea of Galilee in 1951, is one of three similar ivory heads known to date. The other two were unearthed more than fifty years ago: one, in 1931, in the early excavations at Jericho, and the other, in 1933, in the excavations of Ay (et-Tell) in the hill country north of Jerusalem. The head from Beth Yerah is the best preserved; the Jericho head is blackened by fire, and much is missing from the Ay head, which has been reassembled from fragments. All three come from Early Bronze levels and can be assigned, with a fair degree of certainty, to Early Bronze Age III, in the mid-third millennium B.C.

The head is heavily stylized, and its basic cubic shape is preserved: the back and the trapezoidal top are very slightly curved and the round base is flat. The sunken triangle, cut out in the center of the forehead, and the deeply hollowed almond-shaped eyes were originally inlaid. The skin folds above the eyes and in front of the muzzle are represented by well-defined grooves; the mouth is indicated by a semicircular ridge. The missing ears and horns were made separately, perhaps of different materials, and inserted into holes. The head could be attached, as a finial or decoration, to some other object by means of the bottom holes, which are interconnected.

The other two heads are almost identical in size (Jericho head: height 4.7 cm. [1⅞ in.]; Ay head: height 4 cm. [1⅝ in.]) and in design. Therefore, it can be reasonably assumed that all three were the products of a single workshop. In any case, they certainly represent the same sculptural tradition.

The bull, symbolizing a number of deities, was an integral part of Near Eastern iconography in all periods. It is not surprising, therefore, that numerous comparative examples can be cited. But though each shares some stylistic peculiarities with this group of three heads, none is sufficiently similar to provide a close parallel. Thus it can be assumed that the heads were locally made by experienced ivory cutters who were skilled in the use of the drill and the awl.

Bull-head carvings feature prominently in the small corpus of art objects that has survived from the Early Bronze Age. Indeed little representational art has survived from this period. However, a number of bone carvings indicate that the art of ivory carving, which flourished in the preceding Chalcolithic period, was not completely lost.

The ivory heads are luxury products, made of a

35

costly and rare material. The head from Beth Yerah was found in a columned building, and the one from Ay in a temple. The head from Jericho came from a building outside the fortifications. Thus, though the exact function of these small sculptures is obscure, there is little doubt that they formed part of some ceremonial and cultic equipment.

REFERENCES: *P. Bar-Adon, Another Ivory Bull's Head from Palestine, *Bulletin of the American Schools of Oriental Research* 165 (1962), pp. 46–47; A. Ben-Tor, An Ivory Bull's Head from Ay, *Bulletin of the American Schools of Oriental Research* 208 (1972), pp. 24–29.

35. Large Bowl

Beth Yerah
2650–2350 B.C.
Pottery; height 24 cm. (9⅝ in.), diameter
47 cm. (18½ in.)
Excavations of the Israel Department of
Antiquities and Museums
IDAM 51-3418

Seldom can a group of objects be connected with any particular ethnic element or population movement. Yet such seems to be the case with the type of pottery vessels to which the present bowl belongs. In Israel this type is called "Khirbet Kerak [Beth Yerah] ware" after the site on the shores of the Sea of Galilee where it was first found in quantity and where this bowl was unearthed.

The Khirbet Kerak ware belongs to a larger group of pottery vessels distinguished by shape and decoration as well as by peculiarities of production techniques. Elsewhere, the group has been referred to as "black or dark gray burnished ware" or "red-black burnished ware." The diffusion of this ware extends over vast areas, from Transcaucasia—Georgia, Azerbaijan, and Armenia—through East and Central Anatolia, then farther south to Syria, Lebanon, and Israel. Many scholars believe that this ware—which reached Canaan from the north, probably through the Orontes Valley—may be connected with waves of migratory movement rather than with trade relations. It is therefore not surprising that Khirbet Kerak pottery is common in what is now northern Israel and Syria, where it has been found on numerous sites, whereas none has been recorded south of Jericho and Tell Erani.

These vessels are clearly different from contemporaneous local ceramics. The most common shapes in the Khirbet Kerak ware repertoire are plates, bowls, kraters, and cups; pots and jugs are also known. Among the more unusual forms are lids, horseshoe-shaped hearths, and tall, biconical, hollow stands. The vessels are always handmade, heavily slipped, and

35

99

highly burnished. The red-black color scheme was intentionally achieved, through controlled smoke-blackening of certain areas.

The decoration is mainly geometric. Relief bands may cover the entire surface or parts of it; in addition to bands, such as adorn the present bowl, knobs and incised and grooved patterns are common. Occasionally a human or animal head or a stylized bird is added as a decorative element or as an ornamental handle.

REFERENCES: *R. Amiran, Connections Between Anatolia and Palestine in the Early Bronze Age, *Israel Exploration Journal* 2 (1952), pp. 89–103, pls. 5–7; C. A. Burney, Eastern Anatolia in the Chalcolithic and Early Bronze Age, *Anatolian Studies* 8 (1958), pp. 157–209, especially pp. 173–74; R. Amiran, *Ancient Pottery of the Holy Land*, Jerusalem–Ramat Gan, 1969, pp. 68–75.

36. Cup

Ein Samiya
2200–2000 B.C.
Silver; height 8.2 cm. (3¼ in.)
Excavations on behalf of the Archaeological Staff Officer, Judaea and Samaria
ASOJS 2919

Every excavation holds a promise of surprise finds, and at Ein Samiya the silver goblet fulfilled that promise beyond expectation. It was found in a two-chambered shaft tomb typical of the period in both form and contents. Deposited with the cup were sixteen small pottery jars and two four-spouted pottery lamps; a dagger, a spear butt, and a knife blade (all probably of copper); and carnelian beads. All the artifacts in this homogeneous assemblage are well designed and well made, but none are outstanding. The silver cup, on the other hand, is clearly a stranger to the group. It is unique, not only in Canaan but in the entire ancient Near East, both in the material from which it is made—sheet-silver—and in its decoration.

Originally the cup was probably more or less biconical. What remains of the broken lower part is geometrically decorated with a band of chevrons surmounted by a band of herringbone pattern. The upper part consists of two richly representational scenes (fig. 42) executed in repoussé and incision, which may be interconnected by recurring elements such as the rosettes and the serpents. On the left, rising from the hindquarters of two bulls, is a Janus-headed human torso holding a plant in each hand. An eight-petaled rosette is placed between the two pairs of bull legs. On the right a serpent rears up toward the plant.

The second scene shows a human figure holding one end of a crescent-like "ribbon" studded with circles. Above this is a large, eleven-petaled rosette with a human face in the center. The eyes, nose, and mouth are clearly marked, while the ears merge with the petals. Below the ribbon is another serpent. The fragment of an arm and the corner of a fleecy garment are all that remain of another human figure which would have completed the scene.

All the components are well known in the imagery

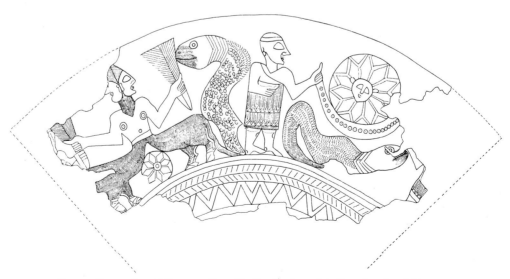

FIG. 42. Decoration of silver cup from Ein Samiya (*opposite*). Drawing: Israel Museum.

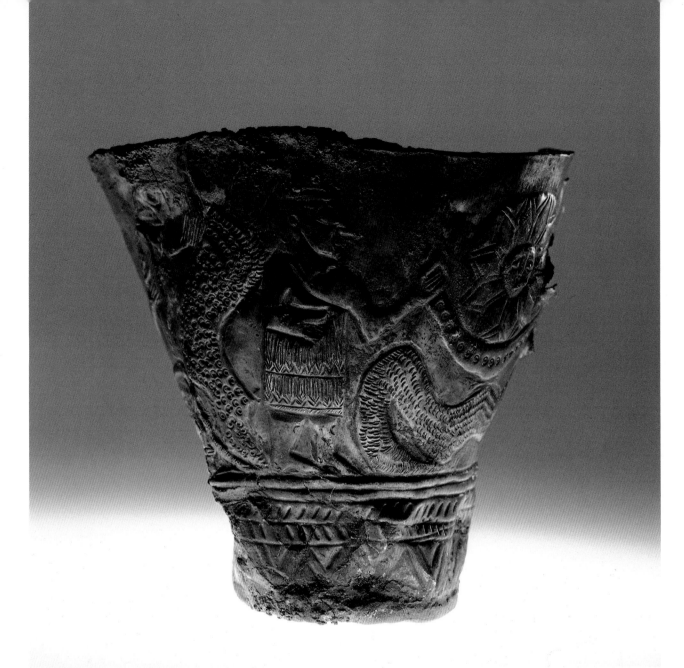

of the ancient Near East and can be found throughout
its history in sculpture, relief, and glyptic art. Yet the
interpretation of the scenes, as well as the myth or
legend they represent, is problematic. The motifs seem
to be fraught with cosmic symbolism: the rosette and
the ribbon having celestial and astral connotations, the
serpents representing chthonic elements, and the styl-
ized plants indicating vegetation. The composite crea-
ture should be seen as a heroic rather than a divine
figure, as he has none of the customary divine attri-
butes (horns or cap); nor do such attributes appear on
the man holding the ribbon.

Where was the cup made? How did it reach its final
destination as a tomb offering in Canaan? There are
no clear answers to these questions. Some compar-
isons with third-millennium representational art from
North Syria and affinities with second-millennium
Hurrian and Hittite art may have special significance
in this context. A connection with the Mesopotamian
epic of creation (*Enūma eliš*) has been suggested. More
recently, an attempt was made to trace the origins of
this goblet to the northern Caucasus.

Whatever its origin, the cup seems to be foreign to
what is known of local culture in the third millenni-
um. Already damaged when deposited in the tomb, it
must have been a treasured possession. Whether it was

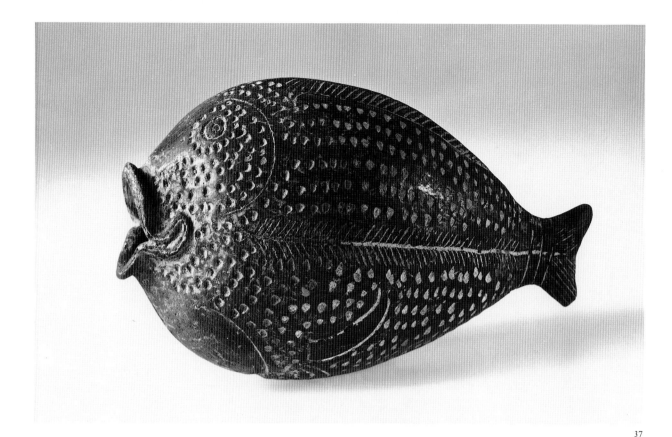

taken by a soldier as booty, brought from afar as a cherished family heirloom, or acquired through trade and valued mainly for its costly material remains a matter of intriguing speculation.

REFERENCES: *B. Shantur and Y. Labadi, Tomb 204 at 'Ain-Samiya, *Israel Exploration Journal* 21 (1971), pp. 73–77; Z. Yeivin, A Silver Cup from Tomb 204A at 'Ain-Samiya, *Israel Exploration Journal* 21 (1971), pp. 78–81; Y. Yadin, A Note on the Scenes Depicted on the 'Ain-Samiya Cup, *Israel Exploration Journal* 21 (1971), pp. 82–85; M. Tadmor, in *Highlights of Archaeology: The Israel Museum*, Jerusalem, 1984, pp. 42–43; M.-H. Carr Gates, Casting Tiamat into Another Sphere: Sources for the 'Ain-Samiya Goblet, *Levant* 18 (1986), pp. 75–81.

37. Fish-Shaped Vessel

Tell Poleg
19th–18th century B.C.
Pottery; 11 × 19 cm. (4⅜ × 7½ in.)
IMJ 68.32.150

There is a mixture of stylization and naturalism in this pottery object. The plump body, the open mouth with curving corners, and the round eyes are natural-istically depicted. Stylistic convention is, however, evident in the spine, which is represented twice—once on each side of the fish. The fins and gills are schematically rendered by incised lines, and the scales are indicated by rows of punctured dots. Both lines and dots are filled with white paste, forming a lively contrast to the brownish-gray burnished surface.

The vessel sits gracefully on a small flattened area of the belly; the rest of the body appears to float above this base. It seems unlikely that this object served as a container, since only a small quantity of liquid could be stored below the level of the open mouth. Alternatively, it may have been used as a drinking cup or a playful ornament. When placed in the tomb as an offering, it was already slightly damaged at the tail.

Stylistically, the vessel belongs to a type known as "Tell el-Yahudiyeh ware," named after the site in the Nile Delta where it was first found (see also cat. no. 38). Juglets are the commonest form in this ware, but zoomorphic vessels, fish- or bird-shaped, are also attested. The surface of this pottery is always dark-slipped and burnished, and the white-filled punctured decoration is inherent to the type.

Significantly, Tell el-Yahudiyeh vessels are found in Egypt, the Sudan, Canaan, and Cyprus and as far north as Ugarit on the Mediterranean coast. Clearly they were fashionable luxury products, which, because of the political stability and economic prosper-

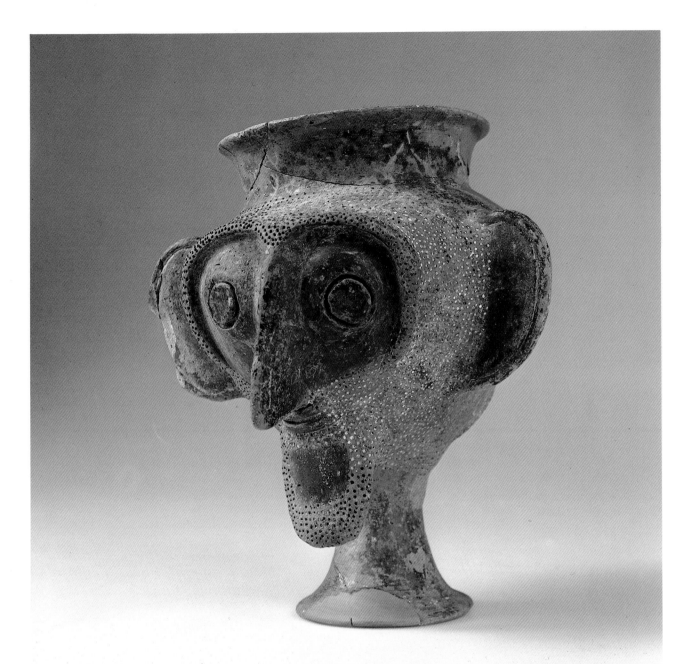

ity of the times, spread over wide areas. The shape of the Tell el-Yahudiyeh juglets, which is derived from common Canaanite juglets of the period, may perhaps indicate that Canaan was the original home of this ware.

REFERENCES: R. Amiran, *Ancient Pottery of the Holy Land*, Jerusalem–Ramat Gan, 1969, pp. 116–20; *R. Gophna, Ichthyomorphic Vessel from Tel-Poleg, *Museum Haaretz Bulletin* 11 (1969), pp. 43–45, pl. IX; M. Tadmor, in *Highlights of Archaeology: The Israel Museum*, Jerusalem, 1984, pp. 44–45.

38. Anthropomorphic Vase

Jericho
18th–17th century B.C.
Pottery; height 21 cm. (8¼ in.)
Excavations of the Institute of Archaeology,
University of Liverpool
IDAM 32.1366

Like the fish (cat. no. 37), this vessel is an example of Tell el-Yahudiyeh ware. A high-footed deep krater of

a type common in the period, this vase was given the appearance of a modeled head, making it a unique masterpiece of Canaanite ceramic art. The white-filled punctures, the hallmark of Tell el-Yahudiyeh ware, are ingeniously used here to represent the hair and the beard. Strangely, the hair appears also on the forehead. The rest of the surface is left dark and highly burnished, in a manner typical of the ware.

All of the facial features seem to have been intentionally exaggerated, almost to the point of being grotesque. Certainly this is not a naturalistic representation or an attempt at portraiture. The curved brows that surround the circular eyes extend halfway down the cheeks and are echoed by the curved flaps of the ears that also serve as handles. The long thin nose is very prominent. Its tip overhangs the closed but smiling mouth. The beard is no wider than the slender pedestal. The neck of the vase crowns the forehead, producing the impression of a separate element placed on the head.

The vase was found in 1930–31, during the early excavations in the cemetery at Jericho. It was deposited, with numerous pottery vessels, weapons, and scarabs, in the earliest level of Tomb 9, described as "a substantial grotto with a chamber 3 to 4 metres wide and a shaft 4 metres deep." The shape of the krater and the vessels deposited with it place it in the second stage of the Middle Canaanite period.

REFERENCE: *J. Garstang, Jericho: City and Necropolis, *Annals of Archaeology and Anthropology* 19 (1932), pp. 45–46, pl. XLIII.

39. Two Female Figurines

Gezer
16th century B.C.
Gold; IDAM 74–877, height 16.1 cm. (6⅜ in.);
IDAM 74–878, height 10 cm. (4 in.)
Excavations of the Hebrew Union College,
Jerusalem

These figurines formed part of a small hoard found in a storeroom just inside the south gate of the city of Gezer. It was buried in a corner of the room a few centimeters below the floor. For whatever reason, the owner abandoned this little treasure, and subsequently, during the destruction of the city, the whole complex was covered and sealed by heavy mud-brick debris. These figurines, a few fragments of a similar silver figurine, a gold bezel for a scarab ring, an amethyst

scarab, and four gold earrings were discovered during the last hours of the final season of excavations at Gezer in 1973.

Both figurines are made of sheet-gold in the repoussé technique, supplemented by engravings and punctures. In both, the body is rendered in a sketchy manner; the arms are partly cut away from the body; the palms and feet are not marked. The larger figurine depicts a nude woman, with a schematically rendered pubic triangle surmounted by a belt. The other woman is draped in a sari-like garment, with each fold of the cloth bordered by a row of dots, as if beaded. Both women wear composite collar-necklaces. In addition, the larger figurine has a separate torquelike necklace. The faces are depicted in detail in an identical manner; only the headgears are different.

These works are examples of a genre of female figurines that was popular in Canaan and in the ancient Near East. Most numerous were pottery plaque figurines, which were easy and inexpensive to produce. Metal examples—in gold, silver, or copper—are relatively few, as they were always more expensive and had to be made by expert smiths. Moreover, in all periods, metalsmiths were eager to remelt broken and discarded objects and jewelry in order to obtain raw material.

Nude female figures, represented here by the larger figurine, have a long history and can be traced from Iran and Mesopotamia through the ancient Syrian states to Canaan and Egypt. The high headgears and the broad collar-necklaces are Egyptian elements that became integrated into Canaanite sculpture.

Draped female figurines are, however, quite rare. Also uncommon in this part of the world are torques, which are usually connected with the well-known "torque cultures" of Europe. However, this may be partly due to the fact that such small, separately made elements could have been easily lost.

The female figurines are usually regarded as representations of Canaanite deities. The high headgear is one of the iconographic elements associated with these images, together with such attributes as flowers, snakes, and accompanying animals. The identification of these figures is not easy, because of the pronounced schematization of Canaanite representational art and because of the paucity of adequate literary sources of the period. Therefore, the question of whether these are representations of major Canaanite goddesses—such as Anat or Astarte—or of minor protective deities must remain open.

REFERENCE: *J. D. Seger, Reflections on the Gold Hoard from Gezer, *Bulletin of the American Schools of Oriental Research* 221 (1976), pp. 133–40.

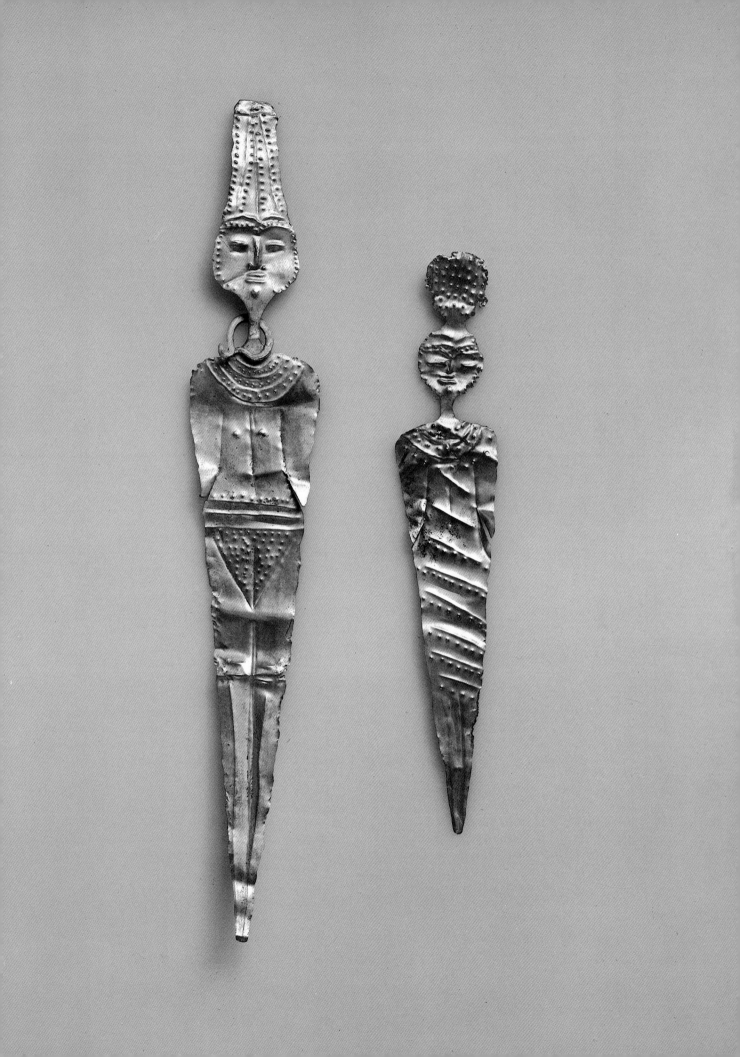

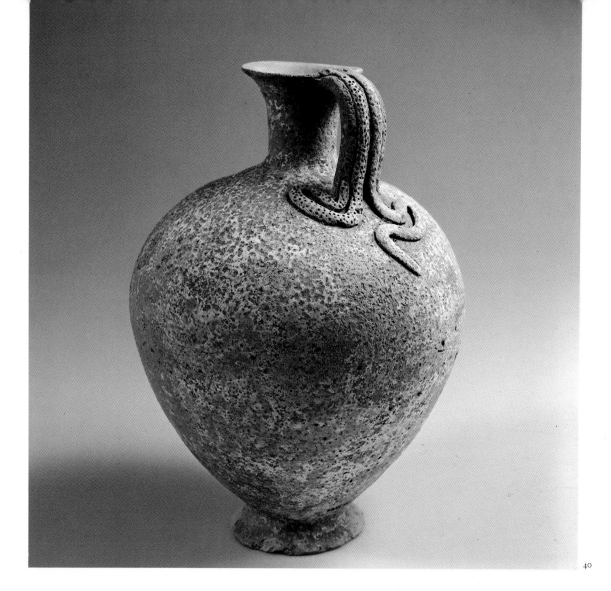

40

40. "Snake Jug"

Provenance unknown
Mid-second millennium B.C.
Pottery; height 32 cm. (12⅝ in.)
IMJ 70.63.102

There must have been a tradition of excellence among potters of the second millennium. This "snake jug" is one of the numerous pottery vessels of remarkably fine workmanship that are elegant and aesthetically pleasing to the modern eye.

In his publication of the excavations at Tell el-Ajjul, Sir Flinders Petrie coined the term "chocolate-on-white ware" for vessels covered with a thick creamy-white slip, highly burnished, and decorated with a distinctive chocolate-brown painted design. This jug seems to be an example of this ware, although the painted decoration is lacking. It has all the other characteristics of this ceramic family—excellence of technique and elegance of shape, thick white slip (now pitted), and lustrous burnish. The raised ring-base and

the globular body, the wide neck, and the flaring rim are also typical of this ware.

Both the triple handle and the snake application are frequently attested in the ceramic repertoire of this period. Here, however, the execution of the snake motif is unusual. Snakes were generally represented in various degrees of schematization: sometimes as plain ribbons stiffly overlying the handles and occasionally curving in a more naturalistic manner. The snakes on this jug are, however, by far the most realistic representations known from this period. Both snakes curl sinuously as if crawling on the shoulder of the vase and up the handle; their heads rest on the lip of the vessel. The eyes are perforated, and the bodies are covered by tiny punctures.

The provenance of this jug is unknown, but the fact that it is so well preserved suggests that it was a tomb offering.

REFERENCES: R. Amiran, *Ancient Pottery of the Holy Land*, Jerusalem–Ramat Gan, 1969, pp. 158–60; *M. Tadmor, in *Highlights of Archaeology: The Israel Museum*, Jerusalem, 1984, pp. 46–47.

SCULPTURES FROM HAZOR

Cat. nos. 41–43

15th–13th century B.C.
Excavations of the James A. de Rothschild Expedition to Hazor on behalf of the Hebrew University, Jerusalem

Historical memory had for centuries maintained that "Hazor was formerly the head of all those kingdoms" (Joshua 11:10). Hazor is one of the few Canaanite cities mentioned in Mesopotamian cuneiform texts; the city is listed in Egyptian royal inscriptions, and its king corresponded with the Amarna pharaohs. In addition, there are numerous references to Hazor in the Bible throughout the period of the Monarchy, until the city was destroyed in 732 B.C. by Tiglath-pileser III of Assyria (2 Kings 15:29).

These references underscored the city's importance and helped prompt the excavations of Tell el-Qedah, the large mound in Galilee that was identified with Hazor. Soundings were made in 1928, and in four seasons beginning in 1955, the high mound and the Lower City of Hazor were extensively excavated. The Shrine of the Stelae and the large Orthostat Temple, both in the Lower City, are among the outstanding architectural finds unearthed in the course of these excavations (see cat. nos. 41 and 42). Both temples are most important additions to the corpus of Canaanite sacred architecture and shed light on the religious practices of the period.

41. Shrine of the Stelae

Basalt
Stelae: IDAM 67–671, 67–672, 67–673, 67–674, 67–675, 67–676, 67–677, 67–679, 67–680; height of largest 65 cm. (25⅝ in.), height of smallest 22 cm. (8⅝ in.)
Stela with hands: IDAM 67–678, height 45.5 cm. (17⅞ in.)
Offering table: IDAM 67–681, length 69 cm. (27⅛ in.)
Statue: IDAM 67–683, height 40 cm. (15¾ in.)
Lion orthostat: IDAM 67–682, 33 × 44 cm. (13 × 17⅜ in.)

The ten stelae, the male statue, the offering table, and the lion orthostat—all made of basalt—formed the furniture of a small temple discovered at the foot of the great earthen rampart on the west side of the Lower City of Hazor (fig. 43). The shrine was a rectangular room (4.75 × 3.4 meters [17 × 11¼ feet]), with an entrance in the center of the east wall. Opposite the entrance, a semicircular niche served as the holy of holies.

The stelae are surprisingly small. All but the central stela are plain, with flat fronts, convex backs, and rounded tops. The central stela bears a relief of two hands raised toward a crescent and a disk. Two small tassel-like circles are carved below the crescent. The offering table is a plain, roughly finished basalt slab.

The statue was found decapitated, and the head was discovered lying on a floor at a lower level. It depicts a man, possibly a priest, seated on a cubelike stool. He is beardless with a shaven head; his skirt ends below the knees in an accentuated hem; his feet are bare. He holds a cup in his right hand, while his left, clenched into a fist, rests on his left knee. An inverted crescent is suspended from his necklace.

The lion orthostat consists of a rectangular basalt slab that originally formed part of the left doorjamb of the temple entrance. The inner side was therefore left rough, while the visible side was smoothed and carved in low relief to represent a lion. The body is almost linear, while the head protrudes from the block and becomes a true three-dimensional sculpture. The lion is shown in a crouching position, with its curving tail ending in a tuft of hair. The mane is indicated by a herringbone design, the muscles of the forelegs are

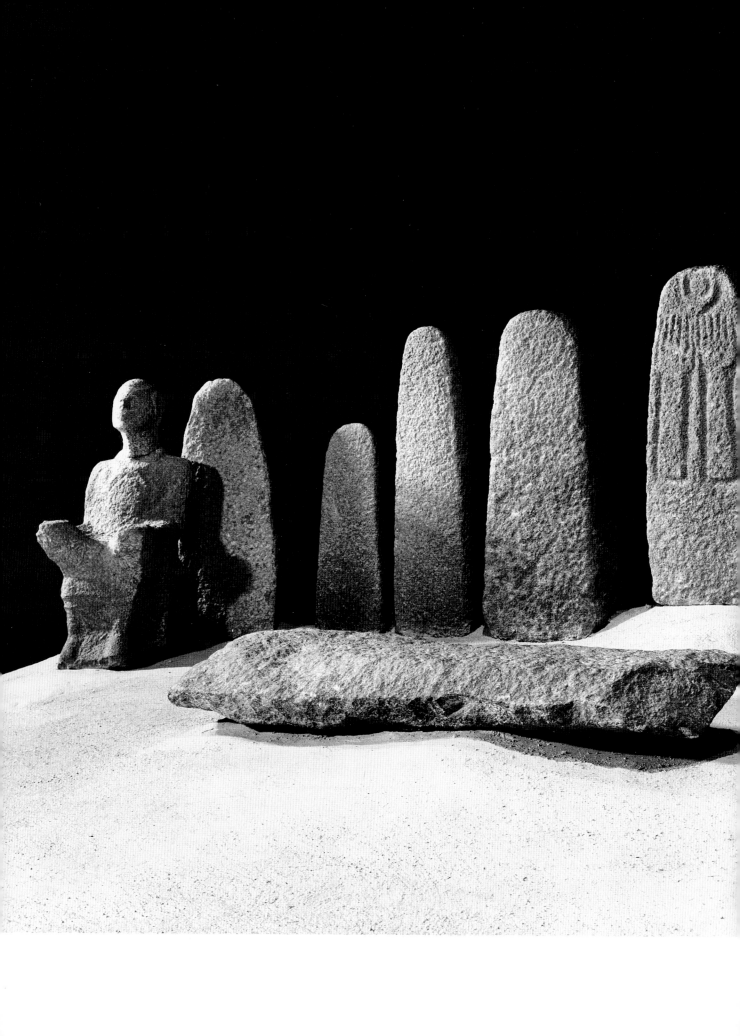

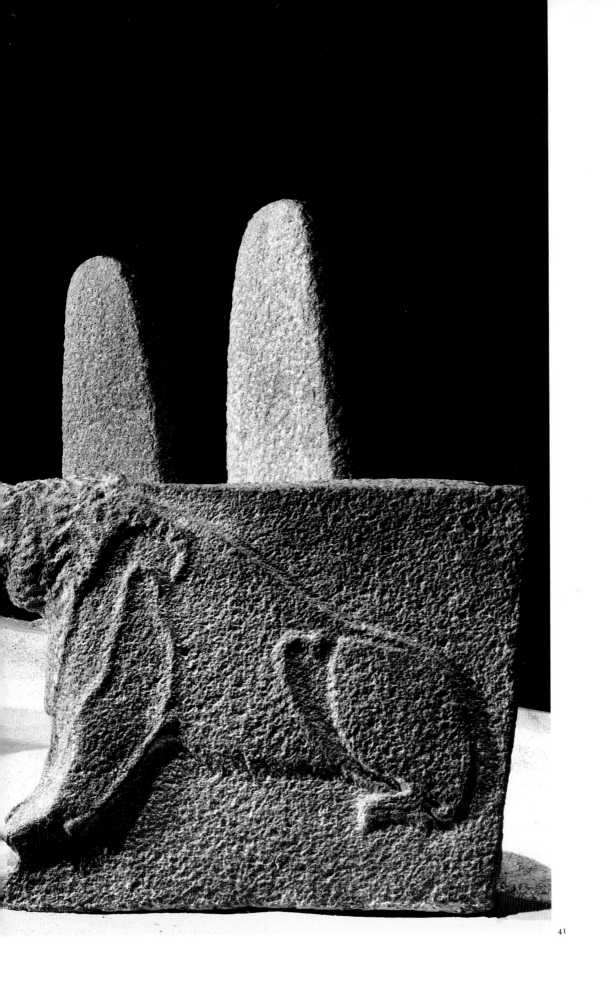

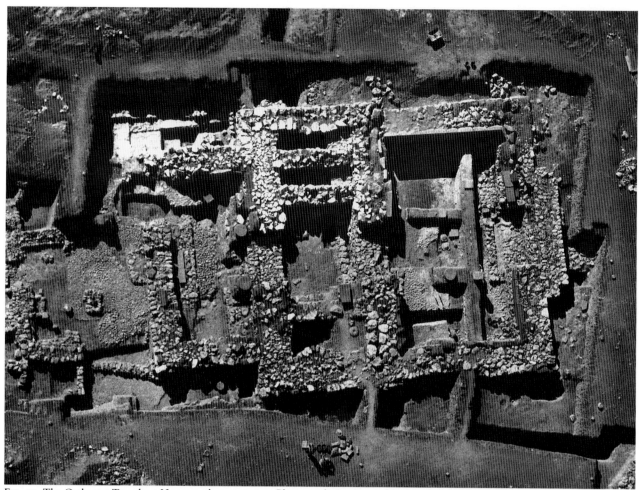

FIG. 43. The Orthostat Temple at Hazor. 13th century B.C. Photograph: Institute of Archaeology, Hebrew University, Jerusalem.

indicated by an irregular loop, and the hindlegs are in high relief. Much of the head is missing, but the mouth appears to have been open.

Stelae are frequently interpreted as being associated with ancestor worship. In ancient Near Eastern iconography, the crescent—represented here on the central stela and on the pendant—was the emblem of the moon god Sin, suggesting that this god, in one of his manifestations, was worshipped in the Shrine of the Stelae. The uplifted hands may be understood as a gesture of supplication, although Yadin (1970, pp. 216–24) proposed that this posture should be associated with a goddess known from much later Punic iconography as Tanit (TNT), who was the consort of the god Sin.

The shrine was used during the fourteenth and thirteenth centuries B.C. and was destroyed in the final conquest of the Canaanite city of Hazor by the Israelite tribes. It can be assumed that the stelae, statue, offering table, and lion orthostat, although found in the latest phase of the temple, were made a few cen-

turies earlier and were transferred to the shrine from an earlier structure.

REFERENCES: *Y. Yadin et al., *Hazor I*, Jerusalem, 1958, pp. 83–92, pls. XXVII–XXXI, CLXXX; Y. Yadin, Symbols of Deities at Zingirli, Carthage and Hazor, in *Near Eastern Archaeology in the Twentieth Century (Essays in Honor of Nelson Glueck)*, J. A. Sanders (ed.), New York, 1970, pp. 199–231; Y. Yadin, *Hazor* (The Schweich Lectures of the British Academy, 1970), London, 1972, pp. 67–73.

42. Lion Orthostat

Orthostat Temple, Hazor
Basalt; 91 × 182 × 60 cm. (35⅞ × 71⅝ × 23⅝ in.)
IDAM 67–1654

Stylistically this massive basalt orthostat is almost identical with the small lion slab from the Shrine of

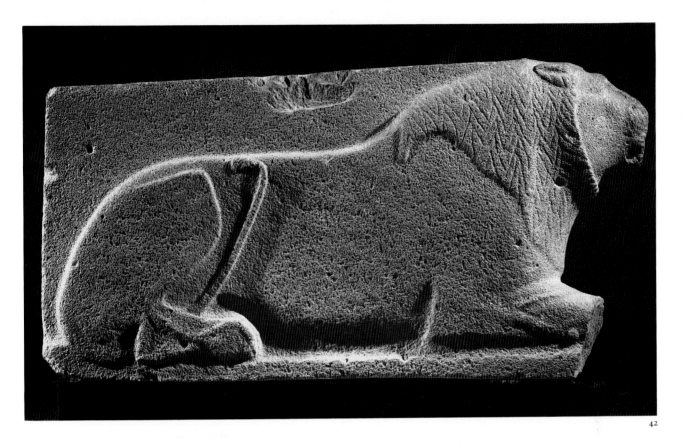

the Stelae (cat. no. 41), but it displays superior work-manship. The differences between the two are insignificant, the most important being the well-defined base upon which this lion crouches (in the smaller orthostat the lion "floats" without a groundline). In this beautifully carved slab, the figure of the lion is of excellent design and execution, in the best tradition of stone carving. The unworked side is on the right, indicating that the orthostat was originally incorporated into the right doorjamb guarding the entrance to the temple. Two large round holes in the top were used to attach the orthostat to the stones above.

This orthostat, discovered in the large Orthostat Temple in the Lower City of Hazor, was not found in situ. Rather it had been thrown into a deep pit under the front wall of the temple porch, deliberately buried under a pile of stones.

The Orthostat Temple had a long existence. In the course of time it developed from a one-hall building into a magnificent tripartite temple with fine basalt orthostats lining the walls of the main hall and of the porch. At all times the holy of holies was at the center of the back wall, on a straight axis with the entrance. In the latest stage two columns were placed in front of the cella, like the "Jachin and Boaz" columns in the Solomonic Temple, which, like the Hazor temple, was also tripartite.

The lion orthostat and other architectural features of this temple find comparisons in the North Syrian

principalities, notably at Alalakh, and in Anatolia in the Hittite empire. Like its smaller counterpart from the Shrine of the Stelae, this large orthostat must be dated to the mid-second millennium B.C.

REFERENCES: D. Ussishkin, The Syro-Hittite Ritual Burial of Monuments, *Journal of Near Eastern Studies* 29 (1970), pp. 124–30; *Y. Yadin, *Hazor* (The Schweich Lectures of the British Academy, 1970), London, 1972, pp. 75–87.

43. Cult Mask

Hazor
14th–13th century B.C.
Basalt; height 14 cm. (5½ in.)
Excavations of the James A. de Rothschild
Expedition at Hazor on behalf of the Hebrew
University, Jerusalem
IDAM 67–1195

This pottery mask, a paradigmatic cult object, was unearthed in a building situated about twenty meters (twenty-two yards) north of the Shrine of the Stelae. The spacious room (or courtyard?), which formed part of a large building, was equipped with benches along the walls and with an installation consisting of a double wall projecting toward the interior of the room.

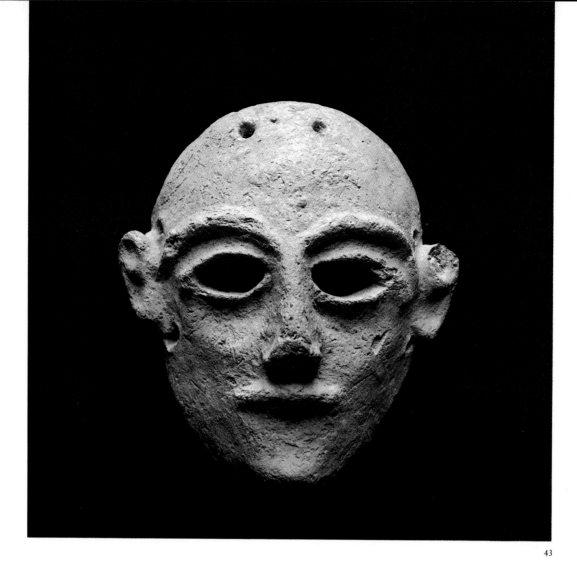

43

The mask was found together with a potter's wheel on this installation, which therefore seems to have been used as a potter's workshop. The mask may have been intended for use in some cult, conducted in the neighboring Shrine of the Stelae; but there is, of course, no certainty in such an assumption.

This mask was shaped by hand like a shallow bowl, thick in section and roughly finished, especially on the inside. The facial contours are sensitively modeled. The eyeholes are cut out; the eyebrows, nose, mouth, and chin are shaped in relief; the ears are modeled from fairly large pellets of clay affixed to the face.

The mask was attached by means of three pairs of holes, two at the sides and one on top. Its small size indicates that it was not intended to be worn by an adult; instead it may have covered the face of a statue or have been suspended from some surface.

REFERENCES: *Y. Yadin et al., *Hazor II*, Jerusalem, 1960, p. 115, pl. CLXXXIII; Y. Yadin, *Hazor* (The Schweich Lectures of the British Academy, 1970), London, 1972, pp. 35–36, 73–74; M. Tadmor, in *Highlights of Archaeology: The Israel Museum*, Jerusalem, 1984, pp. 50–51.

44. Orthostat

Beth Shean
14th century B.C.
Basalt; 89 × 74 × 25 cm. (35 × 29⅛ × 9⅞ in.)
Excavations of the University Museum,
University of Pennsylvania
IDAM I.3861

The interpretation of this scene, unique in the art of orthostat carving, is still uncertain. In both registers the figure of the lion is clear—but should the other animal be identified as a lioness or a dog? Following the discovery of the slab in 1928, the scenes were interpreted as a fight between a lion and a dog (in the lower register the dog bites the lion's back). This interpretation has often been cited since, though the possibility that the other animal represents a lioness has also been suggested.

The similarity between the animals depicted is, in the author's opinion, a weighty consideration. It is difficult to believe that a master carver would portray a lion and a dog as identical in height and physique

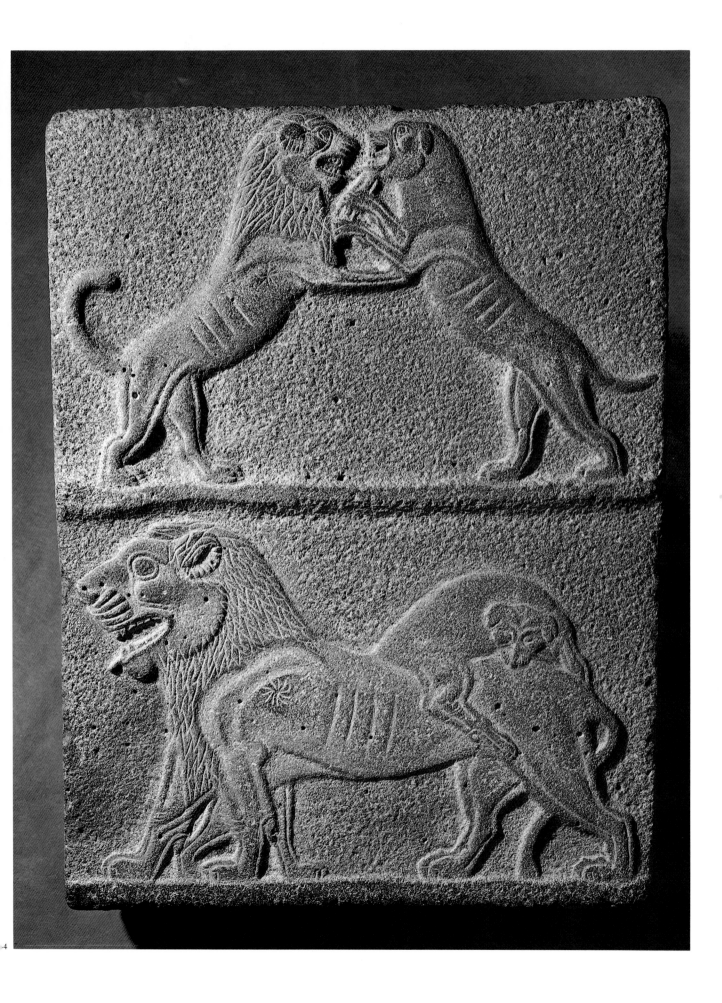

and with the same very characteristic paws. More-over, the face of the animal in the upper register is characteristic of a lioness. If, indeed, the two animals are a lion and a lioness, then the relief represents scenes of play rather than of struggle. In the upper register the two animals face each other, and the lioness rests her forelegs on the lion, who supports her with his right paw. In the lower register the lion stands motionless, his mouth open, while the lioness climbs on his back from behind.

In both scenes, the lion has a starlike tuft of hair ornamenting his shoulder. Such "star" symbols, appearing most frequently on lions, occur not only on contemporaneous representations but also in various media over a wide area and during many centuries. Nearest in time and location are two examples from the Megiddo ivories, dated to the fourteenth–twelfth century B.C. Again, unless a hunting scene was intended, it is difficult to accept that a lion, the king of animals and the manifestation of major deities, whose symbolic nature is accentuated by the "star" shoulder ornament, would be represented as attacked and defeated by a dog.

Comparisons for the present scenes can be sought in glyptic works and ivory carvings, where antithetic animals and combats between animals are frequently depicted. A very similar scene is represented on an ivory fan handle from Enkomi in Cyprus: a lion climbs from behind to bite a bull—his "equal" in ancient Near Eastern mythology and art. Both the ivory carver and the stone cutter were faced with the difficult problem of portraying perspective and action, and this resulted in an awkward representation of the animals climbing from behind.

The present relief was found during excavations at Beth Shean in a bay of one of three defense towers of the "level of Thothmes III." As it was "immediately to the south of the Mekal temple," the excavator assumed that the orthostat was originally placed in a doorway in the inner sanctuary of the temple. A date in the fourteenth century B.C. is plausible for this beautiful relief orthostat.

REFERENCES: *A. Rowe, *The Topography and History of Beth-Shan*, Philadelphia, 1930, pp. 15–16, frontispiece; H. J. Kantor, The Shoulder Ornament of Near Eastern Lions, *Journal of Near Eastern Studies* 2 (1947), pp. 250–74; R. D. Barnett, Ancient Ivories in the Middle East, *Qedem* 14 (1982), especially pl. 30a.

IVORIES FROM LACHISH
Cat. nos. 45–49

14th–13th century B.C.
Excavations of the Wellcome-Marston
Expedition

In the latter half of the second millennium B.C. Lachish was the capital of a Canaanite city-state in the southern hill country (fig. 44). Three letters written by the king of Lachish to his suzerain are preserved in the royal archives at Amarna, and the city is also referred to in several letters of neighboring rulers. The destruction of the Canaanite Lachish is mentioned in Joshua 10, where the conquest of the city by the Israelite tribes and the death of its king are recorded.

In preparation for the excavations at Tell Lachish (Tell ed-Duweir), an area in the northwest corner on the lower slopes of the mound was cleaned and excavated so that it could later serve as a dump site. In the course of the clearance a temple was discovered in the fill of the Middle Bronze Age defensive fosse, or ditch, that surrounded the city. Because of its location it became known in the literature as the "Fosse Temple."

Three consecutive building phases of the temple were noted. The earliest and smallest was from the fifteenth century, and the latest and largest from the thirteenth. The Fosse Temple was destroyed by fire and its site was never reoccupied. It is commonly accepted that this

destruction was caused by the advancing Israelite tribes. No statue of any deity was found in the excavations, and therefore it is not known to whom this Canaanite temple was dedicated. But it has been noted that the name "Elat" (the goddess) appears in a Proto-Canaanite inscription on a ewer which was found discarded in a pit outside the temple; the temple deity may therefore have been one of the major Canaanite goddesses.

The numerous finds shed light on the cult. In every room and in a pit outside, an astonishing profusion of pottery came to light. On the platform of the shrine were found precious offerings made of ivory and alabaster, faience and glass, as well as jewelry, scarabs, and seals. Egyptian stylistic influences and imports predominate. Among the precious objects found in the temple were the Lachish ivories. Given their findspot, they should be dated to the thirteenth century B.C. But it is probable that they are older than that and were preserved and cherished by the priests, who transferred them from an earlier structure as part of the original equipment of the shrine.

There are two likely sources for ivory as a raw material, Egypt being the principal and earliest supplier. Syria, however, must also be considered as a source in the second millennium. A general of Tuthmosis III (1504–1450 B.C.), the great conqueror of Syria and Canaan, reported that in the land of Niy in north Syria he "hunted one hundred and twenty elephants for the sake of their tusks." In the palace of Yarim-Lim, king of Alalakh (eighteenth century B.C.), a store of tusks was found in situ. Some of these were used in local workshops; others must have been exported or given as gifts by the kings of Alalakh. Syrian tributaries are depicted bringing ivory to the pharaohs in the Theban tombs of the Eighteenth Dynasty (1504–1310 B.C.), and ivories from Phoenicia and Syria were sought by the kings of Assyria in the first millennium.

Ivory cutting is among the finest achievements of Canaanite art, and the Lachish ivories are to be listed among the outstanding assem-

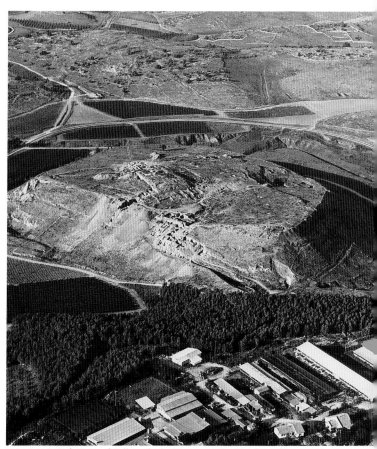

FIG. 44. Aerial view of Tell Lachish. Photograph: Abraham Hay.

blages uncovered in excavations of major Canaanite cities such as Hazor and Laish (Dan). Recently found and published is a group of ivories from a palace at Kamid el-Loz (ancient Kumidi in southern Lebanon) which are typologically very close to those from Lachish despite local variations. It is likely that several workshops of ivory cutters were active in Canaan and that each court employed its own expert craftsmen.

There is little doubt that these small pieces were made by a single artist or at least in the same workshop. One can easily forget that these objects served as finials and inlays of artifacts now lost. They possess a monumentality and sculptural quality that belie their diminutive size.

REFERENCES: *O. Tufnell et al., *Lachish II: The Fosse Temple*, London, 1940; R. D. Barnett, *The Nimrud Ivories*, London, 1957, pp. 91, 94; R. Echt, in *Frühe Phöniker im Libanon, 20 Jahre deutsche Ausgrabungen in Kāmid el-Lōz*, Mainz, 1983, pp. 79–94.

45. Human Head

Ivory; height 5.4 cm. (2⅛ in.)
IDAM 34.7705

This head was used as an inlay. It has a flat, slightly concave back, which seems to have been intentionally incised. The face is beautifully modeled, and all the details are well executed. The receding forehead, large eyes, well-shaped nose with marked nostrils, and faintly smiling lips give the oval face expression, despite the lack of hair and ears. The pupils may have been painted. The ivory is blackened by fire.

REFERENCE: *O. Tufnell et al., *Lachish II: The Fosse Temple*, London, 1940, pp. 59–60, pl. XVI:2.

46. Two Gazelle Heads

Ivory; IDAM 34.7702, height 5 cm. (2 in.); IDAM 34.7703, height 3.7 cm. (1½ in.)

These two heads, set on long, slightly inclined necks and sculpted in the round, were originally used as fin-ials or handles, which were fastened by means of circular mortises. Both have circular cavities for attaching the ears and horns, which were separately made. In each head a broken-off tenon in one of the ear holes is all that remains of those missing parts. The carefully modeled eyes are large and wide open. The larger gazelle has its mouth open; the tongue shows and the nostrils are flared, as if panting. Both heads are blackened by fire.

REFERENCE: *O. Tufnell et al., *Lachish II: The Fosse Temple*, London, 1940, pp. 59, 61, pl. XVII:13, 14.

47. Duck Head

Ivory; length 6 cm. (2⅜ in.)
IDAM 34.7704

This very naturalistic duck has a long and sensitively modeled bill. The round eyes with central dot were undoubtedly made by a compass. There is a circular mortise in the base of the short neck. It was the fashion to use such duck heads as handles of cosmetic

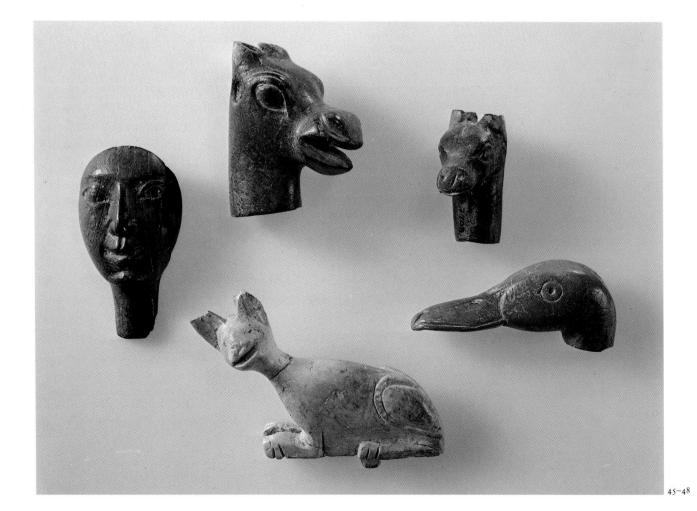

containers, and numerous examples have been found at almost every major site as far north as Ugarit (for an example of an ivory animal-head stopper from Lachish, see cat. no. 80). Therefore, there is little doubt that this head was used in a similar manner. The ivory is blackened by fire.

REFERENCES: *O. Tufnell et al., *Lachish II: The Fosse Temple*, London, 1940, pp. 59, 61, pl. XVII: 10; L. Woolley, *Alalakh*, London, 1955, p. 289, pl. CXX.

48. Cat

Ivory; length 7.4 cm. (2⅞ in.)
IDAM 34.7734

Sculpted in the round, this animal has a flat base with a tenon to attach it to some other object. The cat crouches attentively, as if watching or listening; its mouth is open, the head raised sideways, and the un-usually large ears pricked. The tail encircles the hindleg; the paws are schematically rendered. This figurine, found in a side room, escaped the fire, and therefore the ivory still retains its natural color.

REFERENCE: *O. Tufnell et al., *Lachish II: The Fosse Temple*, London, 1940, pp. 32, 61, pl. XVII:9.

49. Unguent Flask

Ivory; height 24.5 cm. (9⅝ in.)
IDAM 34.7699

The most outstanding of the Lachish ivories is this elegant flask in the shape of a woman wearing a long dress. The upper part is narrow and tubular with two looplike handles. The head and the neck, separately fitted, are surmounted by a spoon stopper in the form of a hand (also a separate attachment). A tube connects the body of the flask with the spoon. When the flask was tilted, a few drops of the perfume would pour into the spoon; after use, the remainder of the precious liquid would flow back into the flask without waste. The base of the flask, now missing, must have been in the form of a flat disk, separately fitted.

The head is worked in detail. The short but elaborate wig, large eyes, and well-formed nose, lips, and chin are all in accord with contemporaneous stylistic traditions. The skirt is ornamented with rows of palmettes, each with a now-missing inlaid center; it is

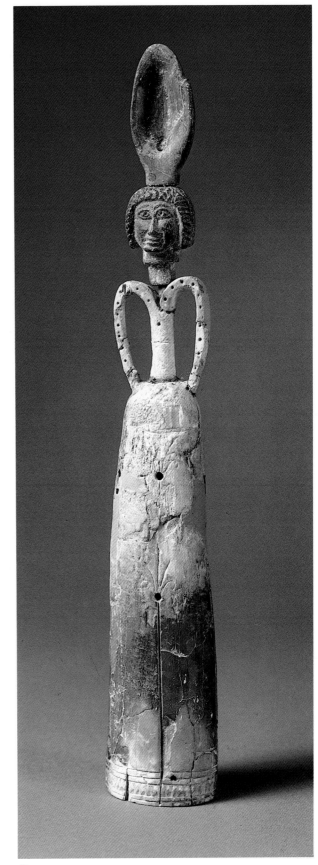

49

bordered by a zigzag pattern and horizontal lines at the bottom. The outer sides of the arms are also decorated with a zigzag pattern, while the front and back are punctured (perhaps for inlay).

This flask, found in the shrine, was blackened in the conflagration that marked the final destruction of the temple.

This perfume flask is a beautiful example of such objects, which are known from Egyptian representations, mostly as tribute from Canaan. Separate pieces, such as spoons or heads, are occasionally found in excavations, but this flask is unique in its elaborate masterly design and in its completeness.

REFERENCES: *O. Tufnell et al., *Lachish II: The Fosse Temple*, London, 1940, pp. 59–60, pl. XV; Y. Yadin et al., *Hazor III–IV*, Jerusalem, 1961, pls. CCXL:10, CCCXXIII:1–3.

50. Plaque of a Canaanite Goddess

Lachish
13th century B.C.
Gold; 20.4 × 11.2 cm. (8 × 4⅜ in.)
Excavations of the Institute of Archaeology,
Tel Aviv University, and the Israel Exploration
Society
IDAM 78–1

This plaque, portraying a goddess standing on a horse, was uncovered in a Canaanite temple that was partially exposed on the summit of Tell Lachish during the second series of excavations at the site. The temple was found in a very poor state of preservation: it was destroyed by fire and was plundered and looted both

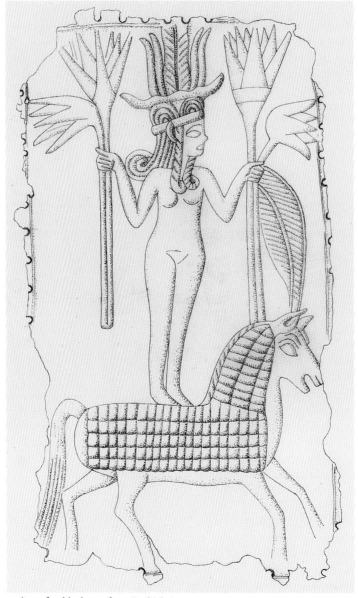

FIG. 45. Decoration of gold plaque from Lachish (*opposite*). Drawing: Israel Museum/ Florica Vainer.

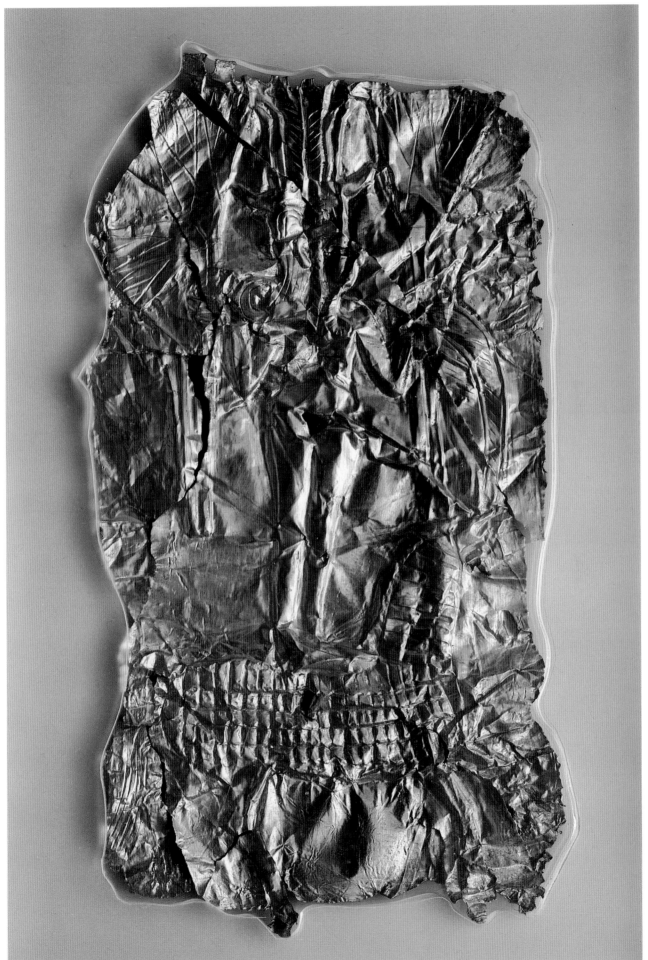

before and after its destruction, so that few of its original furnishings were recovered.

Built of brick laid upon stone foundations, the temple consisted of an antechamber, a main hall, and a cella. The hall was rectangular (16.5 × 13.5 meters [18 × 15 yards]) with a brick-paved floor, and the walls were decorated with painted plaster; the roof was laid on cedar beams. Two columns in the center of the hall supported the roof, and three ornamental columns stood along the hall's eastern wall. A wide doorway led from the hall to an adjacent area. There, crumpled and torn into five pieces and subsequently sealed by destruction debris, the present gold plaque was found.

The body of the nude goddess is depicted in a frontal position, while her head and feet are shown in profile, turned in the direction of the horse's head (fig. 45). She has an elaborate coiffure held by a fillet placed low on her forehead. Two locks of hair frame the face, ending in Hathor curls. She wears a huge crown of horns and ostrich feathers. In each of her raised hands she holds two stalks of lotus flowers, one upright and one drooping. The crown and the lotuses form a lively frame at the top of the plaque.

The horse's head is adorned with tall plumes, and its body is covered by a crisscross pattern, representing an ornate blanket.

This plaque was a decorative element attached to a wood, leather, or cloth surface by means of the perforations along its edges. The design is executed in repoussé and engraving. The goddess's eye and pubic triangle and the horse's eye are pierced, possibly for an inlay.

Although strong Egyptian stylistic influence is evident in the crown, the lotus flowers, and the Hathor curls, this is a product of a Canaanite master. He was intimately acquainted with Egyptian art and borrowed from it freely and heavily; his style, however, is unmistakably Canaanite.

Determining the identity of the goddess poses a difficult problem. The nude female figure is of paramount importance in Canaanite representational art; horned crowns, lotus flowers, Hathor curls, and accompanying animals were all divine attributes. Therefore there is no doubt that the figure represented here is indeed divine, most probably one of the major Canaanite goddesses. An identification with Astarte–Ashtoreth, who was often associated with horses, is a likely possibility but must remain tentative. In the Late Bronze Age, Canaanite representational art became highly conventionalized, consistently using a few stereotypes and symbols. This, as well as the lack of inscriptions, precludes any definite identification.

REFERENCES: *D. Ussishkin, Excavations at Tel Lachish— 1973–1977, Preliminary Report, Tel Aviv 5 (1978), p. 21; C. Clamer, A Gold Plaque from Tel Lachish, Tel Aviv 7 (1980), pp. 152–62.

51. Fish

Tell el-Ajjul
Mid-second millennium B.C.
Alabaster; length 15 cm. (5⅞ in.)
Excavations of the British School of
Archaeology in Egypt
IDAM 47.286

This fish-shaped vessel is typologically identical with the pottery fish from Tell Poleg (cat. no. 37). Its capacity is even smaller than that of the pottery fish, and therefore it is even more likely that it was an ornamental vessel or a drinking cup, not meant for storing liquid.

The material is admirably chosen for representing a fish. The semitranslucent alabaster with its parallel, irregular veins evokes the silvery skin of a fish moving through rippling waves. The outline of the body is delineated by incision, as are such anatomical details as the lateral fins, gill, and eye. The open lips form a rim, indented at the corners. A narrow concave base allows the fish to balance on its belly.

Alabaster, a fairly soft and decorative stone, was a favored material for the production of luxury vases. In Egypt alabaster vessels were made as early as the Predynastic Age; somewhat later, in the third millennium, they began to be imported from Egypt into Canaan. During the second millennium the number and variety of imported vessels grew considerably, and Canaanite stone carvers also started to produce vessels from local alabaster, first imitating Egyptian models and later producing their own variations.

The main deposits of local alabaster are found in the Jordan Valley in the vicinity of Beth Shean. It differs from the Egyptian alabaster in composition, being calcium sulfate and not calcium carbonate. It is also softer than the Egyptian stone and is white or light gray rather than yellowish.

A different technique can also be seen in Canaanite alabaster vessels. For hollowing the vessel, the Canaanite stone carver preferred to use a chisel rather than a stone borer or a tubular drill. Therefore vertical chisel marks often remain inside the vessel, serving as an additional criterion for recognizing local wares.

The present fish is unmistakably Egyptian, both in the quality of the stone and in its workmanship. It was found in a large tomb with numerous offerings of pottery, scarabs, and bronze artifacts. Its occurrence at Tell el-Ajjul is not surprising, as this southern Canaanite city, situated close to Egypt, was rich in Egyptian luxury products.

REFERENCES: *W. M. F. Petrie, Ancient Gaza IV, London, 1934, pl. XXXIX:86; I. Ben-Dor, Palestinian Alabaster Vases, The Quarterly of the Department of Antiquities in Palestine II (1945), pp. 93–112; M. Tadmor, in Highlights of Archaeology: The Israel Museum, Jerusalem, 1984, pp. 44–45.

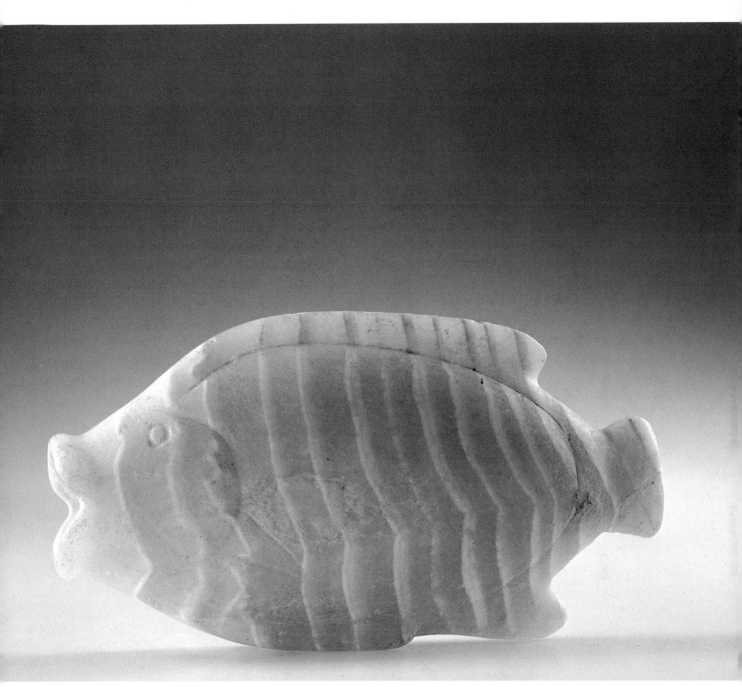

51

JEWELRY FROM TELL EL-AJJUL

Cat. nos. 52–61

Mid-2nd millennium B.C.
Excavations of the British School of Archaeology in Egypt

The finds of gold and silver jewelry from the major Canaanite cities are many, but none can compare with that from Tell el-Ajjul. This important city, roughly twice the size of Megiddo, produced the finest Canaanite jewelry thus far known. Unmatched in quality and quantity, this collection remains an aesthetic and technological marvel.

Part of the jewelry came from the town and part from the tombs. The majority—and the most important in quality—came from domestic hoards, some of which may have been long-treasured heirlooms hidden away for safekeeping. Several hoards also contained scrap gold and silver as well as discarded or broken pieces of jewelry. These may well have belonged to merchants or jewelers who hoped to remelt the precious metals.

Hoards are always difficult to date. The Tell el-Ajjul jewelry poses additional problems since, as is often the case with early excavations, the stratigraphic data are insufficient and often perplexing. Indeed, much has been written on the stratigraphy of Tell el-Ajjul, amending the dates suggested by Sir Flinders Petrie, the excavator of the site. For our purpose, it will suffice to date the jewelry finds roughly to the mid-second millennium. The tradition of fine craftsmanship of both Middle and Late Canaanite periods finds a most accomplished expression here.

The jewelry was made from sheet-gold and wire as well as by casting. The techniques used include engraving and repoussé, granulation and filigree, and inlays and cloisonnés of multicolored glass or paste. Semiprecious stones were also used. The techniques are sophisticated, testifying to a tradition of skilled workmanship.

Issues of origins and sources of influence have frequently been raised. Canaanite jewelers borrowed techniques and motifs from neighboring regions. The influence of Egyptian goldwork is clear, and a number of imports, indisputably from Egypt, served as models for local products. Some dependence on Byblos has been suggested, as well as Mesopotamian and Hurrian influences, the latter in connection with the influx of Hurrian populations into Canaan. However, although Canaanite jewelers in the second millennium were receptive to various influences, they nonetheless created an independent and distinctive style. Some Canaanite jewelry has no counterparts in either Egypt or Cyprus; other styles appeared first in Canaan before reaching Egypt, so the sharing was not one-sided.

Jewelers' hoards and molds for making jewelry are frequent finds in the excavations of many sites, and it is reasonable to assume that there were numerous local workshops. Trade and exchange of gifts between rulers contributed to the dissemination of styles over wide areas. This would explain the striking similarity between the jewelry from Tell el-Ajjul and that from Ebla, Megiddo, Beth Shean, and Lachish. The jewelers of Tell el-Ajjul were leaders in their craft, and the local princes and nobility must have been discriminating customers.

REFERENCES: F. Petrie, *Ancient Gaza IV*, London, 1934, pp. 5–8, pls. XIII–XX; O. Negbi, *The Hoards of Goldwork from Tell el-Ajjul*, Studies in Mediterranean Archaeology 25, Göteborg, 1970; K. R. Maxwell-Hyslop, *Western Asiatic Jewellery c. 3000–612 B.C.*, London, 1971, pp. 102–57; J. R. Stewart, *Tell el-Ajjūl: The Middle Bronze Age Remains*, H. E. Kassis (ed.), in Studies in Mediterranean Archaeology 38, Göteborg, 1974.

52. Hathor Pendant

Gold or electrum; 9.8 × 6 cm. (3⅞ × 2⅜ in.)
IDAM 35.3842

This and the following two pieces (cat. nos. 53 and 54) were part of a large hoard (no. 1299) hidden in a broken pot which contained a collection of intact and broken jewelry. Unlike other pendants in the hoard, this large plaque has remained intact. The face of the goddess Hathor is sculptured in delicate relief, and the forehead ends in a straight line, as if representing a mask. In Petrie's words (1934, p. 6): "The face is carefully worked, with a curiously impassive expression, remote from human feeling. If we can credit such intention of the artist, the idea might be the impartial rule of reproductive Nature."

The pubic triangle is depicted in a geometric manner. The stiff plaque of pale, heavy sheet-gold or electrum is bordered by a single line of dots. The loop, made of the same piece of gold, was worked in detail and folded over. The design was executed by punching over a template and engraving from the back.

52–55

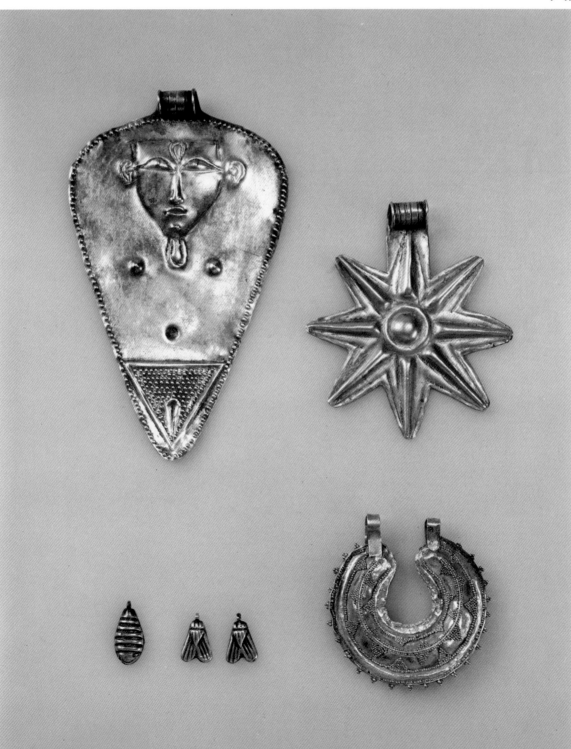

53. Star Pendant

Gold or electrum; width 6.2 cm. (2½ in.)
IDAM 35.3846

Like the Hathor pendant (cat. no. 52), this large pendant is made of pale, heavy sheet-gold or electrum. The shape is cut out and bordered by an incised line. The rays and the circular center of the eight-pointed star are embossed. The rolled-over loop is very similar to the loop of the Hathor pendant, as if made by the same hand.

54. Earring

Gold; height 4.5 cm. (1¾ in.)
IDAM 35.3847

This is one of a pair of very large earrings made of warm, lustrous sheet-gold. Petrie (1934, p. 6) describes the earring in detail: "The plate of each side was swaged into a raised ridge, and the grains piled in position on the slopes. The junctions were all sweated together, and no trace of free solder could be found, all fine interstices were unjoined except by surface contacts. The loops for suspension were not soldered."

The minute, extremely fine granules are clustered in triangles and straight lines that border the design. On the edge freestanding interspaced granules are clustered in groups of three.

55. Fly Amulets

Gold
Flies: IDAM 35.3906, 35.3907, length of each 1.2 cm. (½ in.)
Larva: IDAM 35.3908, length 1.6 cm. (⅝ in.)

These works are three of a group of five amulets (originally the group consisted of four fly amulets and one in the form of a larva). Petrie (1934, p. 7) remarks that these are probably Canaanite in origin, as the comparable Egyptian amulets are "narrower in the wing and not striated." Here the bodies are modeled in relief, and the wings are shown separated. The amulets are made of especially thick sheet-gold.

Small gold flies not unlike these were often distributed to Egyptian soldiers for acts of exceptional valor. It is not, however, known what purpose these amulets served.

56. Four Armlets

Gold; IDAM 32.1805, diameter 7.9 cm. (3⅛ in.); IDAM 32.1806, diameter 7.9 cm. (3⅛ in.); IDAM 32.1807, diameter 8.1 cm. (3¼ in.); IDAM 32.1808, diameter 8.4 cm. (3⅜ in.)

These armlets are four of the ten, belonging to two sets, that were found in the "Cenotaph" tomb that contained a group of gold objects but no bones. The tips of the armlets are decorated with delicately incised lines and oblique strokes to convey some visual interest. The armlets also bear faint notches—from one to five cuts—adjacent to the decorated terminals. One of the armlets has no notching and may form part of a set now in University College, London.

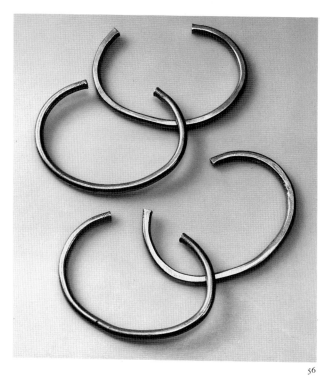

56

57. Ring

Gold; width 2.8 cm. (1⅛ in.)
IDAM 32.1810

This ring was made of heavy gold in one piece. The design enclosed in an oval incised frame shows two jackals heraldically arranged, their bodies facing outward and their heads looking backward toward the center. The body and hindlegs of each animal are indicated by a single curving line; the forelegs are separately delineated. Between the animals is a column with a sketchily rendered Hathor capital.

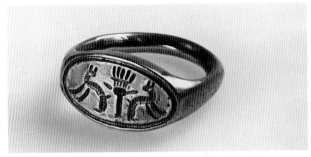

57

58. Pendant

Gold; diameter 3.3 cm. (1¼ in.)
IDAM 35.3910

This pendant (or part of an earring) and five amulets
(cat. no. 55) were found in a house together with a
bracelet fragment (hoard 1313, termed by Petrie the
"group of a trader"). It is a complete circle, consisting
of "two bossed-up plates attached at the edges. Edges
covered by two counter-twisted square wires joined
by sweating; inner edges covered with a V-shaped
strip, sweated on at ends. After this, the grains were
attached by piling and sweating, no solder, and the
hoops sweated on" (Petrie, 1934, p. 7).

59. Pendant

Gold; diameter 3.8 cm. (1½ in.)
IDAM 35.4239

In design this is a star pendant, but it is embossed on a
disk rather than cut out. It was found in the town.

60. Falcon Pendant

Gold; 4.5 × 4 cm. (1¾ × 1⅝ in.)
IDAM 38.535

Three pendants of this very unusual shape were found
at Tell el-Ajjul. No comparable designs are known in
Egypt or elsewhere in the Near East.

The present pendant is made of sheet-gold. The
intricate design of a bird with outspread wings bent to
form the circular outline is made of wire and granula-
tion in a pattern of clusters and triangles. The back was
left undecorated.

58–61

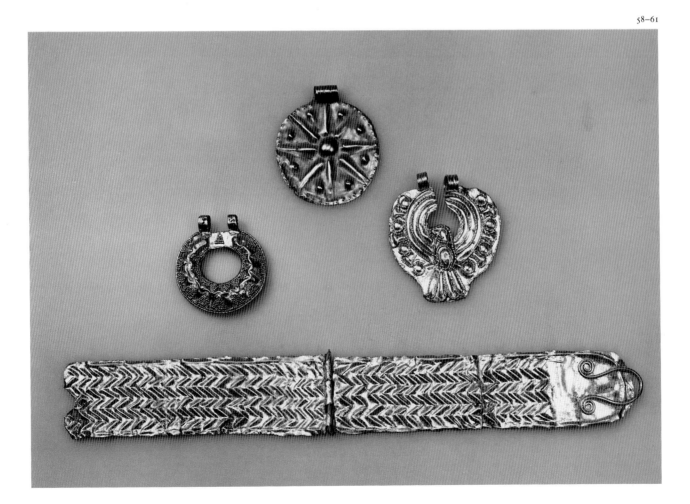

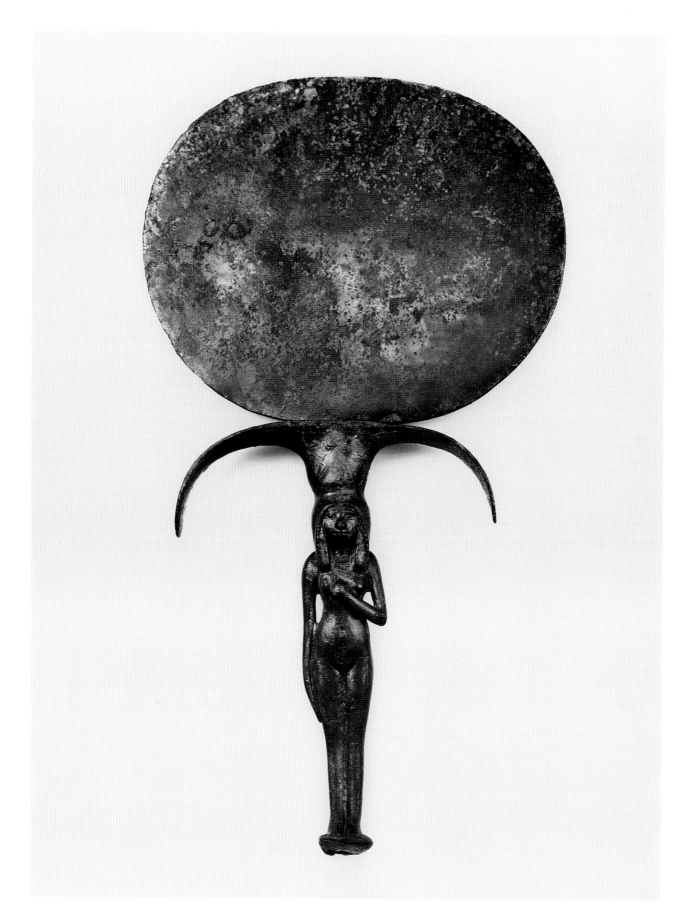

61. Band

Gold; length 20.7 cm. (8⅛ in.)
IDAM 35.3800

These two sections of a band or diadem were found in a tomb together with a toggle pin, gold earrings, silver, rock crystal, and onyx beads, and a few pottery and alabaster jars. Made of bright sheet-gold, the sections are connected by a gold pin. The loop is of heavy wire with coiled ends. The design is continuous, composed of vertically arranged triple zigzag lines.

62. Mirror

Akko
14th century B.C.
Bronze; height of disk 12 cm. (4¾ in.), length of handle 14 cm. (5½ in.)
Excavations of the Israel Department of Antiquities and Museums
IDAM 71–956

This mirror was unearthed in the excavation of several tombs at Akko. The rich grave goods from these tombs include local, Mycenaean, and Cypriot vessels, gold and silver jewelry, cylinder seals, and bronze weapons.

Bronze mirrors like this one must have been popular with Egyptians and Canaanites throughout the second millennium; many of them, preserved together with other funerary offerings, have been found in excavations. The shape of this mirror is typical of the fourteenth–thirteenth century B.C. The handle is in the form of a caryatid bearing on her head a spreading papyrus umbel which supports the slightly elliptical mirror-disk. The maiden stands on a small base with her right foot slightly forward. Her right hand hangs at her side while her left hand supports her breasts.

The mirror and the handle were cast separately. The disk ends in a short tang, which was inserted into a small cavity in the column and secured by a pin; the poor fit was corrected by an additional bronze wedge. Thermal neutron radiography has shown that the handle was cast pointing down at an angle and that the quality of casting is not very good. Both sides of the mirror are convex and therefore would have reflected distorted images.

REFERENCES: *S. Ben-Arieh and G. Edelstein, Akko Tombs near the Persian Garden, *'Atiqot*, English series 12 (1977), p. 29, fig. 15, pl. v; D. Kedem, Non-destructive Analysis of Bronze Objects, *'Atiqot*, English series 12 (1977), pp. 84–85.

63. Pendant

Beth Shean
14th century B.C.
Gold; 4.7 × 2 cm. (1⅞ × ¾ in.)
Excavations of the University Museum, University of Pennsylvania
IDAM J.3810

This pendant is one of the finest examples of Canaanite jewelry. Its elongated shape, which has a rolled-over flat loop, is cut out of pale sheet-gold (or electrum). The border is emphasized by an incised line.

The form of the slender nude figure was incised with a sharp point. She stands on a short groundline, with her head and feet in profile facing right and her body in three-quarter profile. Her long wig falls down her back. Her right arm is raised in blessing, while her left holds a *was* scepter, the symbol of dominion.

This figure is reminiscent of the graceful elongated maidens so frequently depicted in Egyptian art. And indeed, the style of this piece is Egyptian, although the nudity, as well as the freedom of movement expressed in the sketchy but flowing lines, is unusual in Egyptian

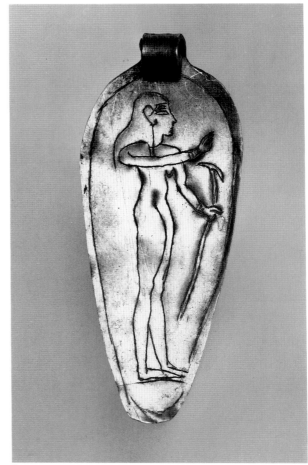

63

representations. Therefore, this pendant appears to be a local work, made by a skilled Canaanite artist who was familiar with contemporaneous Egyptian art.

REFERENCE: *A. Rowe, *The Four Canaanite Temples of Beth-Shean I*, Philadelphia, 1940, pl. LXVIII: 5.

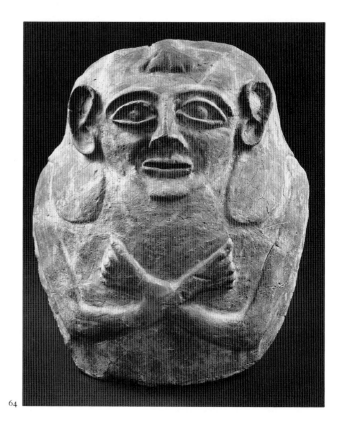

64

64. Anthropoid Sarcophagus and Lids

Deir el-Balah
14th–13th century B.C.
Pottery
Sarcophagus: ASOG 03006 (body) and ASOG 03003 (lid), length 191 cm. (75¼ in.)
Lid: IMJ 71.10.211, length 72.5 cm. (28½ in.)
Excavations of the Institute of Archaeology, the Hebrew University, Jerusalem, and the Israel Exploration Society

A man and a woman were buried in this large pottery coffin with a modeled lid (fig. 46). The man was placed in the coffin first, followed by the woman. The rich offerings placed on top of the bodies included gold and carnelian jewelry, a set of bronze dishes and artifacts, rings, scarabs and amulets, an alabaster cosmetic dish, and pottery vessels. The loosely fitting sculptured lid was then set in place. Two pottery bowls and two large pottery jars completed the finds of Tomb 118 in the cemetery at Deir el-Balah (fig. 47).

This sarcophagus (and its lid) and a separate lid are part of a remarkable and large collection of Deir el-Balah sarcophagi, now at the Israel Museum. Some are life-size, others even larger. They are cylindrical in shape with little attempt to depict body details; only the feet are sometimes indicated.

All the sarcophagi have a large opening in the upper part, on which the lids were fitted. On these lids faces, wigs, arms, and hands are depicted in relief and

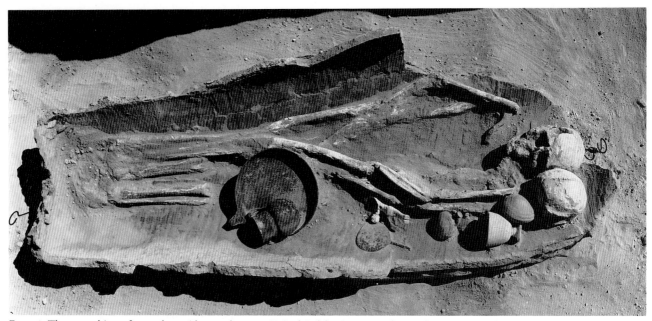

FIG. 46. The unearthing of an anthropoid sarcophagus at Deir el-Balah. Contents of sarcophagus: two skeletons and offerings. Photograph: Institute of Archaeology, Hebrew University, Jerusalem, and Israel Exploration Society/Zeev Radovan.

64

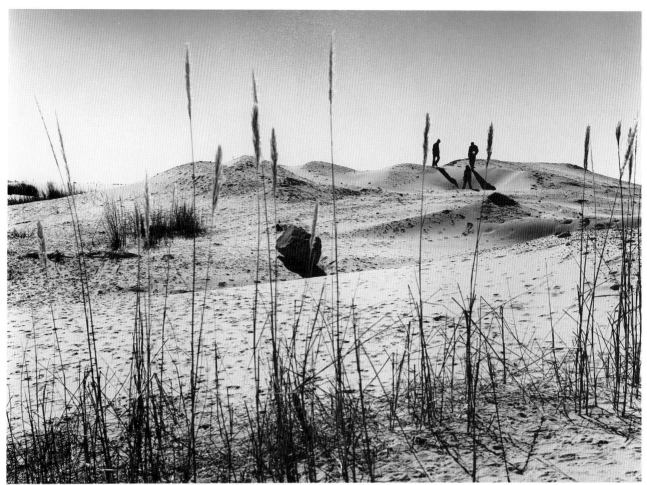

FIG. 47. View of Deir el-Balah before excavation. Photograph: Institute of Archaeology, Hebrew University, Jerusalem, and Israel Exploration Society/Zeev Radovan.

appliqué and by incision. In the majority the heads are clearly delineated; in most cases they were separately molded and applied to the surface. The relief may be high—almost like sculpture in the round—and dramatized, as in the separate lid. Sometimes the relief is low, as in the lid of the complete sarcophagus. In a few cases the facial details were applied to the surface by means of clay pellets, while other details were incised or indented. Sometimes paint was also used.

These large cumbersome coffins were locally made. They were built up of clay coils, roughly smoothed and then fired in an open fire at a low temperature. A kiln discovered in the excavation of an industrial quarter of the nearby town still contained parts of such a sarcophagus, and a clay nose, belonging to a coffin lid, was found nearby.

The custom of burying the dead in anthropoid sarcophagi originated in Egypt. In Canaan this custom is attested at Beth Shean, Lachish, and Tell el-Fara (South). The shape of these pottery sarcophagi resembles that of Egyptian mummy-coffins, which in the New Kingdom were usually made of wood, cartonnage (molded linen and plaster), or stone (for royal burials). Egyptian influence can also be seen in the wigs and the head ornaments, such as lotus flowers, and in the frequent appearance of Osiris beards.

Who was buried in these anthropoid sarcophagi? Recent excavations have shed some light on this difficult question. A residence and a fort uncovered in the vicinity of the cemetery were built in the Egyptian style known from Akhetaten–Amarna: a similar fort is depicted in a relief of Seti I in the great Hypostyle Hall in the Temple of Amun at Karnak. Egyptian influence is also prominent in burial stelae and in scarabs, jewelry, and pottery and alabaster vessels. It seems reasonable to conclude that Egyptian settlers from the nearby town—an Egyptian stronghold—were buried in the anthropoid sarcophagi at Deir el-Balah.

REFERENCES: *T. Dothan, Excavations at the Cemetery of Deir el-Balah, *Qedem* 10 (1979), pp. 46ff.; T. Dothan, *The Philistines and Their Material Culture*, Westford, 1982, pp. 252–88; M. Tadmor, in *Highlights of Archaeology: The Israel Museum*, Jerusalem, 1984, pp. 52–53; T. Dothan, Deir el-Balah: The Final Campaign, *National Geographic Research* 1 (winter 1985), pp. 32–43.

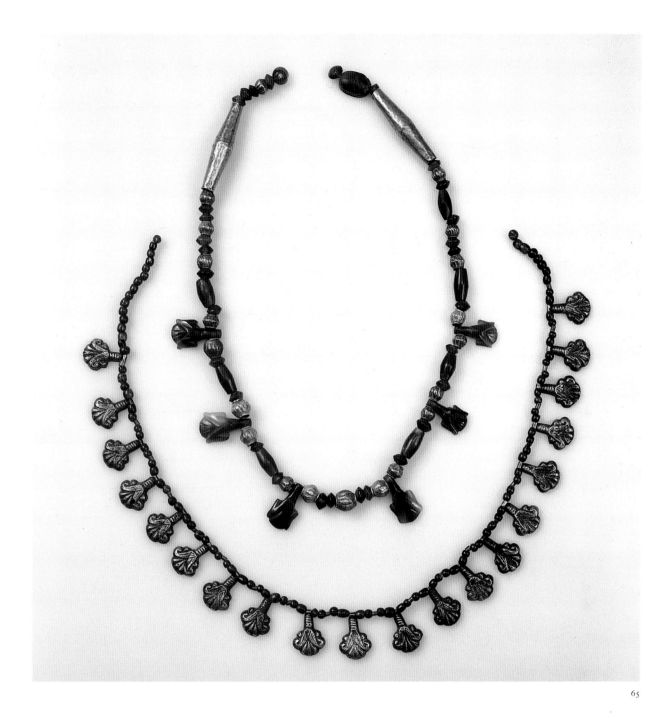

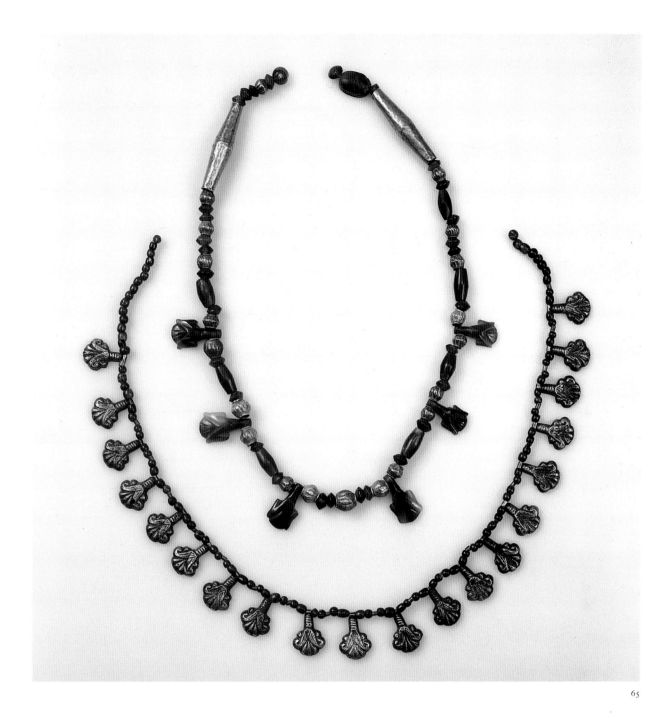

65

65. Two Necklaces

Deir el-Balah
14th–13th century B.C.
Gold, carnelian; ASOG 03023, length 43 cm.
(16⅞ in.); ASOG 03025, length 44 cm. (17⅜ in.)
Excavations of the Institute of Archaeology, the
Hebrew University, Jerusalem, and the Israel
Exploration Society

Among the rich offerings deposited with the dead in
Tomb 118 (see cat. no. 64) were these very fine neck-
laces of gold and carnelian beads. Both were restrung
by the excavators according to the position in which
the elements were found.

One necklace (03023) consists of twenty gold pal-
mettes, spaced between small tubular gold beads and
elongated carnelian beads. The palmettes are made of
gold foil, with flat plain backs separately cut out and
soldered on. The loop, made in one piece with the
back, is rolled over. There are traces of red and black
paint which covered the palmettes. The second neck-
lace (03025) has six stylized carnelian palmettes set
between barrel-shaped fluted gold beads and small bi-

conical carnelian beads. There are also two long biconical gold beads and a plain carnelian scarab.

The necklaces, like numerous other jewels deposited in the anthropoid sarcophagi, are typical in being either Egyptian products or strongly Egyptianizing in style. They belong to that class of objects which, widely diffused in Egypt and Israel as well as in Lebanon, Syria, and Cyprus, testifies to the excellent workmanship, wealth, and international contacts prevailing in the period.

REFERENCE: *T. Dothan, Excavations at the Cemetery of Deir el-Balah, *Qedem* 10 (1979), pp. 77–81.

66. Female Statuette

Deir el-Balah(?)
13th century B.C.
Stone; 17 × 6 cm. (6¾ × 2⅜ in.)
IMJ 70.113.459

This stone figurine is of a type that has only recently been attested at Canaanite sites. It is thought to have originated at Deir el-Balah because several similar figurines, in stone and pottery, have been found in the excavations of the Deir el-Balah cemetery in association with anthropoid sarcophagi (cat. no. 64).

The figure, carved in high relief in soft white stone, is depicted in a frontal position. Nude but for her necklace, the girl is slender with elongated limbs. Her eyes are closed, and a long wig falls over her shoulders. The girl's body is covered with red paint, while the wig, necklace, and pubic triangle are painted black.

The rectangular plaque, flat and disproportionately thick, curves up at one end to form a foot support for the girl. The upper surface and the footrest are painted with red and black bands, which are now almost completely faded.

This plaque belongs to a class of small Egyptian sculptures depicting people lying on beds, which were very popular in the New Kingdom. Those showing a young woman—the majority—are known as "concubine figurines." Others portray nursing women or women with children and occasionally men or couples. In some the bed is realistically depicted with four legs.

A striking feature of this class of figurines is the total absence of any divine symbolism. Their association with burials permits the assumption that they were connected with funerary customs and beliefs. The girl's rigid pose, serenity of expression, and closed eyes are appropriate elements in this context. The fact that such figurines have also been found in private dwellings points to their role as talismans or amulets for the living. Thus, they belonged to the realm of private religious and magical practices, connected both with daily life and with beliefs in afterlife.

66

A mold was found in the excavations of Deir el-Balah for the production of similar pottery figurines, and some of the stone statuettes from Deir el-Balah were also local products. The present statuette is stylistically Egyptian and may have been an import from Egypt. Alternatively, it may have been a local product, carved by a resident Egyptian sculptor.

REFERENCES: *M. Tadmor, Female Cult Figurines in Late Canaan and Early Israel: Archaeological Evidence, in *Studies in the Period of David and Solomon*, Tomoo Ishida (ed.), Tokyo, 1982, pp. 139–73; M. Tadmor, in *Highlights of Archaeology: The Israel Museum*, Jerusalem, 1984, pp. 56–57.

67. Necklace

Beth Shean
12th century B.C.
Carnelian; length 42 cm. (16½ in.)
Excavations of the University Museum,
University of Pennsylvania
IDAM 36.1700

The thirty-seven pendants and amulets that make up this necklace were found in a tomb and restrung. The superb quality of the large carnelian stones and the

67

excellent craftsmanship combine to produce a work of remarkable beauty.

The pendants are carved into various shapes: thirty-two represent lotus seeds; four are in the shape of uraei, wearing the crown of Lower Egypt; and one represents a Hathor head flanked by uraei. All these components occur frequently in New Kingdom jewelry. The flat lotus-seed pendants are also well known from contemporaneous Canaanite jewelry. Uraei and Hathor heads were incorporated in the imagery that spread from Egypt into Canaan.

Nowhere in Canaan was Egyptian presence felt more strongly than in Beth Shean. The names of Ramses II, Seti I, and Ramses III—which appear on the royal Egyptian statues and in hieroglyphic inscriptions of monumental dimensions uncovered in the excavations—bear witness to the importance that the pharaohs of the Nineteenth and Twentieth Dynasties attached to Beth Shean. This imperial stronghold and garrison guarded a most important caravan-road, the route by which the Egyptian army and envoys reached Damascus or the land of the Hittites and maintained diplomatic relations with Babylonia and Assyria. Biblical sources (Joshua 17:11; Judges 1:27) mention Beth Shean among the cities that the Israelite tribes did not conquer, and the numerous finds unearthed in excavations confirm the continuation of Late Bronze stylistic traditions and workmanship. The present carnelian necklace is a good example of this continuity.

REFERENCE: *A. Rowe, *A Catalogue of Egyptian Scarabs*, Cairo, 1936, p. 273, A27; p. 278, A48.

68. Lid of Anthropoid Sarcophagus

Beth Shean
12th–11th century B.C.
Clay; length 63.5 cm. (25 in.)
Excavations of the University Museum, University of Pennsylvania
IDAM P.1431

This lid comes from the cemetery of Beth Shean where it was unearthed, together with some fifty anthropoid sarcophagi of the same kind, in eleven burials dating from the thirteenth through the eleventh century B.C. This type of coffin is larger than life-size and held one or more bodies as well as funerary offerings.

The lids of the Beth Shean coffins are of two types: the majority are modeled naturalistically in life-size, while a few are of "grotesque" style, with exaggerated facial features. This lid belongs to the second category. It combines modeled and applied features, including almond-shaped eyes, straight eyebrows picked out by diagonal incisions, a prominent nose, upper and lower lips separated by a deep horizontal cut, a protruding chin, and large ears. The arms emerge near the top of the head and are bent at the elbows, the outstretched fingers almost meeting below the chin. Bracelets and armlets are indicated by incisions on the wrists and above the elbows. The headdress consists of a horizontal row of projecting knobs beneath two parallel bands.

Significantly, none of the Deir el-Balah coffin lids has the distinctive headgear of this lid. It has been suggested that this headgear represents that worn by the Sea Peoples as they appear on reliefs of Ramses III.

The custom of burial in anthropoid coffins was practiced at other sites in Canaan, notably Tell el-Fara and Deir el-Balah (see cat. no. 64). It originated in Egypt where it was common mainly from the New Kingdom onward. Since Beth Shean was an Egyptian stronghold during the Eighteenth to Twentieth Dynasties, it may be assumed that this custom was introduced by the Egyptian garrisons stationed there. Numerous finds from the city and its cemetery further underline the Egyptian presence in Beth Shean.

REFERENCES: R. Hestrin, *The Philistines and the Other Sea Peoples*, Israel Museum catalogue no. 68, Jerusalem, 1970, pp. 7–9, no. 31; *E. D. Oren, *The Northern Cemetery of Beth Shean*, Leiden, 1973, pp. 132–50, figs. 52:2, 79; T. Dothan, *The Philistines and Their Material Culture*, Jerusalem, 1982, pp. 252, 268–76.

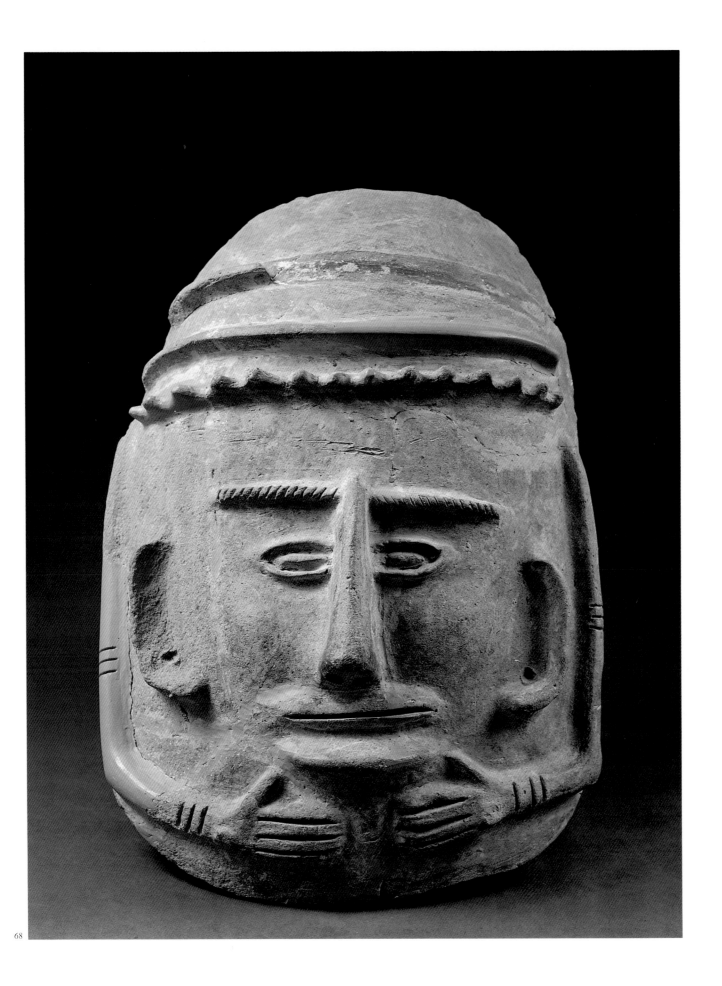

ISRAELITE PERIOD/IRON AGE

1200–586 B.C.

The Israelite period, or Iron Age, begins with the conquest of Canaan by the Israelite tribes and includes the period of the Judges, the United Monarchy, the kingdom of Israel until its conquest in 722 B.C., and the kingdom of Judah. It closes with the destruction of the First Temple in 587/586 B.C.

A dualistic terminology, analogous to that used in discussing the Canaanite periods/Bronze Ages, is helpful in presenting the period from 1200 to 586 B.C. which is accordingly called the Israelite period or the Iron Age. Both terms entail a considerable degree of generalization.

Like the term "Canaanite period," the term "Israelite period" is an ethno-cultural one, based on biblical testimony. It emphasizes the history of Israel and expresses the bond between the land and its people. It does not focus on the role of other contemporaneous peoples who in this period settled in different parts of the country. Their history is of importance only as it touches on the history of ancient Israel.

The term "Iron Age" relates to the material culture and refers to the introduction of iron in the closing centuries of the second millennium. However, the archaeological evidence shows that there was little use of iron during the twelfth and eleventh centuries B.C., when bronze continued to be the most commonly used metal. Indeed, iron artifacts are found widely in Israel only from the tenth century B.C. onward, and the assumption concerning the earlier use of iron is based principally on the biblical passage hinting at a Philistine iron monopoly in the time of Saul: "No smith was to be found in all the land of Israel; for the Philistines were afraid that the Hebrews would make swords or spears. So all the Israelites had to go down to the Philistines

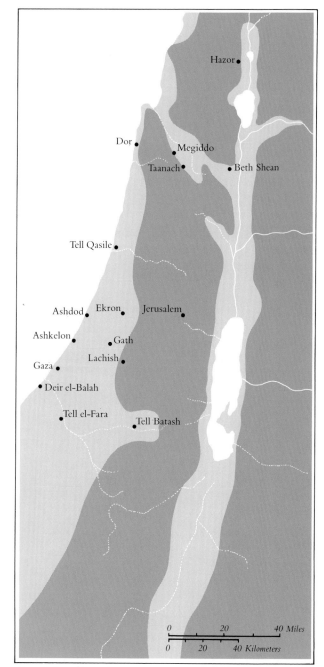

FIG. 48. Israelite I sites.

136

to have their plowshares, their mattocks, axes, and colters sharpened" (1 Samuel 13:19–20).

Although this nomenclature has obvious shortcomings, both terms have become so accepted through long use that they have been retained in this catalogue.

The date chosen as the starting point of the period—1200 B.C.—is not an exact one. It is clear from the archaeological evidence that the decline of the Canaanite culture and the appearance of the Israelites in the country were not discrete historical events but were rather a historical process that lasted for roughly two hundred years. In contrast, 587/586 B.C., the date of the destruction of the First Temple and the end of the period, was a catastrophic turning point in the history of the Israelites and of the land of Israel. Evidence of the destruction has been revealed by excavations, and the echo of its impact reverberates in the words of the biblical narrator and the prophets, as well as in the lamentations of the exiles.

On the basis both of archaeological evidence and of historical reconstruction, which leans on the biblical account, it is customary to divide the span from 1200 to 586 B.C. into two principal periods: 1200–1000 B.C. (the period of the Conquest and the Judges) and 1000–586 B.C. (the period of the Monarchy), with further divisions into subperiods.

THE ISRAELITE PERIOD I/IRON AGE I
1200–1000 B.C.

Toward the end of the second millennium B.C., far-reaching changes were occurring in the relative positions of the major powers of the Near East. The collapse of the mighty empires—Egypt, Babylonia, Assyria, Mitanni, and the Hittite empire—and the advent of the Sea Peoples, the Israelites, and the Aramaeans mark the beginning of a new period.

The Sea Peoples, among whom were the Philistines, spread along the coast from Anatolia and farther south, ravaging the land and arriving at the gates of Egypt, whose long domination of Canaan had declined (fig. 49). Many flourishing cities, such as Ugarit and Hazor, were destroyed at this time. In Canaan, Egypt's weakness and the continual internecine struggles of the local rulers allowed various ethnic groups to gain a foothold, among them some of the Sea Peoples who settled in the coastal plain and established sovereignty there. At the same time the Israelite tribes settled in the hill country farther inland, and the kingdoms of Edom, Moab, and Ammon emerged in Transjordan. In the north the Aramaeans, who would later try to impose their rule over the region, were beginning to expand, and in the northern coastal strip the Phoenician cities were growing in importance.

The biblical books of Joshua, Judges, and 1 Samuel (chapters 1–7) contain references to this formative period, summarizing a process of national consolidation by the tribes. Most important among the scant extrabiblical epigraphic evidence available is the Israel Stela from the reign of the Pharaoh Merneptah (1236–1223 B.C.), which for the first time mentions Israel as an ethnic entity in Canaan.

At first, Israelite settlement was concentrated principally in the hilly region which was only sparsely populated by the Canaanites, as well as in the uninhabited peripheral areas of the desert and the Negev. Settlements in the hill country required the clearing of forests (Joshua 17:15–18) and the breaking of virgin soil for agriculture. In the lowlands important Canaanite cities, such as Megiddo, Taanach, and Beth Shean, continued their Bronze Age cultural tradition without interruption. In consequence, the Israelite settlers were influenced in many ways by their Canaanite neighbors, but gradually they developed their own characteristic material culture.

Archaeological excavations and surveys have revealed a picture of widespread settlement, though on a more modest scale than in Canaanite towns. Against the background of the large, flourishing cities of the preceding period, the transition to small, unwalled settlements, subsisting mainly on herding and agriculture, is

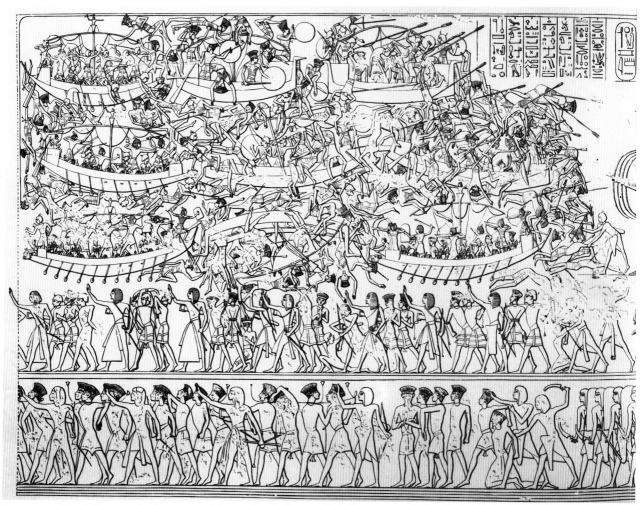

FIG. 49. Naval battle between the Egyptians and the Sea People, from a relief of Ramses III, Medinet Habu, Egypt. First half of 12th century B.C. Illustration from *Medinet Habu I*, University of Chicago Oriental Institute Publications, VIII, Chicago, 1930, pl. 37.

striking. The number of grain silos and large storage jars is remarkable and characteristic of these settlements. The lively trade that thrived in the preceding period came to an end, and imported luxury goods have not come to light in the excavations of Israelite villages. The range of domestic utensils in the new settlements was limited; these simple utilitarian objects consisted mainly of cooking pots, storage vessels, and tools. The use of alphabetic script, that great invention of this region, was increasing and would become an important vehicle in the spiritual development of the Israelites.

In Solomon's time the region of Judah controlled extensive sections of the coastal Via Maris and the King's Highway in Transjordan, which were the principal trade routes linking Egypt and Mesopotamia, the two centers of civilization in the Fertile Crescent. Much of the wealth of the kingdom came from trade monopoly and from its role as middleman between Egypt and the Neo-Hittite states of central and northern Syria.

The United Monarchy broke apart with the accession of Solomon's son Rehoboam (928 B.C.). Henceforth there were two separate states: the kingdom of Israel in the north and the kingdom of Judah in the south. Jeroboam, the founder of the kingdom of Israel, succeeded in detaching the ten northern tribes from Jerusalem and in establishing separate cultic institutions with two main religious centers, one in

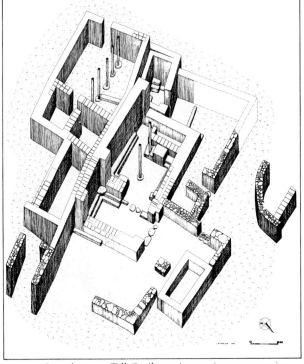

FIG. 50. Sacred area at Tell Qasile, an isometric reconstruction. Mid-10th–early 9th century B.C. Drawing: Lane Ritmeyer.

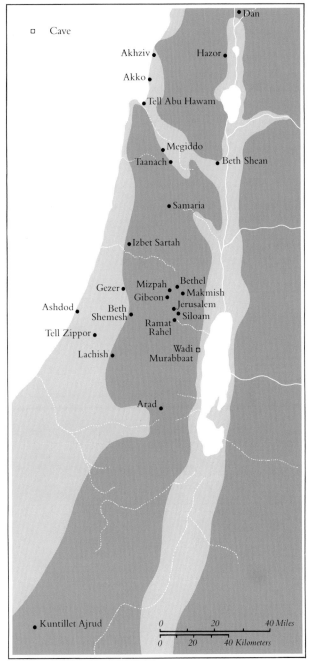

FIG. 51. Israelite II sites.

Bethel and the other in Dan (1 Kings 12:28–29). Recent excavations at the site of Dan in the northern kingdom have revealed a high place and cultic installations (fig. 52).

Under Omri, the sixth king of Israel (882–871 B.C.), a new capital was established at Samaria. The city saw a considerable expansion of royal building projects, especially during the reigns of Omri's son Ahab (871–852 B.C.) and of Jeroboam II (784–748 B.C.). A fine palace was built there, and many of its furnishings were decorated with beautiful ivory carvings (see cat. nos. 81–84). Ahab married Jezebel, the daughter of Ethbaal, king of Sidon, thus strengthening ties with the Phoenicians still further. As a result, Phoenician artistic influence became paramount in many areas of daily life and may be seen in architecture, pottery, and luxury goods. Moreover, the cult of the Tyrian Baal and Asherah were introduced (1 Kings 16:31–33), arousing the ire and the scorn of the prophets.

Archaeological excavations have shown that in the ninth and especially in the eighth century B.C., substantial changes occurred in the urban

pattern, marked by a vigorous development and the construction of large fortified cities. The fortification types include both solid walls (inset-offset) and casemate walls, as well as gate systems with guard chambers. Palaces and public buildings were erected on fortified acropolises. A distinctive monumental style appeared, characterized by ashlar or hewn masonry combined with Proto-Aeolic capitals; examples of the style have been found in the royal cities of Jerusalem, Samaria, Hazor, Megiddo, Ramat Rahel, and elsewhere (fig. 53). The fine masonry of these buildings marks the height of the builder's art in Israel, reflecting the material and economic prosperity of the time. Trade relations flourished due to the development of the road network and the maintenance of security by strongholds and forts.

The reigns of David and Solomon were a golden age in the history of Israel, and much of the biblical literature is traditionally ascribed to these great monarchs. Under them, administrative and military structures were established for generations to come. This was also the time of the kingdom's maximum territorial extent. David conquered the Jebusite city of Jerusalem, making it both the religious and administrative capital of all the Israelite tribes. Solomon built the First Temple there and, continuing his father's policy, undertook an ambitious building program which included the construction of a royal palace and compound. He fortified many cities; particularly famous are the Solomonic gates, excavated at Hazor, Megiddo, and Gezer, which show evidence of centralized royal planning. He also concluded a political-economic

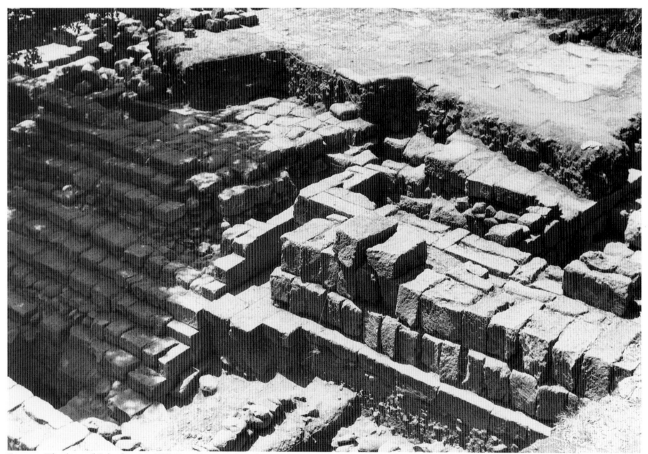

FIG. 52. The *bama* (high place) at Tell Dan. Late 10th–9th century B.C. Photograph: Nelson Glueck School of Biblical Archaeology, Jerusalem.

treaty with Hiram, king of Tyre, and was assisted by skilled Phoenician craftsmen in the execution of his building projects. Solomon even entered on a joint maritime expedition with the Phoenicians, which was sent to the land of Ophir, the source of many luxury goods.

In conflicts with their neighbors, the Israelites were led by the Judges, charismatic figures who acted as military leaders and delivered the people in times of distress. The greatest danger came from the Philistines. The Bible records that the five major Philistine cities—Gaza, Ashkelon, Ashdod, Gath, and Ekron (three of which have kept their names to the present day)—formed a confederacy. Almost nothing is known about the culture of the Philistines, their language, or their religion, but a distinctive pottery, which echoes Aegean styles, is associated with them. However, recent archaeological excavations at Tell Qasile (since the 1950s), at Ashdod (conducted in the 1960s and 1970s), at Tell Batash (Timna) and Tell Miqne (Ekron) (which are still in progress), and at Ashkelon (which is just beginning) will augment knowledge of the

daily life, burial customs, and religion of the Philistines (fig. 50).

Recurrent wars with the Philistines led to the establishment of the Israelite monarchy. Saul, the first king, "secured his kingship over Israel [and] waged war on every side against all his enemies" (1 Samuel 14:47). From this point on, the identity of the country—Eretz-Israel (the land of Israel)—was inseparable from that of the people.

ISRAELITE PERIOD II/IRON AGE II
1000–587/586 B.C.

The United Monarchy begins with the reign of Saul (ca. 1020–1004 B.C.), who succeeded in uniting the Israelite tribes. The kingdom was consolidated by David and his son Solomon, who modeled their administrative organization after that of the neighboring peoples and established a powerful monarchic state.

Most knowledge of this period comes from the biblical books of Samuel, Kings, Chronicles,

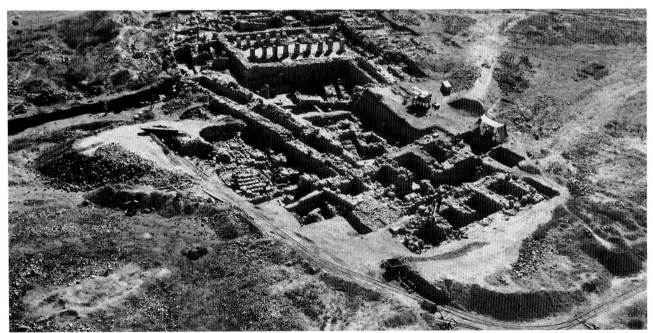

FIG. 53. Aerial view of the Upper City at Hazor. Solomonic gate and casemate wall: mid-10th–early 9th century B.C.; pillared building: 9th century B.C. Photograph: Institute of Archaeology, Hebrew University, Jerusalem.

FIG. 54. The water system at Hazor. 9th–8th century B.C.. Photograph: Institute of Archaeology, Hebrew University, Jerusalem/ Zeev Radovan.

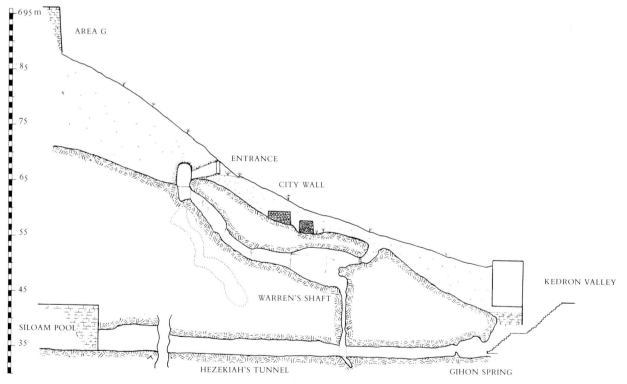

FIG. 55. The water systems of Jerusalem during the Israelite period/Iron Age, a schematic cross-section. Drawing: City of David Archaeological Project.

and the Prophets. Additional information is furnished by the annals of the kings of Assyria and by contemporaneous epigraphic material from Israel and the neighboring states of Moab and Ammon.

Within the large cities new approaches to town planning are evident. Special residential quarters emerged in which the characteristic dwelling was the four-room house. In many of the fortified cities elaborate water systems were installed. These usually included a tunnel to carry springwater to within the city walls, thus ensuring a reliable water supply in times of siege. There are especially impressive systems at Hazor, Megiddo, and Jerusalem and at Gibeon to the north of Jerusalem (figs. 54 and 55).

A distinctive repertoire of pottery vessels is attested in excavations. These include red wheel-burnished "decanters" and the fine so-called Samaria ware as well as imports from Phoenicia, Cyprus, Assyria, and other countries. There is no evidence of monumental sculpture, and little figurative art has survived, probably because of the religious prohibition against graven images. However, the gem cutter's art flourished, and many of the seals are of superb quality (see cat. nos. 89–93). Quite a few bear short inscriptions. The relative abundance of such seals from the eighth through the sixth century B.C. indicates a growth of literacy.

In the mid-eighth century B.C. a momentous change occurred in the Near East. The Assyrian empire under Tiglath-pileser III expanded into Syria and the northern part of Israel, turning Galilee and Transjordan into Assyrian provinces. Dan and Hazor were destroyed, and the inhabitants of the area were exiled to Assyria. A decade later, in 722 B.C., Samaria, the capital of Israel, was captured by Sargon, king of Assyria, thus bringing to an end the kingdom of Israel. Some of its inhabitants were taken away in captivity, and in their place the Assyrians settled people deported from other parts of the Assyrian empire.

After the destruction of Samaria and the exile

Fig. 56. Fortification wall of the Upper City of Jerusalem at the time of Hezekiah. 7th century B.C. Photograph: Jewish Quarter Excavation—Institute of Archaeology, Hebrew University, Jerusalem, and Israel Exploration Society/Dr. Kurt Meyerowitz.

of the Israelites to Assyria, the kingdom of Judah became the sole bearer of the national culture. Judah's population grew, especially in the area of Jerusalem, which absorbed many refugees from the ruined northern kingdom. Recent excavations in Jerusalem have brought to light evidence of this expansion (figs. 56–58). The enhanced status of Jerusalem as the religious and spiritual center for what remained of the Israelite nation found expression in Hezekiah's cultic reforms, which sought to centralize worship in the Temple. The reforms were accompanied by the destruction of high places and other centers of worship outside Jerusalem.

However, during Hezekiah's reign Jerusalem and Judah had to face the most severe crisis in their history. After Sargon's death (705 B.C.),

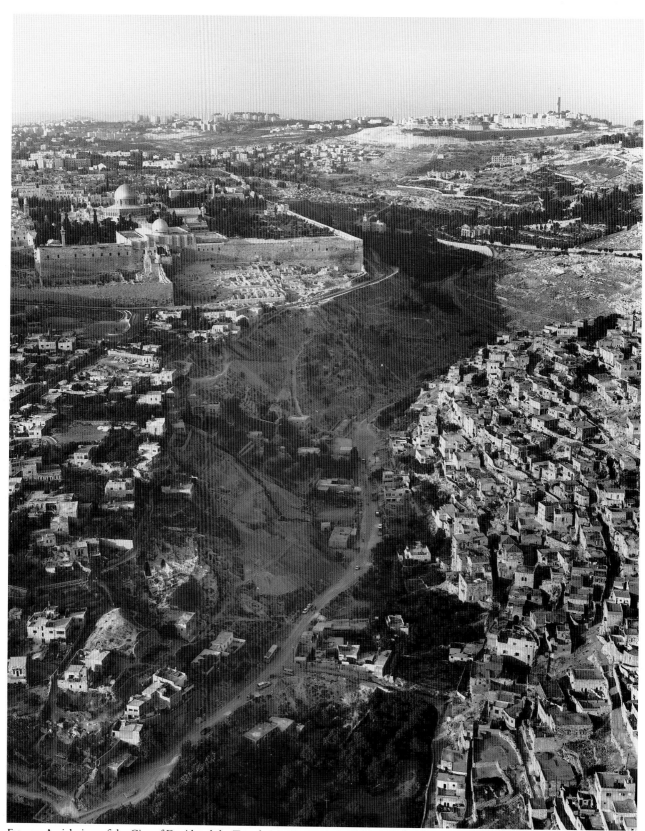

Fig. 57. Aerial view of the City of David and the Temple Mount, Jerusalem. Photograph: Werner Braun.

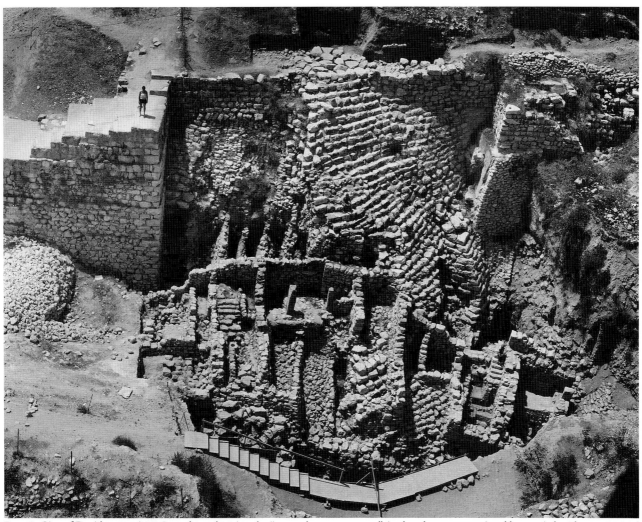

Fig. 58. City of David excavations, Jerusalem, showing the "stepped-stone structure" (10th–9th century B.C.) and houses (7th–6th century B.C.). Photograph: City of David Archaeological Project/Zeev Radovan.

Hezekiah, in league with other rulers and with Egyptian support, rebelled against Assyria. Sennacherib, Sargon's heir, set out in 701 B.C. to suppress the revolt and, in a campaign well documented in the Bible and in Assyrian monuments, conquered most of Judah. He destroyed the Judaean fortresses and captured Lachish after a prolonged siege. The city's capture is depicted on the famous Lachish reliefs (British Museum) from Sennacherib's palace in Nineveh, and recent excavations have revealed the Assyrian siege ramp and Lachish's massive fortifications which are so evident in the reliefs (fig. 59). The Assyrians also laid siege to Jerusalem but made a sudden and unexplained retreat from the Judaean capital. This deliverance was described as miraculous in the biblical books of Kings and Isaiah and enhanced the status of Jerusalem as the only holy city under divine protection. Josiah's reforms (from 622 onward), which were carried out after the decline of Assyrian power, emphasized the religious primacy of Jerusalem. Indeed the temple at Arad, the only cult place known apart from Jerusalem, went out of use at this time.

During the last thirty years of its history, Judah experienced many upheavals. In 609 B.C. Josiah, the king of Judah, was killed in battle against the Egyptian Pharaoh Necho. Egyptian sovereignty over Judah lasted only a few years as

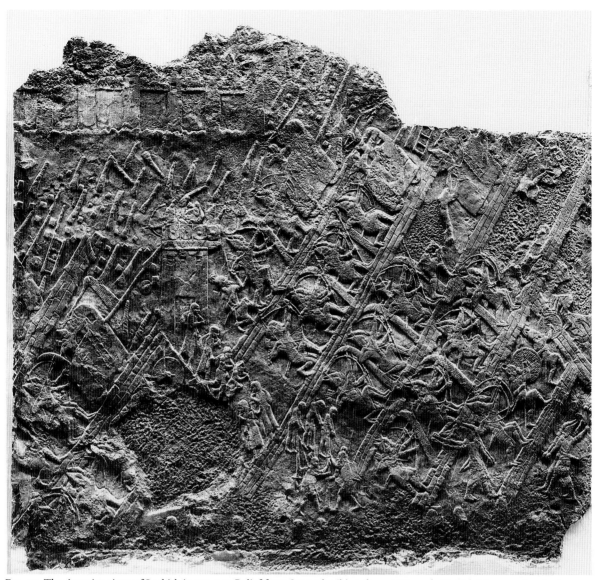

FIG. 59. The Assyrian siege of Lachish in 701 B.C. Relief from Sennacherib's palace at Nineveh (British Museum London). Photograph: Institute of Archaeology, Tel Aviv University/Abraham Hay.

Egypt was defeated shortly afterward by the Chaldean Babylonians, who began a systematic conquest of the cities of Judah. However, the power struggle between Egypt and Babylonia continued, with the Judaean kings taking a pro-Egyptian stance from time to time and finally rebelling against Babylonia. In 589/588 B.C. Nebuchadnezzar reached Jerusalem and exiled the king and thousands of his people. But Zedekiah, the king he appointed, also revolted against Babylonia with Egyptian support. Nebuchadnezzar returned, laid siege to Jerusalem for three years, and captured it, destroying the city and burning the Temple. More inhabitants were exiled to Babylonia, many Judaean cities were destroyed, and the history of the kingdom of Judah in the First Temple period came to an end. This last chapter is documented by epigraphic material— the Lachish letters and seals inscribed with names of persons mentioned in the Bible— and by excavations that have uncovered evidence of the destruction of the Judaean cities. Recent excavations in Jerusalem illustrate the magnitude of this catastrophe.

IVORIES FROM MEGIDDO
Cat. nos. 69–71

14th–12th century B.C.
Excavations of the Oriental Institute, University of Chicago

An outstanding treasure of some three hundred ivory pieces was unearthed during excavations at Megiddo in 1937 (fig. 60). The hoard, which also included jewelry and alabaster pieces, was found scattered on the basement floor of a palace assigned by the excavators to Stratum VII A. It has been suggested that this treasure was the property of the ruling princes of Megiddo and that they may have used the ivories for trade.

This hoard is the largest and most important collection of late-second-millennium ivories discovered in Canaan. An ivory pen-case with the cartouche of Ramses III proves that the treasure was still in use during the reign of this pharaoh (1182–1151 B.C.) and provides a terminus ante quem for this material. Nevertheless, the finds also include pieces which clearly date to the thirteenth and even the fourteenth century B.C. In this heterogeneous assemblage, objects incorporating local Canaanite and Egyptianizing elements are found together with pieces that are Mycenaean or Hittite in style.

REFERENCES: G. Loud, *The Megiddo Ivories*, Chicago, 1939; H. J. Kantor, *The Aegean and the Orient in the Second Millennium B.C.*, The Archaeological Institute of America, monograph no. 1, Menasha, Wis., 1947; R. D. Barnett, Ancient Ivories in the Middle East, *Qedem* 14 (1982), pp. 25–26.

FIG. 60. Aerial view of Tell Megiddo. Photograph: Garo Nalbandian.

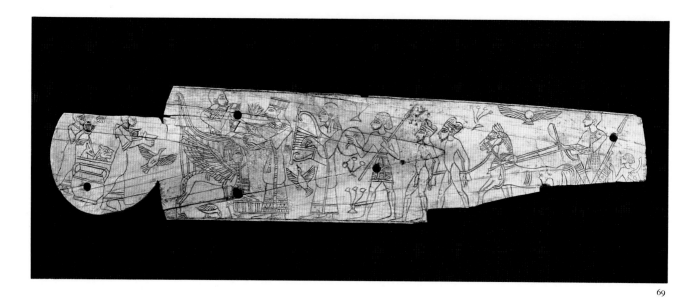

69. Plaque

13th–mid-12th century B.C.
Ivory; length 26 cm. (10⅛ in.)
IDAM 38.780

This plaque combines excellence of workmanship with a wealth of detail and provides a lively glimpse into the court life of a Canaanite ruler—perhaps at Megiddo itself—toward the end of the second millennium. It probably formed part of the inlaid or overlaid ornamentation of a wooden box or piece of furniture. The plaque was attached by nails or pegs through the perforations scattered over the surface; these holes were subsequently concealed by replacing the tiny round pieces that had been removed.

The composite scene seems to represent two successive events which are divided by a vertical row of three plants. At the right a ruler returns from war. He drives a chariot drawn by two horses and is protected by the winged sun disk. Following the chariot is a soldier carrying a scimitar on his shoulder. Two naked and circumcised captives, their hands bound behind their backs, are tied to the headstalls of the horses. The captives are bearded and wear turbans. They are preceded by a bearded warrior, clad in a short kilt and armed with a round shield and a spear.

The scene to the left of the plants depicts a ruler, perhaps the king of Megiddo, seated on a throne with his bare feet resting on a stool. The side of the throne is carved in the shape of a winged sphinx. This throne has several comparisons in Canaanite art: it resembles the one depicted on an engraved ivory plaque from Tell Fara in southern Israel, and it is identical with the throne represented on Ahiram's sarcophagus at Byblos.

The bearded king wears a tight cap, and his ap-

pearance is almost identical with that of the figure standing in the chariot, except that he is dressed in a long-sleeved garment with an ornamental collar. He raises a cup to his lips with his right hand, and he holds a lotus blossom, a symbol of royalty, in his left hand. Facing the king is a woman (perhaps the queen or a princess) who holds the stem of the same lotus blossom, while offering him part of her fringed shawl. She wears a long-sleeved embroidered robe and a low cylindrical turban similar to turbans in other ivory representations of women in this hoard. She is followed by a female musician who is playing a nine-string lyre. Behind the throne are two bearded servants carrying bowls, and between them is a two-handled large jar, probably containing wine. A shelf or serving table holds two zoomorphic drinking cups (rhytons) in the shape of a goat head and an ibex head. Actual vessels such as these were found in the Philistine temple at Tell Qasile near Tel Aviv. Birds and plants interspersed among the figures serve as space fillers.

These complex scenes can be interpreted as depicting the victorious king returning from the battlefield and subsequently celebrating his triumph in what appears to be a cultic ceremony. The ceremony brings to mind the much later relief from Nineveh depicting Ashurbanipal's feast, which Barnett has suggested should be identified with the West Semitic ceremony of the *marzeah*, known to Phoenician, Punic, Israelite, and Judaean societies, which entailed certain cultic practices in the form of a feast.

This plaque displays characteristically Canaanite elements, such as the throne supported by sphinxes, the footstool, the scimitar, and the large jar, mingled with Egyptian, Syrian, and Aegean motifs. The scenes are naturalistically rendered and minutely detailed,

and the plaque is one of the most impressive achievements of Canaanite narrative art.

REFERENCES: *G. Loud, *The Megiddo Ivories*, Chicago, 1939, p. 13, pl. 4; R. D. Barnett, *Assurbanipal's Feast*, *Eretz-Israel* 18 (1985), pp. 1*–6*.

70. Casket with Lions and Sphinxes

13th–12th century B.C.
Ivory; height 7.5 cm. (2⅞ in.), base 13.5 × 12 cm. (5¼ × 4¾ in.)
IDAM 38.816

Carved from a single block of ivory, this beautiful box is decorated on all four sides with figures of lions and sphinxes. The bodies are shown in profile and carved in high relief, while the heads are sculpted almost in the round. The base is larger than the body of the box and forms a platform for the symmetrically arranged striding creatures. Two rectangular slots cut into the top edge (now broken) of one of the sides indicate where the now-missing lid would have been hinged to the box. Ivory pegs stuck in two perforations in the opposite side are all that remain of the closing mechanism.

The heads of the two well-modeled lions are shown en face, their mouths open in a roar. The parallel grooves that delineate the whiskers and the wrinkled skin around the maws contribute to their ferocious appearance. The almond-shaped eyes are outlined by a single incision, and the mane on each is depicted by a barely raised line beginning behind the ears. The details of the legs are carved with special emphasis on the musculature and the paws. The tip of each tail is coiled.

The other two panels are each decorated with a pair of winged sphinxes. These creatures stand back-to-back, their hindlegs slightly touching. Their heads, which were made separately, have not survived, but the holes drilled in the necks indicate where they were attached to the body. The sphinxes on one side retain the lower part of their headdresses, consisting of

70

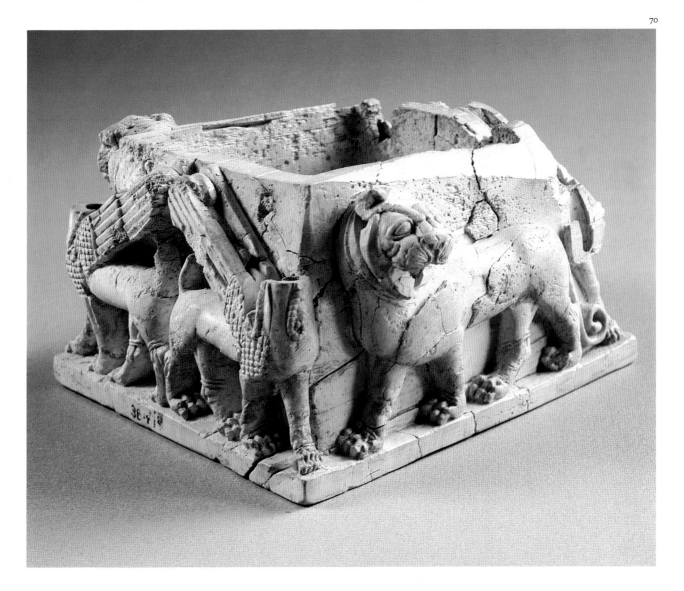

Hathor curls falling over the chest. The feathers of the outspread wings are outlined in diagonally engraved sections, while a scalelike pattern decorates the shoulders and the base of the wings. The upright tails, which touch the wing tips, the long legs with carefully delineated muscles, and the well-executed paws give much naturalism to the figures. These sphinxes and lions are clearly the masterly creation of a skilled craftsman who achieved a sense of power and imminent movement in this miniature format.

The animals are similar in appearance to the guardians of monumental gateways in North Syria and Anatolia, such as the divine figures on massive bases guarding the great gate of the Hittite capital of Hattuša (Boghazköy), dated to the fourteenth-thirteenth century B.C. The lion orthostats from Hazor (cat. nos. 42 and 44) illustrate their use in temples.

The custom of placing giant carved-stone animal figures at city gates and temple entrances was widespread in Mesopotamia. In the Assyrian royal palaces, a single pair of giant bulls with human faces usually guarded the entrance. At very elaborate gateways, such as those of the palace at Khorsabad, the number of protective creatures was doubled, each pair positioned head-to-head in an L-shaped arrangement similar to their placement on this box. Their significance was no doubt religious and their function apotropaic.

Both the roaring lions and striding sphinxes on this box and the similar creatures seen in architectural arrangements convey contained power and readiness to attack. Therefore it seems likely that the miniature creatures, like the giant gatekeepers, were intended to guard the precious contents of the box.

REFERENCES: G. Loud, *Khorsabad I: Excavations in the Palace and at a City Gate*, Chicago, 1936, fig. 45; *G. Loud, *The Megiddo Ivories*, Chicago, 1939, p. 13, pls. 1–3; E. Akurgal, *The Art of the Hittites*, London, 1962, p. 68, pl. 88; R. D. Barnett, *Ancient Ivories in the Middle East*, Qedem 14 (1982), p. 26.

71. Head of a Woman

Late 13th–early 12th century B.C.
Ivory; height 5.3 cm. (2⅛ in.)
IDAM 38.811

This finely modeled head is carved in the round. The elongated eyes are outlined by deep incisions, and the drilled pupils were originally inlaid. Long, incised

eyebrows nearly meet at the bridge of the well-proportioned nose (now damaged). The sensuous, full lips and the delicately shaped chin are soft and feminine. The young woman's elaborate coiffure conceals a good deal of her forehead and extends to her jawline. The hair is rendered by zigzag lines which represent ringlets growing from the top of her head. The long neck is drilled up the center to allow it to be attached to a separately made unit.

The features show strong links with the similarly modeled head that served as a stopper for an ivory perfume bottle found in the Fosse Temple at Lachish (cat. no. 49). The head shown here is also comparable to the heads of the swimming girls fashioned into spoons, Egyptian in origin, which have been discovered in Canaan, Syria, and Cyprus. An ivory spoon with a similar head was found in the Megiddo hoard, and an alabaster spoon decorated with such a head was unearthed at Deir el-Balah. This comparative material suggests a hybrid Canaanite-Egyptian style. The use of female heads in decorating such objects as cosmetic containers, mirror handles, fan handles, and horn-shaped vessels was very fashionable at that period, and it is likely that this head had a similar function.

REFERENCE: *G. Loud, *The Megiddo Ivories*, Chicago, 1939, p. 18, no. 194.

72. "Ashdoda" Figurine

Ashdod
12th century B.C.
Terracotta; height 17 cm. (6¾ in.)
Excavations of the Israel Department of Antiquities and Museums, and the Carnegie Museum, Pittsburgh
IDAM 68–1139

Excavations at Ashdod, one of the five major Philistine cities, have yielded a rich assemblage of figurative art from the Early Iron Age. Among the finds was a female figurine nicknamed by its excavators the "Ashdoda."

The hand-modeled, schematically rendered figurine represents a seated woman merging with the throne on which she sits. The long neck with a birdlike head rests on the straight back of a four-legged throne. The top of the head is slightly concave, the eyes and ears are represented by applied clay pellets, the nose is pinched, and two knobs indicate the breasts. A black-painted necklace with a pendant

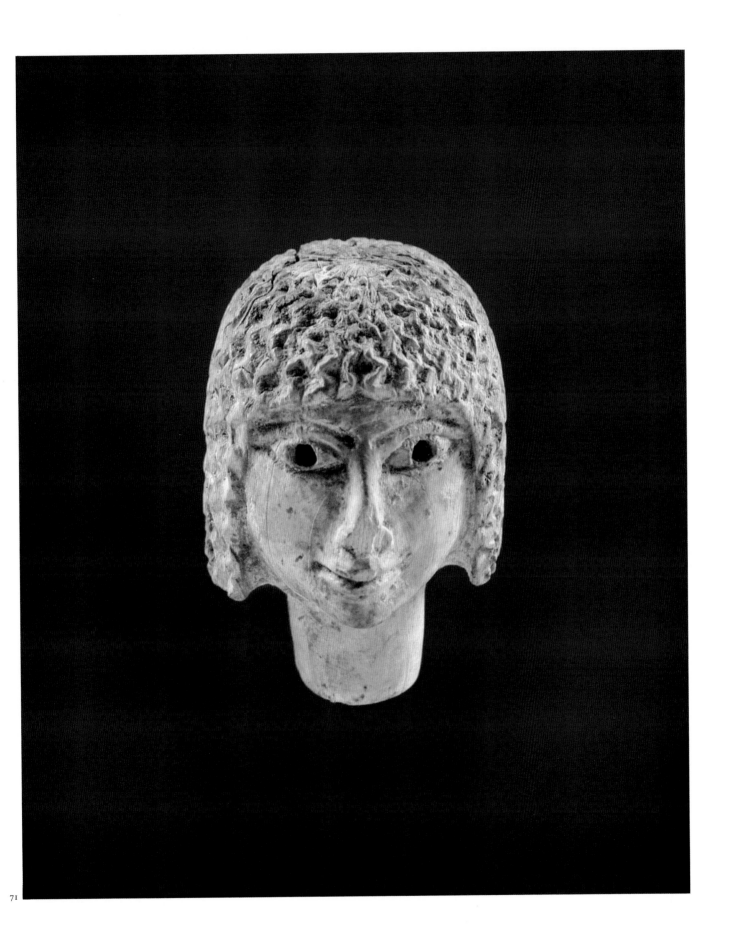

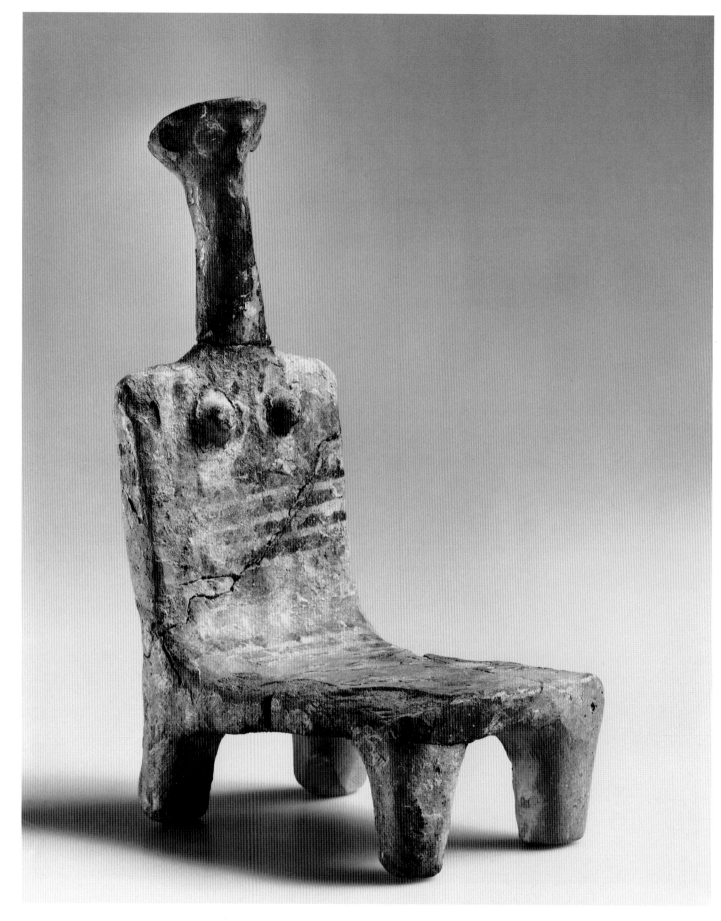

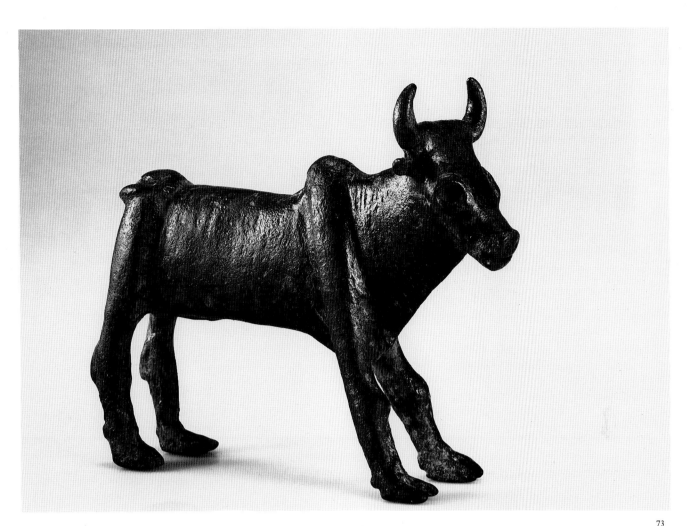

hangs between the breasts, and two small black triangles at the back of the head indicate the hair. The black and red decoration on a background of white slip is characteristic of Philistine pottery.

This type of stylized female figurine is unknown in the local repertoire of representational art in either the Late Canaanite or Early Israelite periods. Its prototype should be sought in the Mycenaean seated female figurines believed to represent the "mother goddess." Such figurines, common in the late Mycenaean III period, are sometimes depicted holding a child. It seems likely that the "Ashdoda," found next to a structure which was probably a cult place, represented a votive offering or a deity.

REFERENCES: G. E. Mylonas, Seated and Multiple Mycenaean Figurines in the National Museum of Athens, Greece, in *The Aegean and the Near East: Studies Presented to Hetty Goldman*, S. S. Weinberg (ed.), New York, 1956, pp. 110–21; *M. Dothan, Ashdod II–III, *'Atiqot*, English series 9–10 (1971), pp. 20–21, 129–30, fig. 91:1, pl. LXXXII and frontispiece; T. Dothan, *The Philistines and Their Material Culture*, Jerusalem, 1982, pp. 234–37; R. Hestrin, in *Highlights of Archaeology: The Israel Museum*, Jerusalem, 1984, pp. 60–61.

73. Bull Statuette

Samaria region
Early 12th century B.C.
Bronze; 12.4 × 17.5 cm. (4⅞ × 6⅞ in.)
Chance find followed by excavations on behalf of the Archaeological Staff Officer, Judaea and Samaria
ASOJS 3941

This bronze figurine of a young bull, one of the finest pieces of sculpture dating from the Israelite period, was executed in the Late Canaanite stylistic tradition and is reminiscent in shape and workmanship of statuettes from that period. Relatively large for its type, it was produced with great care and combines naturalistic and stylized features.

The bull is represented with a triangular head, narrow body, long legs, and a pronounced dewlap. The flattened muzzle has a grooved mouth and perforated nostrils. Each hollow eye socket is emphasized by a protruding ridge and originally must have been inlaid with some other material. The upright horns curve inward, with the ears protruding below them.

Whereas the body of the bull was cast in the lost-wax technique, the legs were molded separately as two long strips of bronze, which were then bent over the body. They form prominent ridges which represent the hump and the protruding pelvic bone. The cloven feet are treated naturalistically, and the short tail curls around the rump. The male sexual organs are shown in detail.

This bull, probably of the zebu type, is one of a limited group of freestanding bronze bull statuettes. An iconographic symbol of power and fertility, the bull was associated with the West Semitic storm-god Hadad, at times identified with Baal. Sometimes bulls served as pedestals on which the image of the god was placed.

This figurine was discovered by chance on the summit of a high ridge overlooking an extensive area. From the remains subsequently uncovered there, an open, partially paved enclosure built of stone can be reconstructed. The site brings to mind the biblical "high places"—open cult areas located on summits of hills and mountains, which served the settlements in their vicinity. The site of this bull statuette appears to have been a center for religious ritual for a group of small settlements in the territory of the tribe of Manasseh and seems to have been in use during the time of the Judges (twelfth–eleventh century B.C.).

REFERENCES: *A. Mazar, The "Bull Site"—An Iron Age I Open Cult Place, *Bulletin of the American Schools of Oriental Research* 247 (1982), pp. 27–42; R. Hestrin, in *Highlights of Archaeology: The Israel Museum*, Jerusalem, 1984, pp. 58–59.

74. Ceremonial Stand

Megiddo
12th century B.C.
Bronze; height 9.8 cm. (3⅞ in.), base 8.5 × 8.5 cm. (3⅜ × 3⅜ in.)
Excavations of the Oriental Institute, University of Chicago
IDAM 36.961

The stand consists of a circular top on a square base, at the corners of which are four plain rods ending in small

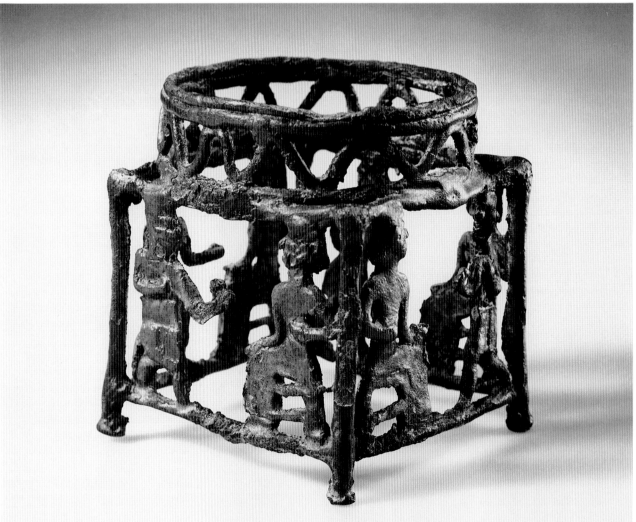

feet. Eight cross-pieces soldered to the tops and bottoms of the corner rods stabilize the stand and form four rectangular frames. The top is made up of two circular rods connected by a wavy rod, and it is soldered to the upper cross-pieces.

On each of the four sides is an identical scene in openwork technique. A male figure wearing a full-length robe sits on a stool. His facial features are clearly marked, and he is probably wearing a wig. His right arm rests on his thigh, while the left is raised to his breast. Opposite him stands a bare-headed man wearing a short kilt. He lifts one arm in a gesture of adoration and folds the other arm across his chest. This composition was frequently depicted in the ancient Near East from as early as the third millennium B.C. onward and is especially common in glyptic art. The lack of details and the crude execution make it difficult to detect any divine attributes, and therefore it is impossible to determine whether these scenes represent a deity worshipped by an adorant or a ruler receiving homage.

This piece belongs to a large group of metal stands which includes tripods and four-sided stands, some on wheels. Its closest parallel is the well-known stand from Kourion (Cyprus) which depicts an ingot-bearer. The Kourion stand is of much better workmanship, however, and has a different scene in each panel. Small stands of this type may represent a scaled-down version of much larger ones which were perhaps made of different materials. Such stands probably served as supports for pottery or metal vessels used in cultic rituals.

Most of these stands have been found in Cyprus, and workshops specializing in the technique of soldering separate pieces of bronze together were probably located there. It is likely that the stand shown here was also manufactured in one of these centers, perhaps by an unskilled hand. These workshops seem to have operated for a relatively short span of time in the late thirteenth and twelfth century B.C. From Cyprus some of these stands found their way—probably through trade—to other parts of the Mediterranean, such as Crete, Greece, Syria, and Israel.

REFERENCES: *H. G. May, *Material Remains of the Megiddo Cult*, Chicago, 1935, p. 19, pl. XVIII; H. W. Catling, *Cypriot Bronzework in the Mycenaean World*, Oxford, 1964, p. 205; H. W. Catling, Workshop and Heirloom: Prehistoric Bronze Stands in the East Mediterranean, in *Report of the Department of Antiquities*, Cyprus, 1984, pp. 69–91.

75. "Orpheus" Vase

Megiddo
11th century B.C.
Pottery; height 21 cm. (8¼ in.), diameter 16.2 cm. (6⅜ in.)
Excavations of the Oriental Institute, University of Chicago
IDAM 36.1321

This elaborately decorated jug is the creation of a Philistine potter who combined foreign and local motifs in the scene he painted on a vessel of local form.

The jug lacks most of its neck and spout. It has a globular body, a strainer inside the broken spout, and a ring-base. As no traces of a handle are visible, it is reasonable to assume that the jug had a basket handle rising from the rim. This type of jug with spout and strainer, called a "beer jug," was a popular form in the Early Israelite period. The strainer served to separate the liquid from the dregs.

The broad band of red and black painted decoration around the vessel is bordered by horizontal lines and is surmounted by geometric patterns. The naively executed scene depicts a man playing a lyre and various animals marching in a procession to the right toward a stylized plant. The representation of a lyre player in vase painting is uncommon, although the motif appears in other media, notably among the modeled figures on the Philistine cult stand from Ashdod (cat. no. 78). At the head of the procession strides a lion(?) with a dog standing above it. The lion is followed by a gazelle and then by the lyre player. A crab is painted above the dog, and two fish—one in front of the lion and the other above the gazelle—serve as space fillers. To the left of the man's head is a scorpion, and behind him stands a horse surmounted by a large bird. Two more fish are shown, one between the horse and the man and the other above the bird. The placing of one object above the other was a convention for representing perspective.

Composite scenes of narrative character were uncommon in local vase painting of this period. However, some of the individual elements on this jug, such as the gazelle and the bird, are well known in the repertoire of Canaanite painted pottery from the Late Bronze Age. Others, like the dog and the horse, are of foreign origin and point to links with Aegean traditions, specifically the contemporaneous Mycenaean III pottery style. Although no comparable scenes on pottery vessels are known, this procession recalls a scene on a cylinder seal from Tarsus in Cilicia.

There has been much speculation regarding the meaning of this intriguing scene. Some scholars be-

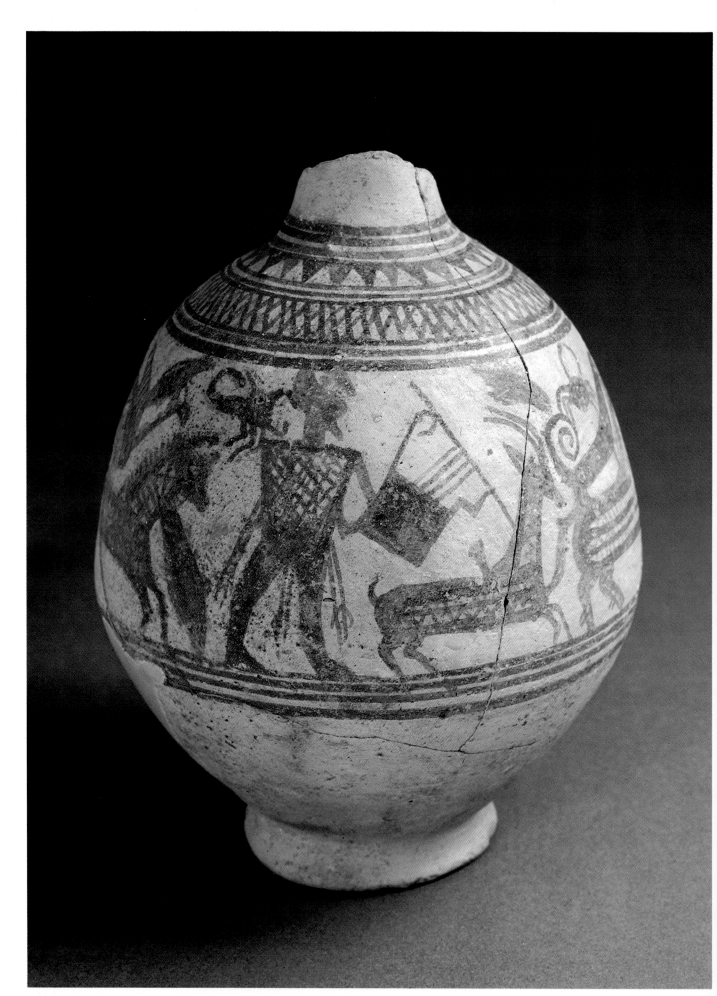

lieve that it depicts a legend similar to the Greek myth of Orpheus playing before the animals, whereas others see in it motifs of daily life connected with singing and playing on festive occasions.

The red and black decoration painted over a white slip, as well as some of the motifs such as the fish and the bird, were common in the Philistine repertoire. Perhaps this delightful vessel, uncovered in the main building of Stratum VI A at Megiddo, which is dated to the period of Philistine and Israelite confrontation, may have been used by a local aristocrat for storing his beer.

REFERENCES: *G. Loud, *Megiddo II*, Chicago, 1948, pl. 76:1; B. Mazar, The "Orpheus" Jug from Megiddo, in *Magnalia Dei: Essays on the Bible and Archaeology in Memory of G. Ernest Wright*, F. M. Cross et al. (eds.), New York, 1976, pp. 187–92; T. Dothan, *The Philistines and Their Material Culture*, Jerusalem, 1982, pp. 150–53.

ZOOMORPHIC BOWLS
Cat. nos. 76 and 77

Ceremonial vessels have always reflected the cultural and religious practices of their times. Among these, special shapes for drinking, such as cups or rhytons, are of particular importance; they also afford a glimpse of contemporaneous artistic fashions. A distinctive class of drinking vessels with attached animal heads opening into hollow tubular rims are known to archaeologists as "kernos bowls." Such bowls occur in Canaan from the Late Bronze Age onward, reaching their greatest popularity in Iron Age I and continuing throughout Iron Age II. Similar bowls are known in Cyprus in Cypro-Geometric I, their popularity declining during the later Geometric period. The early appearance of such vessels in Canaan and their widespread distribution point to their local origin, and it is probably from this country that they reached Cyprus through trade.

In order to drink from such a bowl, the user tipped the bowl slightly to allow the liquid to flow through the inner spout into the hollow tubular rim. Then, by sucking at the outer spout, the user drew the liquid along the tube and sipped it from the animal's mouth. Such a complicated procedure coupled with the elaborate zoomorphic spouts suggests that these were drinking vessels for special ceremonies.

REFERENCES: A. Mazar, Excavations at Tell Qasile, *Qedem* 12 (1980), pp. 106–8; T. Dothan, *The Philistines and Their Material Culture*, Jerusalem, 1982, p. 224.

76. Zoomorphic Bowl

Provenance unknown
11th–10th century B.C.
Pottery; maximum height 12.7 cm. (5 in.),
diameter 20 cm. (7⅞ in.)
IMJ 82.2.3

This vessel, of brown-red clay with coarse inclusions, consists of a shallow bowl with a tubular rim, to which two separately made animal-shaped spouts are attached. The spout at the front is in the form of a stylized, unidentified animal head on a long, hollow neck, with a round mouth, which serves as the opening of the spout, indented nostrils, and separately applied eyes. It is noteworthy that the applied, horizontally grooved eyes seem to imitate cowrie shells, which since prehistoric times were used as inlays, especially for eyes. From both sides of the head project horizontally grooved, stylized horns or ears, and a third protuberance rises between them. This peculiar configuration, which has no parallels, may represent a stylized bull head, with the central protuberance indicating a bump at the top of the forehead.

The inner spout is in the shape of a schematically rendered, unidentified animal, which appears to be drinking from the bowl. The animal's feet rest on the bottom of the bowl. The slanted head is identical with the one at the front, though the horns are broken off and the animal appears to be drinking from the bowl. A scar on its back may once have been a hump such as is found on a bull; another scar is all that remains of the tail.

REFERENCE: *T. Ornan, *A Man and His Land: Highlights from the Moshe Dayan Collection*, Israel Museum catalogue no. 270 (Hebrew), Jerusalem, 1986.

77. Zoomorphic Bowl

Provenance unknown
10th–8th century B.C.
Pottery; maximum height 11.5 cm. (4½ in.),
diameter 12.5 cm. (4⅞ in.)
IDAM 75–115

This red-slipped and burnished receptacle consists of a hemispherical bowl with a hollow tubular rim to which

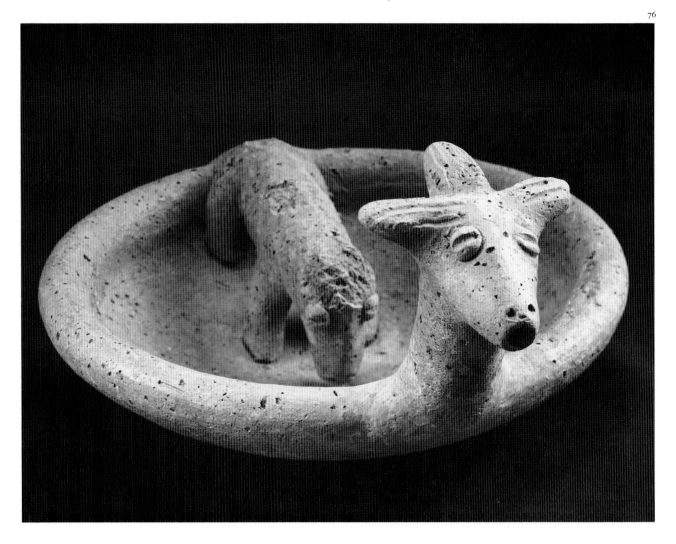

are attached two separately made bull-head spouts. The heads are perched on long, hollow necks. They have circular mouths, which serve as spouts, and applied round eyes. The spout at the front is upright and faces outward, while the other slants down as though the animal were drinking from the bottom of the bowl. A good deal of naturalism is achieved in the upper part of the head—in the long, incurving horns and the protruding ears.

This bowl recalls kernos fragments known from Ashdod and has a close parallel in a bowl from Cyprus, dated to the Cypro-Geometric III period.

Previously unpublished.

78. Cult Stand with Musicians

Ashdod
Late 11th–early 10th century B.C.
Pottery; height 34.7 cm. (13⅝ in.), diameter at base 14.2 cm. (5⅝ in.), diameter at rim 16.2 cm. (6⅜ in.)
Excavations of the Israel Department of Antiquities and Museums, and the Carnegie Institute, Pittsburgh
IDAM 68–1182

This unusual pottery stand consists of a deep carinated bowl mounted on a high cylindrical pedestal. Five figures of musicians stand in rectangular "windows" cut into the pedestal. Four of the figures are modeled in the round, with the lower parts of their bodies merging into the vessel. Their heads are disproportionately

large, with prominent noses and eyes made of clay pellets. The fifth figure is larger than the others and different in style; except for some modeled and applied details, this figure is flat, standing on sturdy legs, and is cut out of the wall of the pedestal. Above the base are four cutout arched openings.

Each of the figures plays a musical instrument—one strikes the cymbals, two play double pipes, a fourth performs on a stringed instrument, probably a lyre, and a fifth shakes a tambourine.

Above the row of musicians runs a procession of three crudely executed animals, partly incised and partly worked in relief. The well-fired stand bears traces of white slip, and on the bowl a decoration of red and black lattice pattern is visible; both are characteristic features of the Philistine ceramic repertoire.

High-footed fenestrated stands are known from other sites throughout the country, while the figures themselves recall both contemporaneous and later figurines found at Ashdod. Musicians played an important part both in court life and in cultic ceremonies throughout the ancient Near East. However, although the depiction of musicians was common in the ancient Levant, this is the only instance known of an orchestra modeled in the round.

The stand, found in an area which seems to have been of cultic significance, vividly illustrates the passage in 1 Samuel 10:5: "After that, you are to go on to the Hill of God, where the Philistine prefects reside. There . . . you will encounter a band of prophets coming down from the shrine, preceded by lyres, timbrels, flutes, and harps, and they will be speaking in ecstasy."

REFERENCES: *M. Dothan, The Musicians of Ashdod, Archaeology 23 (1970), pp. 310–11; T. Dothan, *The Philistines and Their Material Culture*, Jerusalem, 1982, pp. 249–51; R. Hestrin, in *Highlights of Archaeology: The Israel Museum*, Jerusalem, 1984, pp. 64–65.

79. Canaanite Cult Stand

Taanach
Late 10th century B.C.
Pottery; height 53.7 cm. (21⅛ in.), top 24.5 × 22 cm. (9⅝ × 8⅝ in.)
Excavations of the American Schools of Oriental Research and Concordia Seminary, St. Louis, Missouri
ASOJS 4197

This elaborate cult stand is one of the most interesting and intriguing objects from ancient Israel. It was found during excavations at Taanach, a city located some eight kilometers (five miles) southeast of Megiddo, which has yielded impressive finds from as early as the late fourth millennium B.C. continuing through the Israelite period, and whose importance is reflected in both biblical and nonbiblical sources. Taanach is first mentioned in the lists of cities conquered by Tuthmosis III (1504–1450 B.C.) and later in a similar list of conquests by Pharaoh Shishak I (935–914 B.C.). It was the site of the famous battle between the Israelites, who were commanded by Deborah and Barak, and the Canaanites led by Sisera (Judges 5:19). The Israelites probably did not occupy the city before the tenth century B.C., and later it became an administrative center.

The square stand is of poorly fired clay. It is hollow and has an open base, four registers modeled in high relief, and on top a shallow basin which is decorated on three sides with a row of applied button-like disks. The three lower registers each contain a pair of lions or sphinxes arranged so that their heads and forelegs are modeled on the front and their bodies are shown in a striding position on the sides. The sides of the upper register have winged griffins. The back of the stand is plain, with two rectangular cutout openings. With the exception of the main opening in the front, all the other cutout spaces on the front and sides are irregular in shape and are between the animals' legs or above their bodies.

The lowest register displays a nude female figure facing front, her outstretched arms grasping the ears of two flanking lions. The lions' heads, with bared teeth, protruding tongues, and bulbous eyes, convey great ferocity despite their crude execution. The second register contains a pair of winged sphinxes with lions' bodies, female heads, and Hathor headdresses, one on either side of the opening. The third register consists of two heraldically arranged goats nibbling from a stylized tree with three pairs of voluted branches, flanked by two lions similar to those in the lowest

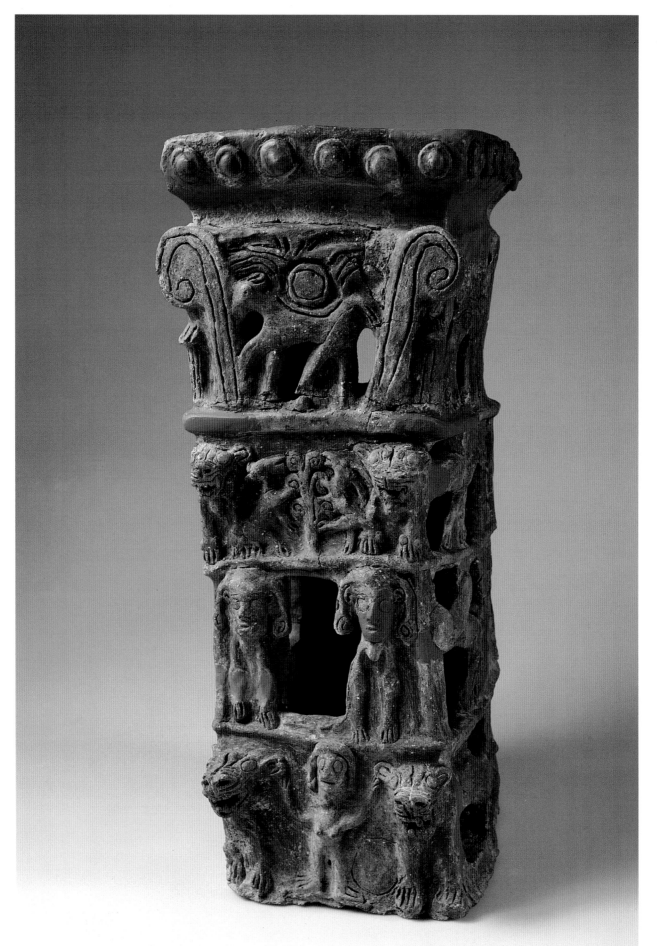

register. In the center of the upper register, a calf facing left is surmounted by a winged sun disk and flanked by a pair of volutes, probably representing columns. Apart from their purely ornamental function, the voluted columns, imitating Proto-Aeolic capitals, recall those flanking the entrance to the Solomonic Temple (1 Kings 7:21–22: "[Hiram] set up the columns at the portico of the Great Hall; he set up one column on the right and named it Jachin, and he set up the other column on the left and named it Boaz. Upon the top of the columns was a lily design.") or depicted on facades of model shrines known both from Israel and Transjordan. Standing on the corners of this register are a pair of objects that may represent cult stands.

Each of the eight side panels incorporates a pair of lions or hybrid creatures, which are reminiscent of the orthostats that flanked the entrances of Syrian and Canaanite temples such as Carchemish and Hazor (see cat. no. 42). They also recall the monumental protective figures at the doorways of later Assyrian palaces.

Since this stand bears no trace of fire or incense, it was probably intended for offerings or libations. Both its shape and motifs place it in a well-known group of cult stands that have been found at Megiddo, Taanach, and Beth Shean. However, this stand is unique in its rich imagery and in its remarkable state of preservation.

The identification of the deities represented on the stand and of their attributes is still a matter of controversy. Throughout the second millennium B.C., the Canaanites depicted their female deities nude, sometimes in association with a lion or a horse, and with outstretched arms holding flowers or snakes (see cat. no. 50). On this stand, the goddess is clearly associated with lions. In this context attention should be drawn to the arrowheads from el-Khadr, dating from the late twelfth century B.C., which bear a Proto-Canaanite inscription mentioning "the Lion Lady."

The sacred tree flanked by two figures was common in Near Eastern iconography of the second and first millennia B.C. This motif is thought to represent the goddess Asherah. Based on biblical references, it is commonly accepted that in the first millennium Asherah was no longer depicted in a figurative manner, but nonfiguratively as a wooden post. Especially significant in this light is a sacred tree flanked by two ibexes in conjunction with a lion painted on a pithos from Kuntillet Ajrud, because Asherah is mentioned in an inscription on the same vessel.

The prominence given to the calf in association with the sun disk, as well as the columns and griffins in the uppermost register, suggest that this is the representation of the main deity. The association of the Canaanite storm-god Baal-Hadad with a bull—well attested in Near Eastern iconography—suggests that this scene refers to Baal (see also the bronze bull figurine from the Samaria region, cat. no. 73). Thus a pair of major Canaanite deities are probably represented on this stand: Asherah, both personified and in the form of the sacred tree, and Baal-Hadad in the form of a calf. Such an identification accords well with the mention of Baal and Asherah in the cuneiform tablets found at Taanach, as well as their frequent joint appearances in the Bible.

REFERENCES: F. M. Cross, Jr., The Origin and Early Evolution of the Alphabet, *Eretz-Israel* 8 (1967), p. 13*; *P. W. Lapp, The 1968 Excavations at Tell Ta'anek, *Bulletin of the American Schools of Oriental Research* 195 (1969), pp. 42–44; W. G. Dever, Asherah, Consort of Yahweh? New Evidence from Kuntillet Ajrud, *Bulletin of the American Schools of Oriental Research* 255 (1984), pp. 21–37; A. Lemaire, Who was Jahweh's Asherah, *Biblical Archaeology Review* 10, 6 (1984), pp. 42–51.

80. Ibex-Head Stopper

Lachish
9th century B.C.
Ivory; 6.9 × 3.7 cm. (2¾ × 1½ in.)
Excavations of the University of Tel Aviv and the Israel Exploration Society
IDAM 78–23

This delicate ivory stopper, carved in one piece in the shape of an ibex head, combines naturalistic and stylized features. The eyes are drilled holes which originally must have been inlaid with some other material. They are outlined by a single groove and emphasized by two semicircular incisions. Drilling was also used in shaping the laid-back ears. The horizontally grooved horns spring from the forehead, curve around the ears, and end at the throat, thus framing the animal's profile. Beneath the chin, traces of a broken-off beard have survived.

Extending from the bottom of the neck is the plug of the stopper, which originally fitted into a container. The stopper is perforated lengthwise, so that the liquid, probably perfume, could be poured out through the animal's mouth.

There are no exact parallels to this object, but its shape is reminiscent of a contemporaneous ivory ibex head from Ashdod which may also have been used as a stopper. Stylistically similar heads can be found in

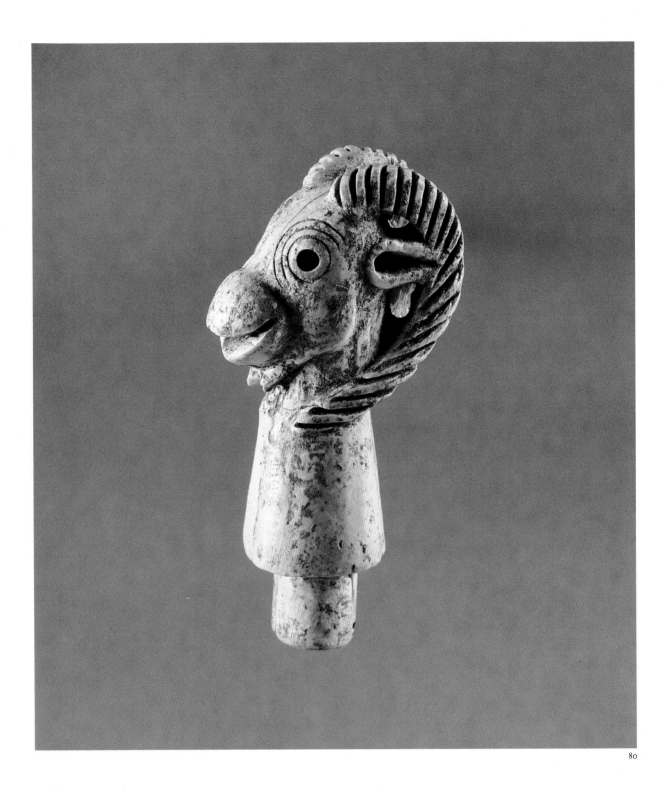

the repertoire of Egyptian and Canaanite cosmetic containers which date to the latter part of the second millennium B.C. Especially notable is the perfume bottle in the shape of a woman from the Fosse Temple of Lachish with its similarly perforated stopper (cat. no. 49). Thus one cannot rule out the possibility that this stopper, though found in the stratigraphical context of the ninth century B.C., may have been made in an earlier period and then handed down as an heirloom.

REFERENCES: O. Tufnell et al., *Lachish II: The Fosse Temple*, London, 1940, pls. xv–xvii; *D. Ussishkin, Excavations at Tel Lachish—1973–77: Preliminary Report, *Tel Aviv* 5 (1978), p. 51, pl. 16:3; M. Dothan and Y. Porath, Ashdod IV, *'Atiqot*, English series 15 (1982), p. 38, pl. xxiii:2.

IVORIES FROM SAMARIA
Cat. nos. 81–84

9th–8th century B.C.
Excavations of the Joint Expedition to Samaria
(Harvard University, the Hebrew University,
Jerusalem, the Palestine Exploration Fund, the
British Academy, and the British School of
Archaeology in Jerusalem)

The art of ivory carving had a long tradition in
the ancient Near East. With its roots in Predy-
nastic Egypt, it developed in Canaan as early as
the Chalcolithic period and flourished in the
Late Bronze and Iron ages (see cat. nos. 13–15,
45–49, and 69–71). Ivory was valued as highly
as gold and silver, and works in ivory declared
their owners' royal or noble status. The Bible re-
counts that during the reign of Solomon, the
king's fleet came in "once every three years"
bearing "gold and silver, ivory, apes, and pea-
cocks" (1 Kings 10:22). Ivory carving was a spe-
cialty of Phoenician artisans. Their handiwork
—in the form of inlays, cosmetic utensils, boxes,
and other items—reached the courts of Assyria
as tribute and booty. Judging from their wide
distribution, ivory objects in the North Syrian
and Phoenician styles became particularly pop-
ular in the ninth and eighth centuries B.C. They
have been found throughout the Near East at
such diverse sites as Arslan Tash, Nimrud,
Khorsabad, Salamis, and Samaria.

The Bible mentions the "ivory palace" that
Ahab built at Samaria (1 Kings 22:39). To the
prophet Amos writing a century later, the "ivory
beds" symbolized the corrupt society of the
Samarian aristocracy which he so abhorred
(Amos 6:4). Ahab was married to the Phoeni-
cian princess Jezebel, and it is tempting to specu-
late that the ivories reflect the pagan cult she
introduced. However, since the Samaria ivories—
many half-burnt—were found in rubbish pits
on the acropolis of the city, they cannot be
assigned with certainty to any particular build-
ing phase.

The Samaria ivories, which number over

FIG. 61. Detail from ivory bed. Salamis, Cyprus; 7th century B.C.
Photograph: National Museum of Antiquities, Nicosia, Cyprus.

five hundred fragments including two hundred
decorated pieces, constitute the most impressive
collection of miniature art found in a royal
Israelite city. Most of the ivories were used for
decorating furnishings such as beds, thrones,
and stools, whereas others were inlaid in wall
panels in the palaces of kings and nobles. The
tradition of such lavish embellishment of furni-
ture in royal apartments in the court of Israel
brings to mind the biblical description of the
decoration Solomon lavished on the doors and
walls of the Temple (1 Kings 6:29–32) and of his
"large throne of ivory . . . overlaid with refined
gold" (1 Kings 10:18–20). The ivory inlays
were made in separate sections, held together by
tenons and secured by small ivory pins. The sepa-
rate plaques were often marked with Hebrew-
Phoenician letters to guide their positioning on
the furniture. The application of such inlaid pan-
els is best exemplified in the richly ornamented
thrones and beds found in a wealthy tomb, dat-
ing to the end of the eighth century B.C., at
Salamis, Cyprus (fig. 61).

Most of the Samaria ivories are carved in
what is termed the "Phoenician" style, which is
marked by a preference for Egyptian motifs, the
Egyptian canon of proportion and symmetry,
and colored glass inlays. Most are executed in

high or low relief, although examples in open-work technique do occur, and a few pieces are carved in the round. Inlays of colored glass or paste and even gold-leaf overlays were often added to the ivories, thus achieving an ornate effect which might well have struck the modern viewer as garish. The Samaria ivories also show an admixture of such local motifs as the double volute and palmette. The ivories could have been made in one of the cities of Phoenicia or perhaps in Damascus. But given the unworked fragments of tusk found at the site as well as the incised Hebrew-Phoenician letters carved on the backs of some of the panels, the possibility exists that some may have been carved locally.

The five works illustrated here (cat. nos. 81–84), demonstrating delicacy of execution combined with refined taste, provide only a small glimpse of the splendid palace ornamentation of the Israelite kings. In 722 B.C. Samaria was destroyed by the armies of Sargon II of Assyria, and most of the luxury items were taken as booty to the royal palaces in Assyria. It is perhaps significant that among the Nimrud ivories one plaque bears a fragmentary Hebrew inscription: "from a great king." These few words are poignant evidence of what must have been the fate of similar treasures from Samaria and Jerusalem.

REFERENCES: J. W. Crowfoot and G. M. Crowfoot, *Early Ivories from Samaria*, London, 1938; R. D. Barnett, *A Catalogue of the Nimrud Ivories*, London, 1957; V. Karageorghis, *Salamis v: Excavations in the Necropolis of Salamis III* (plates), Cyprus, 1974; I. J. Winter, Is There a South-Syrian Style of Ivory Carving in the Early First Millennium B.C.?, *Iraq* 43 (1981), pp. 101–30; R. D. Barnett, Ancient Ivories in the Middle East, *Qedem* 14 (1982).

81. Lion and Bull in Combat

Ivory; 4.2 × 11.8 cm. (1⅝ × 4⅝ in.)
IDAM 33.2552

This plaque depicts a ferocious lion mauling a hapless bull, the talons of one paw digging into the back of the bull's neck while the fierce teeth sink into the bull's throat. The body of the lion is treated smoothly, with an incised band wrapped around the belly; the mane is indicated by irregular groups of incisions. The head of the bull with its long, projecting horns is reminiscent of the cow-and-calf plaques from Arslan Tash and Nimrud. The bull's long tongue, protruding from its open mouth, vividly illustrates the death throes of the suffering animal.

This scene is carved in relief and bordered by a molded frame. The eyes of both animals were originally inlaid. A long tenon with a stud hole on the right and a fragment of another at the lower left corner served to hold the inlay in place. The Hebrew-Phoenician letter *taw* was incised on the back as a guide for placing the piece into the correct position. Despite its miniature scale, this self-contained scene conveys the tension and brute force behind the struggle between these mighty animals.

The subject of animals in combat is among the oldest used in Near Eastern and Mycenaean narrative art. There are numerous comparisons to this scene, such as the depictions of a lion and griffin overwhelming a bull on an ivory mirror handle from Enkomi and on an ivory plaque from the tomb of Ahiram in Byblos. The subject occurs again on an ivory comb from Megiddo, which shows an ibex attacked by a dog. It appears several times on ivory pyxides from Nimrud and is also known from stone reliefs at Carchemish.

REFERENCE: *J. W. Crowfoot and G. M. Crowfoot, *Early Ivories from Samaria*, London, 1938, p. 25.

82. Striding Sphinx

Ivory; height 8.7 cm. (3⅜ in.)
IDAM 33.2572

This openwork ivory plaque, which is part of a larger panel, represents a sphinx striding through a thicket of lotus blossoms. It is framed by a triple border; two

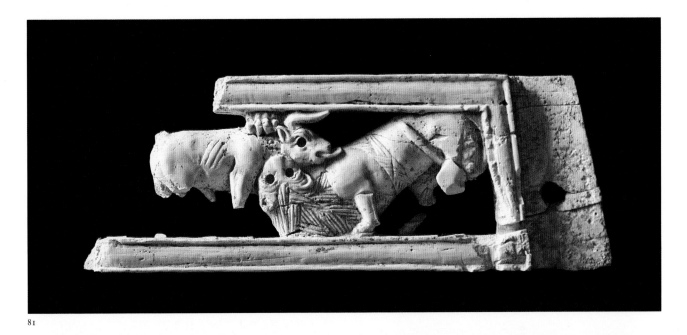

81

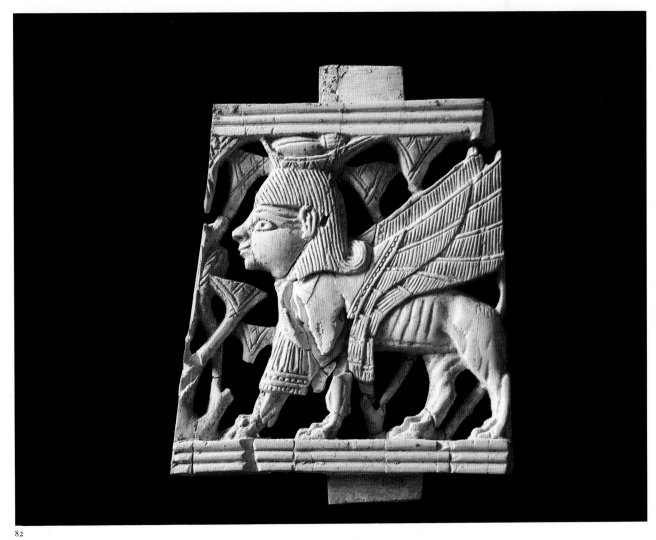

82

167

83

tenons extend above and below for inserting the plaque into a piece of wooden furniture.

The sphinx, depicted in profile, facing left, has a large beardless human face, relatively small hindquarters, and highly exaggerated claws. The face is naturalistically carved with deeply incised slanting eyes and eyebrows, a projecting nose, a well-shaped mouth, and a detailed ear. An Egyptian curled wig, rendered by vertically incised lines, is surmounted by the flattened double crown of Egypt. The spread wings are divided into segments, the feathers indicated by incisions. The figure wears a vertically fluted kilt bordered with beads. The rib cage and musculature of the body and legs are very realistically shown.

Except for small variations in proportions and coiffure, this sphinx closely resembles fine pieces from Nimrud. It shares many details with sphinxes from Arslan Tash and shows strong links with a basalt relief of a walking sphinx, found reused as a building block in the wall of the Umayyad mosque in Damascus.

The sphinx motif was among the Egyptian elements that the Phoenician artisans adopted and then transmitted through their glyptic art. Sphinxes in Phoenician art were often represented flanking the sacred tree, and that may well have been the case with this sphinx. Such an arrangement would be in accord with the Phoenician preference for symmetry.

It is generally accepted that human-headed lions with spread wings can be identified with the biblical cherubim in the description of the Tabernacle (Exodus 25:19), the holy of holies in Solomon's Temple (1 Kings 6:23–28), and Ezekiel's vision (Ezekiel 41:20).

REFERENCES: *J. W. Crowfoot and G. M. Crowfoot, *Early Ivories from Samaria*, London, 1938, p. 20; R. Hestrin, in *Highlights of Archaeology: The Israel Museum*, Jerusalem, 1984, pp. 68–69.

83. Sacred-Tree Plaque

Ivory; 17.6 × 3.4 cm. (6⅞ × 1⅜ in.)
IDAM 33.2565

This ivory panel, delicately carved in high relief, depicts a vertical line of trees representing the sacred-tree motif. From the trunk of each tree springs a pair of lotus blossoms or buds. Tapering upward, the trunk terminates in a voluted capital with a central triangle. A broad fan-shaped palmette rises above each pair of volutes. The motif of voluted capitals is linked with the architectural capitals of the Proto-Aeolic style that have been found at Samaria, Hazor, Jerusa-

lem, Ramat Rahel, and other sites. It has been suggested that the alternating lotus blossoms and buds represent birth and maturity.

The sacred tree is a well-known theme, especially in the glyptic art of Mesopotamia, Phoenicia, and North Syria. This motif, often flanked by human or animal figures, was used in mythological contexts from the third millennium B.C. It continued to appear throughout the second millennium and became particularly popular in the first, often serving as a border decoration. The present design of continuous stylized palm trees is the most beautiful of its kind and brings to mind the descriptions of the decorations in Solomon's Temple (1 Kings 6:29–32).

REFERENCE: *J. W. Crowfoot and G. M. Crowfoot, *Early Ivories from Samaria*, London, 1938, p. 21.

84. Two Crouching Lions

Ivory; height 4 cm. (1⅝ in.)
IDAM 33.2557, 33.2558

This pair of crouching lions is the finest example of ivory carved in the round that has been uncovered at Samaria. The two lions are identical; they are naturalistically represented, resting on their haunches, heads raised and mouths open in a roar. Traces of red coloring are preserved in their mouths, but there is no sign of the protruding tongue that is so common in the Neo-Hittite representations of lions. The eye sockets were originally inlaid with glass or paste. The sharply defined ears, one of which is undamaged, are positioned at the top of the head. The bodies are treated smoothly; the shoulders and hindquarters are delicately modeled, and the legs and paws are carved in detail. The dense manes are represented by irregularly arranged groups of incisions, recalling that of the lion in cat. no. 81.

The slots in the backs of the figures indicate that they were originally attached to something, probably a piece of furniture. The holes drilled in the sides were for pegs that fastened the lions to the piece inserted in their backs. The additional hole in each rump probably served a similar purpose; it was also the point at which a tail must have been affixed.

Strikingly close parallels come from Zinjirli where ivory lions with similarly rendered open mouths and disheveled manes were found. Further comparisons can be made with lions from Thasos in Greece and, to some extent, with lion heads from Arslan Tash.

The lions shown here bring to mind the description of Solomon's ivory throne (1 Kings 10:19–20): "The throne had . . . arms on either side of the seat. Two lions stood beside the arms, and twelve lions stood on the six steps, six on either side."

REFERENCE: *J. W. Crowfoot and G. M. Crowfoot, *Early Ivories from Samaria*, London, 1938, p. 24.

84

85. Balustrade

Ramat Rahel
Late 8th–early 7th century B.C.
Limestone; 37 × 125 cm. (14⅝ × 49¼ in.)
Excavations of the Hebrew University,
Jerusalem, the University of Rome, the Israel
Department of Antiquities and Museums, and
the Israel Exploration Society
IDAM 64–1287

Little has survived of royal architecture and decorative art in Israelite and Judaean cities. However, some sites have yielded remains of architectural ornamentation, of which this window balustrade is one of the finest examples. It and several additional balustrade fragments were uncovered in the ruins of a royal Judaean palace at Ramat Rahel, situated midway between Jerusalem and Bethlehem. The monumental construction of the palace and the ashlar masonry are similar to those of the palace precinct of Samaria.

The balustrade consists of a row of identical colonnettes, each carved in the round in several sections, which include a flat-bottomed shaft, a wreath of drooping petals with molded rings of varying width above and below, and a voluted capital. The separately made colonnettes were joined to the capitals by metal clamps inserted into holes. The colonnettes were arranged in a row and surmounted by a lintel, which has not survived. Two slots, their position marked by red ocher lines, served to attach the lintel to the tops of the capitals.

The well-known motif of "the woman at the window" (fig. 62), represented on carved ivory plaques from Samaria, Arslan Tash, and Nimrud, has provided a vivid illustration of the function of this balustrade as a railing in a palace window. On the plaques the woman looks out a window behind an identical balustrade.

The design of the voluted capitals, derived from the stylized palm-tree motif, is a scaled-down version of the monumental Proto–Aeolic capitals which generally crowned jambs of doorways or pilasters and

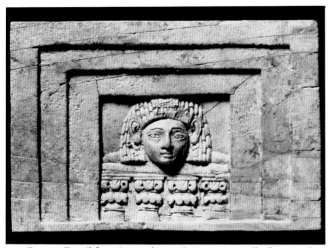

FIG. 62. Detail from ivory plaque. Syrian, reportedly from Arslan Tash, 8th century B.C. Photograph: The Metropolitan Museum of Art (Fletcher Fund, 1957, 57.80.11).

which have been found in the excavations of Samaria, Jerusalem, Hazor, Megiddo, and other sites. A fragment of a colonnette similar to the Ramat Rahel balustrade has recently been found in the excavations of the City of David in Jerusalem, and balustrades of the same type are depicted in stone bas-reliefs from Ramat Rahel and Episkopi in Cyprus.

The architecture at Ramat Rahel and other royal centers reflects Phoenician influence, which began in the time of Solomon, who brought in Phoenician builders and artisans for the construction of the Temple and the king's palace. Elements of this style were incorporated into local traditions, thus creating a distinctive architectural style that became the hallmark of Judaean and Israelite royal cities.

REFERENCES: *Y. Aharoni, *Excavations at Ramat Rahel, Seasons 1961 and 1962*, Rome, 1964, pp. 56–58; P. P. Betancourt, *The Aeolic Style in Architecture*, Princeton, 1977, pp. 40–43; Y. Shiloh, The Proto-Aeolic Capital and Israelite Ashlar Masonry, *Qedem* 11 (1979).

POTTERY MASKS FROM AKHZIV
Cat. nos. 86 and 87

7th–6th century B.C.

An extensive cemetery containing rock-cut tombs was excavated at Akhziv, an ancient harbor located on the southern coast of Phoenicia, north of the port of Akko. The Phoenician tombs, dated to the seventh–sixth century B.C., have yielded a wealth of funerary equipment. Two masks and a figurine of a pregnant woman (cat. nos. 86–88) represent only a small portion of these finds.

Anthropomorphic masks were in use as early as the seventh millennium B.C. (see the Nahal Hemar mask, cat. no. 6), and their use is attested almost without interruption from the Late Bronze Age onward (see the Hazor mask, cat. no. 43). Anthropomorphic pottery masks, both male and female and executed in naturalistic or grotesque style, were common in the Phoenician culture of the seventh and sixth centuries

B.C. and are known from such sites as Khalde and Sarepta along the eastern Mediterranean coast. In the wake of the Phoenician expansion westward, such masks also appear at Punic sites. Several were discovered in Cyprus, dating to the Late Cypriot III period.

Most of the masks are smaller than life-size and could not have been worn by adults—rather, as the suspension holes indicate, they may have been hung on walls or on statues. Many were found in tombs, while others, such as the fragments from Sarepta as well as the masks from Kition, came from sanctuaries. Those placed in tombs may have served to ward off evil spirits, while those found in shrines probably formed part of the cultic equipment or may have been votive offerings.

REFERENCES: P. Cintas, *Amulettes puniques*, Tunis, 1946, pp. 32–64; *W. Culican, Some Phoenician Masks and Other Terracottas, *Berytus* 24 (1975–76), pp. 47–87; E. Stern, Phoenician Masks and Pendants, *Palestine Exploration Quarterly* 108 (1976), pp. 109–18; R. Hestrin and M. Dayagi-Mendels, Two Phoenician Pottery Masks, *Israel Museum News* 16 (1980), pp. 83–88.

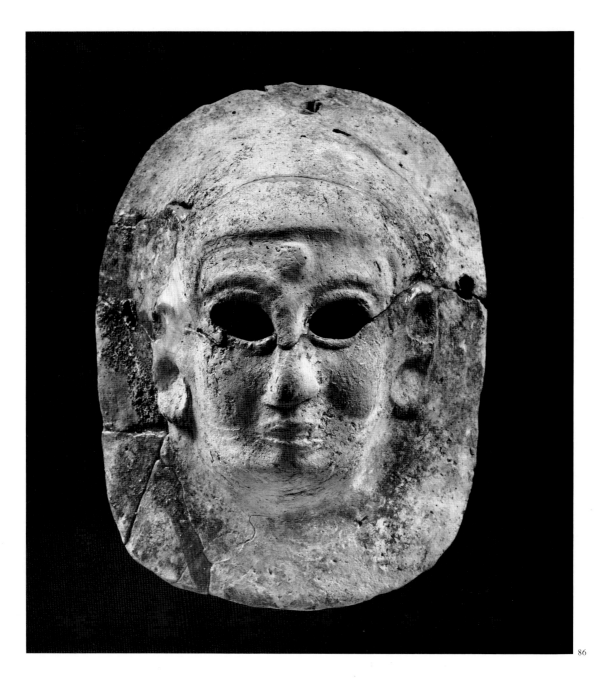

86

86. Mask of a Woman

Pottery; 14 × 11 cm. (5½ × 4⅜ in.)
Excavations of the Israel Department of
Antiquities and Museums and the University
of Rome
IDAM 61–562

This strikingly beautiful mask of a young woman
conveys a mood of dignity and restraint, marked by
the soft and elegant modeling of the individual fea-
tures. Smaller than life-size and sensitively shaped by
hand, the mask includes the upper part of the neck,
the face, and the headdress. The wide cutout eyes,
well-proportioned nose, softly contoured cheeks, and
delicately defined lips endow the face with a consider-
able degree of naturalism. The hair and headdress are
indicated in black and red paint, leaving the clearly
delineated ears uncovered. Three perforations, one on
top of the head and two behind the ears, served for
threading a suspension cord.

A raised disk in the center of the forehead is a well-
known mark that occurs mainly on Punic masks and
may be a divine symbol. This mask belongs to the
Phoenician tradition of pottery masks, and it is very
similar to another mask also found at Akhziv.

REFERENCE: *W. Culican, Some Phoenician Masks and Other
Terracottas, *Berytus* 24 (1975–76), p. 57, fig. 16.

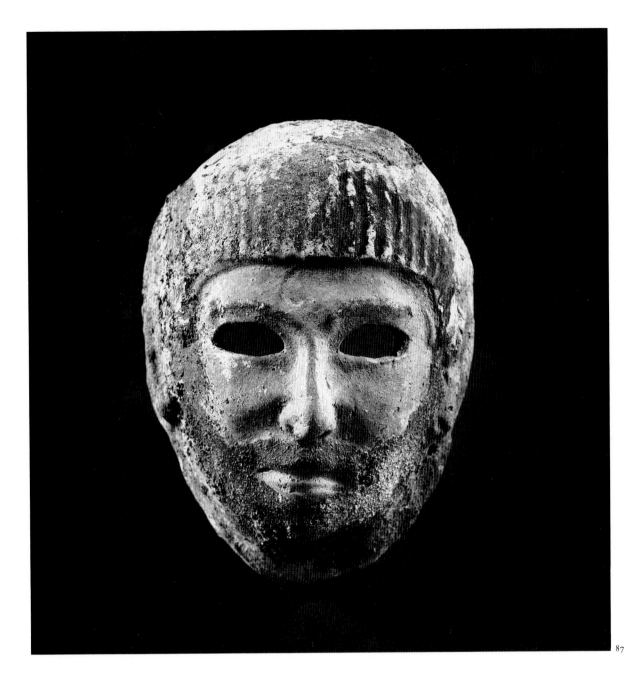

87

87. Mask of a Man

Pottery; 13.2 × 9.7 cm. (5¼ × 3⅞ in.)
Purchased at Akhziv
IDAM 45.1

This well-preserved mask, portraying the face of a man, was shaped by hand and is smaller than life-size. The carefully modeled features include many naturalistic details. The elongated oval eyes are cut out, the cheekbones are high, the ears are well sculpted, and the prominent nose forms a continuous line from the well-defined black-painted eyebrows. The full lower lip of the closed mouth is visible, while the upper one is concealed by a black mustache. The chin is hidden by a black beard which, together with the sideburns and hairline, frames the face. The black-painted hair and beard contrast vividly with the red-slipped face. Parallel grooves define the hair which partially covers the forehead and continues upward. The three suspension holes, one at the top and two below the ears, were made before the mask was fired.

Executed in Phoenician style, the mask closely resembles one in Kition (Cyprus) that was found there in a building which may have been a sanctuary.

REFERENCES: *W. Culican, Some Phoenician Masks and Other Terracottas, *Berytus* 24 (1975–76), p. 55, fig. 10; V. Karageorghis, *Kition: Mycenaean and Phoenician Discoveries in Cyprus*, London, 1976, pl. XVI.

173

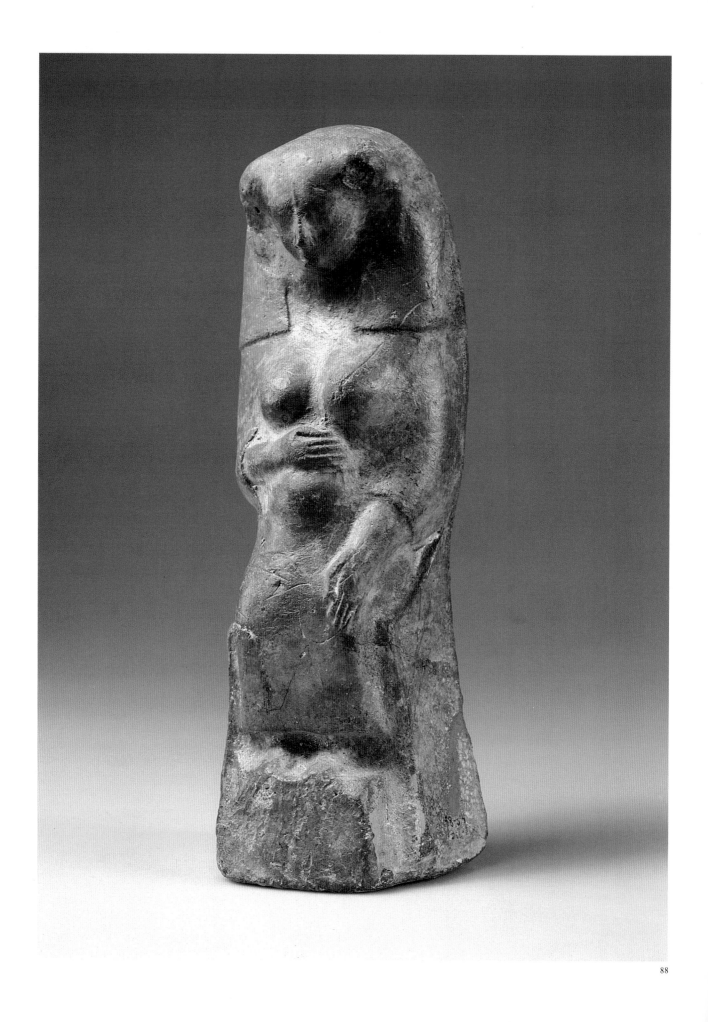

88. Figurine of a Pregnant Woman

Akhziv
7th–6th century B.C.
Pottery; height 23.5 cm. (9¼ in.)
Excavations of the Israel Department of
Antiquities and Museums and the University
of Rome
IDAM 58–314

This sensitively rendered statuette of a pregnant woman was uncovered in a tomb excavated in the Phoenician cemetery at Akhziv. Beautifully preserved and with naturalistic features, she is probably the finest specimen of this type found to date. In her grace and contemplative stillness, she is the embodiment of a woman patiently awaiting the birth of her child.

The woman is depicted seated on a chair, her feet resting on a stool. Her face is softly modeled with a faint archaic smile playing around her lips. The two projections on the sides of her slightly inclined head may indicate curls. An Egyptian-style wig frames her face and ends well below the shoulder line. She wears a plain, long-sleeved robe, seemingly made of a soft material, which subtly clings to her full breasts and distended belly. One of her hands rests on her lap, while the other is placed over her abdomen in the universal gesture of the expectant mother.

The figurine was made in two parts, leaving the interior hollow and the base open. The front and sides were cast in a mold; the plain back was then added by hand and the surface smoothly finished.

Many such figurines are known, mainly from sites ascribed to the Phoenicians along the eastern coast of the Mediterranean and in Cyprus. They have been found on numerous sites in Israel, such as Tell Zippor, Makmish, Tell Abu Hawam, and Beth Shean. Evidently, they had religious or magical properties, but it has not been determined whether they represent a deity associated with childbirth or were amulets to ensure fecundity or easy delivery.

REFERENCES: *M. W. Prausnitz, Notes and News: Achzib, *Israel Exploration Journal* 9 (1959), p. 271; W. Culican, Dea Tyria Gravida, *The Australian Journal of Biblical Archaeology* 1, 2 (1969), pp. 35–50; R. Hestrin, in *Highlights of Archaeology: The Israel Museum*, Jerusalem, 1984, pp. 76–77.

ANCIENT HEBREW SCRIPT
Cat. nos. 89–94

When alphabetic writing was invented in about the seventeenth century B.C., other writing systems had already been in use for a long time. The invention of the alphabet was, however, a revolutionary step in the spread of literacy, which had previously been limited to specially educated individuals.

The earliest evidence of an alphabetic script comes from Canaan. Based on a limited number of signs, it consisted of pictures that symbolized the initial sound of the object depicted (this system is known as acrophony). Consequently, unlike Mesopotamian and Egyptian writing, which required the knowledge of hundreds of signs, the alphabetic system had only twenty to thirty signs and thus greatly simplified reading and writing.

The earliest alphabetic inscriptions in the Proto-Canaanite script, dating from about the seventeenth century B.C., were found at Gezer, Beth Shemesh, and Lachish. These antedate the Proto-Sinaitic inscriptions (dated to ca. 1500 B.C.) discovered at Serabit el-Khadem in the Sinai Peninsula. However, it was not before the mid-eleventh century B.C. that the final evolution from pictographic to linear forms took place, and the shapes of the twenty-two letters, their order, and the direction of writing became stabilized. At this stage the script is termed Phoenician.

The early Hebrew script branched off from either the Proto-Canaanite or the Phoenician script. At first the Hebrew alphabet differed little

FIG. 63. The Siloam Inscription. Jerusalem, late 8th century B.C. Photograph: Istanbul Arkeoloji Müzerleri.

from the Phoenician, and therefore it is difficult to determine whether a particular inscription is in Hebrew or Phoenician. Among the scanty epigraphic data from this period, an inscription found at Izbet Sartah, dating from the twelfth century B.C., stands out as extraordinary. It consists of eighty letters written in five lines by an unskilled hand and was probably an exercise in writing the alphabet. Despite the difficulties in interpreting this text, it provides important evidence that writing was practiced even in a small Israelite settlement in the days of the Judges.

Very few Hebrew inscriptions from the days of the United Monarchy have survived. The earliest seems to be the Gezer calendar of the tenth century B.C., the script of which still resembles Phoenician letter shapes from Byblos. It was only after Solomon's reign, toward the middle of the ninth century B.C., that the Hebrew script developed independent features and became widespread. Ironically, the earliest evidence of the distinctive features of Hebrew script in the ninth century B.C. comes from the Mesha Stela, a commemorative inscription de-

scribing the deeds of the king of Moab, which was written in the Moabite language but in Hebrew script. Kuntillet Ajrud, a religious center in northeastern Sinai, has provided a major contribution to knowledge of Hebrew script in the late ninth–early eighth century B.C. The inscriptions there were incised on stone vessels and written in black and red ink on pithoi and on stuccoed walls.

The majority of ancient Hebrew inscriptions date from the latter part of the First Temple period (that is, the eighth through the early sixth century B.C.) and include inscriptions written by professional scribes as well as by less skilled hands. It was then that the practice of writing reached its fullest extent, literacy being relatively common. These inscriptions, though of little aesthetic appeal, are a crucial source of information about this period.

Most of the surviving records are written on nonperishable materials: the majority are written in ink on potsherds (ostraca) or on pottery vessels, but some are carved in stone or incised on pottery. There is little evidence of a lapidary

script, for unlike the other peoples of the ancient Near East, the Hebrews apparently did not make it a custom to erect royal monumental inscriptions. However, one fine exception is the Siloam inscription found in Jerusalem (figs. 63 and 64). Dating to Hezekiah's reign (on the eve of the Assyrian invasion in 701 B.C.), it commemorates the completion of a rock-hewn tunnel, part of the system designed to bring water into Jerusalem from an underground spring. Only a few burial inscriptions have survived from the time of the Monarchy, among them the inscription of the royal steward in Jerusalem.

Papyrus inscribed in ink was a primary medium for recording matters of the court and the Temple. Unfortunately, papyruses have generally not survived in the humid soil. One exception is a document found in a cave in Wadi Murabbaat, which was preserved because of the dryness of the Judaean Desert. Proof of the widespread use of papyrus is found in the numerous bullae (clay seals from rolled-up papyrus documents) that have survived (fig. 65). A group of some fifty such bullae dating to the early sixth century B.C. has recently been uncovered in the excavations of the City of David in Jerusalem.

Ostraca, the most common Hebrew epigraphic documents, have been found at many sites and provide important information about contemporaneous social, administrative, and political matters. Sixty-three ostraca from the palace at Samaria constitute the most important group of inscribed documents from the Northern Kingdom of Israel. They were probably labels of wine and oil jars kept in the royal storehouses. Administrative matters are reflected in the Arad documents, which include about one hundred ostraca dating mainly from the seventh and early sixth centuries B.C. (see cat. no. 94). Some of these ostraca bear a single name, often a priestly one known from the Bible, while others are concerned with orders for the supply of wine, oil, and flour. Of special historical significance are the ostraca from Lachish, which in-

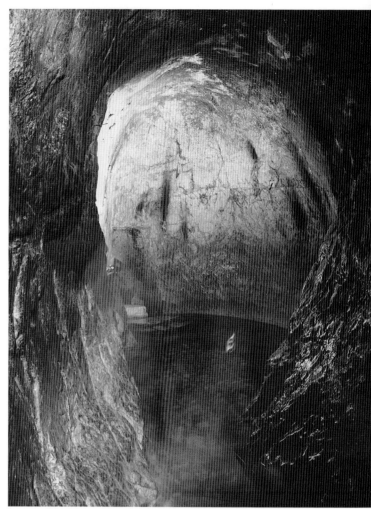

FIG. 64. The Siloam Tunnel in Jerusalem, built by Hezekiah. Late 8th century B.C. Photograph: David Harris.

clude eighteen letters written in the style of the Book of Kings and the prose chapters of Jeremiah. Discovered in the guardroom between the outer and inner city gates in a layer of ashes, they shed much light on the situation on the eve of the Babylonian conquest of the city in 587/586 B.C.

Further epigraphic material is recorded on pottery vessels bearing brief inscriptions that give the owner's name, the contents, or the place of origin. To these should be added the numerous stamped jar-handles which are inscribed with the word *lamelekh* ([belonging] to the king) and the name of one of four cities in Judah. These stamps may indicate that the jars were used for collecting taxes and army supplies. Such stamped jar-handles have been found in great numbers

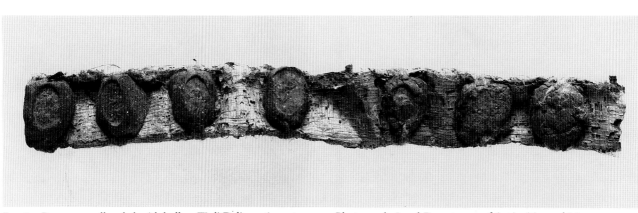

FIG. 65. Papyrus scroll sealed with bullae. Wadi Daliya; 4th century B.C. Photograph: Israel Department of Antiquities and Museums.

at most Judaean sites, dating to the reign of Hezekiah in the late eighth century B.C.

A very special group is formed by the numerous inscribed seals which, in addition to reflecting artistic traditions, convey information about administration, religion, and customs, as well as about the onomasticon in the First Temple period (see cat. nos. 89–93). While some seals display fine artistic skill, others are of poorer workmanship, testifying to their popularity and widespread use among all social classes. Some seals are decorated with designs, mainly derived from ancient Near Eastern mythology, which had become merely ornamental motifs. But most seals are undecorated, bearing only the name of their owner, usually accompanied by that of his father or his title. The seals were generally made of semiprecious stones, limestone, bronze, silver, ivory, or glass. Usually oval (scaraboid) in shape, they were pierced either to be worn suspended from the neck or to be set into a ring.

A distinctive group of seals is inscribed with titles of high-ranking functionaries; many of these titles, such as "royal steward," "scribe," and "servant of the king," are mentioned in the

Bible. Unfortunately no seal or seal impression of a king has as yet been discovered in Israel. The names on the seals are mainly theophoric, containing either a divine name (for example, Amarel and Yirmeyahu) or a divine epithet (for example, Malkiyahu and Adonyah). Shortened names in which the divine element has been either totally or partially omitted (for example, Shaphat) also occur.

The Hebrew script was in daily use until the destruction of the First Temple, when a large part of the population was exiled to Babylonia. The Jews who returned from exile following the Edict of Cyrus spoke Aramaic, the official language of the Persian empire, and wrote in the Aramaic script, from which the modern square Hebrew script evolved.

REFERENCES: R. Hestrin, in *Inscriptions Reveal*, Israel Museum cat. no. 100, Jerusalem, 1973; F. M. Cross, Early Alphabetic Scripts, in *Symposia Celebrating the Seventy-fifth Anniversary of the Founding of the American Schools of Oriental Research (1900–1975)*, Cambridge, 1979, pp. 97–123; R. Hestrin and M. Dayagi-Mendels, *Inscribed Seals—First Temple Period: Hebrew, Ammonite, Moabite, Phoenician and Aramaic*, Jerusalem, 1979; J. Naveh, *Early History of the Alphabet*, Jerusalem, 1982; K. N. Schonville et al., *Sign, Symbol, Script: An Exhibition of the Origins of Writing and the Alphabet*, Madison, Wis., 1984, pp. 32–44.

89. Seal of Jezebel

Provenance unknown
9th–8th century B.C.
Opal; 3.1 × 2.1 × 1.1 cm. (1¼ × ⅞ × ⅜ in.)
IDAM 65–321

This scaraboid seal of gray opal, exceptional in size and workmanship, is richly ornamented in a symmetrical arrangement. The oval base is divided into two registers by a single line. In the upper register a crouching sphinx with a raised tail is depicted wearing an Egyptian headdress and holding an ankh, the Egyptian symbol of life, between its forelegs. The lower register, topped by a winged solar disk, contains a composite scene: a hawk with a flail on its back faces in the same direction as the sphinx and is flanked by two uraei, each with a disk above its head. At the feet of the hawk is a stylized floral space filler, perhaps a lotus blossom.

The seal must have been acquired by its owner af-ter its carving had been completed, and thus the letters of the owner's name had to be dispersed among the motifs in the lower register.

This Phoenician seal bears the name Yezebel (biblical Izebel/Jezebel), recorded in the Bible as the wife of Ahab, king of Israel, and daughter of Ethbaal, king of the Sidonians. Several Phoenician names are compounded with the element *zbl*, and the name Jezebel means "the god Zebul exists." However, though a seal of such quality could have belonged to a queen, there is not sufficient evidence to identify its owner with the biblical Jezebel.

This seal belongs to a relatively small group of seals bearing women's names, which testifies to the elevated social position that women occupied in ancient Israel and in neighboring countries.

REFERENCES: *N. Avigad, The Seal of Jezebel, *Israel Exploration Journal* 14 (1964), pp. 274–76; R. Hestrin and M. Dayagi-Mendels, *Inscribed Seals—First Temple Period: Hebrew, Ammonite, Moabite, Phoenician and Aramaic*, Jerusalem, 1979, p. 48.

89: top, center; 90: top left; 91: bottom right; 92: bottom left; 93: top right. Schematic drawings of the seal impressions appear in Appendix 2.

90. Seal of Shaphat

Provenance unknown
8th century B.C.
Amazonite mounted in gold; seal 1.5 × 1.1 ×
0.5 cm. (5/8 × 3/8 × 1/4 in.), setting 2.5 × 2.3 cm.
(1 × 7/8 in.)
IMJ 71.70.220

This signet ring, the finest of its kind, consists of an oval seal of green amazonite mounted in a gold ring. The joints where the band meets the casing are beautifully worked in the shape of papyrus flowers. The sharp edges of the band, which is square in section, make the ring unsuitable for wearing on the finger, and it was probably worn suspended from the neck. A gold ring of similar design but set with a scarab seal was found in the excavations of Samaria.

The richly decorated flat base of the seal is framed by a single line and divided into two registers of unequal size. The center of the seal is occupied by a four-winged uraeus wearing the crown of Lower Egypt, and below it is a papyrus flower which repeats the design on the setting. The upper register, separated by a horizontal line, contains a row of six uraei.

Four-winged uraei are well attested on Hebrew seals and are also found in Phoenician art. The motifs on the seal reflect a strong Phoenician influence, incorporating Egyptian symbols which had probably lost their original religious significance.

The inscription—"(belonging) to Shaphat"—was probably incised after the seal had already been carved, and thus the letters had to be scattered among the decorative elements. Shaphat is a common biblical name, a hypocoristicon (shortened form) of names such as Shephatyahu, Jehoshaphat, and Shephatel, meaning "God has judged."

Hebrew seals mounted in gold are extremely rare, and in this context this ring is even more special. The relatively small amount of gold and silver jewelry known from the Israelite period may be explained by the biblical passages referring to the heavy tributes paid to foreign conquerors (for example, 1 Kings 14:26; 2 Kings 12:19).

REFERENCES: G. A. Reisner et al., *Harvard Excavations at Samaria, 1908–1910 II*, Cambridge, 1924, pl. 56:d; *I. Ben Dor, Two Hebrew Seals, *Quarterly of the Department of Antiquities in Palestine* 13 (1947), pp. 64–66; R. Hestrin and M. Dayagi-Mendels, *Inscribed Seals—First Temple Period: Hebrew, Ammonite, Moabite, Phoenician and Aramaic*, Jerusalem, 1979, p. 61.

91. Seal of Jeremiah

Provenance unknown
8th century B.C.
Carnelian; 0.7 × 0.9 × 0.5 cm. (1/4 × 3/8 × 1/4 in.)
IMJ 71.93
Teddy and Tamar Kollek Collection, displayed at the Israel Museum

This tiny perforated scaraboid seal of brown carnelian may have originally been mounted in a ring. Its convex, decorated side is framed by a single line and divided into two registers by a double line. The upper register depicts a grazing gazelle; this motif was popular in North Syrian and Phoenician ivories and is repeated on several other Hebrew seals. The lower register bears the inscription "(belonging) to Yirmeyahu [Jeremiah]," incised in the ancient Hebrew script. This well-known biblical name, meaning "God will lift up" or "God is exalted," is recorded on other contemporaneous seals and documents, most notably the Lachish letters, written just months before the destruction of the First Temple in 587/586 B.C.

The excellent workmanship of this seal proves that it was carved by a master who, with a few simple lines, captured the graceful movement of the gazelle.

REFERENCES: *N. Avigad, A Group of Hebrew Seals, *Eretz-Israel* 9 (1969), p. 6 (Hebrew), English summary, p. 134*; R. Hestrin and M. Dayagi-Mendels, *Inscribed Seals—First Temple Period: Hebrew, Ammonite, Moabite, Phoenician and Aramaic*, Jerusalem, 1979, p. 69.

92. Seal of Yaazanyahu, Servant of the King

Mizpah (Tell en-Nasbeh)
Late 8th–7th century B.C.
Agate; 1.9 × 1.8 × 1.2 cm. (3/4 × 3/4 × 1/2 in.)
Excavations of the Pacific Institute of Religion, Berkeley, California
IDAM 32.2525

This dome-shaped seal of gray and brown agate is divided into three registers by two double lines. The lowest register displays a fighting cock in a combative stance, with a tense neck and erect comb. This superbly executed motif occurs on only one other Hebrew seal, that of "Yehoahaz, son of the king," which is almost identical but inferior in quality. It has been suggested

that the rooster was a family emblem of these two officials. In this context, the depiction of a fowl, incised on a cooking-pot handle from Gibeon, is of interest.

In the two upper registers of the seal are carved the name and the title of the seal's owner, "(belonging) to Yaazanyahu, servant of the king." The name, which means "God will listen," is mentioned in the Bible (2 Kings 25:23) as that of an official of Gedaliah, son of Ahiqam, and is also known from the Lachish letters, the Arad ostraca, and the papyruses from Elephantine in Egypt.

The title "servant of the king" was borne by high-ranking officials in the royal administration and is known from the Bible (2 Kings 22:12) and other sources, but the functions of the officials bearing this title are unspecified. Unfortunately this seal does not disclose the name of the king at whose court Yaazanyahu served.

Many seals are chance finds, but this example was found in a stratified excavation. It belongs to an important group of seals owned by royal functionaries that adds significantly to knowledge of the organization and administration of the royal courts of Israel and Judah.

REFERENCES: *C. C. McCown, *Tell en-Nasbeh I: Archaeological and Historical Results*, Berkeley and New Haven, 1947, p. 163; R. Hestrin and M. Dayagi-Mendels, *Inscribed Seals—First Temple Period: Hebrew, Ammonite, Moabite, Phoenician and Aramaic*, Jerusalem, 1979, p. 20.

93. Seal of Maadana, the King's Daughter

Provenance unknown
7th century B.C.
Jasper; 1.3 × 1 × 0.6 cm. (½ × ⅜ × ¼ in.)
IMJ 80.16.57

This tiny seal of excellent craftsmanship belonged to Princess Maadana, the daughter of one of the kings of Judah, whose name unfortunately does not appear in the inscription.

The scaraboid brown-jasper seal is perforated lengthwise. A lyre is carved at the top, and below it the name of the seal's owner is engraved in two lines in the ancient Hebrew script: "(belonging) to Maadana / daughter of the king." The previously unknown name "Maadana" is derived from a Hebrew root meaning "delight."

The lyre represented on the seal is of the asymmetrical type and consists of a sound box with two elegantly curved arms of unequal length connected by a crossbar to which twelve strings are fastened. The center of the sound box is ornamented with a rosette, and a frame of pearls runs around its edge.

The lyre is considered to be the musical instrument closest to the kinnor of David or to that played in the Temple in Jerusalem. Was there a connection between this motif and the owner of the seal? Perhaps Princess Maadana had her seal carved with the emblem of a lyre because she played this instrument.

REFERENCES: *N. Avigad, The King's Daughter and the Lyre, *Israel Exploration Journal* 28 (1978), pp. 146–51; R. Hestrin, in *Highlights of Archaeology: The Israel Museum*, Jerusalem, 1984, pp. 80–81.

94. "House of God" Ostracon

Arad
Early 6th century B.C.
Pottery; 6.2 × 4.3 cm. (2⅜ × 1¾ in.)
Excavations of the Israel Department of Antiquities and Museums, the Hebrew University, Jerusalem, and the Israel Exploration Society
IDAM 67–669

At Tell Arad in the Negev, a fortress was built during the eighth century B.C. on the ruins of an earlier Israelite fortress. Enclosing an area of some fifty square meters (sixty square yards), it was built to serve as a military post and administrative center; it included dwellings, workshops, storerooms, archives, and a temple which went out of use toward the end of the seventh century B.C. The fortress underwent various changes but continued in existence until the fall of the kingdom of Judah in the early sixth century B.C.

Excavations at the site revealed a collection of inscribed finds, constituting one of the most important discoveries in Hebrew epigraphy. Among the more than one hundred Hebrew ostraca—letters, lists, dockets, and so on—is a group of documents belonging to the archives of Elyashib, son of Eshiyahu, who was a high-ranking official, probably the commander of the citadel. They include orders for issuing specific quantities of supplies such as wine, flour, and oil to groups stopping over at the fortress. These documents were

94

written by professional scribes in biblical Hebrew prose, using the ancient Hebrew script.

The letter shown here is addressed to Elyashib. It was sent, presumably from Jerusalem, by one of his subordinates who was there on a mission of inquiry about a certain person: "To my lord Elyashib, may the Lord seek your welfare, and now: Give to Shemaryahu a lethech (?), and to the Kerosite give a homer (?), and as to the matter which you commanded me—it is well; he is in the House of God."

Elyashib is asked to supply some goods to Shemaryahu and to the "Kerosite"; he is also informed that all is well with the man about whom he inquired. The individual is in the "House of God," where he probably found refuge. This letter, written in the early sixth century B.C., must be seen as the earliest epigraphic reference to the Temple in Jerusalem.

REFERENCES: *Y. Aharoni, Arad Inscriptions, Jerusalem, 1981, inscription no. 18, pp. 35–38; R. Hestrin, in Highlights of Archaeology: The Israel Museum, Jerusalem, 1984, pp. 82–83.

PERSIAN PERIOD

587/586–332 B.C.

With the destruction of Jerusalem in 587/586 B.C. and the partial exile of the population of Judah to Babylonia, a new chapter in Jewish history began. Little is known of the first part of this period, which is usually termed "Babylonian" because of the Babylonian domination of Judah. The archaeological evidence shows that many of the southern cities of Judah were destroyed and that their population declined dramatically. However, the settlements in northern Judah continued to exist, though at a low ebb, and their material culture reflects a continuation of the traditions from the preceding period.

Another feature of this period is the spread of the neighboring peoples—Edomites, Ammonites, and Philistines—who penetrated various parts of Judah and settled there. The Shephelah (coastal lowlands) was in the hands of the Ashdodites, and Edomites settled in the Negev.

The conquest of Babylonia by the Persians in 539 B.C. proved a decisive turning point for the whole of the ancient Near East, including Israel. A new epoch now begins in the region, a period of imperial Persian domination, after which the local "Persian period" is named. Until 332 B.C., when the whole of the Near East was conquered by Alexander the Great, the Persians continued to rule this region. Their empire was the largest known to the ancient world, and its borders stretched from northern Africa to southern Russia and from Asia Minor to India.

The fall of Babylonia had far-reaching consequences for the entire region and particularly for the Jewish people. In 538 B.C. Cyrus issued the edict (Ezra 1:1–4) that permitted the Jewish exiles in Babylonia to return to Judah and rebuild the Temple in Jerusalem. This edict was part of Cyrus's policy to appear as the benefac-

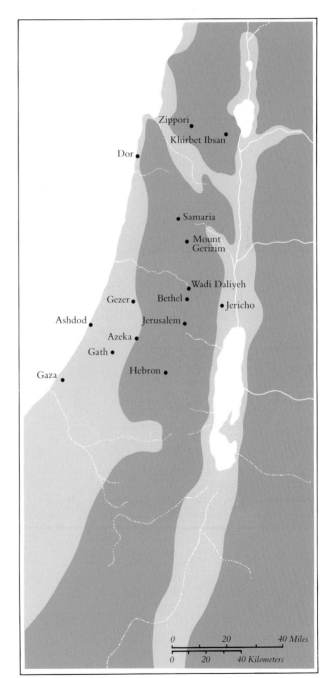

FIG. 66. Sites of the Persian period.

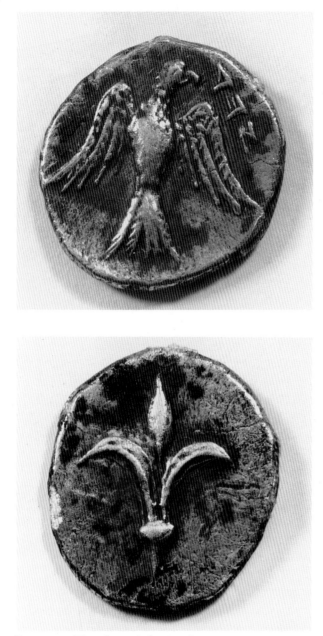

FIGS. 67, 68. Tiny silver coin bearing the name YHD (Jehud), a falcon, and a lily. 4th century B.C. Photograph: Israel Museum/David Harris.

tor of his subject peoples and as the restorer of temples in various parts of the empire. Following Cyrus's edict, groups of exiles returned from Babylonia, and in the reign of Darius I they rebuilt the ruined Temple in Jerusalem. Thus was laid the foundation of the material and spiritual restoration of the Jewish people in its land, and a long, complex chapter—the Second Temple period—began. The Temple was reconstructed and refurbished several times; it reached the height of its glory and fame in Herod's reign, only to be finally destroyed in A.D. 70.

The policy of the Assyrians, who brought new settlers to the ruined territory of northern Israel in the eighth century B.C., led in the course of time to the emergence of a new factor in the area—the Samaritans. At the time of the Temple's rebuilding, at the end of the sixth century B.C., a conflict developed between the Jews who had returned from Babylonia and the people in Samaria, who regarded themselves as co-religionists. Later, in the fourth century B.C., a rift developed between the ruling elite in Samaria and that in Jerusalem. The Samaritans built a temple on Mount Gerizim as a rival to that of Jerusalem and emerged as an independent religious-national entity.

In the administrative sphere, the Persian empire inherited the system of internal subdivision employed by the Assyrians and Babylonians. In addition to Syria, Phoenicia, and Cyprus, Samaria and Judah were included in the fifth satrapy of the empire—Abar-Nahara, or the Land Beyond the River (that is, the Euphrates) (Ezra 8:36). The territory of the province of Yehud (the official Aramaic name of Judah) was much smaller than that of the Judaean kingdom. In the south the border passed near Hebron; in the north it reached the area of Bethel, in the west Gezer and Azeka, and in the east En Gedi and Jericho. Among the other provinces in this satrapy were Samaria, Ashdod, and Gaza, all controlled by royal governors, who supervised administrative matters and tax collection. In fact, the principal Persian influence can be detected in the spheres of government and admin-

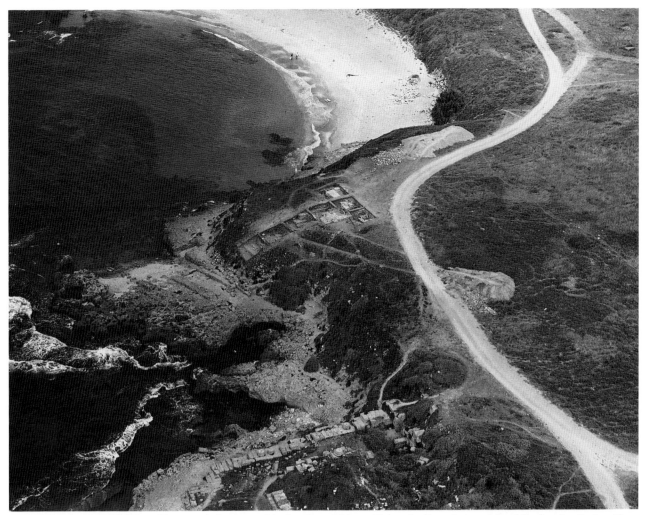

Fig. 69. Aerial view of Tell Dor. Photograph: Institute of Archaeology, Hebrew University, Jerusalem, and Israel Exploration Society/Ilan Stulman.

istration. In this period coins began to come into use for the first time in this area. The coins in circulation in the sixth century B.C. included examples from Greece and the Phoenician cities, as well as locally minted coins. The earliest Greek coin found in Israel was discovered in the excavations of the Shoulder of Hinnom in Jerusalem. It dates to the sixth century B.C. and was probably minted on Kos, a small island in the Aegean. Particularly interesting are the small silver coins inscribed with the name "Yehud" (figs. 67 and 68). This name also appears on numerous stamped jar-handles.

One of the results of Persian rule was the increasing use among the Jews of Aramaic, the official language used in the western part of the empire, and the consequent decline of the use of Hebrew. The inhabitants of Judah also adopted the Aramaic script, from which the square Hebrew script developed.

Important sources for the study of this period are the biblical books of Ezra, Nehemiah, Isaiah (chapters 40–66), Haggai, Zachariah, Malachi, and Esther and several chapters of Chronicles. Various apocryphal books and the writings of Josephus, as well as the Aramaic documents discovered in a Jewish settlement at Elephantine in southern Egypt and the Samaritan documents from Wadi Daliyeh, provide additional information. The coastal area is mentioned in the writings of Greek historians such as Herodotus.

From an archaeological viewpoint, this peri-

od was, until recently, one of the most obscure in the history of Israel, and only because of recent excavations is a clearer picture beginning to emerge. Some continuity of tradition from the preceding period can be traced in the material culture of the Judaean hill country. Pottery vessels, reminiscent in shape and burnish of the vessels of the preceding period, have been found with ceramic vessels that incorporate Assyrian and Egyptian elements. In contrast, a new material culture appears in the coastal area and Galilee, characterized mainly by objects imported from Greece, Cyprus, Egypt, Persia, and the Phoenician cities. Most of the surviving objects, of which a high proportion are imports, were found as grave goods. These included superb metal artifacts, figurines, alabaster, faience, and glass vessels, cosmetic utensils, and gold and bronze jewelry.

In spite of the external and internal wars that plagued the Persian empire, the Persian authorities kept the roads relatively safe and thus encouraged the flourishing of international trade and cultural interaction between countries of the region, among which the land of Israel played an important part. The Phoenician cities, which handled the trade between the Near East and the Mediterranean basin, had an influential role in this system.

The urban character of this period is attested principally by the coastal cities, which were densely populated. Recent excavations, especially those at Dor, reveal a picture of urban planning with streets laid out at right angles on a type of Hippodamian plan with buildings of the open-court style (fig. 69). There is almost no knowledge of contemporaneous fortifications, as only scanty remains of these have been discovered.

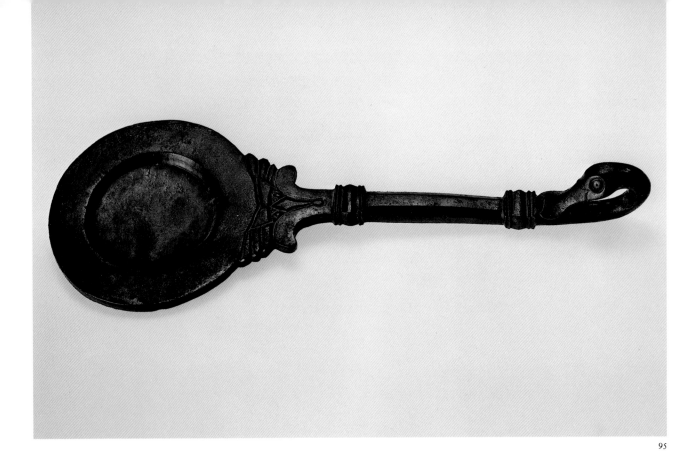

95. Censer with Duck-Head Handle

Khirbet Ibsan
Late 6th–5th century B.C.
Bronze; length 29.5 cm. (11⅝ in.), diameter of
bowl 10.5 cm. (4⅛ in.)
Chance find
IMJ 70.129.690

This graceful cast-bronze censer belongs to a group of
metal objects from a tomb which was discovered by
chance west of the Sea of Galilee. The censer consists
of a shallow bowl with a handle terminating in a duck
head. The handle, long in proportion to the bowl and
elegantly shaped, has been treated with much care.
The faceted shaft is delimited at each end by a broad
"ring," which is rectangular in section. At the point
where the shaft is joined to the bowl, a double volute,
surmounted by a palmette (incomplete to allow con-
nection with the bowl), springs from the ring. These
motifs clearly imitate a column with a base and a vo-
luted capital reminiscent of the Proto-Aeolic style.
They were very common in the art of the Near East
and were subsequently assimilated into the Achaemenid
repertoire. A similar pattern appears on a contempo-
raneous silver ladle found in the excavations of Tell
Fara in the Negev.

The long handle of the present censer terminates
in a duck head, producing a decorative profile. The
head is naturalistically rendered, with strongly em-

phasized eyes, and accurate details of the bill are rep-
resented. The duck-head motif was frequently employed
as a decorative element by Achaemenid metalworkers
for handles of bronze ladles and strainers, continuing
an artistic tradition of many centuries.

This censer may have served as ritual equipment
during some religious ceremonies. A censer recently
uncovered in the excavations at Tell Dor provides the
closest parallel to this object.

REFERENCE: *R. Amiran, Achaemenian Bronze Objects from
a Tomb at Kh. Ibsan in Lower Galilee, Levant 4 (1972),
pp. 135–38.

96. Petaled Bowl

Kibbutz Gath
6th–5th century B.C.
Bronze; height 5.5 cm. (2⅛ in.), diameter
13.2 cm. (5¼ in.)
Chance find
IDAM 55–10

This deep, delicately executed bronze bowl was found
by chance in the fields of Kibbutz Gath. The carinated
bowl has a round omphalos base framed by a plain band.
From the bottom a wreath of twenty-eight narrow-

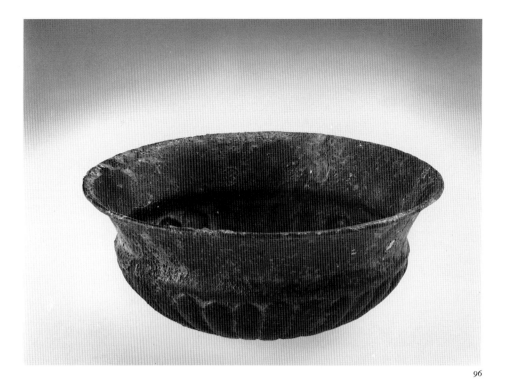

based petals extends up the sides, gradually widening and terminating at the line of carination. Above this the plain upper wall of the bowl rises and splays outward. The bowl was made by casting.

Metal bowls of petal-like design first appeared in Assyria in the eighth century B.C.; they became popular in the Persian period when they were made of gold, silver, and bronze and later imitated in glass.

In the Persepolis reliefs, similarly shaped bowls are carried by tribute bearers and courtiers. Such bowls, which served either as drinking vessels or for libation offerings, are found throughout the ancient world in the Persian period. Though the widespread diffusion of the bowls was partly a result of flourishing trade, many centers must have manufactured them locally.

A variety of metal bowls has been uncovered at sites of the Persian period in Israel. In addition to the imported pieces, a good many bowls, although very similar to their Achaemenid prototypes, were manufactured in Phoenician workshops on the Syrian coast. These reflect the tendency of Phoenician artisans in this period to look to Persia for inspiration rather than to Egypt or Mesopotamia.

The closest parallel to this bowl is an almost identical silver bowl from a richly furnished tomb of the Persian period excavated at Tell el-Fara in the Negev.

Previously unpublished, but see J. H. Iliffe, A Tell Far'a Tomb Group Reconsidered: Silver Vessels of the Persian Period, *Quarterly of the Department of Antiquities in Palestine* 4 (1935), pp. 182–86; N. Avigad and J. C. Greenfield, A Bronze *phialē*—with a Phoenician Dedicatory Inscription, *Israel Exploration Journal* 32 (1982), pp. 118–28.

97. Rhyton

Zippori (Sepphoris)
4th century B.C.
Terracotta; height 29.5 cm. (11⅝ in.)
Chance find followed by excavations of the
Israel Department of Antiquities and Museums
IDAM 79–356

This remarkable terracotta rhyton, consisting of a long horn terminating in the body of a winged hybrid creature, was found by chance at Zippori in Lower Galilee. The lower part of the vessel is made in a double mold while the horn (partly restored) is wheel-made. The

FIG. 70. Detail from vase painting on an Attic krater, which illustrates the use of a rhyton. Late 5th century B.C. Photograph: Kunsthistorisches Museum, Vienna.

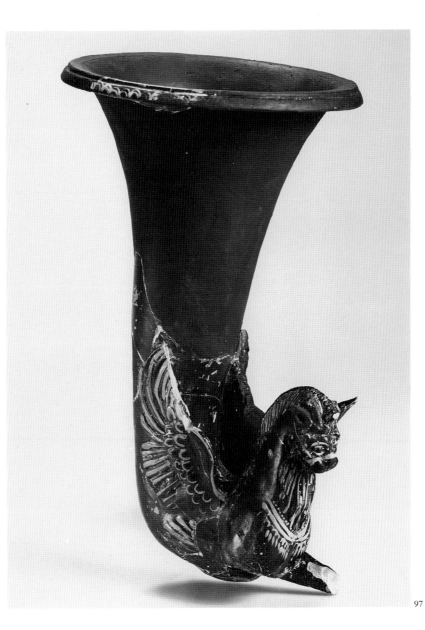

97

protome is in the shape of a legendary animal, with the head of a horned lion and the body of a horse. The ferocious lion's head is plastically modeled; its open mouth, bulging eyes, and thick lower mane, combined with pointed horse's ears and mane, and the addition of horns (now broken) all contributed to the charming peculiarity of this imaginary creature. The red-painted decoration over black glaze serves to accentuate various details, as well as to delineate ornamental elements. Thus, the feathers of the wings are outlined by grooves and emphasized in paint. The reclining creature rests on its forelegs, between which a small hole, serving as an outlet for the wine, was pierced.

The horn-rhyton with an animal protome probably originated in Achaemenid Persia, where it was first produced in precious metals—gold and silver—and later imitated in faience, alabaster, and clay. The manufacture of this vessel in a less costly material proves its popularity among wide classes of society.

Such drinking vessels were also manufactured in Greece, in imitation of Achaemenid prototypes that were probably brought as booty from the Persian Wars which ended in 480 B.C. The present rhyton combines eastern and western features and is executed in the Attic style. Its attribution to the fourth century B.C. is supported by a number of black-glazed Attic sherds found with the vessel.

The use of such a rhyton is shown on a late Attic krater (fig. 70). The rhyton was held upraised, with the thumb covering the hole at its bottom. Releasing the thumb allowed a stream of wine to spurt into a phiale (wine cup), held in the other hand.

REFERENCES: H. Hoffman, The Persian Origin of Attic Rhyton, *Antike Kunst* 4 (1961), pp. 21–26, pl. 12; E. Stern, Achaemenid Clay Rhyta from Palestine, *Israel Exploration Journal* 32 (1982), pp. 36–43; *E. Eisenberg, A Greek Rhyton from Sepphoris, *Qadmoniot* 18, 1–2 (1985), pp. 31–33 (Hebrew).

98. Earring

Ashdod
4th century B.C.
Gold; 1.8 × 1.7 cm. (¾ × ⅝ in.)
Excavations of the Israel Department of
Antiquities and Museums and the Carnegie
Institute, Pittsburgh
IDAM 68–1369

This gold earring, found in the excavations of Ashdod, exemplifies the wealth and the eclectic nature of the Persian period. Designed in the shape of a goat head, this miniature piece is of high artistic quality. Originally it included a hoop, now missing, which was probably either plain or of twisted wire. The hollow goat head is worked in repoussé, with separately made horns of twisted wire and ears produced by hammering. A richly decorated collar is indicated by applied granulation. A small ring extending below the animal's chin served as a clasp. This earring recalls an almost identical piece found at Enkomi (Cyprus) dating from the same period.

Earrings and bracelets terminating in stylized animal heads appear in the fifth century B.C. and are characteristic of Achaemenid Persian art. These motifs gained much popularity and spread throughout the Hellenistic world. Similar earrings have been found in Persia, Phoenicia, Israel, and Cyprus as well as in Greece, Etruria, and southern Italy. The present earring, purely Achaemenid in style, may have been imported from Persia in antiquity. However, it may have been an imitation by a local goldsmith, for stone molds for such objects have been found in Egypt and at Byblos.

REFERENCES: *M. Dothan, Ashdod II–III, 'Atiqot, English series 9–10 (1971), p. 65, pl. XXI:1; K. R. Maxwell-Hyslop, Western Asiatic Jewellery c. 3000–612 B.C., London, 1971, p. 214.

LATE SECOND TEMPLE PERIOD AND PERIOD OF THE MISHNA AND THE TALMUD

332 B.C.–A.D. 640

In terms of western history, the years between 332 B.C. (Alexander the Great) and A.D. 640 (the Islamic conquest) are divided into the Hellenistic, Roman, and Byzantine periods. During this long span of time, lasting almost a millennium, Israel, both politically and culturally, entered the sphere of nonoriental civilizations. In Early Hellenistic times the region was little more than a backwater, and although some great Greek thinkers came from cities like Gadara and Ascalon, the people of this country, their religions and customs, were of little importance to the mainstream of western civilization. Circumstances, however, were different at the end of the period: by the time of the Islamic conquest of A.D. 636–640, the Christian world, as well as the Jews living in large communities dispersed throughout the Roman empire, regarded this country as the Holy Land.

The terms "Hellenistic," "Roman," and "Byzantine" are best used to designate well-dated periods within the framework of the Greco-Roman world. However, in order to understand the events and conflicts that made such a great impact on Jewish history and were so important in shaping the beginning of Christianity, it is best to use a terminology relating to the local history and culture: the Second Temple period, followed by the period of the Mishna and the Talmud.

LATE SECOND TEMPLE PERIOD/
HELLENISTIC AND EARLY ROMAN PERIODS
332 B.C.–A.D. 70

The conquests of Alexander the Great ushered in a new era in the political as well as cultural his-

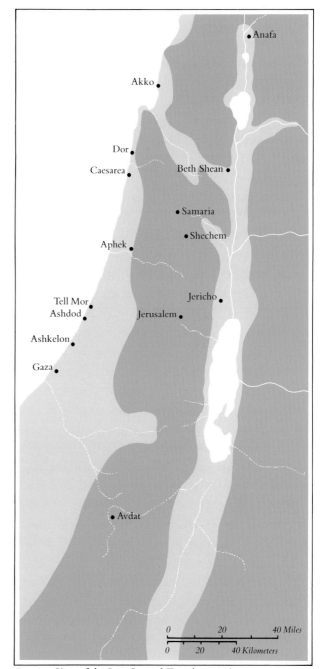

FIG. 71. Sites of the Late Second Temple period.

tory of Israel. The tension between acceptance and rejection of Hellenic civilization determined many aspects not only of the Hellenistic period but also of subsequent periods. In some fields of cultural activity, such as social organization and religious practices, independence from Hellenic prototypes was maintained, and adherence to traditional religious and ethical values was strong. In contrast, the artistic and architectural activity in the country closely followed classical examples, though changing them and adapting them to local tastes.

In purely political terms the early phase of the period under discussion, which roughly corresponds to the Hellenistic period, can be subdivided as follows: the conquests of Alexander and the wars of the Diadochs (332–301 B.C.); Egyptian Ptolemaic rule (301–200 B.C.); Syrian Seleucid rule (200–167 B.C.). During these periods most of the country was a vast battleground for the warring kingdoms to the north and the south. At the same time it was a fertile ground—especially in the coastal strip, in Transjordan, and in some other areas—for the insemination of Greek culture and the adoption of the Greek polis as the favored form of political organization. Consequently there was an influx of settlers from other parts of the Hellenistic world, as well as the introduction of Greek cults and the formation of a Greek-speaking elite. These aspects of the Greek culture so permeated the local non-Jewish civilization that they survived throughout Roman rule.

The struggle between Hellenism and the traditional culture was especially acrimonious in Judaea and Jerusalem. There, following Persian precedent, the Hellenistic powers acknowledged the leadership of the high priest and the Elders and the adherence to Jewish law in everyday life. Nonetheless, there was an infiltration of Greek attitudes, encouraged by the Hellenized upper classes, which unleashed strongly hostile reactions in the conservative, monotheistic, anti-Greek population of Judaea. Fomented further by the desecration of the Temple, by the religious persecution of the Seleucid rulers, and by social stresses, the conflict ended in the Hasmonaean rebellion which brought about the establishment of an independent state in Judaea.

The immensely popular Hasmonaean monarchy opened a new phase in the history of the country, in which the quest for national independence was of paramount importance. No longer simply a religious entity, but similarly centered on Jerusalem and its Temple, it expanded far beyond the boundaries of Judaea, embracing at times almost all of the biblical land of Israel. This independence, first achieved by the Hasmonaean dynasty, was followed by Herod, who was set up as a client king by Rome.

The latest phase of the Second Temple period (which includes the Late Hellenistic and the Early Roman periods) can be subdivided as follows: the Hasmonaean uprising against the Seleucids (167–141 B.C.); the Hasmonaean state (141–63 B.C.); Pompey's conquest and the establishment of a Roman vassal state (63–40 B.C.); Herod's kingdom (40 B.C.–A.D. 6); direct Roman rule (A.D. 6–66); the Jewish War against the Romans and the destruction of Jerusalem and the Temple (A.D. 66–70). This span of approximately 250 years saw the gradual process by which Rome became the master of the eastern Mediterranean. The Jewish nation's refusal to be part of this new world order brought about the bloody war of A.D. 66–70 and the eventual destruction of Jerusalem and the Temple. Thus ended the long period which, despite momentous cultural changes and fluctuation of political regimes, is symbolized by the continuity of the Second Temple. First built by Zerubbabel in 520 B.C., consecrated again by the Hasmonaeans, and lavishly reconstructed by Herod, the Temple stood in Jerusalem as a center of Jewish life and national identity. The dramatic event of its destruction never faded from the memory of the nation, and efforts to overcome this trauma would shadow the entire future history of Judaism.

The Hellenization of the country was felt first and foremost in the founding of many cit-

FIG. 72. Aerial view of Herodion. Photograph: Abraham Hay.

FIG. 73. Aerial view of Masada. Photograph: Abraham Hay.

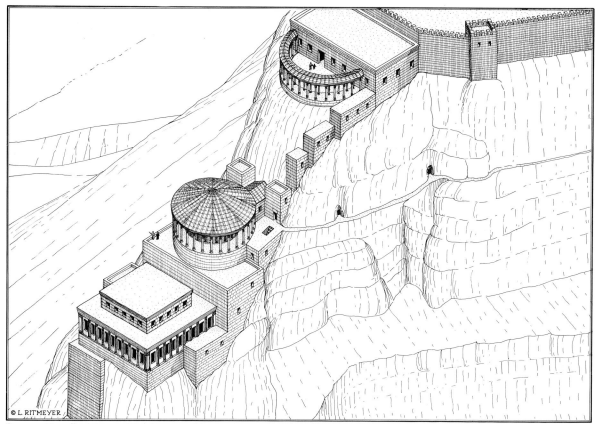

Fig. 74. Herod's palace at Masada, an architectural reconstruction. Drawing: Lane Ritmeyer.

ies, especially in the coastal and low-lying areas of the country. However, for several reasons knowledge of the material culture of the period is limited. The Hellenistic and Roman periods (and sometimes even the Persian period) saw an uninterrupted succession of building activities, in which later constructions were superimposed on earlier ones, making it almost impossible to determine with any confidence which of the remains are confined to the Hellenistic period. Principles of town planning are, however, of help here; in fact, the Greek Hippodamian grid can still be identified in many ancient sites. Furthermore, the interest of earlier archaeologists in the Holy Land was from the outset directed toward biblical antiquities, and it is only fairly recently that extensive excavations of Hellenistic strata or sites have been undertaken. Among the large cities, of foremost importance are Jerusalem, Caesarea, and Dor, and the smaller sites include Aphek, Anafa, and Tell Mor.

The archaeological picture changes dramatically when the Hasmonaean and later the Herodian dynasties ruled in Jerusalem. Both royal houses modeled themselves after the Hellenistic monarchies of the ancient world, emulating their extensive building activities. In recent decades some of the Hasmonaean palaces and fortresses have been excavated or explored, and some of the buildings, previously ascribed to later periods, are now correctly dated to the late second and early first centuries B.C. These include the palaces of Jericho and the palace-fortresses along the Jordan Valley.

The building projects undertaken by Herod are the most impressive. His activity as a builder surpassed in scope and scale anything known in the country before him, and some of his undertakings were the largest of their kind in the contemporaneous world. He built the platform of the Temple Mount in Jerusalem and its buildings, the palaces at Herodion and Jericho, and

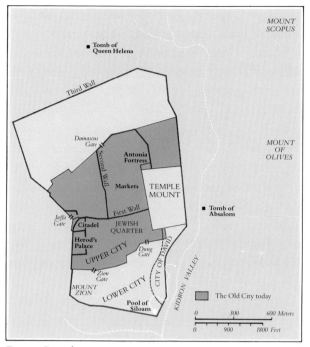

FIG. 75. Jerusalem, 1st century B.C.–1st century A.D.

where the majority of the Jewish population lived, were destroyed or deserted after A.D. 70 and thus much has been preserved for the excavator to discover. On the other hand, the large flourishing cities with their overwhelmingly pagan populations and their numerous art works were continuously occupied; their public buildings—theaters, baths, marketplaces, and so on—were used, renovated, and rebuilt throughout the Late Roman and Byzantine periods and sometimes even later. As a result, most of the artifacts from Early Roman times were destroyed or lost in antiquity.

PERIOD OF THE MISHNA AND THE TALMUD/LATE ROMAN AND BYZANTINE PERIODS

A.D. 70–640

The destruction of the Second Temple (A.D. 70) was a major turning point in Jewish history. The Temple was not only the religious focal point of the country, but its spiritual and administrative institutions were the heart of Jewish national life. The fall of Jerusalem and the ensuing devastation of Judaea completely shattered the traditional administrative and behavioral systems that governed Jewish life.

The survival of Judaism was assured by the vigorous spiritual energy of the Sages who, established in Yavneh, recreated the authority of the Sanhedrin, now exiled from Jerusalem. This Patriarchate, with its peculiar blend of spiritual and political authority, also succeeded in exercising its hegemony over the Jews in the Diaspora, a growing part of the Jewish nation.

Nonetheless, expectations of national revival were not abandoned, and the Bar Kokhba uprising (A.D. 132–135) was a heroic attempt to reestablish Jewish sovereignty in Jerusalem. It was only after this revolt, which was cruelly crushed by Hadrian's legions, that violent attempts at hastening the liberation were discredited and relegated to a distant messianic future.

the port at Caesarea. Many places, including Jerusalem and Masada, owe their present aspect to Herod's activities. He is believed to have taken a personal part in planning the buildings and supervising their construction (figs. 72–74).

In spite of the thoroughly Hellenized character of the architecture in these periods, the decorative and the applied arts developed a distinctive style. Its outstanding feature is the complete absence of figurative art, which is in conformity with the Jewish prohibition on representing the human form. The most common elements are architectural facades and floral and geometric motifs. In general, there is a tendency toward a certain simplification and schematization of the motifs borrowed from the classical artistic vocabulary. Most conspicuous is the absence of any traces of major art works in predestruction contexts, which otherwise show a high standard of living and artistic appreciation, as exemplified by the palaces of Jericho and the mansions of the wealthy inhabitants of Jerusalem in the first century A.D.

Jerusalem and most of the towns in Judaea,

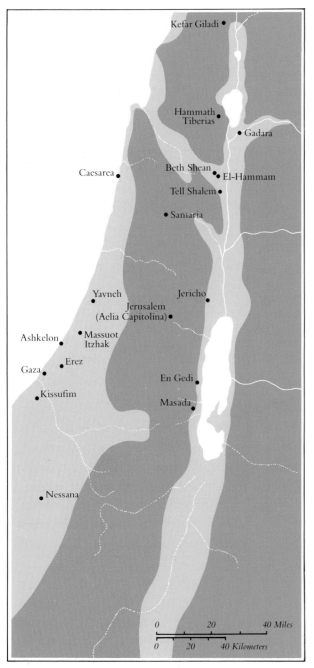

Fig. 76. Sites of the period of the Mishna and the Talmud.

As a result of the Bar Kokhba Revolt, the center of Jewish population and cultural activity, headed by the Sanhedrin, moved from Judaea to Galilee. There, about A.D. 200, the greatest of the Sages, Rabbi Judah the Patriarch, codified the Mishna, the oral law that until then had been passed from generation to generation by word of mouth. This compilation, set down in writing, later became the basis of the Gemara, which incorporated discussions, comments, and amplifications on the text. The Mishna and the Gemara together constitute the Talmud—the basis for normative Judaism as it is known today—which gave its name to this very important period in Jewish history.

Relations between the Jewish population and the Roman government underwent many changes. In the second century A.D., following the Bar Kokhba Revolt, many oppressive measures were imposed, including a decree forbidding Jews from entering Aelia Capitolina, the Roman colony built on the ruins of Jerusalem. During the third century A.D., under the Severan emperors, the Sanhedrin in Galilee was highly esteemed and maintained a close relationship with the emperors, but in the early fourth century, when Christianity became the official religion of the empire, anti-Jewish legislation was again enforced, and the Sanhedrin was finally abolished in A.D. 425.

Christianity was born in Palestine about a generation before the destruction of the Temple. Though Christian teachings and beliefs at first spread among the Jews both locally and in the Diaspora, the legitimacy of the Jewish-Christians within the community of normative Judaism was soon questioned. Thus, during the third century A.D., the spread of Christianity in Palestine (with its large Jewish population) was slower than in the rest of the empire and was largely confined to the Greek pagan cities.

A major change occurred in A.D. 324, when Constantine became sole Christian ruler of the empire. The Holy Land was one of the chief concerns of this emperor and of his family (especial-

FIG. 77. The Roman forum at Samaria–Sebaste. Photograph: David Harris.

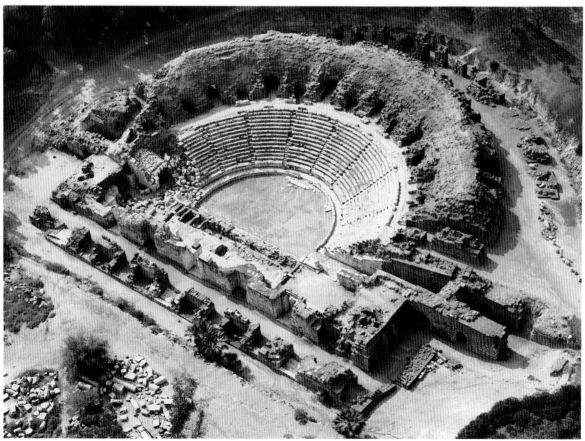

FIG. 78. The Roman theater at Beth Shean–Scythopolis. Photograph: David Harris.

ly his mother, Helena), who erected magnificent churches on many of the newly rediscovered holy places, mainly in and around Jerusalem. This imperial building activity was emulated by subsequent rulers. It was further encouraged by an increasing influx of pilgrims and an important monastic movement centered in the Judaean Desert near Jerusalem and in the south of the country.

With the Islamic conquest in A.D. 640, once again the cultural affiliations of the country were directed toward the East. Byzantine influences, however, were slow to die and are evident in the administration and in the building activities of the first Islamic rulers.

The beginning of this long period in A.D. 70 and its end in A.D. 640 are fixed, but between these dates the subdivisions are arbitrary and flexible. In the domain of archaeology and art history the division separating the Late Roman from the Byzantine periods usually falls at the end of the first quarter of the fourth century A.D. Indeed, the second and third centuries A.D. present a strongly pagan Roman aspect, especially in the large urban centers, with their highly developed pagan civilization. Some of the more spectacular finds of Late Roman art come from cities like Beth Shean–Scythopolis, Caesarea, and Samaria, where pagan cults and the official cult of the emperor were established. The architecture in those cities is typically Roman, with

FIG. 79. Roman jug. The human face on the handle was deliberately defaced, probably by its Jewish owner. 2nd century A.D. Photograph: Shrine of the Book, Israel Museum/David Harris.

FIG. 80. Detail from mosaic pavement from the church at Tabgha on the Sea of Galilee. 6th century A.D. Photograph: Garo Nalbandian.

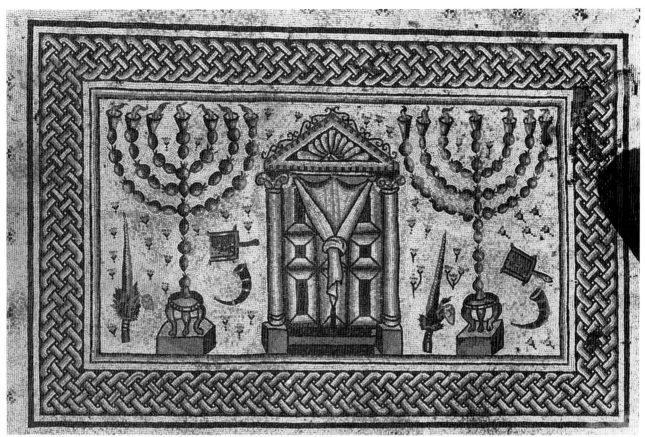

Fig. 81. Detail from mosaic pavement from a synagogue at Hammat Tiberias. 4th century A.D. Photograph: Israel Department of. Antiquities and Museums and Israel Exploration Society/Zeev Radovan.

theaters, temples, baths, and military installations, while the objects found there are often of pagan character (figs. 77 and 78). At the same time, through many vicissitudes, the Jewish culture continued to exist and develop its own religious and national traditions. The objects hidden in caves by Jewish rebels from the time of the Bar Kokhba Revolt attest to the rigorous observance of the prohibition of human representation, to the extent that human forms were carefully effaced from imported vessels (fig. 79).

The fourth to seventh centuries A.D., on the other hand, lack any monumental works of art but are marked by extensive religious building activity—both Jewish and Christian. The use of different symbols and iconography distinguishes very clearly the art and the architecture of the Jewish and the Christian populations, although both employed the same techniques and the same artistic language. This distinction is evident in the large corpus of mosaics from this period (figs. 80 and 81). Unlike the buildings of Roman times, which were elaborately decorated on the outside, the Byzantine buildings and especially the synagogues and churches had plain exteriors but were lavishly decorated inside, usually with intricately designed mosaic floors that took on a more and more iconic character. In minor arts too, the use of religious symbols increased, and the menorah with its accompanying ritual symbols or the cross appears on a variety of objects.

99. Panther

Avdat
1st century B.C.
Bronze; height 4.8 cm. (1⅞ in.)
Excavations of the National Parks Authority
IDAM 64–1582

This female panther is portrayed with its teeth bared, tongue hanging out, and left forepaw raised in self-defense. The stance, smooth musculature, and pendulous teats contribute to the naturalism of the figurine. This small piece is cast in bronze, with the spots inlaid with black paste. The eyes were also inlaid.

The figurine was found at Avdat, a city established by the Nabateans in the fourth century B.C. on the caravan route from Petra to Gaza (fig. 82). The Nabateans were an Arab nomad tribe that controlled the trade routes leading from the Mediterranean to Elat, and especially the Indian spice trade. This panther, as well as other figurines from Avdat, although uncovered in the ruins dated to the first century A.D., has affinities with Hellenistic sculptures from Alexandria and should therefore be considered Hellenistic. Besides characteristically Nabatean artifacts and pottery, Nabatean sites have yielded a variety of Hellenistic and Roman finds.

REFERENCE: *P. P. Kahane, in *From the Beginning: Archaeology and Art in the Israel Museum*, London, 1968, p. 114, pl. 92.

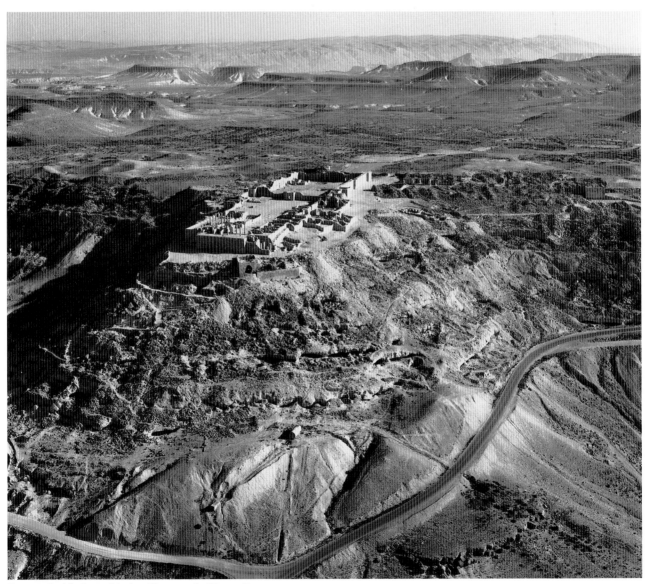

FIG. 82. Aerial view of Avdat. Photograph: Werner Braun.

100. Pontius Pilate Inscription

Caesarea
A.D. 26–36
Limestone; 82 × 65 cm. (32¼ × 25⅝ in.)
Excavations of the Istituto Lombardo, Milan
IDAM 61–529

A unique historical document, this limestone block bears a fragment of a dedication to Pontius Pilate, the Roman prefect of Judaea in A.D. 26–36, who is traditionally believed to have authorized the execution of Jesus. Although his name is known from literary sources, especially from the New Testament and the works of Josephus, no contemporaneous archaeological, epigraphical, or numismatic evidence of his existence was known until the discovery of this block.

The fragmentary Latin inscription reads: " . . . TIBERIEUM / . . . [PO]NTIUS PILATUS / . . . [PRAEF]ECTUS IUDA[EA]E." The inscription probably pertains to a building (the Tiberieum), whose location is now unknown, which was erected in Caesarea in honor of the Emperor Tiberius by Pontius Pilate, prefect of Judaea.

Caesarea, on the coast halfway between Gaza and Akko–Ptolemaïs, owed its grandeur to Herod, who founded the city between 22 and 10 B.C. in honor of his patron Augustus, the first emperor of Rome. Its harbor, among the greatest on the Mediterranean coast, remained important throughout the Crusader period. Caesarea was the major city of Judaea and its capital during the Roman and Byzantine periods (fig. 83).

Among its many splendid ruins is the theater which was built by Herod, reconstructed several times, and still used in Byzantine times, when part of it was transformed into a fortress. In one of its reconstructions this stone with its dedicatory inscription was used as a step and was cut to the size required by its new function, thereby damaging the inscription.

REFERENCES: *A. Frova et al., *Scavi di Caesarea Maritima*, Milan, 1965, p. 217; Y. Israeli, in *Highlights of Archaeology: The Israel Museum*, Jerusalem, 1984, pp. 92–93.

FIG. 83. The Roman aqueduct at Caesarea. 1st century B.C. Photograph: David Harris.

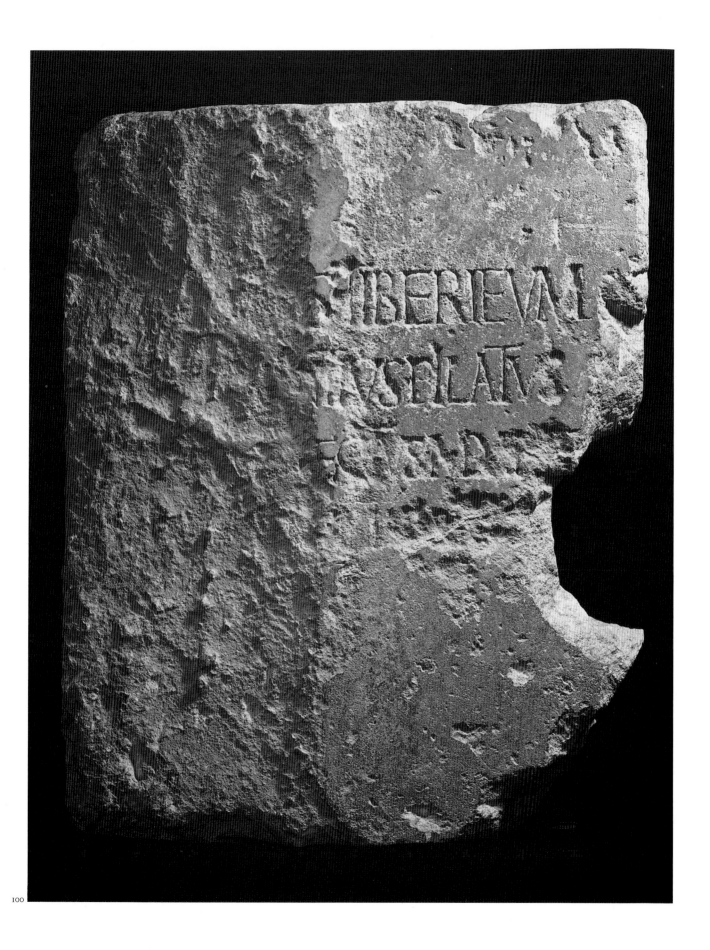

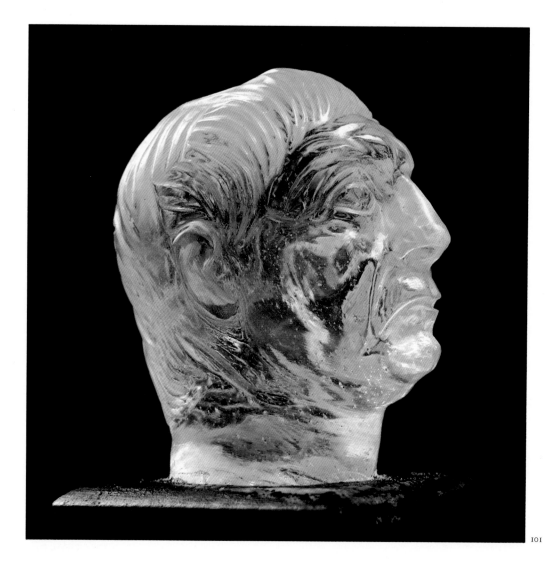

101

101. Portrait of the Emperor Vitellius

Provenance unknown
1st century A.D.
Rock crystal; height 3.5 cm. (1⅜ in.)
IDAM 31.1

This miniature portrait, delicately carved in rock crystal, has been identified as that of the Emperor Vitellius (A.D. 69), but recently this identification has been contested. The tiny head—broken off at the base of the neck, but otherwise intact and in perfect condition—was originally part of a bust or statuette. The realistically rendered face is that of a mature person, and the head has a very forceful left profile. The frontal aspect is rather awkward, as it is too deeply engraved. The deep wrinkles on the brow and around the eyes are carefully portrayed. The stylized locks of hair are indicated by grooves. The pupils and irises are incised. The drooping, thin-lipped mouth and the bulbous nose impart an air of ennui which is also seen in many other portraits of the first century A.D.

This piece is said to be from Caesarea. Alexandria was a center for carving in the round of precious stones, but imperial portraits in such stones are well represented in many other places.

REFERENCE: *J. H. Iliffe, A Portrait of Vitellius(?) in Rock Crystal, *Quarterly of the Department of Antiquities in Palestine* I (1932), pp. 153–54, pl. LVIII.

102. Multiple-Nozzle Lamp

Provenance unknown
1st century A.D.
Pottery; width 35 cm. (13¾ in.)
IMJ 71.82.298
Gift of the Friends of the Museum and Morris and Helen Nozette through the Morris Nozette Family Foundation

This is the largest and most beautiful of the Roman pottery lamps found in Israel. Ring-lamps with as

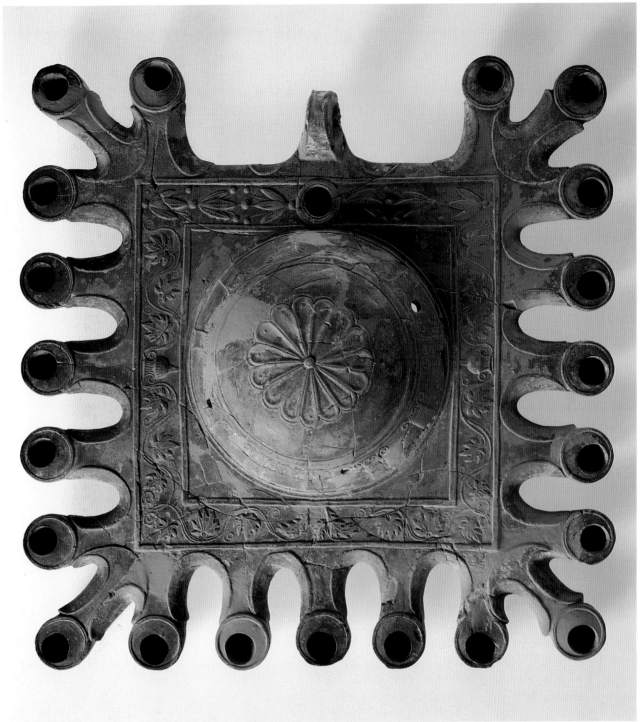

many as seventeen radiating nozzles are known from Hellenistic and Roman times. Several ring-lamps of the Herodian type, such as this one, are in public collections, and fragments of such lamps have been found in excavations. A complete Roman ring-lamp, richly decorated with floral motifs, was recently excavated in Jericho.

The present lamp has twenty-one nozzles. Square in shape, it has a dome covering the center which is usually open in ring-lamps. When suspended by chains attached through the three holes in the dome, it keeps a perfect horizontal balance. The handle for carrying the lamp is next to the filling hole. The lamp was produced in a complicated two-part mold, the dome in the upper mold having no counterpart in the lower one.

The lamp displays many of the elements and characteristics of Early Roman lamps manufactured in the eastern empire. The center of the dome is decorated with a rosette, and around the dome's base runs a frieze

of eleven pillars crowned by voluted capitals, somewhat like Ionic columns. The dome and its decorative elements reflect the appearance of interiors in Early Roman buildings.

The square body of the lamp is decorated with a rinceau of laurel branches on the side of the filling hole and friezes of vine leaves and tendrils springing from amphorae on the other three sides. These motifs were also popular in the art and architecture of this period.

The ornamental motifs of this lamp, although Early Roman in style, are familiar from Jewish decorative art and architecture. The exceptional size and magnificence of the lamp, as well as its unusually large oil receptacle, may suggest that it was used on Jewish ceremonial occasions and holidays.

REFERENCE: *U. Avida, in *Highlights of Archaeology: The Israel Museum*, Jerusalem, 1984, pp. 98–99.

103. Head of a Youth

Provenance unknown
1st century A.D.
Bronze; height 15.5 cm. (6⅛ in.)
IMJ 77.25.997
Acquired from the Jonas collection

This cast bronze head, with a mottled brown and green patina, was broken off a statuette some 65 centimeters (25½ inches) high. The head is slightly inclined to the right, and the eyes look down, probably at something held in the right hand. The pupils are drilled, but no traces of inlay are left. The hair is cut short, with a whorl of four locks at the crown. The curls are somewhat thicker around the face, and there is a crudely executed square knot high above the forehead. There are three holes which originally held a wreath.

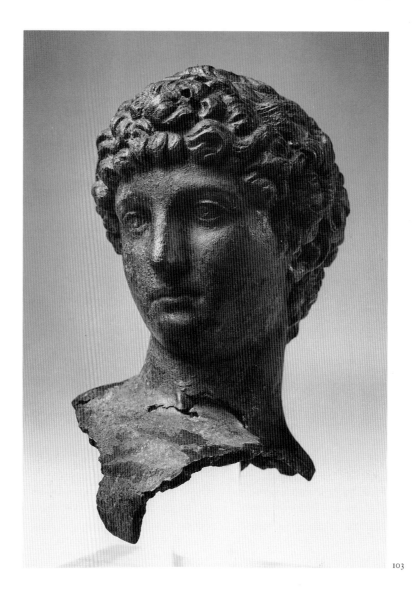

103

Although it is probably a Roman work of the first century A.D., the head recalls Greek prototypes of the fourth century B.C., such as the Boy of Marathon. Rather than a god or an athlete, it represents a young initiate, with the long lock of hair to be dedicated to the deity knotted above his forehead.

Such finds of Roman art are uncommon in Israel, and the statuette probably comes from one of the major Roman centers such as Beth Shean or Samaria. Some of the objects in the Jonas collection are said to be from Samaria, where Kore was worshiped in a large sanctuary (cat. no. 119). If indeed the head was part of a statuette from Samaria, it would be appropriate to interpret it as a depiction of an initiate.

Previously unpublished.

THE CITY OF JERUSALEM
Cat. nos. 104–11

"Whoever has not seen Jerusalem in its splendor has never seen a fine city" (Babylonian Talmud, Succah, 51b).

The image of Jerusalem that was current for two thousand years was formed at the end of the Second Temple period in the first century B.C., in the days of the city's prosperity and wealth and the great building projects of the Hasmonaean kings and Herod the Great (fig. 84). At this early date a large part of the city walls, the citadel on the west, the layout of streets and markets, and, above all, the enormous platform on which the Temple stood in the east of the city assumed their present form. Herod undertook the vast project of reconstructing the Temple together with building a system of access roads, squares, and public buildings. This ambitious building campaign was designed to glorify his name, as well as to facilitate the movement of the throngs of pilgrims who came to the city at the festivals to worship in the Temple.

Numerous excavations over the last hundred years provided some information about ancient Jerusalem. However, it is only during the last fifteen years that excavations to the south and west of the Temple Mount, in the Jewish Quarter (the Upper City of the Second Temple period), and on Mount Zion have given a much clearer picture of ancient Jerusalem. Much information has been gathered about parts of the city about which little had been known; the houses and the shops along the streets have been brought to life, and a reconstruction of the remarkable city plan has been made possible.

The excavations near the Temple Mount revealed principally remains of the monumental urban plan of the streets leading to the Temple, together with the columns, capitals, and decorated elements of the buildings that stood in the courtyard of the Temple. The excavations in the Jewish Quarter and on Mount Zion, on the other hand, uncovered remains of secular Jerusalem seldom mentioned in literary sources—houses and domestic utensils and other objects of daily use.

Some of the Second Temple period objects from Jerusalem discussed here (cat. nos. 105–9) were discovered in one of the most luxurious mansions excavated in the Jewish Quarter (figs. 85 and 86). Josephus writes that the priestly families and the aristocracy lived in this area, and his account has been confirmed by the evidence uncovered in the excavations. The house, which stood opposite the Temple Mount, was constructed on two levels. The ground-floor rooms were built around a spacious, stone-paved inner court. They were paved with mosaics, and their walls were decorated with frescoes or with stucco imitating ashlar masonry. Fragments found on the floors show that the ceilings were also decorated with stucco. Several ritual baths and cisterns were preserved, as well as store-

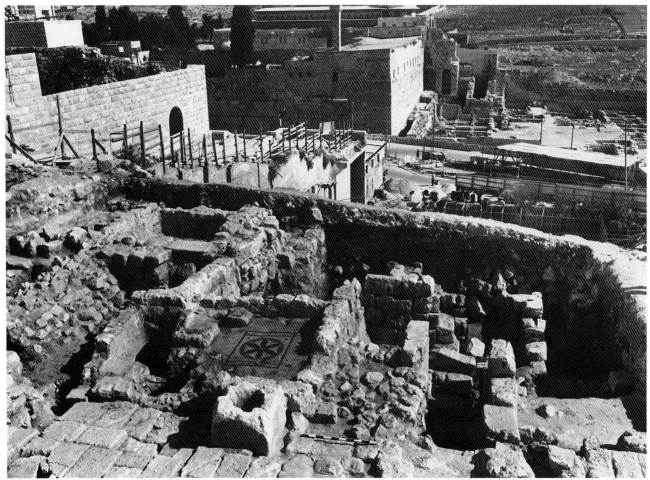

FIG. 84. Mansion in the Jewish Quarter of Jerusalem (viewed from the west), overlooking the Temple Mount. 1st century A.D. Photograph: Jewish Quarter Excavations—Institute of Archaeology, Hebrew University, Jerusalem, and Israel Exploration Society.

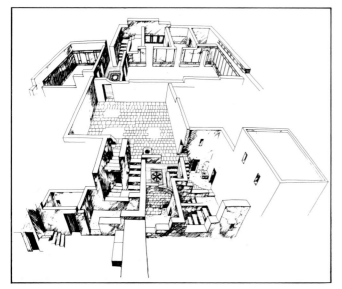

FIG. 85. Mansion in the Jewish Quarter of Jerusalem (viewed from the east), an isometric drawing. (See fig. 84.) Drawing: Peter Bogod.

rooms in the basement under the courtyard. A staircase led to the upper story which did not survive. The finds in the mansion, though not abundant, are of fine quality. They include elaborate glass vessels, metal tools, and stone furniture which show awareness of contemporaneous international styles.

Not all the houses in the Upper City were as spacious as this one, but in all of them there were several ritual baths and other bathing installations. The water supply system—cisterns and the aqueducts that brought water to Jerusalem —was highly developed, but even so the number of bathing installations is surprisingly large. Ritual baths were essential to every observant Jew, and it appears from the excavations that the population of Jerusalem was particularly meticulous in the observance of the laws of purity. Moreover, among the profuse architectural orna-

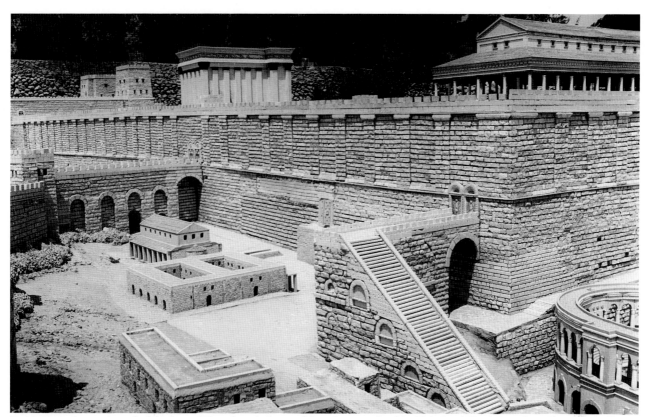

Fig. 86. Jerusalem at the end of the Second Temple period, a model on the grounds of the Holy Land Hotel, Jerusalem. Photograph: Garo Nalbandian.

ments, mosaics, frescoes, and other objects discovered in the Jerusalem excavations, there are almost no animal or human representations, again demonstrating strict observance of Jewish law.

Stone tables and stone vessels of various types and sizes have been discovered in Jerusalem in surprising quantities, indicating that they accounted for a large part of such objects in daily use. Although some of the forms are known from the Roman world, most were made from the local limestone in local workshops. The widespread use by the Jews of Jerusalem of stone vessels, though they were undoubtedly more expensive than the usual pottery utensils, is once again explained by the scrupulous observance of the laws of ritual purity, according to which stone vessels are not susceptible to uncleanness. A stone vessel would preserve its purity and its usability even after it had come into contact with a source of defilement.

The stoneworking craft in Jerusalem appears to have been highly developed. Furniture, domestic utensils, and tableware for daily use were made from the local stone in numerous workshops. The Jerusalem artisans also carved sarcophagi, elaborate facades for monumental tombs, and ornamental architectural elements. They put a characteristic local stamp on their various products, though these were made in the contemporaneous Hellenistic and Roman styles.

The image of Jerusalem that many people have is formed by the ideas, beliefs, and associations drawn from thousands of years of tradition. The excavations in Jerusalem have, however, given a more realistic picture of the city as an important metropolis of the Hellenistic-Roman world. The fashions that spread throughout this world are evident in Jerusalem's buildings and products, but at the same time Jewish law was closely observed and its stringent restrictions were followed amid the great wealth and flourishing creativity.

REFERENCES: B. Mazar, *Mountain of the Lord*, New York, 1975; Y. Yadin (ed.), *Jerusalem Revealed*, New Haven and London, 1976; N. Avigad, *Discovering Jerusalem*, Jerusalem, 1983.

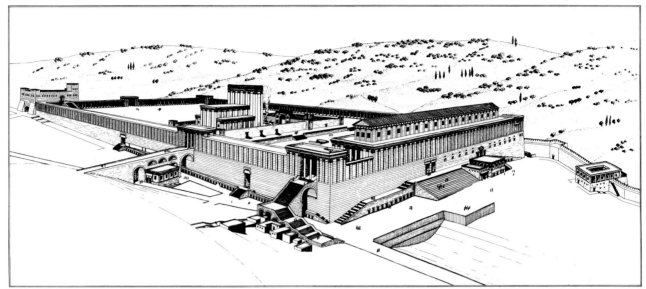

FIG. 87. The Temple in Jerusalem, an architectural reconstruction. Drawing: Lane Ritmeyer.

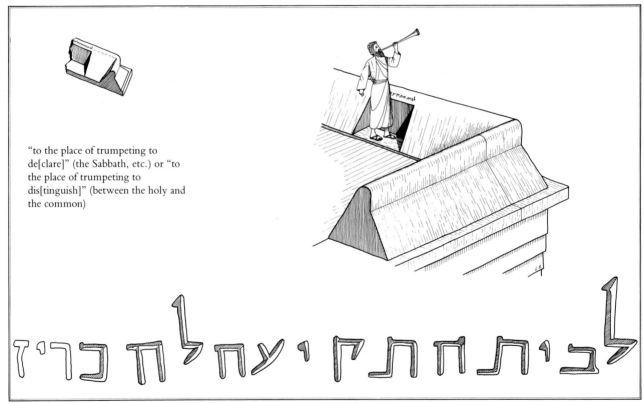

"to the place of trumpeting to de[clare]" (the Sabbath, etc.) or "to the place of trumpeting to dis[tinguish]" (between the holy and the common)

לבית התקיעה להכריז

FIG. 88. The Place of Trumpeting at the top of the temple compound. Drawing: Lane Ritmeyer.

104. "Place of Trumpeting" Inscription

Jerusalem
1st century B.C.
Stone; 31 × 84 × 26 cm. (12¼ × 33⅛ ×
10¼ in.)
Excavations of the Israel Exploration Society
and the Hebrew University, Jerusalem
IDAM 78–1415

This large Hebrew inscription, which reads "to the place of trumpeting," was discovered in the excavations near the Temple Mount in the Old City of Jerusalem (figs. 87 and 88). It was inscribed on a huge block of stone that formed part of a parapet on a building at the southwest corner of the Temple enclosure; it fell to the street below when the Temple was destroyed. Both the Lower City to the south and the Upper City to the west were visible from this elevated position.

In his *History of the Jewish War* (IV, 9, 12), Josephus records that a priest stood on the roof of the priests' chamber to proclaim by trumpet blasts the approach of the Sabbath and, on the next evening, its close. The Mishna (Succoth 5, 5), when discussing the trumpet blasts required on various occasions, also mentions the three blasts proclaiming the separation of the holy (the Sabbath) from the common (the rest of the week).

In the inscription the words "to the place of trumpeting" are followed by another word, of which only two letters and part of a third have survived. This word can be completed in a number of ways, depending on the reading of the third letter. Two readings can be suggested: "to the place of trumpeting to de[clare]" (the Sabbath, etc.) or "to the place of trumpeting to dis[tinguish]" (between the holy and the common).

With the exception of this inscription, little remains of the buildings that stood on the vast Temple platform. Though brief and fragmentary, the inscription illustrates one of the means of communication between the priests in the Temple and the people in the city.

REFERENCES: Y. Israeli, in *Inscriptions Reveal*, Israel Museum catalogue no. 100, Jerusalem, 1973, no. 168; *B. Mazar, *Mountain of the Lord*, New York, 1975, p. 138; B. Mazar, Herodian Jerusalem in the Light of the Excavations South and Southwest of the Temple Mount, *Israel Exploration Journal* 28 (1978), p. 234.

Finds from a Mansion of the Second Temple Period

Cat. nos. 105–10

Jewish Quarter, Jerusalem
1st century A.D.
Excavations of the Hebrew University, Jerusalem, the Israel Department of Antiquities and Museums, and the Israel Exploration Society
REFERENCE: *N. Avigad, *Discovering Jerusalem*, Jerusalem, 1983, pp. 95–120.

105. Table

Stone; top 76 × 46 cm. (29⅞ × 18⅛ in.), height of leg 66.5 cm. (26⅛ in.)
IDAM 82–551

This is a fine example of a rectangular table supported on a central leg. One of the tabletop's long sides is carved with a running pattern of paired leaves and a rosette in the center. The other sides are plain. The top is polished, but the underside is not. A square projection on the underside fits into a hollow in the table leg. The leg itself is a thick column, with a base and capital carved in Doric style. Double lines, incised horizontally, represent column drums, but the leg is made of a single piece of stone.

The tabletop and the leg were found separately, but they fit together. It seems likely that here, as elsewhere in the Roman world, such furniture parts were manufactured in standard dimensions so that they were interchangeable.

Rectangular tables supported on one leg have been discovered in Italy, and they are known from ancient paintings and literary sources. To improve stability, they were usually placed against a wall and were therefore often decorated only in front. A carved tabletop discovered in Jerusalem bears a representation of a similar table with various utensils on it and two large jars below. In the houses excavated in the Jewish Quarter, tables of this type were very common, together with lower three-legged tables.

105

106. Plate

Limestone; height 4.9 cm. (1⅞ in.), diameter
17.2 cm. (6¾ in.)
IDAM 82–1000

This soft limestone plate has vertical sides and a shallow disk-base. This type is among the most common flat stone vessels of the end of the Second Temple period in Jerusalem. Its shape imitates that of Roman terra sigillata plates with an angular profile. It is a good example of a vessel turned entirely on a lathe by rotating the block of stone against the carving knife held by the craftsman. The final polish, the profiled rim, and the ridge near the bottom were also made on the lathe.

The soft Jerusalem stone was made still softer by soaking in water, and the carving was done with woodworking tools. The lathe was a technical improvement on the usual methods of stoneworking and allowed relatively rapid production of a series of identical vessels. The utensils turned on the lathe are mostly imitations of pottery shapes and were undoubtedly used for the same purposes. Other stone vessels found in Jerusalem, shaped with a knife, gouge, or chisel, are rectangular or oval in shape. Their prototypes, no doubt of wood, have not survived.

107. Measuring Cup

Limestone; height 12.9 cm. (6 in.), diameter
11.4 cm. (4½ in.)
IDAM 82–1002

The "measuring cup" is one of the most typical products of the stoneworker's craft in Jerusalem. These vessels, made in various sizes from soft limestone in an almost standard shape, have been found in large numbers in Jerusalem and Judaea.

The almost vertical sides, flat base, and pierced

213

rectangular handle are characteristic of this type of cup. Some have a spout on the rim, perpendicular to the handle, to facilitate pouring. It is not clear whether these vessels were used as cups or whether, as their generally accepted name indicates, they were used as dry measures.

The outside of this cup was shaped with a chisel about 15 millimeters (1/16 inch) wide; short strokes of this tool created a decorative pattern. In contrast, the inside was hollowed out with less care, and the bottom of the cup was left rough.

108. Lamp

Limestone; height 4.4 cm. (1¾ in.), diameter 10.4 cm. (4⅛ in.)
IDAM 82–1006

This lamp is made of the local soft limestone of Jerusalem. Its shape—a slightly concave disk with a large opening—is identical with the type of pottery lamp most commonly found in the first century A.D. in the Jerusalem area. This lamp was made partly on a lathe and partly by hand. The top and the bottom, with a broad ring-base and incised decorative circles, were lathe-turned. The sides were fashioned with a chisel or gouge, and the interior was summarily worked both on the lathe and with a chisel. The working of a lamp like this one could not have been easy, since it

has closed areas that are difficult to reach with carving tools; this may be why this lamp is the only example of its kind.

109. Small Bowl

Pottery; height 4.8 cm. (1⅞ in.), diameter 8.4 cm. (3¼ in.)
IDAM 82–1032

This hemispherical pottery bowl has a rounded rim, a central depression (omphalos), and a ring-base. The bowl is red-slipped, a characteristic feature of the fine red pottery known as eastern terra sigillata which was prevalent in the East from the second half of the second century B.C. onward. The relationship of this ware, which consists mainly of plates and small bowls, to western terra sigillata is still unclear.

110. Fresco Fragment

32 × 39 cm. (12⅝ × 15⅜ in.)
IDAM 82–1104

This fresco fragment was discovered in the hall of the mansion. It contains a stylized floral motif, painted in

FIG. 89. Main hall of the mansion in the Jewish Quarter of Jerusalem (fig. 84), a reconstruction based on fragments of wall stucco. Drawing: Lane Ritmeyer.

red, black, and yellow on a white background. The design is composed of festoons, from the center of which fruits(?) are suspended. The fragments of this fresco were found stuck to a later layer of plaster modeled to resemble ashlar masonry, and the gouges in the fresco were intended to anchor this second layer. Other stucco fragments found in the hall are modeled in relief in imitation of ashlar masonry and large panels; they also show that before the redecoration the walls had been ornamented with colorful frescoes.

Pieces of painted plaster were recovered in the excavations in small fragments, generally in debris and not on the walls. However, enough has survived to suggest that many of the houses in Jerusalem were decorated with frescoes, some of geometric designs or imitating marble slabs, others with architectural motifs and floral decorations (fig. 89). Most fragments were executed in the wet fresco technique. The colors of the frescoes, their organization, and the few compositions that have been preserved are in the manner of the wall paintings popular in the Hellenistic-Roman world. However, in Jerusalem there are no figurative representations, again pointing to the strict observance in Jerusalem of the commandment "Thou shalt not make to thyself any graven image."

111. Corinthian Capital

Jerusalem
1st century A.D.
Limestone; extant height of column 220 cm.
(86⅝ in.), height of capital 56 cm. (22 in.),
diameter of capital 46 cm. (18⅛ in.), diameter
of base 47 cm. (18½ in.)
Excavations of the Hebrew University,
Jerusalem, the Israel Department of
Antiquities and Museums, and the Israel
Exploration Society
IDAM 82–1157

A glimpse of the monumental architecture in the
Upper City of Jerusalem is provided by this fine Co-
rinthian capital, which is carved from hard local lime-
stone. Unlike the elaborate acanthus leaves usual on

Corinthian capitals, the leaves here are smooth and
plain, except for the central rib. Above each pair of
slender volutes, below the corners of the abacus, is an
additional smooth leaf with a curving tip. Two lily
scrolls were added on one side—another feature un-
usual in a Corinthian capital. On the flat top of the
abacus is a low broad boss with a square hollow for
the attachment of the architrave.

The carving of the capital was not completed.
Some areas are not smoothed, and on one side there is
an incised outline of a lily in preparation for carving
that was never carried out.

Two column-drums, one of which rests on a base,
were discovered next to the capital, and they probably
belong to the column on which the capital was set.
Lugs such as the one that has survived on one of the
drums were used for erecting the columns but were
not always removed after the completion of the

work. Its diameter indicates that the column was about 5 meters (5½ yards) high, with a gently tapering shaft.

The capital differs slightly from the usual design of the Corinthian order, but similar examples have been found in the eastern Mediterranean. At least four other capitals, almost identical to the present one, were discovered in the tomb of Queen Helena of Adiabene in northern Jerusalem, probably belonging to the funerary monument which rose above the rock-cut facade of the burial complex.

The present capital was discovered within the Jerusalem city limits, and therefore, although it was not associated with any particular structure, it must have adorned a building rather than an elaborate tomb facade. It was found in a layer of fill that precedes the end of the Second Temple period. A fragment of another identical capital was found nearby. Did time or circumstances prevent the ancient architect from using the capital in the construction of a building? Although this would explain why it was preserved almost intact, the question must remain unanswered.

REFERENCES: *N. Avigad, Excavations in the Jewish Quarter of the Old City of Jerusalem, 1970, *Israel Exploration Journal* 20 (1970), p. 136; N. Avigad, *Discovering Jerusalem*, 1983, p. 151.

BURIAL CUSTOMS IN JERUSALEM
Cat. nos. 112–15

From the time of Herod and his dynasty until the destruction of the Temple, Jerusalem was renowned for the magnificence of its buildings—from the king's palace in the west to the Temple built by Herod in the east. But not only the living were housed in splendor—at some distance from the city walls richly decorated, often pyramid-shaped funerary monuments were erected near the burial caves. Some of these monuments have survived in the Kidron Valley (fig. 91). According to Josephus and several travelers of the Roman and Byzantine periods, the funerary monument of Queen Helena of Adiabene and her family, who were converts to Judaism, was surmounted by three pyramids that served as a landmark for those entering Jerusalem from the north. The splendid funerary monuments and the richly ornamented tomb-facades of wealthy Jerusalem families were built in a mixture of styles which is characteristic of the Late Hellenistic and Early Roman periods (fig. 92). Their decorations were carved by Jeru-salem craftsmen who incorporated motifs from Jewish art of the Late Second Temple period.

Two thousand years ago the Jewish cemeteries of Jerusalem extended principally to the east, north, and south of the city, although some burial caves have also been discovered in the west. Burial in family tombs, usually caves, was customary from very early times, and from the Hellenistic period onward, burial niches (*kokhim*) were hewn from the inner walls of the caves (fig. 90). However, an unusual phenomenon—known from the last century before the destruction of the Temple and for about 150 years after—was the custom, principally observed in and around Jerusalem, of collecting the bones of the dead after the flesh had decomposed. This custom, which is attested in numerous burial caves, seems to contradict the usual rules of Jewish burial, but it was the accepted practice for over two hundred years and is described in literary sources. Judging by the finds, it seems that until Herod's reign an individual's body was placed in a niche in the family tomb; the bones were later collected and deposited in a special repository or a communal pit in the burial chamber. From the time of Herod onward, special chests—ossuaries

FIG. 90. Burial cave in the Sanhedria Quarter of Jerusalem. 1st century B.C.–1st century A.D. Photograph: Zeev Radovan.

FIG. 91. Funerary monuments in the Kidron Valley, Jerusalem. Photograph: Garo Nalbandian.

—were used to hold the bones of an individual or of a group of relatives. According to this custom, the deceased was laid to rest in a burial niche. After a year, when the flesh had decayed, the bones were collected and put into an ossuary. Recent research suggests that this practice is based on the evolution of the idea of resurrection on the Day of Judgment into a belief in individual physical resurrection. Though the origin of this idea is not clear, there is no doubt that it was well suited to the changing situation under the Hasmonaeans, and it became widely accepted, especially in Pharisaic circles.

Ossuaries were a local custom, found almost exclusively in Jerusalem and its environs. They exemplify a popular art form in which familiar contemporaneous motifs were adapted to carving on soft limestone. Thousands of ossuaries have been discovered in the burial caves surrounding Jerusalem. Their length is roughly that of the thigh bone—the longest in the body—and their basic shape is that of a box with a flat, vaulted, or gabled lid. Many of the ossuaries are plain; others bear a simple geometric decoration, such as a rosette or a stylized floral motif, incised and carved with the aid of a ruler and compass. Architectural elements inspired by tomb facades and funerary monuments were also popular motifs. Designs based on freehand drawings appear occasionally.

The ossuaries were carved and decorated by Jerusalem stone carvers who also produced a variety of stone vessels, some of which were undoubtedly made from the blocks hewn from the interior of ossuaries. The craftsmen prepared ossuaries for sale in the workshops, and the relatives of the deceased bought them ready-made. Often the name of the deceased, and sometimes his vocation and his relationship to other members of the family, would be added. These inscriptions were incised sketchily and carelessly,

FIG. 92. Detail from tomb facade, decorated with vines and grape clusters. Jerusalem; 1st century B.C.–1st century A.D. Photograph: Amos Kloner.

usually without any consideration for the decoration. Only in a very few cases does the inscription reveal the hand of a skilled scribe. The languages used are Aramaic, Hebrew, and Greek, and the inscriptions are sometimes bilingual. Some of the ossuaries were unfinished when they were placed in the burial caves; this is the case with some of the most elaborate examples (see cat. no. 115).

In addition to ossuaries of soft limestone, there are also ossuaries and sarcophagi of hard limestone, carved in low relief. The latter show that the custom of burying individuals in coffins continued simultaneously with bone collection in ossuaries. The sarcophagi also show a close stylistic affinity to the ornamentation of the tomb facades, and the traces left by the carving tools are identical in both ossuaries and sarcophagi. The tomb facades and the elaborate sarcophagus decorations epitomize the distinctive and remarkable local art created by the Jerusalem stone carvers.

REFERENCES: N. Avigad, The Architecture of Jerusalem in the Second Temple Period, in *Jerusalem Revealed*, Y. Yadin (ed.), New Haven and London, 1976, pp. 17–20; L. Y. Rahmani, Ancient Jerusalem's Funerary Customs and Tombs, Parts 1–4, *Biblical Archaeologist* 44 (1981), pp. 171–77, 229–35; 45 (1982), pp. 43–53, 109–19.

112. Funerary Inscription of Uzziah, King of Judah

Jerusalem, provenance unknown
1st century B.C.–1st century A.D.
Stone; 35 × 34 × 6 cm. (13¾ × 13⅜ × 2⅜ in.)
IMJ 68.56.38

This stone tablet bears the inscription: "Hither were brought/The bones of Uzziah/King of Judah./Do not open!" This epitaph once marked the place, now unknown, where the bones of King Uzziah were re-interred many centuries after his death in the eighth century B.C. It is written in Aramaic, a language spoken in Israel during the Second Temple period (as

were Hebrew and Greek) and in a style of script that dates it to the latter part of the Second Temple period.

The Bible, which records Uzziah's deeds, fortification projects, and conquests, also describes his burial (2 Chron. 26:23): "Uzziah slept with his fathers in the burial field of the kings, because, they said, he was a leper." Evidently the leper king was not buried in the royal tombs within the City of David, but elsewhere, probably outside the city walls. Josephus also relates (*Antiquities of the Jews*, IX, 10, 4) that "he was buried alone in his gardens." It is not clear whether Uzziah's disease was leprosy in the modern sense, but certainly those suffering from what the Bible terms "leprosy" had to live in isolation and be buried in a place set apart from usual burial sites. The removal of Uzziah's

remains from the original burial place may have been connected with the expansion of the city at the end of the Hasmonaean period or in Herod's reign.

The prohibition against opening the tomb in this and in other burial inscriptions is known as early as the First Temple period. It also appears on ossuaries and occurs up to the Islamic conquest. This stone tablet probably served to seal the burial niche, or it may have been set in the wall above that niche.

The inscription was discovered more than fifty years ago in the collections of the Russian Orthodox monastery on the Mount of Olives. There was, however, no record of the place where it had been found at the end of the nineteenth century. This is the only ancient object known on which the name of a king of Judah appears; its importance is therefore considerable, even though it dates from a period much later than Uzziah's reign.

REFERENCES: *E. L. Sukenik, Funerary Tablet of Uzziah King of Judah, *Palestine Exploration Fund Quarterly Statement* (1931), pp. 217–21; Y. Israeli, in *Inscriptions Reveal*, Israel Museum catalogue no. 100, Jerusalem, 1973, p. 120, no. 255.

113. Ossuary with Masonry Decoration

Mount Scopus, Jerusalem
1st century B.C.
Limestone; 41 × 93.5 × 34 cm. (16⅛ × 36¾ × 13⅜ in.), lid 14 × 84 × 24.5 cm. (5½ × 33⅛ × 9⅝ in.)
Excavations of the Israel Department of Antiquities and Museums
IDAM 71–435

This soft limestone ossuary is a superb example of the stonecutter's craft. Using a ruler and compass, he created a splendid and dignified decorative design.

Each side of the ossuary is decorated with an incised design representing a seven-course ashlar wall, enclosed in a frame consisting of a shallow groove. Horizontal joints are indicated by a single incised line, and vertical ones by a double line. The ashlars vary in length and are arranged in random fashion, thus producing the effect of a real wall. Above the wall is a cornice carved with a band of leaves. On one long side two circles are lightly incised, as if in preparation for carving rosettes.

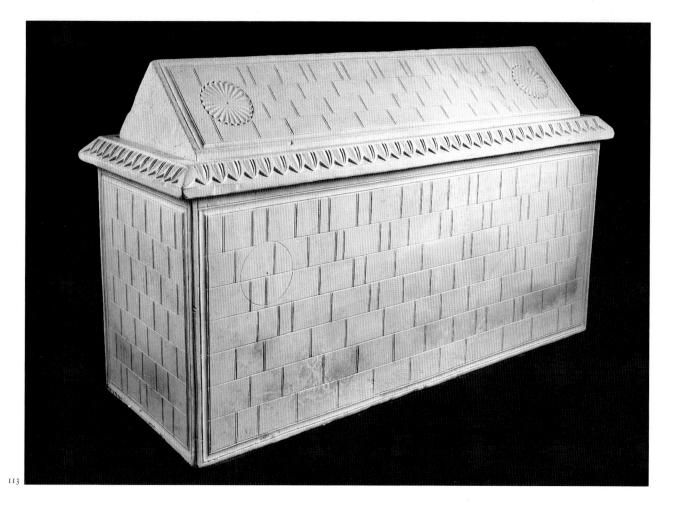

113

The gabled lid rests on an inner ledge about 2 centimeters (¾ inch) below the rim of the ossuary. Like the ossuary chest, it is incised on both long sides with a "wall" design of four courses within a shallow frame. Two multipetaled rosettes are superimposed on the ashlars. Both short sides of the lid are plain, and one of them bears an Aramaic inscription incised in two lines (twenty-seven letters), written in the semi-formal square Herodian script with some cursive traits. The writing is continuous, so that there are alternative possibilities for dividing it into words. The reading of several letters in the first line is not definite, and the meaning of the last word, although it is entirely legible, is not clear in the context.

In the second line the names Eleazar and Shappira are mentioned; they are presumably the names of the people whose bones rested in the ossuary. Eleazar, a common name, appears on another ossuary from the same cave.

Three alternative readings have been suggested: 1. "Nobody has abolished his entering/Not even Eleazar or Shappira." "Entering" is interpreted here as "entering the grave," that is, entering the Sheol or "the house of eternity." 2. "No man can go up [from the grave]/Nor [can] Eleazar or Shappira." There seems to be a contradiction between this reading and the concept of the resurrection of the dead. However, it has been suggested that the inscription implies only human incapacity to arise from the grave. 3. "By no means [is it allowed] to introduce [anyone]/but Eleazar and Shappira." This would refer to a prohibition on inserting the bones of other people into the ossuary, similar to the warning "Do not open!" (see cat. no. 112).

The ossuary was discovered in a rock-cut burial cave on the southeastern slope of Mount Scopus. The tomb consisted of a single chamber with a central pit, seven burial niches (kokhim), and a rock-hewn shelf. Some of the niches were still sealed at the time of discovery, but the tomb had been robbed in antiquity. Only a few of the nine soft limestone ossuaries found in the tomb were decorated. The offerings included several pottery vessels (most of them lamps and bottles) and an iron ring with a red glass bezel bearing a representation of Fortuna–Tyche. They show that this cave was first used for burial in niches at the end of the Hasmonaean period during the first half of the first century B.C. About a generation later, the bones were gathered in one niche. In later burials, bones were collected in ossuaries which were placed in the niches, some of which were then sealed. Other ossuaries were placed on the shelf.

The ashlar-wall design, known from several other specimens, is characteristic of the decorative reper-toire of the ossuaries, which incorporated architectural elements copied from contemporaneous tomb facades.

REFERENCES: *L. Y. Rahmani, A Jewish Rock-cut Tomb on Mt. Scopus, 'Atiqot, English series 14 (1980), pp. 49–54; J. Naveh, An Aramaic Consolatory Inscription, 'Atiqot, English series 14 (1980), pp. 55–59; F. M. Cross, A Note on a Burial Inscription from Mt. Scopus, Israel Exploration Journal 33 (1983), p. 245; E. Puech, Un Emploi de WL' méconnu en Araméen et en Hebreu, Revue Biblique 91 (1984), p. 88–101.

114. Sarcophagus from a Nazirite Family Tomb

Mount Scopus, Jerusalem
First half of 1st century A.D.
Limestone; 41–42.5 × 187 × 45.5 cm.
(16⅛–16¾ × 73⅝ × 17⅞ in.), lid 17.5 ×
189.5 × 47.5 cm. (6⅞ × 74⅝ × 18¾ in.)
Excavations of the Hebrew University,
Jerusalem
IDAM 74–1552

The sarcophagus and its lid are made of hard limestone, and both are richly decorated. The front is carved with a symmetrical floral motif in shallow relief enclosed in a molded frame. In the center is a stylized lily from which spring meandering stems with leaves and two large, pendent bunches of grapes. Six rosettes, each different, fill the empty spaces. The ornamentation is skillfully carved and has a feeling of movement and naturalism, even though it is composed of highly stylized elements. Three square holes near the bottom, of which two are joined by a small channel, were intended for draining fluids from the coffin.

The gabled lid is decorated along its entire front with a densely carved band of myrtle(?) leaves tied with ribbons. On the narrow sides are rosettes, and the back is plain. The care lavished on this sarcophagus is evident in a repair on the back rim of the lid, where a defective part was replaced by a new, precisely fitting piece.

The Mount Scopus sarcophagus is the most elaborate of the small group of Jewish sarcophagi found in Jerusalem which are all made of hard limestone and decorated with stylized floral elements in relief. An identically decorated lid was found in a tomb on the Mount of Olives. A sarcophagus discovered in Herod's family tomb to the west of Jerusalem and another, from Queen Helena of Adiabene's family tomb, the so-called Tombs of the Kings, bear similar patterns.

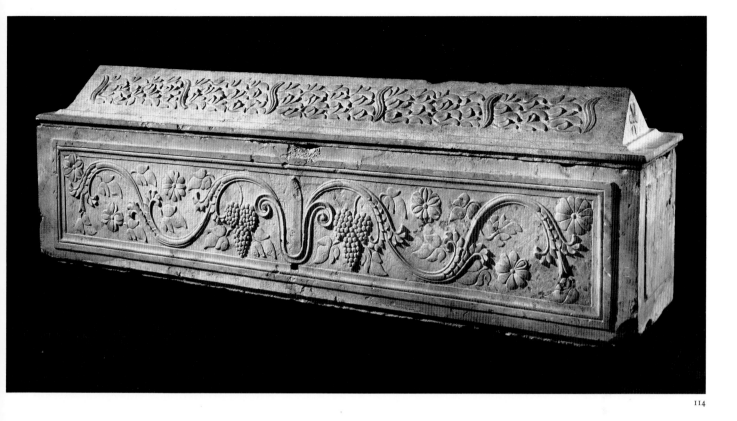

Similar elements also appear on the facades of several of the more elaborate Jerusalem tombs, particularly on the pediments carved in the rock above the entrances. They are derived from contemporaneous Late Hellenistic art but tend to be more stylized and less naturalistic and incorporate floral elements from the repertoire of Jewish art.

The tomb in which this sarcophagus was discovered is located on Mount Scopus in the grounds of the Hebrew University. It is one of the finest sepulchers of the wealthy Jerusalemite families. The rock-cut cave has a central chamber from which three smaller chambers open (fig. 93). The walls and the vaulted ceiling are lined with ashlar masonry of excellent workmanship. Two sarcophagi and fourteen ossuaries were discovered in the tomb, but otherwise it was almost completely empty. The second sarcophagus was plain with a vaulted lid. The ossuaries were of the usual sort, some decorated with rosettes and others plain. Inscriptions on the ossuaries mention the names of Hananiah, son of Yehonatan the Nazirite, and Shalom (Salome), wife of Hananiah. It may be significant that Hananiah's bones were placed in a plain ossuary, while the bones of his wife were laid in a decorated one.

The Nazirite custom was well known among the Jews. If a man was a Nazirite, he took a vow to abstain from drinking wine and from cutting his hair for a certain period of time. Nazirites came from all levels

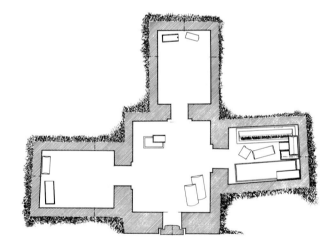

FIG. 93. Plan of the Nazirite burial cave on Mount Scopus, Jerusalem. 1st century A.D. Drawing: Institute of Archaeology, Hebrew University, Jerusalem.

of society, and Yehonatan the Nazirite, whose family was buried in this tomb, must have been a member of a prominent family and a man of means.

REFERENCE: *N. Avigad, The Burial-Vault of a Nazirite Family on Mount Scopus, *Israel Exploration Journal* 21 (1971), pp. 185–200.

115. Ossuary with Architectural Decoration

Mount Scopus, Jerusalem
1st century B.C.
Stone; 47 × 81 × 40.5 cm. (18½ × 31⅞ ×
16 in.), lid 21.5 × 84 × 43 cm. (8½ × 33⅛ ×
16⅞ in.)
Excavations of the Israel Department of
Antiquities and Museums
IDAM 74–1508

This unusual ossuary is one of eighteen which were
discovered in a burial cave on the southern slope of
Mount Scopus. It is decorated on all four sides with
architectural facades and doorways. The front is
carved with six pilasters topped by capitals which in
turn support a cornice. In the center is an elaborate

design depicting a doorway with prominent door-
posts, surmounted by a gable with a lily at its apex.
The doorway is flanked by pilasters bearing capitals
surmounted by arches. Within each niche stand differ-
ent stylized plants, each of which emerges from the
center of an open flower.

The back of the ossuary resembles the front but
is unfinished, and a carved gable replaces one of the
arches.

One of the short sides bears a facade spanned by
a shallow arch supported by pilasters with capitals,
which frame a doorway with a broad lintel sur-
mounted by a gable. Within the tympanum is a
"shield" with a curling tendril beside it. Between the
gable and the arch are four more similar "shields."
The recessed doorway has a double-leaved door
carved into panels.

The other short side depicts a facade with four pil-

lars topped by capitals carrying an open entablature. The central doorway has doorposts, a profiled lintel, and a gable with an acroterion in the shape of a stylized flower. The recessed double-leaved door is carved into panels. Around the upper edge of the ossuary chest runs a projecting cornice-like ridge, cut off on one of the short sides by the shallow arch.

The vaulted lid has a projection near the center with a sunken six-petaled rosette. The lid, which is smoothly finished and polished, seems too large for this ossuary and was probably made for another of similar type.

The back was obviously abandoned in the middle of the work, and on the short sides some details were left unfinished. The ossuary does, however, show the various stages of the stonecutter's work and illustrates how he used his tools. He first marked out the division of the area to be decorated with fine incisions, which are still visible. He then carved the main lines of the design (as on the back of this ossuary), and finally he completed the details and gave it a final polishing.

It is not known whether or not the craftsman who produced this unusual ossuary was copying an actual building. There is a striking resemblance between the facades on this ossuary and the carved facades and funerary structures at Petra, which reflect a mixture of styles from the Late Hellenistic and Early Roman periods. It is likely that similar monuments which may have existed in Jerusalem inspired the designs on this ossuary. The human figures that stand in the niches in a pagan building are replaced here by plants.

REFERENCE: *A. Kloner, A Splendid Ossuary from Jerusalem Bearing a Monumental Façade Motif, *Qadmoniot* 17, 4 (1984), pp. 121–23 (Hebrew).

ANCIENT COINS
Cat. no. 116

Ancient coins are among the most important sources for reconstructing and understanding certain periods of history. They are historical documents, and the symbols and inscriptions depicted on them express the goals and philosophy of the minting authorities. A special coin "language"—using abbreviated inscriptions and designs—was developed by the minters; this enabled them to use a small area efficiently and to express ideas of surprising complexity.

The exact date of the beginning of real coinage (as opposed to barter money) is still not clear; the earliest coins seem to be those struck in some Greek states of Asia Minor in the second half of the seventh century B.C. The first coins were uniface, bean-shaped pieces made of electrum. Only later, in the sixth century B.C., did pure metals—gold and silver—come into use.

FIG. 94. Silver drachma struck at Gaza, incorporating Phoenician and Athenian elements. Ca. 400 B.C. Yoav Sasson collection. Photograph: Israel Museum/David Harris.

FIGS. 95, 96. Silver hemiobol struck by the local authorities in Jerusalem under Ptolemy II, depicting the king's head and an eagle with the Hebrew inscription YHDH (Judaea). Ca. 260 B.C. Photograph: Israel Museum/Zeev Radovan.

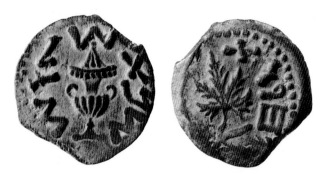

FIGS. 99, 100. Bronze prutah of the Jewish War against Rome, depicting a Temple vessel and a vine leaf. Struck at Jerusalem in A.D. 68. Photograph: Israel Museum/Zeev Radovan.

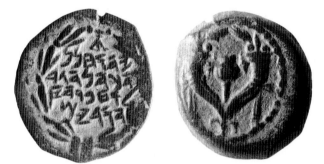

FIGS. 97, 98. Bronze prutah of John Hyrcanus II (63–40 B.C.) with ancient Hebrew script and a double cornucopia. Photograph: Israel Museum/Zeev Radovan.

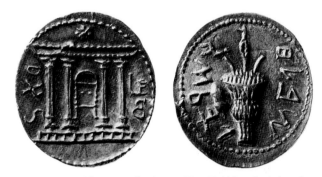

FIGS. 101, 102. Silver tetradrachma of Bar Kokhba, depicting the facade of the Temple in Jerusalem and the four species for the Festival of the Tabernacles. Struck in A.D. 133. Photograph: Israel Museum/Zeev Radovan.

The coins were issued by commercially powerful Greek city-states and later by the Achaemenids of Persia. As time went on, the need for small change in the marketplace became so pressing that tiny gold and silver coins were issued. These were a nuisance to produce and to use, and eventually bronze was introduced for small change, a practice that became widespread at the beginning of the Hellenistic period in the last third of the fourth century B.C.

Another important change in coinage was initiated at this time by Alexander the Great. Many different denominational systems were being used by the various minting authorities, thus causing confusion in the marketplace. However, from Alexander onward an attempt was made to internationalize monetary standards and thereby simplify the fiscal market. Henceforth, throughout the Hellenistic world,

basically the same standards and denominations were used. Thus both the Ptolemies of Egypt and the Seleucids of Syria used the Greek light drachma as their basic unit. When Roman currency was introduced, the denar was made equivalent to the Greek drachma.

The Romans introduced a new dimension to coins by stamping them with propaganda or commemorative messages. An additional monetary innovation of the Roman period was the right granted by the emperors to hundreds of provincial cities throughout the empire to mint their own coins. This was part of a general policy aimed at promoting peace and loyalty in the empire; by raising the rank of these cities, the emperors hoped to undermine national sentiments and aspirations. These local coins convey in symbols and words something of the nature of each city—its religion, major products, or

some other recognizable attribute. In the Hellenistic and Roman periods coins were also sporadically struck by autonomous or semiautonomous provinces and cities. The Jewish and Nabatean coins can be included in this category.

In the Holy Land coins were first minted no earlier than 400 B.C. The first issues, which were apparently struck at Gaza, then a principal center of commerce, were rather peculiar. In order to produce small denominations for the local market, the authorities took the Athenian tetradrachma, the international currency of the time, and cut it into fragments which were then heated and reworked. The resulting silver coins were round or bean-shaped, and they contained small segments of larger designs, such as the nose of the goddess Athena or the legs of the Athenian owl. Only later in the fourth century B.C. were real coins struck at Gaza (fig. 94) and at other mints in the Holy Land (Ashdod, Ashkelon, Jerusalem, and Samaria). Except for their Semitic inscriptions, these silver coins (some of them among the most beautiful coins ever struck in the region) usually imitated their Athenian prototypes. During this period the first Jewish coins, bearing the inscription YHD (Judaea), were minted in Jerusalem. In the time of Alexander the Great, gold, silver, and bronze coins were struck at Akko, but there is no certain evidence of minting elsewhere. During the third century B.C. the policy of the Ptolemies was to allow no independent minting, yet surprisingly, Jewish coins, imitating Ptolemaic coins but with Hebrew inscriptions, were struck in Jerusalem (figs. 95 and 96). Under the Seleucids in the second century B.C., several mints were active in Judaea, and after the Hasmonaean revolt at the end of the century, Jewish autonomous coins were again struck by at least four different Hasmonaean rulers (figs. 97 and 98). When Herod the Great came to power in 37 B.C., there began an era of Herodian minting that lasted until A.D. 100. Most conspicuous for their beauty are the silver and bronze coins struck during the two Jewish wars against the Romans (figs. 99 and 100). The tragic conclusion of the Second Jewish War marks the end of Jewish coinage in ancient times (figs. 101 and 102).

The numerous excavations undertaken in Israel during the last two decades have yielded many thousands of single coins, as well as several dozen hoards. These have been an invaluable aid in the dating of archaeological finds and strata and have provided solutions for many historical enigmas.

REFERENCE: Y. Meshorer, *Ancient Jewish Coinage*, 2 vols., New York, 1982.

116. The Siloam Hoard

Jerusalem
A.D. 66–70
Bronze pyxis and 12 silver coins; height of pyxis 9 cm. (3½ in.), diameter 7.5 cm. (3 in.)
The Israel Museum, Jerusalem
On loan from the Reifenberg family, Jerusalem

The circumstances of this find are not clear. The pyxis, containing approximately forty Tyrian and Jewish shekels, is said to have been found in the Siloam area of Jerusalem. It was bought by a dealer in 1950 who sold the coins one by one until Professor A. Reifenberg purchased the pyxis with the remaining twelve unsold coins (nine Tyrian and three Jewish shekels). The latest coin in this hoard is a Jewish shekel of Year Two of the Jewish War against Rome, struck in A.D. 67.

The bronze pyxis is of excellent workmanship, with concave sides and a ring-base. The tight-fitting lid has a profiled handle ending in a pierced knob. Such containers are known in pottery from Greece in the sixth and fifth centuries B.C. In Roman times they

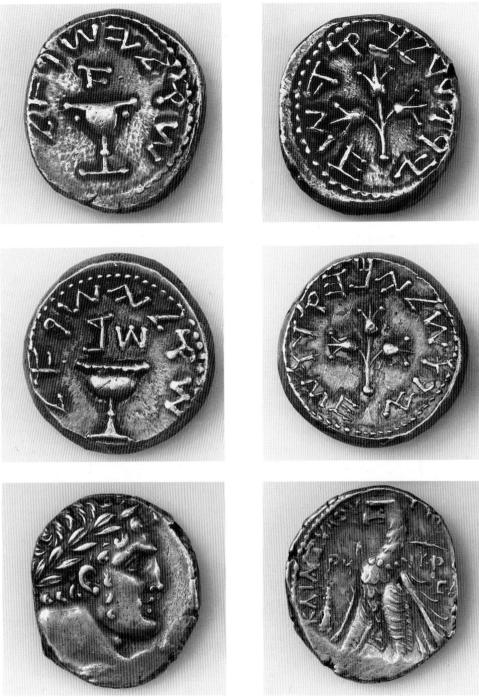

FIGS. 103–8. Three Jewish shekels of the first and second years of the Jewish War against Rome (A.D. 66–67). Photograph: Israel Museum/David Harris.

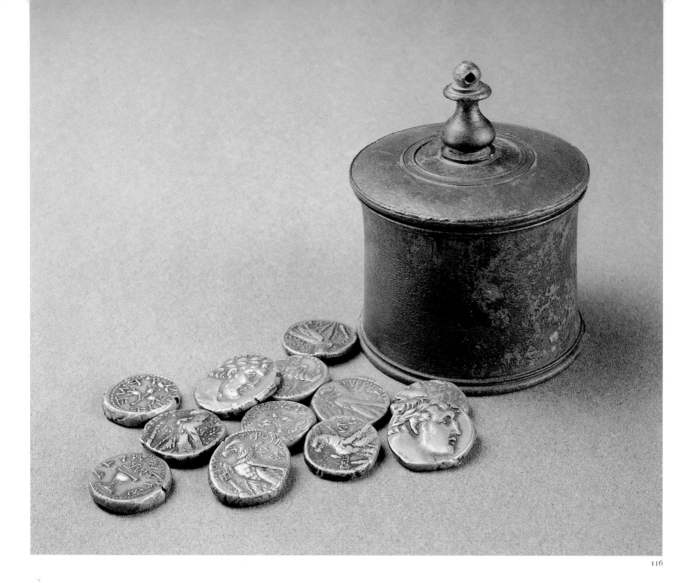

116

were made of a variety of materials, including iron, ivory, tin, lead, silver, gold, and, of course, bronze. Pyxides were used to hold medicines, toilet articles, or coins, jewels, and other articles of value.

Hoards have a special place among numismatists as they normally contain coins in circulation at the time of concealment. In many cases, hitherto unidentified pieces could be interpreted because they were found in hoards together with well-known coins.

This hoard is particularly important because it contains both Tyrian and Jewish shekels (figs. 103–8). In the past Jewish shekels were attributed to the Hasmonaean period and were thought to have been struck under Simeon the Hasmonaean (140–135 B.C.). This find, however, showed that Jewish shekels were circulated together with late Tyrian shekels. The Tyrian shekels are clearly dated to the sixties of the first century A.D. and are worn to a greater extent than the Jewish shekels, proving that the Jewish shekel was struck during the war of A.D. 66–70.

It has recently been suggested that the late Tyrian shekels, such as those found in this hoard, were also struck in Jerusalem. Tyrian shekels were the official currency, declared by the Jewish Sages to be the only money accepted by the Temple in Jerusalem. When Tyre stopped minting these coins, apparently in the time of Augustus, the Jewish authorities in Jerusalem (Herod and the high priest) had to continue to supply these "official" coins. They are different in style and inscriptions from the real Tyrian coins and are called "Jerusalemite silver" in Mishnaic sources.

The latest date on "Tyrian" shekels indicates that they ceased to be minted at the outbreak of the Jewish War against Rome in A.D. 66. At this time the first Jewish shekel, dated "Year One," appears. The associated change in designs is most significant. Instead of the head of Herakles and an eagle, the Jewish shekel displays a temple vessel (the Omer cup) on one side and a branch with three pomegranates (a symbol of purity) on the other. The Hebrew inscriptions read "Holy Jerusalem" and "shekel of Israel."

REFERENCES: *A. Reifenberg, *Ancient Jewish Coins*, Jerusalem, 1947, pp. 30–31; Y. Meshorer, One Hundred Ninety Years of Tyrian Shekels, in *Studies in Honor of Leo Mildenberg*, Wetteren, Belgium, 1984, pp. 171–79; Y. Meshorer, in *Highlights of Archaeology: The Israel Museum*, Jerusalem, 1984, pp. 122–23.

117. Statue of Hadrian

Tell Shalem
A.D. 135–138
Bronze
Head: IDAM 75–763; height 37 cm. (14⅝ in.)
Breastplate: IDAM 75–764; height 52 cm. (20½ in.)
Chance find followed by excavations of the Israel Department of Antiquities and Museums

This statue was found by chance at Tell Shalem, situated about 12 kilometers (7½ miles) south of Scythopolis (Beth Shean). Subsequent excavations at the site revealed a camp of the Sixth Roman Legion (Ferrata). The fragments of this statue were found in a building which stood in the center of the fort (perhaps the *principia*).

The statue is one in a series of representations of standing cuirassed emperors represented in the *ad locutio* manner (greeting his troops). But most of the surviving statues are marble, and of the many bronze statues that must have existed, only a few heads have been preserved. Hence the importance of this find, which is further enhanced by the high aesthetic quality of the statue.

The head, cast in one piece and found intact, is one of the finest extant portraits of the emperor and is of a type (Terme 8618) popular in the provinces.

The breastplate—also of excellent workmanship—depicts a mythological battle, a subject not often seen on cuirassed statues. It has been suggested that the scene shows a duel between Aeneas, wearing a Phrygian cap, and Turnus, the king of the Rutuli, after which the triumphant Aeneas attained the status and the title of "Father of the Roman Race."

Hadrian, who ruled from A.D. 117 to 138, saw himself as one of the founding fathers of Rome, and therefore such an interpretation of the scene on his cuirass is plausible. Although he is regarded as one of the most enlightened of the Roman emperors, his attitude toward Judaea and the Jews was hostile, and part of his overall policy was the eradication of an independent Jewish national entity. The establishment of the Roman colony of Aelia Capitolina on the ruins of Jerusalem, the building of pagan shrines on the site of the Temple, and other oppressive measures provoked the outbreak of the Bar Kokhba Revolt (A.D. 132–35), which was fought with extreme cruelty by the Romans.

The statue was found in several pieces: the head and the breastplate (both of which were found in one piece), parts of the back, fragments of the arms, the paludamentum (military cloak), some of the *pteryges* (plain lappets), and a toe of the right foot. A second bronze head and some other pieces of metal were found with these pieces.

REFERENCES: G. Foerster, A Cuirassed Bronze Statue of Hadrian, *Israel Museum News* 16 (1980), pp. 107–10; U. Avida, in *Highlights of Archaeology: The Israel Museum*, Jerusalem, 1984, pp. 90–91; *G. Foerster, A Cuirassed Bronze Statue of Hadrian, *'Atiqot*, English series 17 (1986), pp. 139–60, pls. XXIV–XXXVIII.

118. Head of a Young Woman

Provenance unknown
Hadrianic, A.D. 117–138
Marble; height 32.5 cm. (12¾ in.)
IDAM 45.3

This portrait of a young woman is carved in fine-grained white marble. The nose is broken, as is the base of the neck which was intended to be inserted into a bust or a statue. The surface of the portrait, except for parts of its left side, is slightly abraded. The back of the head is fairly roughly executed. The hair-dress contrasts stylistically and technically with the milky smoothness of the face. The pupils of the eyes are not drilled and still bear faint traces of paint. The modeling, although somewhat inexact in the anatomical details, is very engaging in its rendering of an attractive young Roman matron.

The head belongs to a group of female portraits with elaborate coiffures consisting of complicated arrangements of plaits encircling the crown of the head in a turban-like fashion. The group is assigned to the second century A.D. Similar coiffures are seen on coins of Marciana and Matidia, Trajan's sister and niece; of Sabina, Hadrian's wife; and of Faustina, wife of Antoninus Pius. The present head probably represents a private person. Here the coiffure is arranged in four pairs of plaits; these plaits are parted at the back of the head where some unbraided hair is arranged symmetrically in four waving curls. The bottom pair of plaits runs up to the ears; the other three cross over the forehead, the right three plaits over the left ones and then tucked under them. The crown of the head is covered with a fabric headdress. Ten locks are arranged in symmetrical waves from the central parting above the forehead.

Such Roman female portraits are rarely found in Judaea. Stylistic considerations suggest a late Trajanic or early Hadrianic date (first half of the second century A.D.), which would accord with the historical

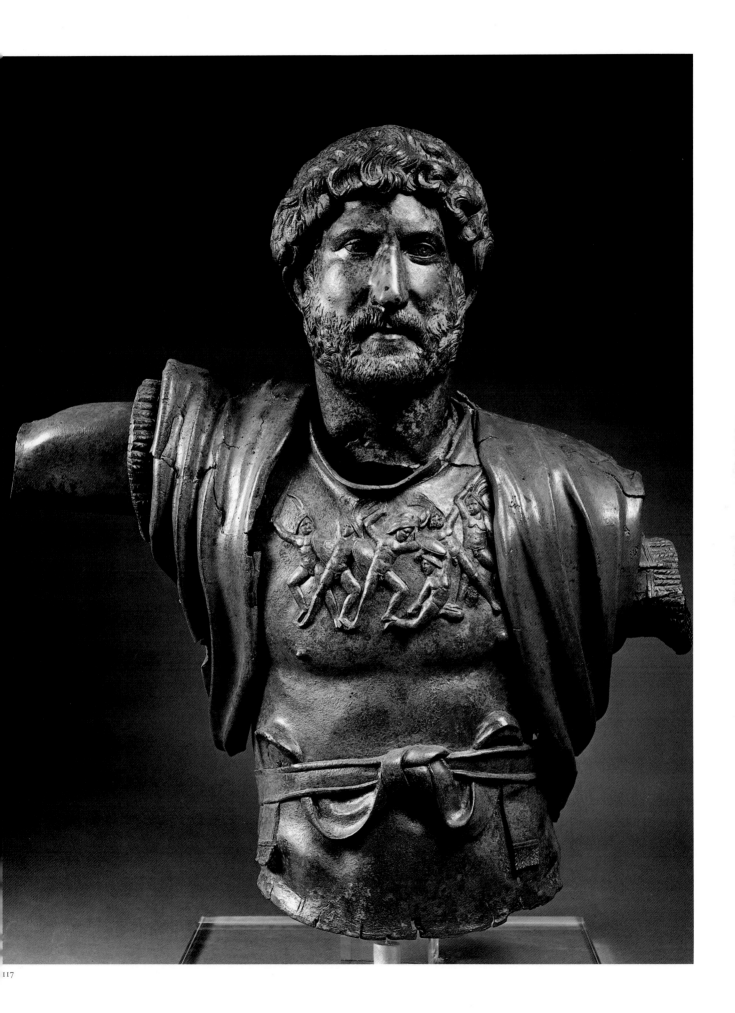

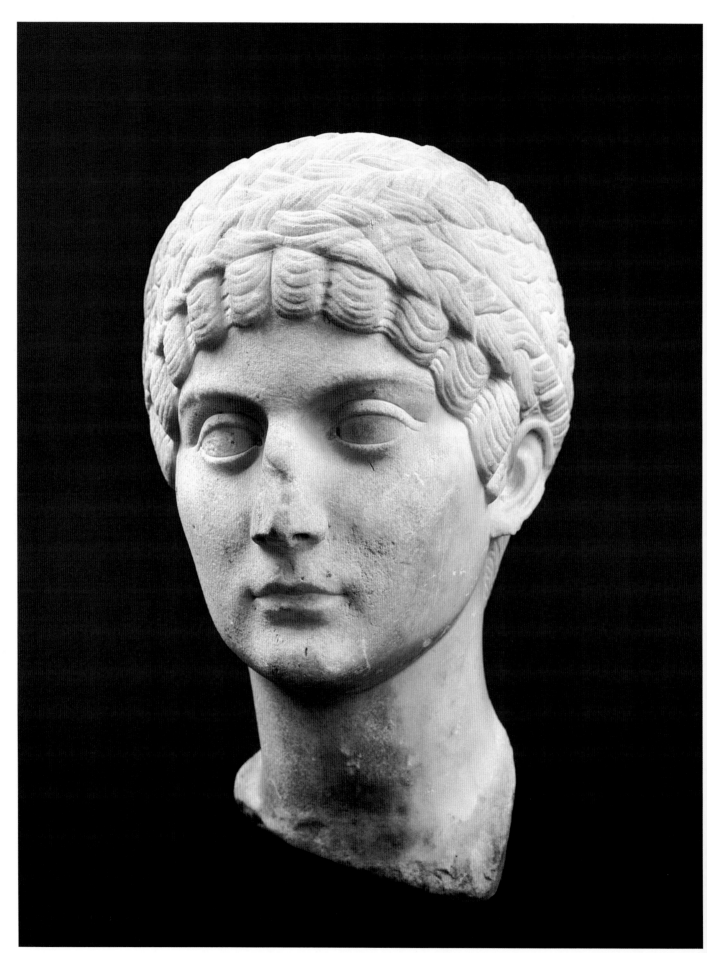

and archaeological evidence documenting a strong Roman presence at that time. Its provenance is unknown, but it is said to come from the Jordan Valley, probably the Beth Shean area, which has yielded some of the most impressive finds of imported Roman art of the second century A.D. (notably the bronze statue of Hadrian, cat. no. 117).

Previously unpublished.

119. Statue of Kore

Samaria
Late 2nd century A.D.
Marble; height 120 cm. (47¼ in.)
Excavations of the Joint Expedition to Samaria (Harvard University, the Hebrew University, Jerusalem, the Palestine Exploration Fund, the British Academy, and the British School of Archaeology in Jerusalem)
IDAM 32.2435

The statue, probably from the end of the second century A.D., represents the goddess Kore (Persephone). She holds a long torch in her right hand and a sheaf of wheat in her left, attributes of her dichotomous life on earth and in the underworld. She wears a long chiton and a himation, and a veil hangs from her diademed head. Traces of red paint are seen on the statue, though they have faded slightly since they were reported by the excavators.

The statue has been partially restored from fragments, some of which were recovered from a cistern together with other marble pieces. One of these bears a painted Greek inscription: "One goddess, the ruler of all, great Kore, the invincible."

A Hellenistic temple to Kore, standing within a large temenos, existed in Samaria as early as the fourth century B.C., and the cult of the goddess is attested on coins and in inscriptions as late as the third century A.D.

REFERENCES: *L. K. Crowfoot, G. M. Crowfoot, and K. M. Kenyon, *Samaria-Sebaste III: The Objects from Samaria*, London, 1957, p. 73, pls. VIII, IX; D. Flusser, The Great Goddess of Samaria, *Israel Exploration Journal* 25 (1975), pp. 13–20.

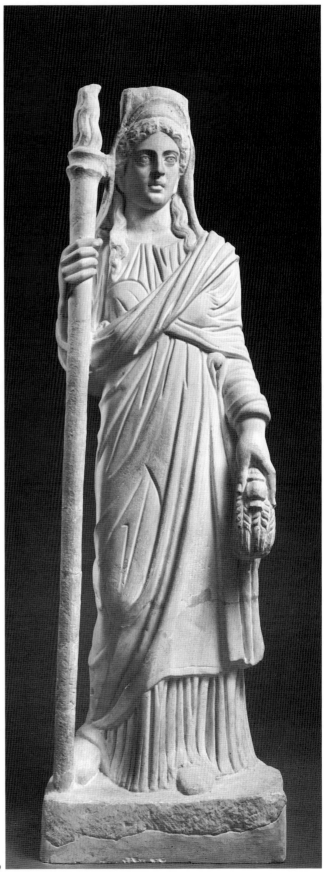

119

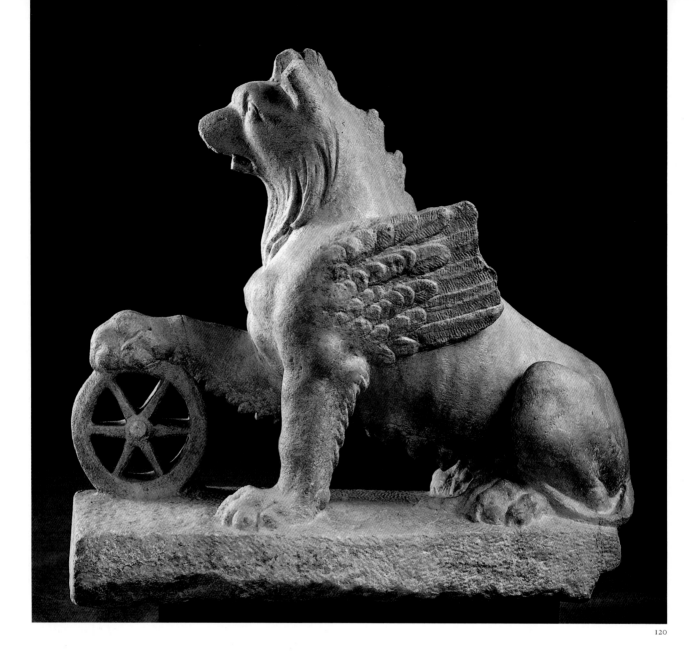

120

120. Griffin

Erez
Early Severan, A.D. 210–211
Marble; 48 × 53 cm. (18⅞ × 20⅞ in.)
IDAM 57–866

There are three works relating to Nemesis, the awesome goddess of vengeance, on display in the Israel Museum. The first is a marble statue from Alexandria which shows the goddess in her anthropomorphic form, leaning on the wheel of fortune. The second is a small weight in the form of Athena, with the Nemesian griffin on her shield. The third, and most interesting, is this marble statue of the griffin with its right paw placed on the Nemesian wheel of fate. The first comes from Egypt, the other two from the

northwestern Negev, a region traditionally under Egyptian influence.

The griffin from Erez was found by chance in the fields of the kibbutz of that name. The creature has a beak attached to a feline head with prominent ears and horns; it has a lion's body with short, thick paws and a tail. Two rows of teats hang from its belly, and in front, at shoulder height, there are two human breasts. The griffin is winged and sits on its hindquarters, its right paw resting on a six-spoked wheel. The wings, the upper part of the head, and the beak were damaged in antiquity.

The socle of the statue is inscribed in Greek: "Year 522. I, Mercurios, son of Alexander, dedicate [this statue] during my priesthood." The date corresponds to A.D. 210/211.

The cult of Nemesis and her attribute, the griffin,

was widely practiced in Roman Egypt and is well documented in archaeological finds, numismatics, and epigraphy. Some objects (now lost) relating to Nemesis and her griffin are said to have been found in the northern Negev at the end of the nineteenth century. The evidence is sufficient to suggest that her powers were feared and placated in that region and that a temple dedicated to Nemesis may have existed somewhere between Ashkelon and Gaza.

Nemesis, personifying divine punishment of human presumption following a stroke of good fortune, seldom appears in early Greek art. When she does, she is always represented as a woman. In later times she is represented—sometimes winged—with the attributes of the wheel of fortune and the griffin, a symbol of her unpredictable and swift retribution. It was probably in Alexandria that she lost her anthropomorphic character and became completely assimilated with the griffin and the wheel. In the Late Hellenistic and Roman periods, this previously somewhat obscure deity achieved an immense popularity. In those times of political and economic turmoil, when the established order was changing—and not for the better—Nemesis and her turning wheel of fortune became a deity to be feared and propitiated. It is likely that soldiers, among whom Nemesis was an especially revered deity, were responsible for spreading her cult in the pagan urban centers along the Mediterranean coast to Egypt.

REFERENCE: *J. Leibovitch, Le Griffon d'Erez et le sens mythologique de Némésis, *Israel Exploration Journal* 8 (1958), pp. 141–48, pls. 25–29:F.

121. Statuette of a Maenad

Provenance unknown
Early 3rd century A.D.
Marble; height 59 cm. (23¼ in.)
IMJ 76.53.64
Gift of Col. Henry Crown, Chicago, in memory of his son Robert, through the Jerusalem Foundation

This freestanding figure of a woman, her drapery fluttering wildly, looks back in terror or ecstasy. Although she is carefully carved in the round, she resembles the representations in relief of maenads on Dionysiac sarcophagi. The raised and deeply incised eyes and the heavily undercut drapery suggest that this is a work from the period of the Severan emperors (A.D. 193–225).

The statuette is said to come from Beth Shean.

Previously unpublished.

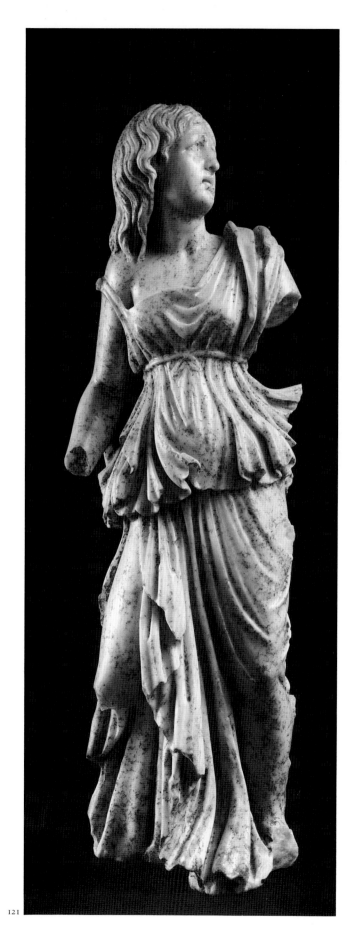

121

122. Jewelry

Nahal Raqafot, Jerusalem
First half of 3rd century A.D.
Gold inset with pearls and semiprecious stones
Ring: IDAM 73–940; length of seal 2.5 cm.
(1 in.)
Earring: IDAM 73–941; height 4.2 cm. (1⅝ in.)
Brooch: IDAM 73–933; height 5.3 cm. (2⅛ in.)
Excavations of the Israel Department of
Antiquities and Museums

The three pieces of jewelry, together with some other fragmentary gold ornaments, were found in a rock-cut tomb on a hillside west of Jerusalem. The tomb contained a lead sarcophagus decorated with a pattern of intersecting cables forming triangles and lozenges that frame satyr masks and colonnettes. Lead sarcophagi were common in the third century A.D., and those which were not robbed in antiquity often contain jewelry.

The heavy gold ring was found inside the coffin with some fragments of plain gold headbands and a second gold ring. The present ring has an elliptical loop and a flattened oval bezel set with a two-banded blue onyx intaglio showing a cuirassed elephant. Representations of elephants from the public shows of Rome were well known in the second century A.D., and this intaglio was probably made in that city.

The other two pieces of jewelry, together with part of a gold diadem, were deposited on top of the closed coffin and were probably torn off the mourners' garments at the time of burial as an expression of grief and as an offering to the deceased.

The earring is a well-known type that had many variations and that has been found in a number of tombs of the third century A.D. It consists of a rosette soldered to a horizontal bar of juxtaposed animals which was punched out from gold sheet. The rosette encloses a baroque pearl on a wire backed by a gold cup. The three pendants attached to the bar are composed of a garnet in a gold bezel setting from which a baroque pearl hangs. The animals on the horizontal bar show some affinities with the "animal style" of the steppes, but unlike the brooch, this earring has many parallels in local finds.

The brooch consists of an oval frame of sheet gold enclosing an onyx cameo of four light and dark layers. The cameo represents the bust of Minerva, hel-

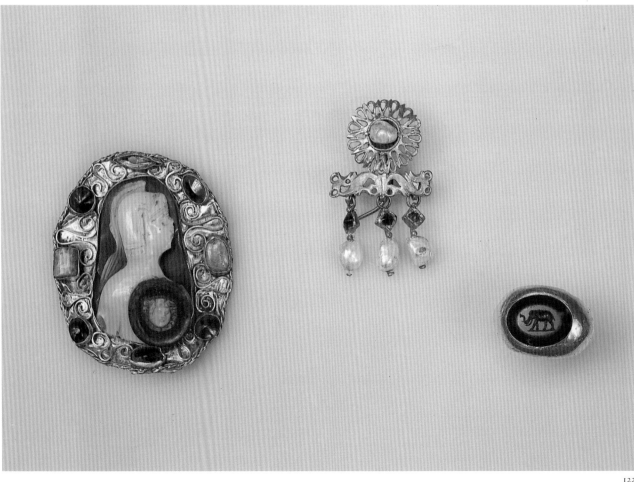

meted and holding a round shield with a gorgoneion in the center. The frame has eight bezel settings holding two emeralds and five garnets. One stone is missing. The stones are of different sizes; most are oval, but one of the emeralds is cylindrical and is probably a bead. The frame has a cable border, and filigree loops ending in spirals separate the settings.

The profile of Minerva was chipped off in antiquity, and the pin, catch, and hinge are missing, probably torn off during the mourning ceremony.

This brooch and the diadem from Kefar Giladi (cat. no. 123) are the only jewelry of polychrome style found in Israel. The Kefar Giladi diadem is crude and barbaric, but the brooch is a good example of filigree work and bezel setting in that style. Such jewelry is rare in the second and third centuries A.D. and even rarer in the Mediterranean area. The closest parallels come from the southern Russian steppes; the present brooch probably originated in that area and may have been brought to Jerusalem by a Roman soldier.

REFERENCE: *L. Y. Rahmani, Roman Tombs in Nahal Raqafot, Jerusalem, 'Atiqot, English series 11 (1970), pp. 77–88, pls. XXI–XXIV.

123. Diadem

Kefar Giladi
3rd century A.D.
Gold with stone, glass, and mother-of-pearl insets; length 29 cm. (11⅜ in.)
Excavations of the Israel Department of Antiquities and Museums
IDAM 61–482

This rare diadem, made in the polychrome style of Late Roman times, is an unusual find in Israel.

The heavy diadem, of crude workmanship, is impressive in its barbaric design and the colorful effect of the large, unmatched insets. The band is made of fairly thick, ribbed gold foil, slightly wider at the center. Plain gold bands of this kind are not uncommon in funerary contexts throughout Israel, but the Kefar Giladi diadem is unusual in that it is studded with nine colored insets. These are of different shapes, sizes, and materials and clearly were not cut especially for this piece of jewelry. There is an attempt at symmetry in the alternation of square and oval shapes and in the arrangement of colors: in the center is a large

123

piece of blue glass, flanked by two smaller round insets of mother-of-pearl, followed by two square stones —a green beryl on the left and a white feldspar on the right—oval pieces of blue glass, and square green beryls.

The diadem was found—with a gold chain-bracelet threaded with emerald beads—in a heavy lead coffin excavated at the site of a mausoleum near Kefar Giladi in Upper Galilee.

Lead coffins were popular in the eastern Mediterranean in Late Roman times and many of these originated in a workshop in Sidon. The decoration of the Kefar Giladi coffin—reliefs depicting Herakles in a gabled frame, a lion, Corinthian columns, and panels of grape clusters, vine tendrils, and birds—has many affinities with the style of that workshop. Such coffins were produced with Jewish, Christian, or pagan symbols; the one discussed here is obviously pagan.

It is not known whether the present diadem was made locally, imitating imported examples, or whether it was brought by Roman soldiers as part of their loot. The rarity of such finds would suggest the latter. This diadem reflects the increasingly polychrome character of Late Roman jewelry, which, under the influence of the northern barbaric styles, favored varied materials and colors rather than form and delicacy of technique.

REFERENCE: *J. Kaplan, A Mausoleum at Kfar Giladi, *Eretz-Israel* 8 (1967), pp. 104–13, pls. XIV–XVII (Hebrew), English summary, pp. 71*–72*.

124. Ganymede and the Eagle

Samaria
3rd–4th century A.D.
Bone; height 7.8 cm. (3⅛ in.)
Excavations of the Joint Expedition to Samaria (Harvard University, the Hebrew University, Jerusalem, the Palestine Exploration Fund, the British Academy, and the British School of Archaeology in Jerusalem)
IDAM 35.3650

This small bone statuette was found in 1935 during the excavations at Samaria "inside the porch of a late Roman house. . . . On the floor of the house a coin of Gratian and two others perhaps of the fifth century were found" (Crowfoot et al., 1957, p. 84). However, the style of the figurine indicates a date not later than the fourth century A.D.

The figurine is carved in the round, but the back is very summarily rendered. It is slightly broken—the left wing of the eagle and the left arm of Ganymede, as well as both his legs below the knees, are missing. Otherwise the statuette is in good condition; the surface of the bone is smooth and well preserved.

The treatment of the abduction of Ganymede in the present figurine follows that of Leochares' famous statue of the fourth century B.C., although with significant deviations. While the earlier statue represented the moment of takeoff, with the eagle spreading its wings and straining to lift its prey, the sculptor of the Samaria statuette has chosen to depict a tranquil moment in the flight. Ganymede is comfortably nestled between the claws of the eagle; his body seems weightless and in complete repose. The eagle looks down to meet Ganymede's upward gaze. This is the most tenderly executed part of the composition, and the face of the Trojan boy is very sensitively rendered. In contrast, other parts of the figurine, such as the boy's hands and the eagle's claws, are crudely carved.

The school of bone carving active in Israel during the Late Roman and Byzantine periods frequently represented mythological themes, but the present statuette differs completely, both in technique and in style, from the products of that school. There was, however, a celebrated school of ivory carving in Alexandria which exported its products throughout the Roman empire, and this Ganymede may well have been fashioned there.

REFERENCES: *J. W. Crowfoot, G. M. Crowfoot, and K. M. Kenyon, *Samaria-Sebaste III: The Objects from Samaria*, London, 1957, p. 84, pl. XIV, 5; R. Rosenthal, Late Roman and Byzantine Bone Carvings from Palestine, *Israel Exploration Journal* 26 (1976), pp. 96–103.

125. Plaque Against the Evil Eye

Provenance unknown
5th century A.D.
Limestone; 31.5 × 27.5 cm. (12⅜ × 10⅞ in.)
Collection of the Institute of Archaeology, the Hebrew University, Jerusalem
Hebrew University 2473

This soft limestone plaque is carved in a gabled architectural design. The recessed facade, without intermediate molding, creates a strong interplay of light and shadow that gives an effect of depth. Parts of the plaque are cut out, and there is a suspension hole at the top of the gable. The plaque was covered with a light-colored slip, overpainted with red, traces of

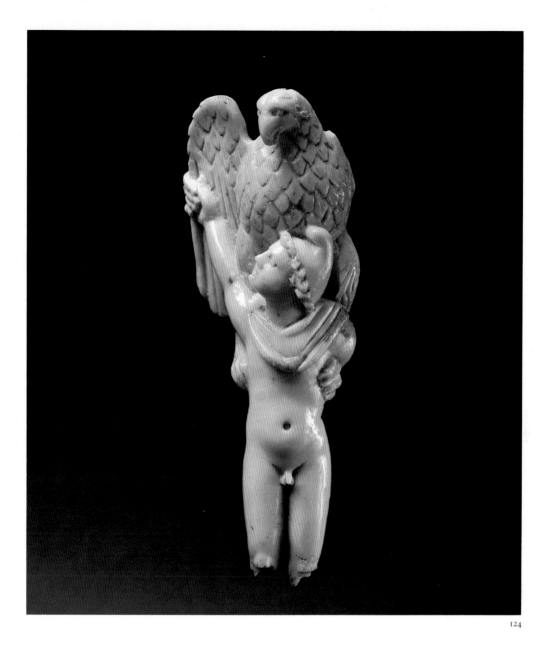

124

which still remain. The sockets in the four corners of the central niche indicate that two pivoting panels covered the central hollow. This circular hollow, as well as the three semicircular ones at the top, were originally inlaid with mirrors, of which one has survived in place.

The main element of the composition is the central niche which once held the largest mirror. Such niches housing sacred objects are a commonplace in the artistic vocabulary of the period and have their origin in much earlier times. The composition, symbolic and apotropaic in character, is enhanced by the four mirrors, intended to distract and ward off the evil eye.

A considerable number of stone and clay plaques inlaid with mirrors—of different shapes and forms (sometimes even figurines)—have been found, mostly in tombs. The symbols appearing on the plaques identify their owners as Jewish, Christian, or pagan.

The present plaque bears typical Jewish symbols. The niche is flanked by two menorahs (seven-branched candelabra) standing on tripods and worked in bead-like segments reminiscent of the "cups and flowers" of the biblical description (Exodus 25:33). From Late Roman times onward, this combination of a shrinelike construction flanked by menorahs, sometimes in association with other Jewish ritual objects, was depicted on many objects and buildings. Its most impressive manifestation is on the mosaic pavements in the synagogues of the period (see cat. no. 148). This symbolic grouping is commemorative of the Temple of Jerusalem and its implements, but no doubt its memorial

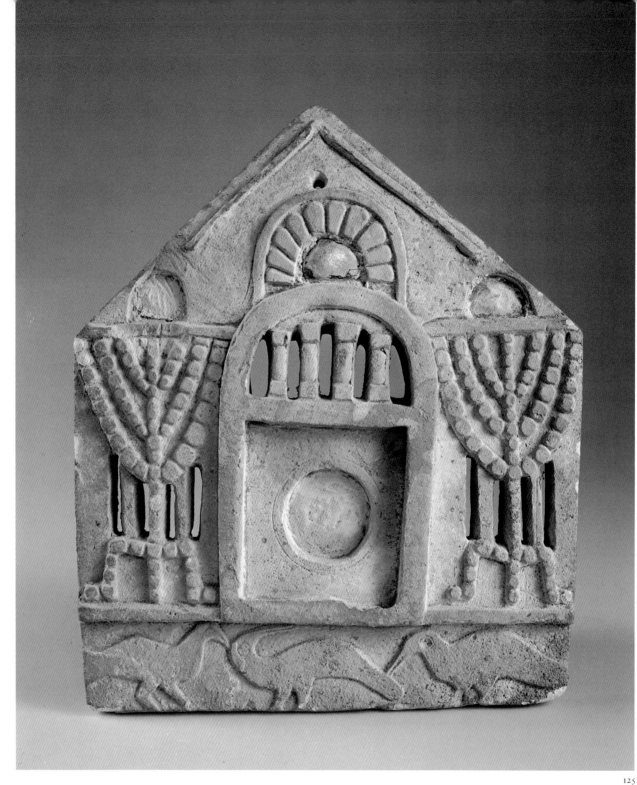

character is coupled with a strong yearning for a national and religious revival. On this plaque, it is represented as the wall facing Jerusalem in a synagogue of that time, with the gabled roof, the imposing central door, and the two lateral doorways in front of which stand the menorahs. The base is decorated with a frieze of three birds, a not uncommon instance of animal decoration in religious Jewish art.

Thus this protective plaque embodies elements of personal and national salvation, while its rather rudimentary and naive style reflects the credulity inherent in magical objects of popular appeal.

REFERENCES: *L. A. Mayer and A. Reifenberg, Three Ancient Jewish Reliefs, *Palestine Exploration Quarterly* 70 (1937), pp. 136–39, pl. VII:1; L. Y. Rahmani, Mirror-Plaques from a Fifth-Century A.D. Tomb, *Israel Exploration Journal* 14 (1964), pp. 50–55.

126. Jewish Oil Lamp

Provenance unknown
5th–6th century A.D.
Bronze; height 11 cm. (4⅜ in.), length
16.5 cm. (6½ in.)
Schloessinger Collection, Institute of
Archaeology, the Hebrew University,
Jerusalem

Oil lamps, by their nature both functional and decorative, have always been good indicators of the artistic and cultural fashions of their day. Like other small objects in daily use in the Byzantine period, they reflect the prevailing religious trends—not only the rise of Christianity but also the consolidation and new self-assertiveness of Judaism after the loss of the Temple as a focal point of worship. In addition to the innumerable pottery lamps that have survived, a few elaborate bronze lamps are known. Because of their size and costliness, these gave greater expression to contemporaneous cultural trends than did their pottery counterparts.

This large lamp was cast in one piece—except for the now-missing lid of the filling hole—with a handle-guard consisting of a menorah and other Jewish symbols. It is the only known specimen of its kind. Un-

like the common pottery lamps, which changed style and form frequently, large metal lamps clung to traditional Roman shapes. The rounded wick-hole separated from the oil receptacle by a well-defined nozzle, the completely round body, and the almost vertical handle-guard follow well-established Roman artistic traditions. These features are rarely seen in pottery lamps but are common in the large bronze lamps which, as a rule, had a raised ring-base and a socket so that they could be placed on the spikes of elaborate metal candlesticks or candelabra.

In Byzantine times the handle-guards often featured religious symbols. Here the menorah is flanked by the lulav (palm branch) and etrog (citron) on the right and the shofar (ram's horn) on the left.

The menorah, which usually is represented standing on a tripod, is here shown without a base, thus perhaps indicating that the base was not an integral component of the original sacred object. Otherwise the menorah is cast in the usual rendering of the biblical "cups and flowers" motif and has a horizontal bar supporting the flames.

REFERENCES: *R. Rosenthal and R. Sivan, Ancient Lamps in the Schloessinger Collection, Qedem 8 (1978), no. 662; U. Avida, in Highlights of Archaeology: The Israel Museum, Jerusalem, 1984, pp. 106–7.

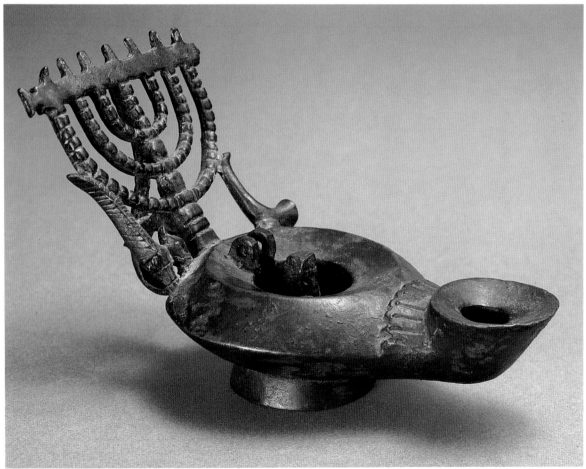

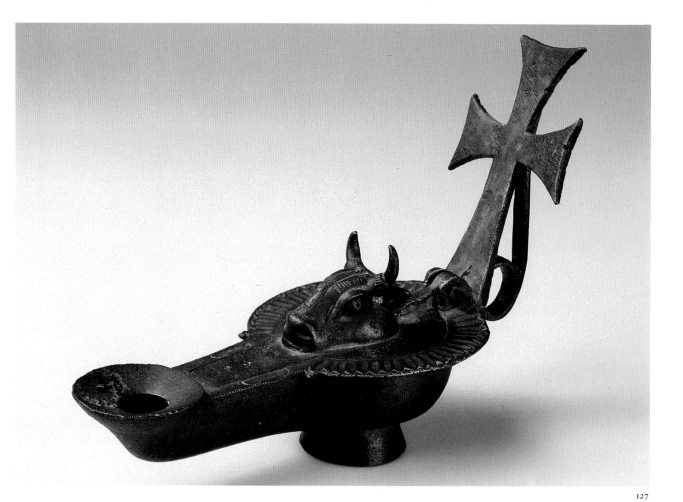

127

127. Christian Oil Lamp

Beth Shean
5th–6th century A.D.
Bronze; height 16 cm. (6¼ in.), length
21.5 cm. (8½ in.)
Excavations of the Israel Department of
Antiquities and Museums
IDAM 52–134

This lamp, cast in one piece except for the lid of the
filling hole, was excavated in a Byzantine building in
Beth Shean, known as the "mansion" because of its
size and the quality of the many artifacts it yielded.
The lamp is of a well-known type, and there is a large
corpus of Byzantine bronze lamps featuring crosses
on their handle-guards, many of them found during
scientific excavations. Together with the innumerable
pottery lamps decorated with crosses or other Chris-
tian motifs, they reflect the spread of the Christian
population prior to the Islamic conquest in the sev-
enth century A.D.

REFERENCES: *N. Tsori, Bronze Utensils from Byzantine Beth
Shean, *Qadmoniot* 3 (1970), pp. 67–68 (Hebrew); U. Avida,
in *Highlights of Archaeology: The Israel Museum*, Jerusalem,
1984, pp. 106–7.

128. Fragments of a Mosaic Floor

El-Hammam
4th–6th century A.D.
Stone and glass; boy 64 × 68 cm. (25¼ ×
26¾ in.), fish 46 × 137 cm. (18⅛ × 54 in.)
Excavations of the Israel Department of
Antiquities and Museums
IDAM 51–246

These two contiguous slabs, found near Scythopolis
(Beth Shean), are a small fragment of a floor mosaic,
probably from the triclinium of a villa. The tesserae
are stone and blue glass. The slabs show part of the
border of the mosaic, consisting of a peopled scroll,
and a small part of the central carpet, which must
have depicted a Nilotic scene on a white background.
Such scenes are well known in the country, and one
was excavated in Beth Shean itself.

Previously unpublished.

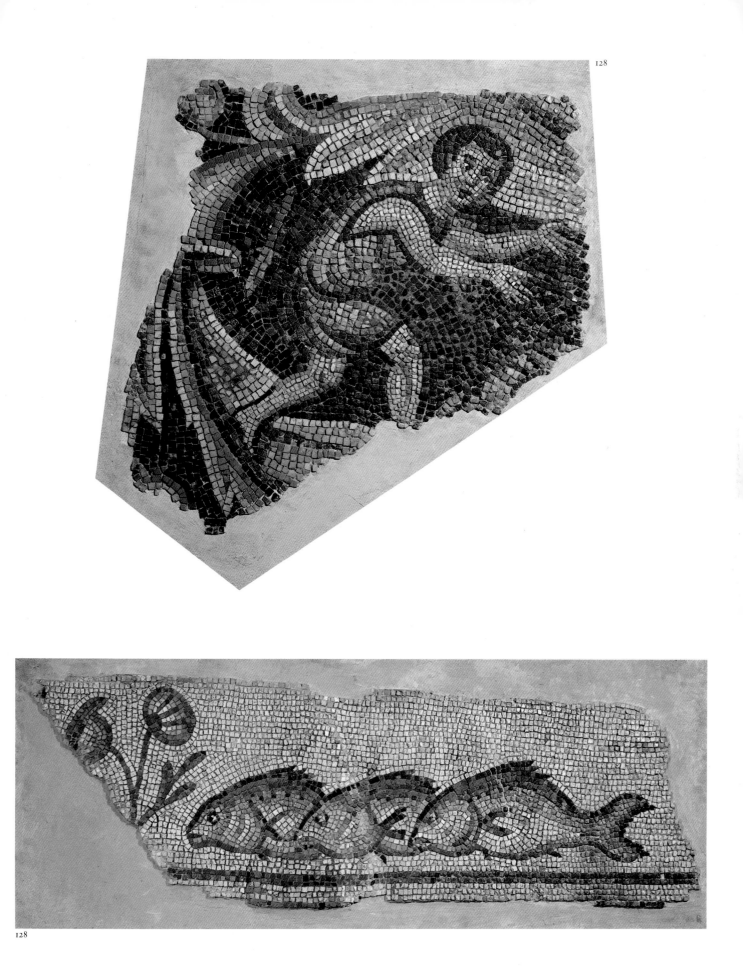

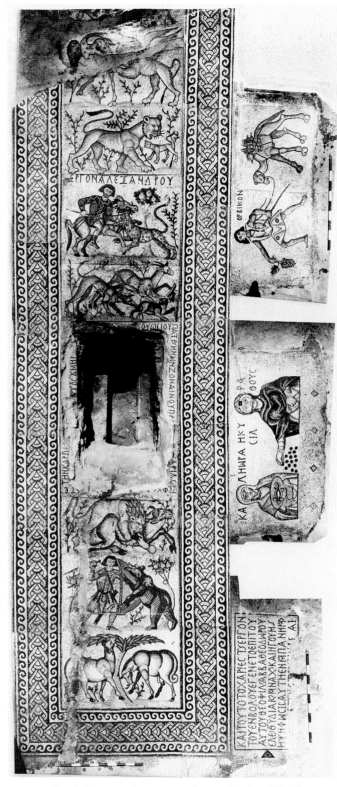

FIG. 109. Detail from mosaic pavement from a church at Kissufim. 6th century A.D. Photograph: Israel Department of Antiquities and Museums/Zeev Radovan.

129. Mosaic Pavement

Kissufim
A.D. 576–578
Stone and glass; 154.5 × 160 cm. (60⅞ × 63 in.)
Excavations of the Israel Department of Antiquities and Museums
IDAM 77–416

These two scenes form part of the mosaic floor of a sixth-century Byzantine church uncovered in the fields of Kibbutz Kissufim. It was built on the plan of an early Christian basilica, with a nave, two aisles, and a semicircular apse in the east wall, as well as a narthex and an atrium with a cistern. Only some of the foundation walls have survived, but fortunately substantial parts of the exquisite floor mosaic, composed of stone and green glass tesserae, have been preserved (fig. 109). These include two inscriptions which provide the exact dates, corresponding to A.D. 576 and 578, when different parts of the floor were laid.

In addition to the inscription in the nave and some of the intercolumniations, the largest (11 × 2.4 meters [12 × 2⅝ yards]) and most important part of the mosaic floor to have been preserved is in the north aisle. This carpet, enclosed in a broad guilloche frame, is composed of twelve animal scenes, of which three include hunters, and some of which are accompanied by short inscriptions. The two scenes presented here show a lion attacking a bull and a hunter fighting with a bear. An undulating groundline with trees and shrubs separates the scenes.

The Kissufim mosaic, known for its excellence of design and execution, is unparalleled among the many mosaic pavements known in Israel. The western Negev, where it was found, is rich in contemporaneous mosaic floors. Literary sources also mention magnificent wall mosaics in Gaza, which was apparently an important center for mosaic workshops of different styles in the fifth and sixth centuries A.D.

Mosaic floors are among the most characteristic artistic achievements of the Byzantine period in Israel. Although there is a tradition of the mosaic craft going back to the Hellenistic period (second century B.C.), it flourished and achieved a wide popularity in the Byzantine period, when mosaics were used to pave synagogues, churches, and secular buildings.

REFERENCE: *R. Cohen, The Marvelous Mosaics of Kissufim, *Biblical Archaeology Review* 6 (1980), pp. 16–23.

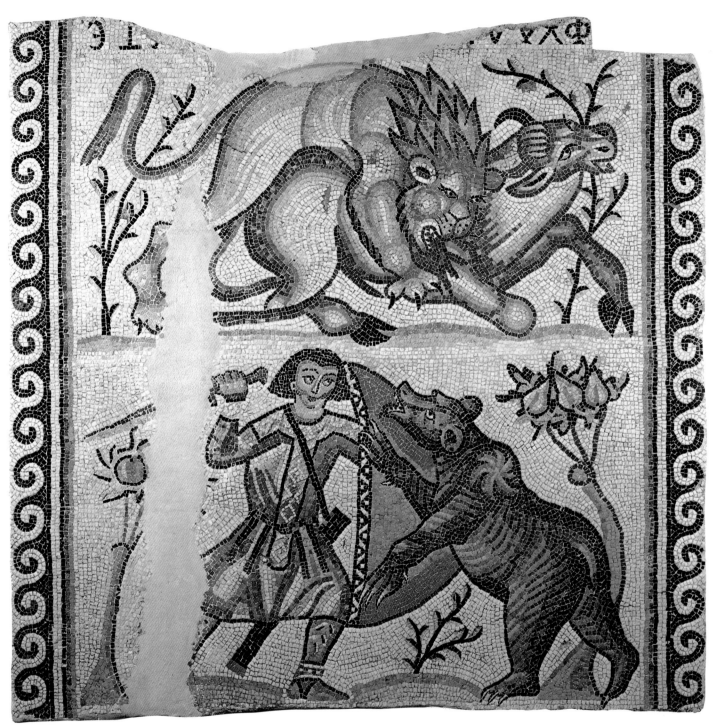

129

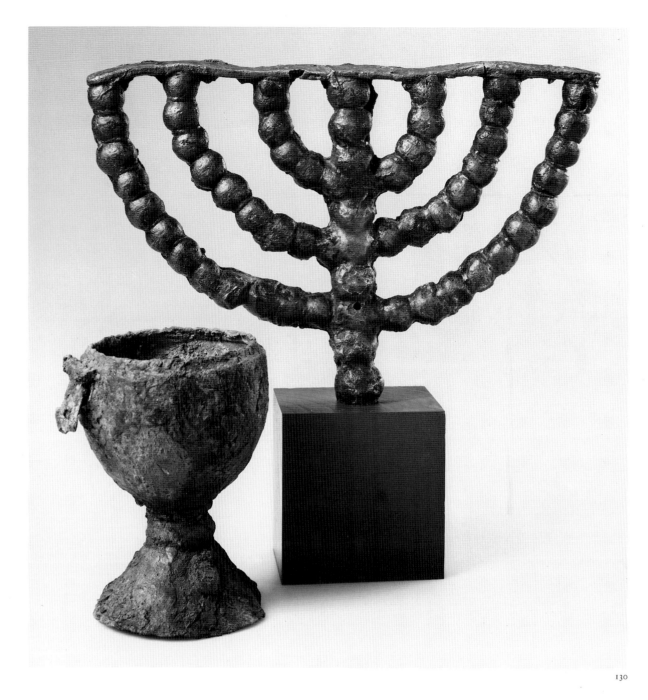

130

130. Finds from the Synagogue of En Gedi

6th century A.D.
Bronze
Menorah: IDAM 70–612; height 14.5 cm.
(5¾ in.), width 21.5 cm. (8½ in.)
Pyxis: IDAM 70–1746; height 11 cm.
(4⅜ in.), diameter 8 cm. (3⅛ in.)
Excavations of the Hebrew University,
Jerusalem, the Israel Exploration Society,
the Israel Department of Antiquities and
Museums, and the En Gedi Field School

This bronze menorah and pyxis were found in the excavations of a synagogue at En Gedi (fig. 110), a prosperous Jewish village that was destroyed, together with its synagogue, during the reign of Justinian in the mid-sixth century A.D. The synagogue was the last in a series built on the site, and like its predecessor of the third century A.D., it was lavishly decorated with floor mosaics. These yielded several inscriptions in Hebrew and Aramaic, a beautiful central carpet with peacocks and birds, and, in front of the north wall, a panel with three menorahs.

The building, like all ancient and modern synagogues, was oriented toward Jerusalem, to the northwest of En Gedi. The menorah and pyxis were found next to a semicircular niche in the north wall, which housed the Ark of the Law.

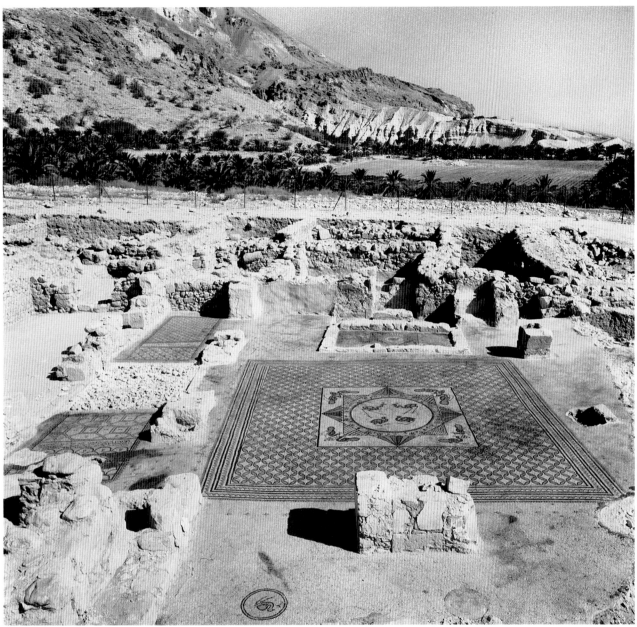

FIG. 110. Mosaic pavements of the synagogue at En Gedi. 6th century A.D. Photograph: Israel Museum/Nir Bareket.

The solidly cast menorah is of poor workmanship and was not worked over after casting. The branches consist of a series of knobs representing the "cups and flowers" of the biblical description of the Temple menorah (Exodus 25:33). A bar, on which lighted oil lamps were placed in the larger prototype, runs across the top of the seven branches. The importance of this object surpasses its artistic merits, as it is one of only two three-dimensional menorahs that have been found in ancient synagogues. The other is a large stone menorah, found at Hammath–Tiberias, indicating that menorahs were part of the fixtures in ancient synagogues.

The pyxis is hammered in two parts out of a sheet of bronze. The lid is missing, but the hinge is still in place. No other such boxes have been found in ancient synagogues, and one can only guess at its purpose. As it was found near the Holy Ark, it can be assumed that it had a function in the religious services.

REFERENCES: H. Shanks, *Judaism in Stone*, Washington, 1979, pp. 131–42; *D. P. Barag, Y. Porat, and E. Netzer, The Synagogue at En-Gedi, in *Ancient Synagogues Revealed*, L. I. Levine (ed.), Jerusalem, 1981, pp. 116–19.

131. Fragment of a Synagogue Screen

Ashkelon
6th–7th century A.D.
Marble; 19 × 47 cm. (7½ × 18½ in.)
Permanent display at the Israel Museum from the collections of the Deutsches Evangelisches Institut für Altertumswissenschaft des Heiligen Landes, Jerusalem

This marble slab, broken off at the ends, is carved on both sides. It comes from Ashkelon, together with two other blocks bearing a dedicatory inscription with a date corresponding to A.D. 604. These blocks undoubtedly came from a synagogue that existed in Ashkelon in antiquity, where they formed part of a waist-high screen assembled from marble slabs and colonnettes. Such screens were erected in synagogues and churches of the Byzantine period and were intended to separate areas in these buildings. The groove on the bottom of the block indicates that it was posi-

tioned on top of a larger slab, which formed the main part of the screen.

The decoration on both sides is basically the same, although the execution is less fine on what probably was the reverse. The decorative components are the menorah, accompanied by the lulav (palm branch), etrog (citron), and shofar (ram's horn). The bar that runs across the top of the menorah is surmounted by flowerets (on one side) and triangles representing flames (on the other). The interlacing circles, which originally ran on both sides of the menorah, contain rosettes; the spaces between them are filled with flowers seen in side view. These two conventionalized views of the flower, in profile and from above, with their intricate play of circles and curves, are well-known elements of Jewish iconography in the Roman and Byzantine periods and can be traced to early times.

REFERENCES: *E. L. Sukenik, *Ancient Synagogues in Palestine and Greece*, The Schweich Lectures 1930, London, 1934, pl. XIV; B. Narkis, in *The Age of Spirituality*, K. Weizmann (ed.), New York, 1979, pp. 378–79.

131

132. Chancel Screen

Massuot Itzhak
6th–7th century A.D.
Marble; 91 × 118 cm. (35⅞ × 46½ in.)
IDAM 53–4

This marble slab was found near Massuot Itzhak in the western Negev. Almost identical slabs with the "wreathed cross" and ivy tendrils supporting two other Maltese crosses were found in many other sites from Beth Shean to Nessana, indicating that they were centrally manufactured and supplied. Marble chancel screens, some of them with remarkable latticework carving, adorned both churches and synagogues of the period.

The Byzantine period saw an exceptional increase in the use of marble, unlike any other period since the introduction of this stone as a major building material during the second century A.D.

REFERENCE: *Y. Tsafrir, *Eretz-Israel from the Destruction of the Second Temple to the Muslim Conquest, II: Archaeology and Art*, Jerusalem, 1984, pp. 391–400.

132

ANCIENT GLASS
Cat. nos. 133–41, 146, and 147

The origins of glassmaking and the early stages of its development are still shrouded in mystery. However, it is currently agreed that glass vessels were first produced in northern Mesopotamia at the end of the sixteenth century B.C. and that not long afterward they were being produced in Egypt. Multicolored glass vessels, made in Egypt and brought to Canaan with other imported goods, were discovered in the Late Bronze Age sanctuaries of Beth Shean, Megiddo, and Lachish. Also during the Late Bronze Age, other items fashioned from glass, such as female plaque figurines, medallions, and beads, made their way from Mesopotamian centers of production to Canaan, and it may be that eventually some of these small glass pieces were produced in local workshops from glass imported in the form of ingots. Most of these imported and locally made items were related to ritual and were brought as offerings to sanctuaries, either for their intrinsic value or as containers for oils and spices.

Because of the political upheavals that shook the region, glass production ceased in the major centers at the end of the second millennium B.C. and was only resumed in Mesopotamia some three hundred years later, using the traditional process of shaping the vessel around a core made of other material. Concurrently, the use of molds for making glass objects, already known in the second millennium B.C., was further developed in Assyria and Phoenicia. In this process monochrome vessels of blue-green or colorless glass were carved out of previously molded blocks of cold glass and were engraved by the same methods used for lapidary work. A relative abundance of such vessels was discovered in palaces of the eighth century B.C. at Calah-Nimrud in Assyria, and it is assumed that they were created by Phoenician artisans at the court of the Assyrian king. It may well have been these same craftsmen who also produced the colored glass inlays that were set into Phoenician ivory carvings such as those discovered in Samaria.

Toward the middle of the first millennium B.C., the centers of glass production moved westward from Mesopotamia to eastern Greece. This move was accompanied by a significant change in the shape of glass vessels produced by the core method. Large numbers of glass vessels imitating Greek pottery shapes were produced in these new centers and were circulated throughout the Mediterranean lands by Greek and Phoenician merchants. Only a few artifacts

FIG. 111. Refuse of glass production from a workshop in Jerusalem. 1st century B.C. Photograph: Jewish Quarter Excavations—Institute of Archaeology, Hebrew University, Jerusalem, and Israel Exploration Society/Zeev Radovan.

of this period have been found in Israel, but they are most important because they were discovered in dated tomb groups, indicating the beginning of this series. However, there is apparently no proof for the commonly held assumption that these vessels were produced by Phoenician glass artisans in the Levant.

The significant increase in the number of glass vessels from the second and first centuries B.C. indicates a considerable advance in production methods, as well as the existence of nearby centers of manufacture. While there are no artifacts which point to the local production of luxury items such as those attributed to Egypt and Rome, there is no doubt that an established center for the production of molded bowls for a mass market was located in one of the countries on the eastern Mediterranean coast. This breakthrough in the production of utilitarian glassware was closely followed by the revolutionary development of glassblowing.

In the first century B.C. the unique properties of glass, which allow it to be blown in a hot, molten state and then to retain the resultant shape when gradually cooled, were discovered. Some insight into the stages by which this process was perfected can be gained from an unusual group of artifacts found in the excavations of the Jewish Quarter in Jerusalem. Waste material from a glass workshop was discovered in a pool in the Upper City: side by side with large quantities of broken pieces of molded bowls in the Hellenistic tradition were found hundreds of thin glass tubes and broken twisted glass rods (fig. 111). A few small blown-glass bottles, some of them distorted, possibly in the course of production, as well as small glass bulbs and glass tubes with slightly bulbous ends were also found in the refuse. These finds show that by the middle of the first century B.C. glass workers were inflating the ends of glass tubes by blowing, perhaps even before metal blowpipes came into common use.

Where was glassblowing first invented? An account by Pliny the Elder of the early impor-

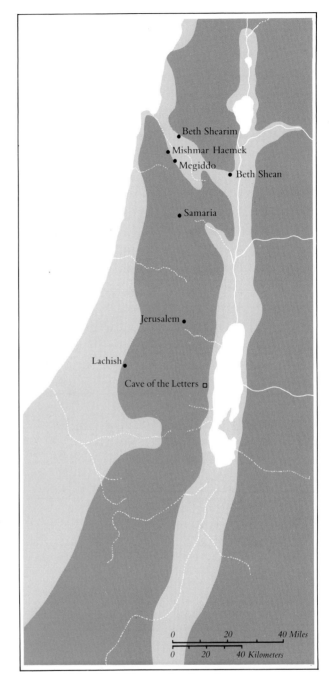

FIG. 112. Major sites in history of ancient glass.

tance of Sidon and the Plain of Akko in glassmaking points perhaps to the shores of the eastern Mediterranean as the region in which this technique originated. Wherever the technique had its roots, the find in Jerusalem is the earliest known example of the glassblowing industry. Glass tableware, receptacles, and storage containers gradually replaced pottery vessels to a great extent. The expansion of the glass industry is reflected in the funerary offerings found in excavations. Evidence of the widespread use of glass vessels also comes from the Talmud where a *kos* (cup) is understood to be made of glass unless specifically stated otherwise (as is the case with the English word "glass").

Although glass vessels were produced in numerous widely separated centers, the Early Roman period was characterized by a considerable stylistic uniformity. While regional and local characteristics soon began to appear, a strong similarity remained with respect to the style of decoration and to techniques. This can be explained by the migration of glassmakers to Europe from the eastern Mediterranean production centers, which remained the source of innovations throughout the Roman period.

Remains of the glass industry are among the important excavated finds in Israel. Unique among these remains is a very large slab of glass found in the ancient necropolis of Beth Shearim in an unused cistern. This huge block, weighing over eight tons and measuring $3.4 \times 1.95 \times 0.5$ meters ($133\frac{1}{8} \times 76\frac{3}{4} \times 19\frac{3}{4}$ inches), may represent an unsuccessful attempt to produce raw glass for sale to artisans. Such glass was sold in blocks, like metal ingots, to workshops where it was melted down and then worked.

Religious symbols were prominent in the ornamentation of glass vessels of the Late Roman and Byzantine periods. A group of vessels of special shape and bearing Jewish and Christian religious symbols was produced in Israel, presumably as containers for water, oil, or soil from the Holy Land or as mementos that brought blessings and good fortune. These vessels are dated to the late sixth century A.D. and can be seen as one of the last expressions of the Byzantine art of glassmaking in Israel.

REFERENCES: D. B. Harden, Ancient Glass, I: Pre-Roman, *Archaeological Journal* 125 (1968), pp. 46–72; II: Roman, ibid. 126 (1969), pp. 44–77; III: Post-Roman, ibid. 128 (1971), pp. 78–117; D. B. Barag, Glass, in *Encyclopaedia Judaica* VII, Jerusalem, 1971, cols. 604–11.

133. Amphoriskos

Beth Shean
6th century B.C.
Glass; height 9.2 cm. (3⅝ in.), diameter
4.7 cm. (1⅞ in.)
Excavations of the Israel Department of
Antiquities and Museums
IDAM 51–7310

Before the development of glassblowing, glassware shapes were very similar to those of contemporaneous pottery, stone, or faience ware. Glass vessels were generally produced by the "core" method, a complicated technique that was understood only through the minute observation and analysis of ancient glass remains and that has subsequently been successfully reproduced by modern artisans. In this technique threads drawn from a viscous lump of glass are densely wound around a core composed of sandy material mixed with clay and a binding agent. This core is shaped like the inner cavity of the desired vessel and attached to a metal rod. After the core is covered with glass thread, it is repeatedly exposed to heat; the surface is smoothed by rolling on a stone slab, eventually resulting in a total encasing of the core with glass. The rim, handles, and base were applied while the vessel was still attached to the rod. Ornamentation was generally added at this stage, in the form of threads of colored glass which were combed in different directions to form zigzags, festoons, or feather patterns. After the vessel cooled,

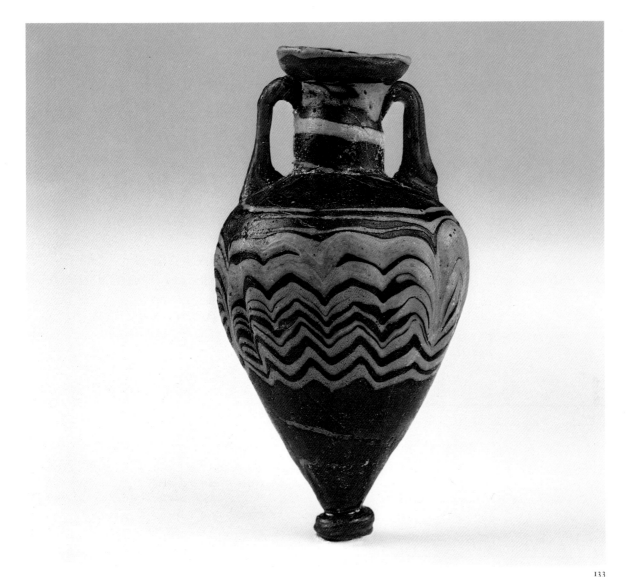

133

the core was broken down and removed. Vessels created by this complicated method are small, and their interior walls are rough, often incorporating bits of the core material. The polychrome glass is generally opaque and only occasionally translucent.

The present amphoriskos is a fine example of vessels created by the core method. It has a pear-shaped body, a short neck, two handles, and a button-base. The ornamentation is of yellow and blue glass threads wound around the vessel and in part combed into a zigzag pattern.

More than sixty almost-round beads were found together with the amphoriskos. The beads are of light blue glass, the majority being inlaid with "eyes" of dark blue on a white background. Eye beads of this sort were produced in the Phoenician world at least from the beginning of the sixth century B.C. and are commonly found in Israel.

The small amphoriskos and the beads were discovered in a tomb in the Beth Shean Valley, a few kilometers north of the town of Beth Shean. The tomb, excavated in 1951, is one of four rock-hewn tombs that contained pottery vessels typologically dated to the beginning of the sixth century B.C. This date is significant as it provides proof of an earlier appearance of this type of core glass than could be otherwise assumed on the basis of finds in eastern Greek production centers.

REFERENCES: *N. Tsori, Short Report on the Excavations at Beth Shean 1950–51, *Bulletin of the Department of Antiquities* 5/6 (1957), p. 17, pl. I:C (Hebrew); D. P. Barag, Mesopotamian Core-Formed Glass Vessels (1500–500 B.C.), in A. L. Oppenheim et al., *Glass and Glass-Making in Ancient Mesopotamia*, Corning, N.Y., 1970, pp. 196–97, n. 231; D. B. Harden, *Catalogue of Greek and Roman Glass in the British Museum*, London, 1981, pp. 51–54, 58ff., 161–63.

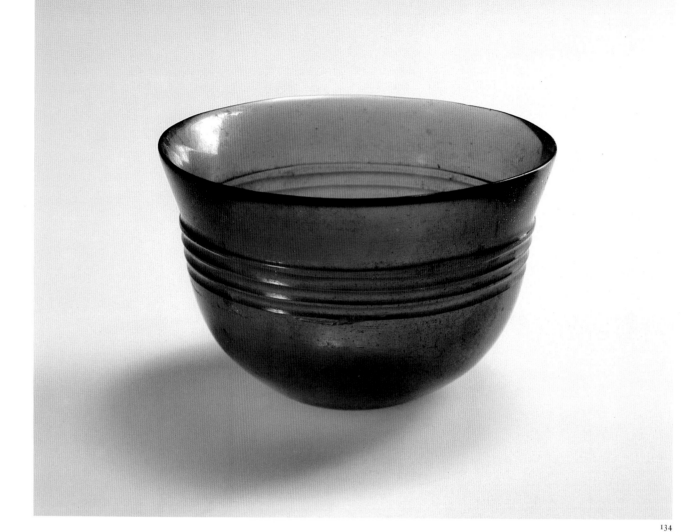

134. Bowl

Provenance unknown
2nd–1st century B.C.
Glass; height 6.3 cm. (2½ in.), diameter
10 cm. (3⅞ in.)
IMJ 73.16.89

An interesting phenomenon of the Hellenistic period, which may well testify to a change in eating habits, is the presence of an increasing number of deep drinking bowls of metal, clay, and glass. The large quantity of glass bowls of this type is particularly surprising, since glass is the most recent of the three materials and had not been used as tableware before this period. Numerous fragments of bowls, their interiors almost always decorated with concentric grooves, have been discovered at every Hellenistic site excavated in Israel and represent the majority of the glass artifacts known from the second and first centuries B.C. There is no

doubt that this abundance reflects an advance in production techniques, which enabled the Hellenistic glassmakers to produce large quantities of these bowls relatively cheaply.

The present bowl, made of almost transparent blue glass, is hemispherical in shape with a concave base. Three parallel wheel-incised grooves encircle the bowl about 2 centimeters (¾ inch) below the rim, forming a ring of three ridges above which the wall of the bowl everts slightly. The outer surface of the bowl below the ridges is fire-polished (smoothed by direct exposure to heat), while the interior and the upper part of the exterior are wheel-polished. The glass has only a few bubbles, and the bowl is in nearly perfect condition.

The technique of producing glass vessels in molds was known from the earliest days of glassmaking. However, the specific method by which these Hellenistic bowls—both plain and radially ribbed—were produced remained a mystery until recently, when a

modern craftsman was able to duplicate the process. It is surprisingly simple: the artisan prepares a small disk of glass and lays it upon a convex mold or "former," which is the size of the bowl's interior. The mold and the disk are then heated in a furnace until the viscous glass coats the mold. The bowl's outer surface is perfectly smooth because of its direct exposure to heat, while its inner surface, which was in contact with the mold, requires additional polishing by wheel when cool. Wheel marks are discernible on most of the bowls of the period, and the present bowl is no exception.

In general, this vessel fits well into the larger corpus of Hellenistic bowls. However, its shape differs slightly from the norm, since its blue color is more often found in ribbed rather than plain bowls. Its excellent state of preservation is quite rare.

REFERENCES: K. Cummings, *The Technique of Glass Forming*, London, 1980, pp. 23–31; *Y. Israeli, in *Highlights of Archaeology: The Israel Museum*, Jerusalem, 1984, pp. 114–15; D. F. Grose, Glass Forming Methods in Classical Antiquity: Some Considerations, *Journal of Glass Studies* 26 (1984), pp. 28–31.

TOMB GROUP FROM MISHMAR HAEMEK
Cat. nos. 135–40, 142–45

1st century A.D.
Excavations of the Israel Department of Antiquities and Museums

A small tomb in the Jezreel Valley, near Kibbutz Mishmar Haemek, was uncovered in the course of paving a road. The rock-hewn tomb was entered through a vaulted passageway with a small niche on one side and a chamber containing seven burial niches (*kokhim*) on the other. The tomb had been plundered in ancient times, and the slabs that sealed the niches had been thrown into the center of the chamber together with those burial offerings that were not removed.

Despite its state of disarray, this family tomb contained a wealth of grave furnishings, including pottery, glass, bronze and iron vessels, bone objects, jewelry, and beads. Based on the typology of some of the finds, the tomb has been dated to the second half of the first century A.D. This date is particularly significant for the glass assemblage, for it indicates the variety of shapes and styles that were in the repertoire of blown glass at that early stage of its development.

The glass vessel most commonly found in Roman tombs of the first century A.D. in Israel is the so-called tear bottle with an elongated neck, which undoubtedly contained perfume or unguent, perhaps used in funerary rites. In the earliest burials of the Roman period—in ossuary tombs, for example—these bottles are often the only glass pieces present. At Mishmar Haemek a large number were discovered together with similar pottery vessels. The ceramic version of this type was widespread in the Hellenistic period but was gradually replaced by its glass counterpart in the Roman period. The large number of beakers and plates found in this tomb is impressive. There is good reason to assume that the beaker—very common in glass but rare in pottery—may have originated as a glass form, later to be imitated in clay. Conversely, the angularity of the various types of plates shows the influence of terra sigillata dishes which had been in use since the first century B.C.

Outstanding in this tomb group is the large number of mold-blown glass vessels which are generally identified as Sidonian and dated to the first century A.D. From early times that city was famous as a center for the production of glass and is mentioned as such in ancient literature. Some glass artisans working in the western part of the empire added the word "Sidon" next to their names as proof of their professional standing. The molded decoration of Sidonian glassware includes floral and geometric patterns as well as depictions of various objects, arranged in horizontal bands or within architectural frames; some vessels bear blessings in Greek. The designs all belong to the repertoire of motifs characteristic of the eastern Mediterranean in the Hellenistic and the Early Roman periods. This glassware was exported to distant places and has been found on the shores of the Black Sea, on the Adriatic coast, in the Aegean Islands, and in Cyprus.

The group of artifacts discovered at Mishmar Haemek is outstanding in its richness and variety. The glassware, especially the mold-blown vessels, is typical of the workshops of the eastern Mediterranean coast in the first century A.D.

135. Small Jug

Glass; height 8.7 cm. (3⅜ in.), diameter 6.7 cm. (2⅝ in.)
IDAM 78–121

Made of almost colorless glass with a blue tinge, this juglet has a squat conical body, a cylindrical neck, an everted rim which folds inward, and a slightly concave base. On the upper part of the body, a very thick ridge is pinched out of the bubble. A strap-handle with three sharp, high ridges is attached to the body just above the thick ridge; the handle terminates at the rim in a thumb rest.

The vessel has been mended. There is a weathering crust, primarily in the interior.

Previously unpublished.

136. Amphoriskos

Glass; height 8.5 cm. (3⅜ in.), diameter 4.3 cm. (1¾ in.)
IDAM 78–189

This elegantly formed amphoriskos has a pear-shaped body, a cylindrical neck, a ring-rim folded inward, and a slightly concave base. Two handles of blue translucent glass, attached at the shoulder and below the rim, stand in sharp contrast to the translucent white body of the vessel. There are a few weathering stains, and the vessel has been mended and slightly restored.

Examples of this fairly common type of small blown-glass amphoriskos have been found in Italy, the Greek Islands, and Dura-Europus. In most cases the body and the handles are of contrasting colors.

Previously unpublished.

137. Pair of Date Bottles

Glass; IDAM 78–131, height 6.7 cm. (2⅝ in.), diameter 3.1 cm. (1¼ in.); IDAM 78–132, height 6.4 cm. (2½ in.), diameter 3.1 cm. (1¼ in.)

These yellow-brown glass bottles were blown in the same two-part mold. Their wrinkled bodies are so similar to that of a ripe date that one wonders if the molds were prepared on the fruit itself. The neck of each vessel is very short, and the rim is folded inward. Both vessels are covered with a white weathering crust.

Date bottles have been discovered in places far removed from their centers of production in the Levant. It is not known whether this broad distribution was a result of their interesting shape or perhaps of their special contents.

Previously unpublished.

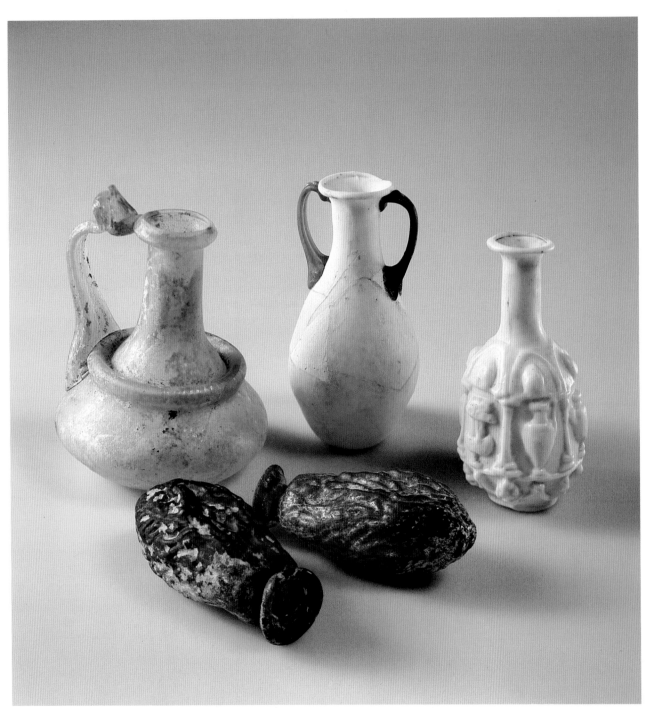

138. Hexagonal Bottle

Glass; height 8.1 cm. (3⅛ in.), diameter
3.8 cm. (1½ in.)
IDAM 78–110

This bottle, with its six panels depicting vessels, be-
longs to the most common series of mold-blown Si-

donian glassware. Conspicuous within this series is
the large number of pieces made from almost opaque
white glass, most of which appear to have come from
an identical series of molds.

The body of this white translucent bottle is almost
cylindrical, with a cylindrical neck, a wide mouth, a
splayed rim folded inward, and a ring-base. Each of
the six panels on the body contains either a jug, an

amphora, or a vase, each motif appearing twice. The panels are framed by columns with bases and capitals. Tall, slightly pointed arches on the shoulder of the vessel contain an indistinct design, perhaps representing a fruit. The lower portion of the bottle is decorated with wreaths, which hang from the center of each panel and alternately frame clusters of grapes and of pinecones (or etrogs?).

The vessel was blown in a tripartite mold which included the base. The seams joining the sections were intentionally concealed behind the decorative columns and are only distinguishable at the base.

Blowing into molds is a technique that exploited to the full the basic method of glassblowing and improved on it. The shape, size, and decoration of the vessel could be precisely determined in a relatively simple way: since the air which the artisan forced through the blowpipe pressed the glass bubble into the form of the mold, only an external mold was required. The molds, fashioned out of clay or lime plaster, were made of several parts. In this way, a large series of virtually identical vessels could be created, with the possibility of varying the color from one vessel to the next.

The importance of the Mishmar Haemek piece lies in the fact that it is one of the few examples of this type to be found in a datable context.

Previously unpublished.

139. Dish

Pottery; height 2.6 cm. (1 in.), diameter
15.1 cm. (6 in.)
IDAM 78–68

This flat-bottomed dish with vertical sides has a pointed rim and a ring-base. The lower edge of the exterior is emphasized by a sharp ridge. The dish belongs to the eastern terra sigillata group.

Previously unpublished.

139

140. Dish

Glass; height 2.5 cm. (1 in.), diameter 18 cm.
(7⅛ in.)
IDAM 78–89

Like its pottery counterpart, this is a flat-bottomed
dish with vertical sides. The sides are folded outward
upon themselves for their entire height, thus creating
a double wall. At the bottom of the exterior there is
an additional fold in the form of a coil which creates a
broad ring-base. The dish was originally of colorless
glass with a green tinge, but it is now mostly covered
by a dark iridescent film.

Previously unpublished.

141. Facet-Cut Bowl

Provenance unknown
2nd century A.D.
Glass; height 6.5 cm. (2½ in.), diameter
10.6 cm. (4⅛ in.)
IMJ 81.43.117
Gift of Mr. Yaakov Salomon, Haifa

From the beginning, glass served as a substitute for
precious stones, and some of the techniques used in the
manufacture of glass objects—abrasion, incision, and
polishing—were identical with those used for work-
ing stone. The high-speed rotation of wheels of various
sizes, combined with powdered hard stone, made it

141

possible to shape a piece of cold glass into a vessel and to ornament it. Even after the discovery of glassblowing and the development of simpler and faster means of production, carving and engraving of cold glass were used for finishing and embellishment.

This bowl is a simple half-sphere of blown glass. The outer surface is entirely covered with a carved decoration consisting of two bands of oval facets enclosed by horizontal incisions. On the base is a design of larger round facets.

Vessels embellished by means of carving, engraving, and polishing were probably produced in Alexandria from the beginning of the Roman period and were popular throughout the entire ancient world,

from Britain in the west to Afghanistan in the east. A large group of glass objects was discovered at a royal estate at Begram, near Kabul, which testifies to the richness and variety of the carved glass of the Roman period. In Israel a fine example is the carved glass plate (figs. 113 and 114) hidden in the Cave of the Letters in the Judaean Desert during the Second Jewish War against the Romans in A.D. 135.

In the later Roman period (second–third century A.D.) large groups of glass vessels decorated in similar style were found at Dura-Europus in eastern Syria, as well as in the Black Sea area, and according to some, they were also produced in these regions. Migrant artisans probably brought this style from Egypt to Eu-

260

FIG. 113. Glass plate in its wrapping. Cave of the Letters; 2nd century A.D. Photograph: Werner Braun.

FIG. 114. Glass plate. Cave of the Letters;
2nd century A.D. Photograph: Shrine of the
Book, Israel Museum/David Harris.

rope, and similar vessels were produced in the glass workshops at Cologne in the Rhine Valley.

Despite the relatively abundant examples of facet-cut vessels that have been published, only one piece, also of unknown provenance, is an exact parallel to the present bowl. In view of its perfect shape and its delicate ornamentation, the bowl should be assigned to the early group of facet-cut vessels made in Alexandria and dated to the second century A.D.

Previously unpublished, but see Y. Yadin, *The Finds from the Bar Kochba Period in the Cave of the Letters*, Jerusalem, 1963, pp. 106–10, fig. 40, pl. 29; D. B. Harden et al., *Masterpieces of Glass*, The British Museum, London, 1968, no. 103; *Catalogue of the Constable-Maxwell Collection*, Sotheby's, London, 1979, no. 120.

142. Chain and Bell

Bronze; length of each link 1.4 cm. (9/16 in.), height of bell 1.2 cm. (1/2 in.)
IDAM 78–138

The chain has sixteen links, each made of double metal wire bent into two perpendicular loops. On each link is a ring made of a bent strip of bronze. The cone-shaped bell is made of sheet metal and hangs from a double-wire loop. All that remains of the clapper is a double wire, at the end of which was undoubtedly a bead or another wire ring.

Previously unpublished.

143. Earring

Gold; diameter 1.8 cm. (3/4 in.)
IDAM 78–137

This plain earring is made of gold leaf wrapped around filler material. It is round in cross-section, thicker at the center and tapering to a thin wire bent into a loop at one end and into a hook (now broken) at the other. A tiny convex disk is attached just above the loop.

Considering the wealth of this tomb, it is surpris-

ing that only one plain gold earring has been found. It may well be that it was overlooked by grave robbers who vandalized the tomb.

Previously unpublished.

144. Spoon

Bone; length 3.8 cm. (1 1/2 in.), diameter of bowl 2.3 cm. (7/8 in.)
IDAM 78–146

The shallow bowl of this spoon has an omphalos encircled by two grooves; there are more concentric grooves near the edge. The handle, round in cross-section, is joined by a triangle to the back of the bowl.

Previously unpublished.

145. "Aucissa" Type Fibula

Bronze; length 5.3 cm. (2 1/8 in.)
IDAM 78–158

This fastener belongs to a well-known group of fibulae of western origin, sometimes bearing Celtic names, which were brought to the East by Roman soldiers. A very similar one was found, together with a Jewish coin from Year Two of the First Jewish War against the Romans, in a Roman tomb excavated on the grounds of the Archaeological Museum (Rockefeller) in Jerusalem.

The arched body of this fibula consists of a band with raised borders and a triple ridge down the center, the middle spine being beaded. At one end the strip widens and forms a loop to accommodate the wider end of the tapered iron pin. The clasp at the other end, formed by folding the edge of a flattened triangle, has a round knob at its tip. Rust from the pin has spread partway up the body of the fibula.

Previously unpublished, but see Y. Israeli, in *Inscriptions Reveal*, Israel Museum catalogue no. 100, Jerusalem, 1973, p. 119, no. 252.

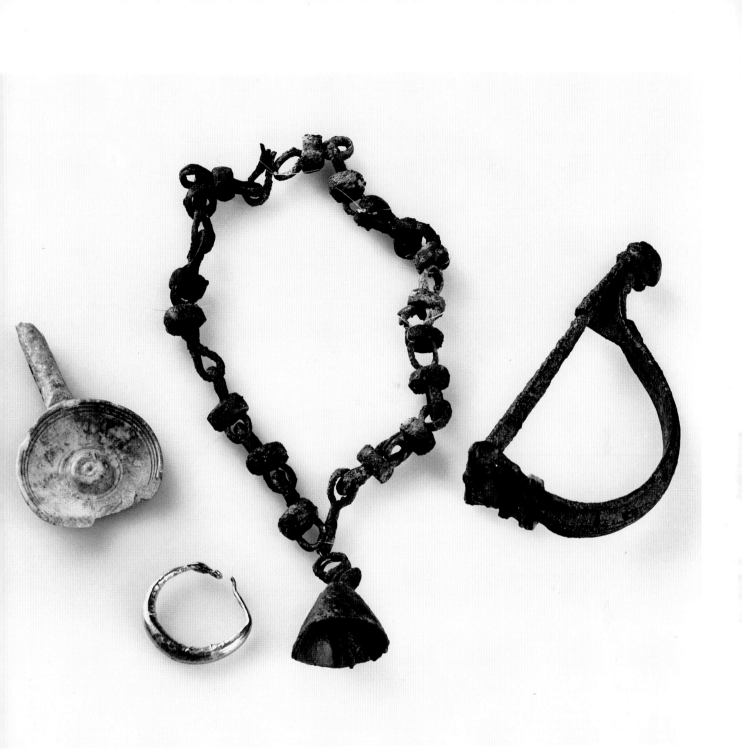

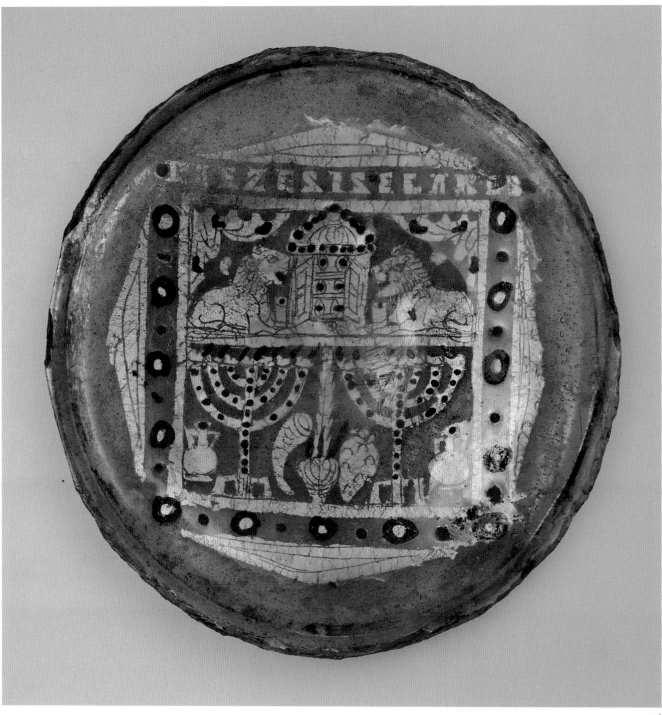

146

146. Gold-Glass Base

Roman catacombs (?)
4th century A.D.
Glass and gold leaf; diameter 10 cm. (3⅞ in.),
thickness 0.9 cm. (⅜ in.)
IMJ 66.36.14
Gift of Mr. Jacob Michael in memory of his
wife Erna Sondheimer-Michael. Previously in
the collection of Count Goluchów

Bowls embellished with gold leaf pressed between
two layers of glass were among the luxury items pro-
duced in the Hellenistic world. In the Late Roman
period the same technique was used in small plaques
which were embedded in the plastered walls of the
catacombs in Rome next to the burial niches, perhaps
as a means of identifying the person interred there.

These small disks are in fact the bases of bowls or
cups, a few of which still retain part of their original
sloping sides, although in most cases the latter were
completely broken off and removed before the bases
were implanted into the plaster. Since no complete
vessels with gold-glass bases have been found, there is
no agreement among scholars as to their original
shape. The inscriptions which appear on some of the
bases are legible from the inside of the vessels, and
this is additional proof that the vessels were used for
drinking.

These gold-glass bases were prepared by a compli-
cated process comprising several stages: gold leaf was
glued onto a glass disk, and the design was incised
into the gold; then a glass bubble was blown on top of
the gold leaf, trapping it between two layers of glass.

Gold-glass bases became known with the discov-
ery and exploration of the catacombs in the seven-
teenth century, and much has been published about
them. Of the hundreds of known bases, many bear
Christian motifs, while some are decorated with bibli-
cal scenes, animals, or "portraits" of the deceased.
Only a dozen or more have Jewish motifs; the present
example is one of the best of this category.

The design is arranged within a square frame di-
vided into two registers. The upper register contains
the domed Ark of the Law, its open doors revealing
three shelves of scrolls shown in profile. It is flanked
by crouching lions, and an unidentified object appears
between them and the doors. Tied curtains are at the
corners of the frame. In the lower register there is a
lulav (palm branch), an etrog (citron), and a shofar
(ram's horn) between two menorahs (seven-branched
candelabra) with tripod bases and an amphora. A Greek
inscription written in Latin characters above the frame
reads: "Pie Zeces ELARES" (Drink, live, Elares), a

drinking toast popular in the East, which was also
adopted in the western part of the empire. The other
three sides of the frame consist of a row of alternating
gold and blue dots. The whole decoration is enclosed
within four gold triangles. Some details are incised in
the gold leaf, while others are picked out in red and
blue dots.

This small glass piece contains most of the charac-
teristic motifs of Jewish art in the Late Roman and Early
Byzantine periods. This kind of design commemorates
the Temple, its ritual appurtenances, and its ceremo-
nies. Surprisingly, there is greater detail here, despite
the complicated gold-glass technique, than in the larger
representations—for instance, the binding of the palm
branches and the shape of the oil lamps at the top of
the candelabra. A gold-glass base depicting a very
similar combination of Jewish motifs is in the Vatican
Museums in Rome.

A square frame of gold leaf flanked by triangles is
found only on a small number of gold-glass bases, al-
most all of which bear Christian scenes, and it is rea-
sonable to assume that both these Christian and Jewish
glass pieces were created by the same artisan or work-
shop.

REFERENCES: *P. P. Kahane, in *From the Beginning: Archaeology
and Art in the Israel Museum, Jerusalem*, London, 1968,
p. 129, pl. 103; A. Cohen-Mushlin, in *Age of Spirituality*,
K. Weitzmann (ed.), New York, 1979, pp. 380–81.

147. Decorated Jug

Provenance unknown
4th century A.D.
Glass; height 31.5 cm. (12⅜ in.), diameter
15.2 cm. (6 in.)
IMJ 81.43.115
Bequest of Mr. Yaakov Salomon, Haifa

Among the luxury wares created during the fourth
century A.D. in the glass-production centers of the
Levant, a group of large tableware vessels shared a
number of common characteristics, including shape
and overall design. Each of these vessels incorporates
a coil of glass pinched into ribs at intervals either to
finish the rim or the base or to serve as an added ele-
ment around the neck. Like so many other glass vessels,
they emulate fine contemporaneous metalware. At the
same time, the additional ornamentation of many of
these jugs sometimes produced unique vessels.

This jug is made of almost colorless glass with a

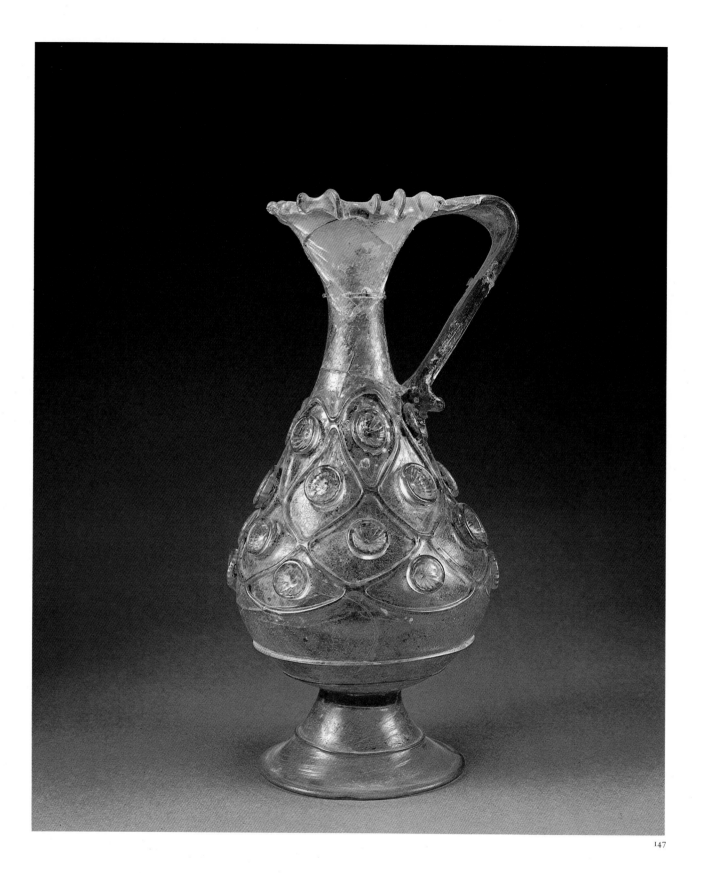

147

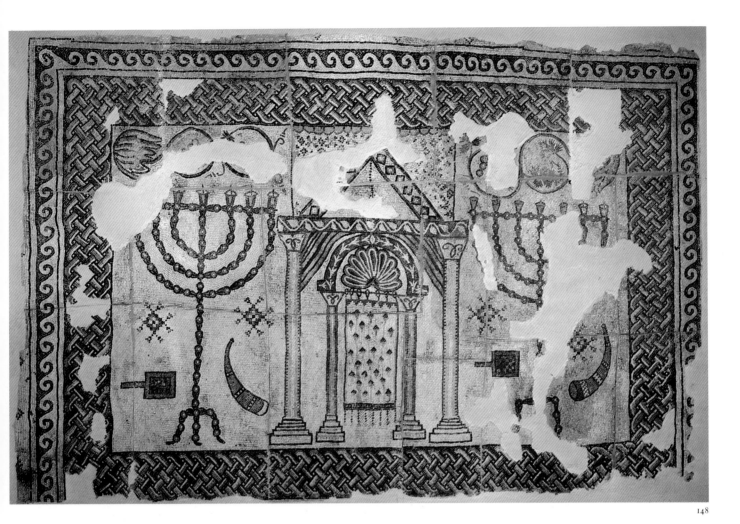

greenish tinge. It has a pear-shaped body and a funnel-like rim to which a pinched colored strip has been added. The high-footed base is splayed; the broad, flat handle extends horizontally from the rim, curving sharply to meet the shoulder of the vessel. The main decoration is on the body, around which five parallel glass trails were wound and nipped together when the glass was still hot, resulting in a diamond-patterned net. In the center of each of the twenty-four diamonds is a thick glass disk stamped with radial ribs to form a rosette. Additional threads are wound around the base and the neck.

A similar diamond design is found on a number of jugs of this type, and on two of them there are blue blobs in the center of each diamond. Disks with impressed rosettes are found on other glass vessels of different shape and size. However, the specific manner in which known elements have been combined on the present jug makes it unique.

In the third and fourth centuries A.D., there was a remarkable similarity in certain types of vessels and especially in decoration techniques between the glassware originating in the glass-production centers of the eastern Mediterranean and those in western Europe, particularly in the area of Cologne. Scholars assume that this is a result not so much of extensive commercial ties and large-scale export from the East, but rather of the migration of the artisans themselves, who carried styles and techniques to the western parts of the empire.

REFERENCE: *D. P. Barag, Two Masterpieces of Late Antique Glass, *Israel Museum Journal* 2 (1983), pp. 35–38.

148. Mosaic Pavement

Beth Shean
6th century A.D.
Stone and glass; 286 × 429 cm. (112⅝ × 168⅞ in.)
IDAM 63–932

The laying of mosaic pavements is documented in Israel as early as the Hellenistic period (Tell Anafa),

and this art was popular throughout the Byzantine and Islamic periods. Local mosaic artists followed the techniques and employed the idioms of ornamentation prevalent in the large artistic centers of the time (such as Antioch and Daphne); they did, however, succeed in producing groups of mosaic floors that are well defined by their iconography and style and that served the purposes of specific ethnic or religious communities.

One of these groups comprises the well-known mosaic floors that decorated the basilical synagogues of the Byzantine period. Especially characteristic are the mosaic carpets nearest the apse which usually depict the Temple facade with its sacred implements; this composition, popular in the Jewish art of the period, appears on many artifacts and architectural fragments.

This panel from Beth Shean comes from a synagogue excavated in 1962. Stone and glass tesserae of six colors in different shades are used in this mosaic. In the center is a representation of a shrine within a shrine, which, though probably depicting a synagogue facade behind which the Torah shrine is seen, unequivocally evoked for its viewers the Temple in Jerusalem. The meticulous representation of the embroidered and tasseled curtains of the shrine is unusual. The shrine is flanked by two huge menorahs accompanied by shofars and incense shovels, emphasizing the evocation of the Temple.

In the Byzantine period every town or village with a Jewish community had a synagogue, and many places, such as Beth Shean–Scythopolis had more than one. Synagogues are known to have existed even when the Temple of Jerusalem was the sole focus of Jewish worship, but after its destruction the synagogues grew in importance and dimensions and took on some of the holiness of the Temple. During the Byzantine period the synagogues were decorated with mosaics whose iconography, often representational and narrative in character, was highly evolved.

REFERENCES: *N. Tsori, The Ancient Synagogue at Beth Shean, *Eretz-Israel* 8 (1967), pp. 149–68 (English summary, p. 73); A. C. Mushlin, *Age of Spirituality*, K. Weitzmann (ed.), New York, 1979, pp. 375–76; M. J. Chiat, Synagogues and Churches in Byzantine Beit She'an, *Journal of Jewish Art* 7 (1980), pp. 22–24.

THE DEAD SEA SCROLLS

In 1946 or 1947 a Bedouin shepherd found by chance the first seven Dead Sea Scrolls. This, the greatest archaeological find ever made in the Holy Land, led to the eventual discovery of some eight hundred manuscripts in Hebrew and Aramaic—most in fragments but some in fine condition—in eleven caves on the northwestern shore of the Dead Sea.

Soon after the initial discovery of the scrolls in the first cave, scientific excavations were begun in ruins on an adjacent site, Khirbet Qumran (fig. 116). The investigations, carried out between 1951 and 1956, revealed a large compound, the center of the Jewish sect that had owned and used the scrolls. The sectarians had lived in the neighboring caves (traces of habitation have been found in about thirty of them) and most probably in tents and huts, of which nothing has remained. The compound, like many desert ruins in the Near East, has survived the ravages of time relatively well. It served for the communal activities of this monastic community (fig. 117). The sectarians gathered there for study and prayer, communal meals, and various other activities, including the copying of sacred books and other crafts required to meet the needs of a self-sufficient society. The community's farm was discovered at a nearby oasis, 'Ain Feshkha ('Enot Suqim).

A remarkable feature of the compound was its network of water reservoirs, fed by an aqueduct that brought winter flash-flood waters from a nearby wadi. This was a vital feature in this arid region, where rainfall, then as now, averages about 25 millimeters (⅛ inch) a year.

Of the eleven caves at Qumran in which scrolls were found, all but one had been excavated by the Bedouin prior to the scientific explorations; the archaeologists, however, carefully

FIG. 115. Dead Sea sites.

Fig. 116. Aerial view of Qumran from the south. Photograph: Werner Braun.

reexamined all of them (fig. 118). The results of the archaeological excavations, in concert with the contents of the Dead Sea Scrolls, reveal a broad picture of the sect and its history.

THE FIRST SEVEN SCROLLS

It was a fortunate coincidence that the first scrolls to be discovered were exceptionally well preserved and that they were representative of the entire group from Qumran.

Two of these seven contain books of the Bible, and this general proportion has held true for the entire group. Both of these scrolls are of the Book of Isaiah. The surviving library of the community at Qumran contains manuscripts of all the books of the Old Testament except the Book of Esther, which the sectarians apparently did not consider worthy. One of the Isaiah scrolls (ms. A) contains all sixty-six chapters of the biblical book. The Bible manuscripts from Qumran have immense significance because they are twice as old as the earliest known copies of

the Bible and they predate the canonization of the Hebrew Bible. Until the Qumran discovery, the oldest extant manuscripts of the Bible (with a few minor exceptions) were no older than the tenth century A.D.; but these scrolls are from the first century B.C. and the first century A.D. The canonization of the Hebrew Bible evolved at the very end of the first century A.D. at Jamnia (Yavneh) in the Holy Land, the spiritual center of Judaism following the destruction of Jerusalem

Fig. 117. "Community center" at Qumran, an architectural reconstruction. Drawing: Lane Ritmeyer.

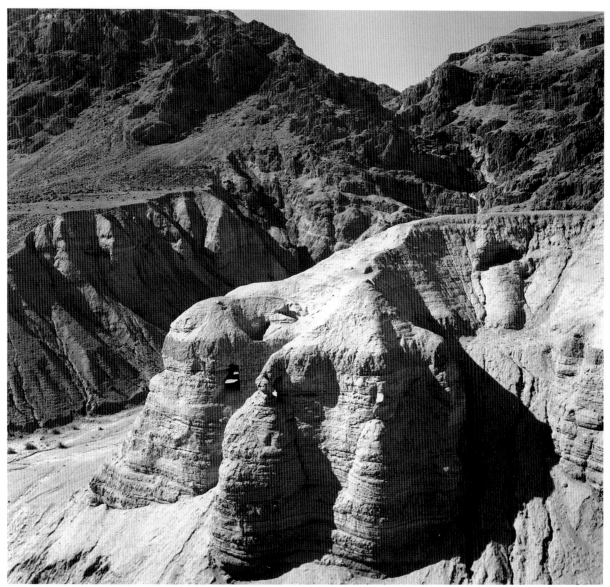

Fig. 118. Marl cliffs near Qumran in which caves were dug. On the left is Cave No. 4, the richest of the eleven Qumran caves. Photograph: David Harris.

in A.D. 70. The Qumran manuscripts thus afford a glimpse of the variant texts of the Bible current before this standardization. The most amazing point, however, is that the texts of these early manuscripts differ only slightly from the Hebrew Bible in use today.

Four of the scrolls are sectarian. The Qumran community was apparently the earliest monastic society in the western world, and its Manual of Discipline (or Community Rule) contains this extremist community's rules concerning admission, behavior, and punishments; this scroll also describes the sect's rites and theological teachings. The Thanksgiving Scroll contains some for-

ty psalmlike hymns, many of which begin with the words "I thank thee, O Lord."

The Qumran sectarians believed in the imminence of an eschatological war heralding a messianic age. The sectarians were actively preparing for this event by repairing to the desert where they could attain purity and escape from the corrupting influence of the "Sons of Darkness." The scroll entitled "The War of the Sons of Light Against the Sons of Darkness" is a military manual describing preparations for the final war; it gives details regarding conscription, units, weapons, signals, and, of course, the prayers to be recited during the course of battle.

The Habbakuk Commentary, a composition typical of the Qumran literature, is discussed in cat. no. 149.

The seventh scroll, the Genesis Apocryphon, is a version of the Book of Genesis retold in Aramaic, the popular language of Palestine at that time, in an expanded and elaborated form. This interesting scroll is unfortunately in a very poor state of preservation.

THE SECT'S HISTORY

Three complementary sources help in reconstructing the history of the Dead Sea sect: archaeology, the scrolls, and contemporaneous historians (notably the Jewish authors Philo and Josephus and the Roman Pliny the Elder). The archaeological evidence indicates that Qumran was settled some time in the mid-second century B.C. and was abandoned about A.D. 68, apparently upon its conquest by the Roman army during the Jewish War. The palaeography of the scrolls supports such a time-span. The scrolls themselves are notoriously poor in strictly historical data. Such historical personages as the central figure in the history of the sect, called the "Teacher of Righteousness," cannot be identified (all that can be said about him is that he was an anti-Hasmonaean priest, probably of the Zadokite line). A general outline of the sect's history can be gleaned, however, from the existing evidence. The sectarians first occupied Qumran under one of the earlier Hasmonaean rulers—either Jonathan (152–142 B.C.) or Simeon (142–134 B.C.), the archenemy of the sectarians, whom they called the "Evil Priest." Except for a possible gap (31–4 B.C.), the Qumran compound was occupied by the sectarians for about two hundred years.

Perhaps the most important theological doctrine differentiating the sectarians from the rest of Judaism was their belief in predestination, coupled with a dualistic view of the world. Thus, one was born either into the "Sons of Light" or into the "Sons of Darkness." The elect are born into the Sons of Light; the accursed are born into the Sons of Darkness. Since the Lord is omnipotent, human free will cannot exist, and God's omniscience precludes any act not predestined by him. This is epitomized in the Manual of Discipline (III:15–17): "From the God of Knowledge comes all that is and shall be. Before every thing existed He established their whole design, and when, as ordained for them, they come into being, it is in accord with His glorious design that they fulfill their work. The laws of all things are unchanging in His hand and He provides them with all their needs." The sectarians went into the desert to "separate from the congregation of evil men" (Manual of Discipline V:1–2). They formed a community led by priests of the Zadokite lineage (that is, descendants of Zadok, a priest under David and Solomon). The archaeological evidence, as well as the literary (the scrolls and the contemporaneous historians), suggests that this was a monastic community, perhaps the first such in the western world—a celibate, male society sharing property and leading a life of great purity in anticipation of the eschatological war. A belief in the coming of the Messiah, to be preceded by a cataclysmic war, was held by most Jews of this period, but the Qumran sectarians were particularly fervent, devoting their entire lives to preparation for these great events.

In the practical realm the sect's most significant feature was its calendar. This was based on a year of 364 days, always reckoned from a Wednesday (the fourth day of Creation, on which the luminaries were created) and having exactly fifty-two weeks divided into four seasons; each week began on a Wednesday, and holidays and festivals always fell on the same day of the week. It is not known how the sectarians reconciled this calendar with the astronomical calendar or whether they sought to do so at all.

The evidence culled from the various scrolls points to the identification of the Qumran sectarians as an extremist faction of the Essenes,

one of the three major movements within Judaism in the days of the Second Temple. The most detailed description of this tripartite division of Judaism—Sadducees, Pharisees, and Essenes—is found in Josephus, and many of the details he gives about the Essenes correspond with the teachings and practices of the Qumran sect. The overall picture of the Essenes is one of an ultra-conservative movement standing in sharp contradistinction to the liberal tendencies of the Pharisees, the forerunners of normative Judaism. After the Jewish War against the Romans, the Essenes (like the Dead Sea community) disappeared from the stage of history, though there is tenuous evidence to suggest that they continued a clandestine existence for some centuries.

THE DEAD SEA SECT AND CHRISTIANITY

The Qumran sectarians were apparently known to Jesus, though he did not share their specific theological views. The sectarians did, however, have an impact on later stages of Christianity. Strong Qumranic influence can be detected in the Epistles of Paul, as well as in the Gospel and Epistles of John. It is significant that both the scrolls and the New Testament frequently quote the same biblical passages. The phrase "New Testament," as well as the concept underlying it (that is, the establishment of a new covenant), is derived from Jeremiah (31:31–33) and is used too in the scrolls. Like the sectarians, John the Baptist acted upon the biblical passage, "A voice cries: In the wilderness prepare the way of the Lord" (Isaiah 40:3); this verse is quoted in the Manual of Discipline (VIII:13–14; IX:19–20), and it appears in all four of the Gospels.

Such concepts in the New Testament as predestination, election, contradistinction of flesh and spirit, and the dualism of light and darkness and of truth and falsehood (prevalent particularly in John) are related to the theology of the Dead Sea sect. Considerable affinity also appears to exist between the early Jerusalem Church and the Qumran community in such details as their daily sacred meals and shared property. The channels through which such sectarian concepts entered Christianity are as yet obscure, but their existence appears to be certain.

OTHER MANUSCRIPTS FROM THE JUDAEAN DESERT

The discovery at Qumran was entirely unexpected. After a century of archaeological research in the Holy Land, most scholars had despaired of finding actual manuscripts. It was thought that the dampness of the winter months precluded any survival of manuscripts written on organic materials. Once the Dead Sea Scrolls had been found, however, a frenzied search commenced in the Judaean Desert, in which both Bedouin and archaeologists took part, with the Bedouin generally gaining the upper hand. In a narrow strip several kilometers wide and some eighty kilometers long, west and northwest of the Dead Sea, manuscripts were found at five sites besides Qumran. The finds date from several periods, ranging from the fourth century B.C. to the eighth century A.D. and are in several languages and scripts.

The southernmost site in the Dead Sea region at which manuscripts were found is Masada, Herod's palatial fortress famed as the site of the last stand of the Jews in their fierce struggle against Rome in the first century A.D. The arid climate of Masada preserved fourteen fragmentary scrolls—biblical, apocryphal, and sectarian.

A specifically sectarian scroll found at Masada is the Songs of the Sabbath Offerings, which reveals its identity by using the calendar peculiar to the sect. This scroll, found in a precisely dated context (A.D. 74), lends further proof for the dating of the bulk of the scrolls from Qumran.

REFERENCES: F. M. Cross, *The Ancient Library of Qumran and Modern Biblical Study*, Garden City, N.Y., 1961; G. Vermes, *The Dead Sea Scrolls: Qumran in Perspective*, Cleveland, 1978.

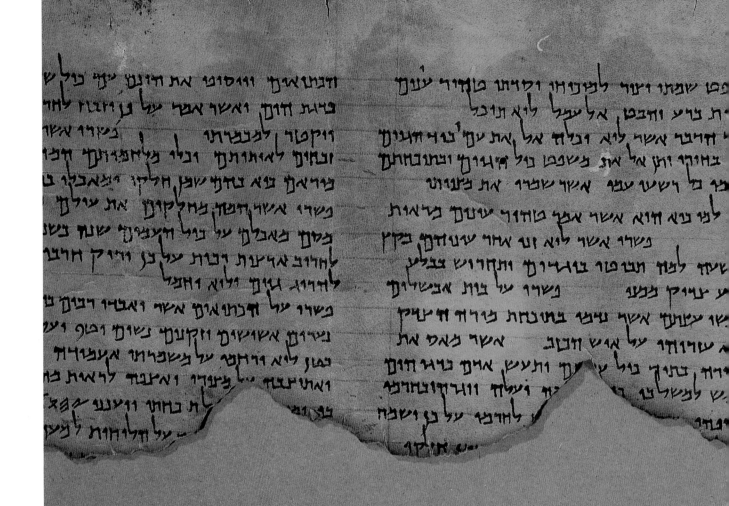

149. The Habakkuk Commentary

Copied at the end of the 1st century B.C.
13.7 × 142 cm. (5⅜ × 55⅞ in.)

The Habakkuk Commentary belongs to a literary
genre typical of the Dead Sea sect. It is not a biblical
commentary in the modern sense, but a religious
composition that interprets scripture (in this case, the
Book of Habakkuk) so as to reveal allusions to the
history of the sect, its past and future, its leaders and
adversaries. Commentaries such as these are almost
the only sources for the sect's history. As a rule, they
allude to personalities and parties by symbolical (ty-
pological) epithets such as the "Teacher of Righteous-
ness" (the sect's founder and leader); the "Evil Priest"
(the sect's archenemy); the "Seekers After Smooth
Things" (the sect's rivals, the Pharisees).

The Habakkuk Scroll was the first commentary to
be discovered, and it is the best preserved of the com-
mentaries. It has survived almost in its entirety (13 col-
umns; length 142 centimeters [55⅞ inches]), except
for the scroll's lower part and a section of column 1
that have been damaged.

One of the scroll's most interesting passages tells
of the Evil Priest's persecution of the Teacher of Righ-
teousness. On Habakkuk 2:15 ("Woe to him who
causes his neighbours drink of the cup of his wrath
and makes them drunk to gaze on their shame"), the
scroll comments: "Interpreted, this concerns the
Wicked Priest who pursued the Teacher of Righteous-
ness to the house of his exile that he might confuse
him with his venomous fury. And at the time ap-
pointed for rest, for the Day of Atonement, he
appeared before them to confuse them, and to cause
them to stumble on the Day of Fasting, their Sabbath
of repose."

149

The Evil Priest, most probably one of the early Hasmonaean kings who also officiated as High Priest, was able to attack on the Day of Atonement because the Dead Sea sect kept a different calendar from that of the rest of Israel. Their Day of Atonement was for the Evil Priest an ordinary weekday.

It should be noted that the tetragrammaton, the sacred name of Jehovah, is written in the scroll in the ancient Hebrew script.

REFERENCES: M. Burrows, *The Dead Sea Scrolls of St. Mark's Monastery 1*, New Haven, 1950, pp. xix–xxi, pls. 55–61 (facsimile and transliteration); G. Vermes, *The Dead Sea Scrolls in English*, 2nd ed., Harmondsworth, 1975, pp. 235–43 (translation).

150. The Masada Psalms Scroll

1st century A.D.
25.5 × 20.5 cm. (10 × 8 in.)
Excavations of the Hebrew University, Jerusalem, the Israel Exploration Society, and the Israel Department of Antiquities and Museums

At Masada, the tremendous rock fortress which rises some 400 meters (430 yards) above the western shore of the Dead Sea, Herod the Great (reigned 37–4 B.C.) built a luxurious palace which was also a well-defended and well-supplied citadel (figs. 73 and 74).

About a century later, at the very end of the Jewish War, Masada served as the last stronghold of the rebels against Rome. When the Romans, after a meticulously laid siege, succeeded in breaking into Ma-

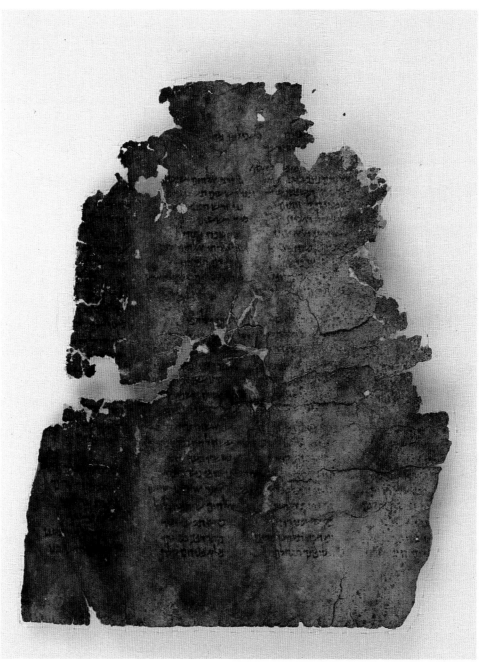

150

sada (April 10, A.D. 73 or 74), they found that the 960 defenders—men, women, and children—had chosen to commit suicide rather than fall into captivity. Two old women and five children were the only survivors.

All of the information on the history of Masada comes from Josephus's *History of the Jewish War*; there is good evidence that his detailed account is based on Roman military reports.

The site was excavated for twelve months in 1963–65 by some two thousand volunteers. The excavations, led by the late Professor Yigael Yadin, uncovered virtually the whole site—Herod's palaces, fortifications, storehouses, and living quarters, as well as architec-tural remains and small finds from the time of the Jewish War.

Fourteen manuscripts—biblical, apocryphal, and sectarian—were discovered in Masada. Besides the interest of their contents, these scrolls are of great importance as comparative material, since their date can be accurately fixed as no later than A.D. 74.

The present manuscript contains parts of the Book of Psalms, chapters 82–85. Except for one variation, the Masada Psalms are identical with the Massoretic text (*textus receptus*).

REFERENCE: Y. Yadin, *Masada: Herod's Fortress and the Zealots' Last Stand*, London, 1966, pp. 170–72.

APPENDIX I

CHRONOLOGY

PALEOLITHIC	
Lower Paleolithic	1,500,000–100,000 Before Present
Middle Paleolithic	100,000–40,000 Before Present
Upper Paleolithic	40,000–18,500 B.C.
EPIPALEOLITHIC	18,500–10,300 B.C.
NATUFIAN	10,300–8500 B.C.
NEOLITHIC	
Pre-Pottery Neolithic	8500–6000 B.C.
Pottery Neolithic	6000–4500 B.C.
CHALCOLITHIC	4500–3150 B.C.
CANAANITE/BRONZE AGES	
Early Canaanite/Bronze I	3150–2850 B.C.
II	2850–2650 B.C.
III	2650–2350 B.C.
IV	2350–2200 B.C.
Middle Canaanite/Bronze I	2200–2000 B.C.
IIA	2000–1750 B.C.
IIB	1750–1550 B.C.
Late Canaanite/Bronze I	1550–1400 B.C.
IIA	1400–1300 B.C.
IIB	1300–1200 B.C.
ISRAELITE/IRON AGE	
Israelite/Iron I	1200–1000 B.C.
IIA	1000–900 B.C.
IIB	900–800 B.C.
IIC	800–586 B.C.
SECOND TEMPLE PERIOD	
Babylonian and Persian	586–332 B.C.
Hellenistic I	332–167 B.C.
Hasmonaean/Hellenistic II	167–40 B.C.
Herodian/Early Roman	40 B.C.–A.D. 70
PERIOD OF THE MISHNA AND TALMUD	
Late Roman	A.D. 70–324
Byzantine	A.D. 324–640

THE KINGS OF ISRAEL

Saul	ca. 1020–1004 B.C.
David	1004–965
Solomon	965–928

JUDAH		ISRAEL	
Rehoboam	928–911 B.C.	Jeroboam	928–907 B.C.
Abijam	911–908	Nadab	907–906
Asa	908–867	Baasha	906–883
Jehoshaphat	867–846	Elah	883–882
Jehoram	846–843	Zimri	882
Ahaziah	843–842	Omri	882–871
Athaliah	842–836	Ahab	871–852
Joash	836–798	Ahaziah	852–851
Amaziah	798–769	Jehoram	851–842
Uzziah	769–733	Jehu	842–814
Jotham	758–743	Jehoahaz	814–800
Ahaz	733–727	Jehoash	800–784
Hezekiah	727–698	Jeroboam	784–748
Manasseh	698–642	Zechariah	748
Amon	641–640	Shallum	748
Josiah	640–609	Menahem	747–737
Jehoahaz	609	Pekahiah	737–735
Jehoiakim	609–598	Pekah	735–733
Jehoiachin	597	Hoshea	733–724
Zedekiah	596–586		

THE HASMONAEAN DYNASTY

Jonathan	152–142 B.C.
Simeon	142–134
John Hyrcanus	134–104
Aristobulus	104–103
Alexander Jannaeus	103–76
Salome Alexandra	76–67
Aristobulus II	67–63
Hyrcanus II	63–40
Matthias Antigonus	40–37

THE HERODIAN DYNASTY

Herod the Great	37–4 B.C.
Archelaus	4 B.C.–A.D. 6
Herod Antipas	4 B.C.–A.D. 39
Philip	4 B.C.–A.D. 34
Herod Agrippa I	A.D. 37–44
Agrippa II	A.D. 53–100 (?)

APPENDIX 2

SCHEMATIC DRAWINGS OF SEAL IMPRESSIONS

CAT. NO. 89. Seal of Jezebel. Inscription: "(belonging) to Jezebel"

CAT. NO. 92. Seal of Yaazanyahu, servant of the king. Inscription: "(belonging) to Yaazanyahu, servant of the king"

CAT. NO. 90. Seal of Shaphat. Inscription: "(belonging) to Shaphat"

CAT. NO. 91. Seal of Jeremiah. Inscription: "(belonging) to Jeremiah"

CAT. NO. 93. Seal of Maadana, the king's daughter. Inscription: "(belonging) to Maadana, the king's daughter"

SELECTED BIBLIOGRAPHY

AHARONI, Y. *The Archaeology of the Land of Israel: From the Prehistoric Beginnings to the End of the First Temple Period.* Translated by A. F. Rainey. Philadelphia, 1982.

AHARONI, Y. *The Land of the Bible: A Historical Geography.* Translated by A. F. Rainey. Rev. and enlarged ed. Philadelphia, 1979.

AHARONI, Y., and Avi-Yonah, M., eds. *The Macmillan Bible Atlas.* Rev. ed. New York–London, 1977.

ALBRIGHT, W. F. *The Archaeology of Palestine.* 4th rev. ed. Harmondsworth, England, 1960.

AMIRAN, R. *Ancient Pottery of the Holy Land.* Jerusalem–Ramat Gan, 1969.

ANATI, E. *Palestine Before the Hebrews: A History from the Earliest Arrival of Man to the Conquest of Canaan.* 2 vols. New York, 1963.

AVI-YONAH, M., and Stern, E., eds. *Encyclopedia of Archaeological Excavations in the Holy Land.* 4 vols. Jerusalem, 1975–78.

BEN-SASSON, H. H., ed. *History of the Jewish People.* Cambridge, Mass., 1976.

BRIGHT, J. *A History of Israel.* 3rd ed. Philadelphia, 1981.

GRANT, M. *The History of Ancient Israel.* New York, 1984.

KENYON, K. *Archaeology in the Holy Land.* 4th ed. London, 1979.

LEVINE, L. J., ed. *Ancient Synagogues Revealed.* Jerusalem, 1981.

PRITCHARD, J. B., ed. *Ancient Near Eastern Texts Relating to the Old Testament.* Princeton, 1955. Supp., 1969.

PRITCHARD, J. B., ed. *The Ancient Near East in Pictures Relating to the Old Testament.* Princeton, 1954. Supp., 1969.

VAUX, R. DE. *The Early History of Israel.* 2 vols. London, 1978.

YADIN, Y., ed. *Jerusalem Revealed.* Jerusalem, 1975.